DATE			

ERRATA

p. 27 The captions to the portraits of Mignard and Louvois
should be transposed.

p. 36 The upper plan is reversed in relation to the topography
of the site.

p. 77 The captions 'Wolf heads' and 'Faun heads' should be
transposed.

'Since there is an infinity of objects
to draw the eye in every direction, and since one
is so often puzzled to decide where one should turn next,
it is best to follow the route that I shall set out
here, so as to see each thing in the most
convenient order and without
undue fatigue.'

ANDRÉ FÉLIBIEN
In *La Description du Château de Versailles*
(Paris: chez Antoine Vilette, 1694)

STÉPHANE PINCAS

VERSAILLES

THE HISTORY OF THE GARDENS
AND THEIR SCULPTURE

Photographs by
MARYVONNE ROCHER-GILOTTE

*With 664 illustrations,
568 in color*

THAMES AND HUDSON

For Marie

'O! a cherubim thou wast, that did preserve me!'
Shakespeare, *The Tempest*, Act I, Scene 2

My thanks go to M. Pierre Lemoine, who was Conservateur en Chef of the Château of
Versailles in 1983 and encouraged me in the present project; to M. Jean Dumont, Architecte en Chef, and his
successor, M. Pierre-André Lablaude; to Mme Nadine Pluvieu; and to M. Marty and his team of gardeners.
I am also indebted to Mlle Christiane Pinatel and Mlle Raymonde de Bellaigue for their advice, and to the
Bibliothèque Municipale de Versailles. My wife, her brother Gilles Tenaille, and my friends Philippe Quidor,
Yasha David, Vincent Delloye, Alain Decruck, Patrice Cazes, Michel Reinarz, Bilal Dallenbach and Jean-Pierre
Jirou-Najou were unstinting with their help and support. Special thanks go to Fiona Cowell and to
Emily Lane at Thames and Hudson, and, last but not least, to Maryvonne Rocher-Gilotte,
whose talent has contributed so much to this study of the gardens of Versailles.

S P

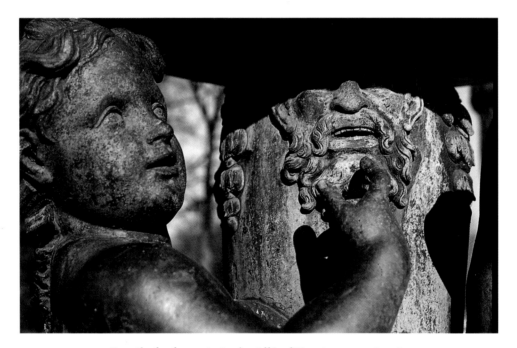

Detail of a fountain in the Allée d'Eau (see pp. 58–59)

Translated from the French, *Versailles: Un jardin à la française*, by Fiona Cowell

First Published in the United States of America in 1996
by Thames and Hudson Inc., 500 Fifth Avenue, New York, New York 10110

Library of Congress Catalog Card Number 96-60114

ISBN 0-500-01701-8

Printed and bound in France

CONTENTS

Introduction

SEVENTEENTH-CENTURY VERSAILLES exemplifies in its most perfect form the French garden, as distinct from the Italian garden which preceded it in the Renaissance and early Baroque period and from the English garden which followed it in the eighteenth century. The French garden was held in low esteem in the reigns of Louis XV and XVI, and ridiculed by the French Romantics, who thought of it as the place 'where all summer long, so many worthy families yawn away their Sundays'.[1] Even to this day, the style is undervalued by those who prefer the supposedly more natural charm of the English garden, as in Marie-Antoinette's Hameau. These detractors are echoing the celebrated critic, the Duc de Saint-Simon, who already in Louis XIV's lifetime declared that Versailles was 'the dreariest, the most unrewarding of places, without a view, without woods, without water, without earth. [The king delights in] tyrannizing over nature, holding her down under a weight of art and precious objects…[to the point that] in order to gain the coolness of the shade one must cross a vast torrid zone, terminating inevitably in a choice of steps up or down.'[2]

But the gardens of Versailles do not deserve that harsh judgment. They were the first amusement park of the modern era, offering the permanent spectacle of a variety of highly imaginative water features, scattered through the shady seclusion of the bosquets.* The rigid arrangement of formal parterres and rectilinear allées was enlivened by the glimpse of a cascade, a grotto, a *théâtre de verdure*, a maze. You could relax beside tranquil stretches of water inhabited by swans, or be diverted by statues and fountains that spoke their own allegorical language, in a constantly changing festive atmosphere.

If the gardens now speak to us less cogently it is because they have lost much of their original charm, because we see in them only the cold grandiloquence of a past age, and because, moreover, we associate them with the swarm of imitations, some more successful than others, that spread over the whole of Europe, such as Queluz in Portugal, La Granja in Spain, Herrenhausen and Herrenchiemsee in Germany, Schönbrunn in Austria, or Peterhof in Russia.

The advent of absolute monarchy in France saw the birth of the gardens of Versailles, which with those of Vaux-le-Vicomte, Chantilly, Saint-Cloud and Sceaux marked the culmination of a long tradition of formal gardening and represented a unique moment in French history.

The Baroque garden

The French garden came into being in the era known in France justifiably as the 'Grand Siècle'. In the political realm, the seventeenth century saw Europe become the amalgam of nation states that we know today, while its religious aspirations were nourished by the Baroque art created in Italy by the Counter-Reformation to the glory of the Roman Church.[3]

Absolute ruler of the richest and most populous country of Europe, Louis XIV (1638–1715) took his inspiration from this new aesthetic model, and purposely bent its message to serve his own ends. As Ernst Gombrich observed, 'the display and splendour of royalty was deliberately used' by the king in his political programme.[4] He exercised the power he acquired in this way in domestic politics to stand firm against a still restless nobility, and in foreign politics to assert the pre-eminence of his kingdom over his European neighbours.

Substituting his grandeur for the glory of the Roman Church, trumpeted in Italy by Baroque art, he first singled out a symbol with which to identify himself. He then chose a place for its display, and finally set the scene in the fêtes or entertainments in which his court was both guest and actor.

When he assumed personal control of government in 1661 at the death of Cardinal Mazarin, Louis was the living representative of the centuries-old Capetian line. During the Renaissance it had been fashionable to identify royal authority with such mythological figures as Jupiter, Hercules or Apollo, but Louis concentrated uniquely on Apollo, whose sign, the sun, he borrowed for his own glorification. Through this symbol he intended to radiate light and warmth not only to the French people but to the whole earth.

For a long time he bowed to the tradition of a perambulatory court, moving from Paris to Compiègne or from Saint-Germain-en-Laye to Fontainebleau, before finally fixing on Versailles and making his favourite residence the stage on which to enact his game of privilege.

From 1661 onwards, fête followed fête. They were especially sumptuous when they celebrated a particular event, such as the first achievements in the gardens in 1664, the end of the War of Devolution with Holland in 1668, or the reconquest of Franche-Comté in 1674 (see pp. 260–67). In 1664 *Les Plaisirs de l'Isle Enchantée* lasted three days. The fête opened with a tournament in which the whole court participated, with the king playing his part in lavish fancy dress. It continued with tilting at the ring which was won – by arrangement – by the brother of Louise de La Vallière, the king's favourite. The festivities concluded on an 'enchanted island' built on a stretch of water that later became the Bassin d'Apollon, where Louis was released from an evil spell cast on him by a sorceress. In 1668 the playwright Molière and the composer Lulli combined their talents to devise a new fête, the *Grand Divertissement Royal*. Plays and entertainments were staged in various places: on the parterres, in the allées and bosquets. Every fête concluded with fireworks which seemed to engulf the château in flames. In short, the king amused himself, and with him all the nobility of France.

But if Versailles was for the king the means to satisfy his taste for sport and spectacle, the royal residence enabled him at the same time to make a display of strong authority to his nobility. As early as 1663 he founded the Petite Académie round four well-known literary figures, including Charles Perrault, who later wrote the fairytales. Its mission was to develop the themes of royal propaganda and to concentrate all iconography on the theme of the sun. At a tournament in 1662 Louis bore a shield decorated with the sun in glory, and it was also noted that on the feast of St Louis, the king's name-day (25 August), the rays of the setting sun exactly aligned with the main axis of the gardens and lit up the palace windows.

The converging of the nobility on Versailles for all these celebrations caused some domestic problems. On the occasion of the *Plaisirs de l'Isle Enchantée* no provision had been made

*For French garden terms, see the Glossary, p. 275.

for the lodging of so many self-important people and they were forced, with a very bad grace, to sleep wherever they could. In 1668 the king prudently limited the festivities to a single day so that everyone could go home at the end. This situation induced Louis to encourage the development of the town of Versailles by exempting its citizens from taxation, and as a result private houses sprang up everywhere. At the same time, André Le Vau was enlarging the west façade of the palace, which looks out over the gardens. These were further enhanced, given increased importance by the open vistas created by the gardener André Le Nôtre and the formation of new bosquets – the Labyrinthe, Théâtre d'Eau, Salle des Festins and Salle de Bal – which rounded off the work on the Ménagerie and Orangerie. Charles Le Brun designed the statues and fountains. Evocative names were given to the bassins: Apollo, Latona, Enceladus, Flora, Ceres, Bacchus, Pluto. The vast allegorical programme of Renaissance inspiration no longer celebrated the harmony of the universe but sang a hymn of praise to the glory of the Sun King.

In 1674 the fête celebrating the recovery of Franche-Comté also celebrated a new phase of work in the gardens. This time the nobility was already in residence at Versailles, so it was possible to prolong the entertainment for three months. From 1682 the grounds of the Orangerie were doubled in size, more improvements were made to the gardens, and Jules Hardouin-Mansart – the successor to Le Vau – extended the palace by two great wings to north and south. Louis XIV installed his ministers and established Versailles as the seat of government. France was now centralized.

The Classical garden

In 1682, at the age of forty-four, Louis XIV settled permanently at Versailles. He had emerged victorious from two conflicts against Spain and the Austrian Empire; England had not fully recovered her strength after the Civil War; and Germany was still a collection of disparate states. The king had now established his power internally, and concentrated on proving himself in the European field. No longer was he dependent on the device of the sun: he had become Louis the Great. In the gardens the ascendancy of Apollo was over, and inspiration now came direct from the glory of France. One of the bosquets incorporated a triumphal arch, another – the Bosquet des Dômes – contained two pavilions decorated with trophies of arms celebrating France's victories. In a third a colonnade was erected purely as a symbol of prestige and with no mythological connotations.

Art became French, and if in spirit it still looked to the Italian Baroque, in form it became increasingly Classical. New institutions had been created to put art at the service of the state: the king founded the Comédie Française to give a base to Molière's theatre company, put Lulli at the head of the Paris Opéra, and charged the Académie with the standardization of the French language.

Running parallel with all these efforts, the presses were turning out lavishly illustrated books to publicize the fêtes to a general audience. Journals describing the sumptuousness of the festivities found their way to all the European courts, and ambassadors informed their sovereigns of events in the royal residence. Every dazzled prince wanted his own Versailles.

Now established as the cultural centre of Europe, France finally discarded her Italian model. In the early 1660s Rome had still exerted a very direct influence on garden design, and was the source from which Colbert bought statues – both originals and copies of the finest pieces like the Belvedere Apollo. A few years later, however, a new institution opened in Paris, the Académie Royale de Peinture et de Sculpture, which would enable French artists to come to the fore. So successful was this venture that by 1682 France was producing works of art comparable in beauty to anything Italian. Statuary marble replaced stone, and bronze took the place of *métail* (an alloy of various metals, at Versailles specifically of lead and tin) which up to then had been used for fountains. Moreover, while Italian gardens favoured a Mannerist sort of Baroque, in France a different style developed, in which a taste for the spectacular was tempered by moderation and harmony. Versailles had become a Classical garden.

Meanwhile, Louis XIV had aged. Fêtes which previously had been organized solely for his pleasure and that of his court now became propaganda pieces for the triumph of France. The king no longer danced in them or took an active part, leaving that role to the professionals. Colbert, the minister responsible for the early successes of the reign, had just died, as had also Louis' queen, Marie-Thérèse, who was replaced at Versailles by Madame de Maintenon. Molière too was dead, and Le Brun was shortly to be disgraced. It was the end of fantasy, of *joie de vivre*, of the freedom which was manifest even in the effects of surprise devised for the bosquets.

Louis XIV turned to Hardouin-Mansart, who gave the gardens a simplicity bordering on rigidity by cutting new paths and removing from certain bosquets features that required a great deal of maintenance. In fact, expensive new wars were forcing the king to make sacrifices. The new wings of the palace were costly, and so too was supplying the fountains with water. A great reorganization was undertaken, with a resulting loss of variety in the gardens as they evolved towards the lighter Rococo style of the next century.

This slow transformation gathered momentum after the king's death in 1715. His successor Louis XV was less interested in gardens, and at the same time the vogue for the English garden was gaining ground. Louis XVI, who came to the throne in 1774, and his Queen Marie-Antoinette started to modify the gardens in line with the new fashion, and after the interlude of the Empire, when Napoleon wanted to replace the whole layout with a park celebrating his military victories, Louis XVIII returned briefly to the idea of an English garden. His influence remains in a single bosquet, the Jardin du Roi.

The gardens of Versailles have had a rich and complex existence. In their present form one can still discern all the changes of fortune they have endured, and feel the nostalgic mood of the Romantic era mingling with the evergreen memory of the century which created them.

'*The palace of Louis XIV speaks solely of the power of a sovereign and a political regime.*'

PIERRE DE NOLHAC
Introduction to *La Création de Versailles* (1901)

Versailles enjoyed two centuries of greatness during its existence as a royal palace: from the acquisition of the seigneury by Louis XIII in 1632 to its transformation by Louis-Philippe in 1833 into a 'national museum dedicated to all aspects of the glory of France'. Pierre de Nolhac, Curator from 1892 to 1919, restored the magnificence of the buildings, while at the same time the landscape architect Henri Duchêne was bringing the style of the French garden back into fashion.

Boxwood (*Buxus sempervirens*)
The importance of plant material in garden design must not be underestimated, and each of the three sections into which this work is divided will be preceded by an introduction to one of the three main species most characteristic of the French garden: box, yew and hornbeam. Only in box could the crisp elegance of the parterres be realized, especially the *parterres de broderie* which the royal gardener Claude Mollet the elder made fashionable at the beginning of the seventeenth century. Formed of scrolls and arabesques, with the pattern heightened by different background colours (white gravel, black pounded slate, or red crushed clay tile), these 'embroideries' of box gradually took the place of the earlier borders of lavender, rosemary or myrtle (probably sweet gale, *Myrica gale*), which had to be replanted every three years. The foliage of box has a pungent odour, but the plant has the advantage of being long-lived and easy to clip.

I
THE GARDEN IN FRANCE

The evolution of the French garden

The evolution of Versailles

The layout of the gardens

The evolution of the French garden

Renaissance gardens

THE WORDS 'garden' and '*jardin*' both come from the Germanic *gard*, whose Indo-European root, in common with that of the Latin *hortus*, designates an enclosed space. When the Greeks, and following them the Romans, wanted to describe a particularly magnificent garden they used the word 'paradise', a term borrowed from ancient Persia where it meant a royal enclosure or park.[5] While the medieval garden remained little more than an enclosure, that of Versailles may truly be considered a paradise. In France, the transition from the earlier to the later garden ideal was a very gradual process.

Every continent, every era has taken pride in its own form of garden. Since the end of the Middle Ages, modern Europe has seen three great movements in garden history and has identified with three versions of paradise: the Italian garden, the French garden and the English garden. The Italian garden of the Renaissance was the inspiration for the French garden, which was perfectly in tune with the spirit of the seventeenth century.

As the Renaissance drew Europe out of the Middle Ages, so it drew the garden back to the tradition of the gardens of Antiquity and away from the utilitarian role to which it had been relegated. Following the *pax romana* and the first centuries of Christianity, the Germanic invasions gave rise to a long period of insecurity. Enclosed within the safety of a monastery, gardens merely supplied provisions: medicinal herbs, fruit and vegetables, a few flowers for the altar. Italy was the first country to experience anew the art of gracious living, and to rediscover a taste for the pleasure garden. In his *Opus ruralium commodorum*, written at the dawn of the fourteenth century, the Italian Pietro de' Crescenzi made a distinction between the utilitarian garden of the ordinary man and that of a great lord, which was primarily for pleasure.[6] As André Chastel observed, 'The Renaissance intellectual, in common with the prince and the merchant, was deeply aware of the charm of a garden; it embodied for him the beneficence of nature, and the quality of happiness to be found there could be described only by reference to Eden.'[7]

Eden and paradise – the words are synonymous. In the next century the writings of Leon Battista Alberti and the humanist Francesco Colonna prepared the way for the first Italian paradises.[8] In this classic moment of the Renaissance, a new harmony was created between garden, dwelling and site, heightened by a symbolic decoration of which the sole purpose was to extol nature and glorify the universe.

In the fourteenth and fifteenth centuries there were already famous gardens in France, such as those of Robert d'Artois at Hesdin, of King Charles V in Paris, or of René d'Anjou in the Loire Valley and in Provence. But it was not until the sixteenth century that the château could put aside its defensive function, and its *seigneur*, drawing on Italy for inspiration, could start to imitate her gardens.[9]

However, the medieval tradition of the enclosed garden was slow to fade. Another century would pass before French garden design first assimilated and then finally threw off the constraints of its Italian model, and revealed its remarkable ability to create the new paradise of the *jardin à la française*, with Versailles marking the apogee of the style. For in spite of similarities, France was not Italy. Châteaux and gardens were already in existence, and had to be transformed and rearranged. The landscape was also different: in France the terrain was more open and less rugged, with an abundance of rivers and ponds. These conditions were conducive to a new breadth of style, with schemes of considerable originality for the use of water.

Garden decoration nevertheless long continued to owe much to Italy, with the idea of pleasure only slowly gaining ground over utility. To quote André Chastel again, 'The finest achievements of the sixteenth century lay in the development of a site into a unity of architecture and garden. It is these ambitious compositions…that give us the most revealing insight into the spirit of the age. They embody everything: the social prestige of luxury allied to control of the land and to a new use of plants and planting, for which the terraces and the display of water provided a spectacular setting. The complete freedom of architectural composition could accommodate all the caprices of the illustrious owners.'[10]

Now vanished or altered out of recognition, these French Renaissance gardens can be explored only through the drawings and engravings of Jacques Androuet du Cerceau the elder (reproduced here on pp. 11–13), who published *Les Plus excellents bastiments de France* in 1576 and 1579.

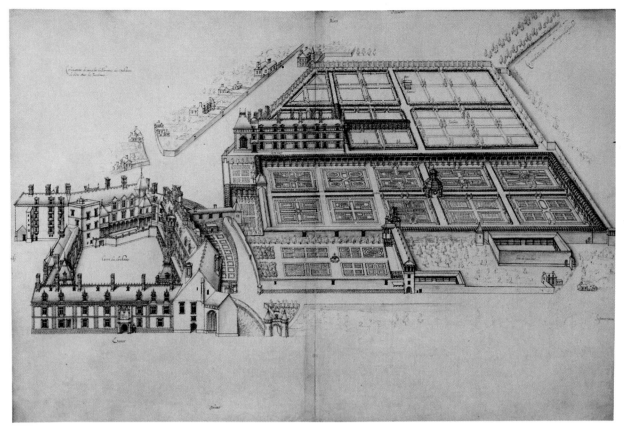

Blois

At Charles VIII's Amboise the gardens were inside the fortifications and were composed of square beds planted with basil, camomile, hyssop, marjoram, parsley, sage, daisies, thyme, sorrel, lavender, rosemary and 'myrtle' or sweet gale, combining utility with pleasure.

At Blois, although the gardens were still walled and separate from each other, they now rose in three terraces outside the fortifications. Next to the first garden lay a second, much larger, which was girdled with *berceaux* and soon included a space for orange trees with a wooden shelter for the winter – probably the first orangery in France. On the higher level an even larger garden contained the *potager*, or kitchen garden.

'Paradise on earth!' This enthusiastic response to Italian gardens by Charles VIII marks the point of departure for the Renaissance garden in France. On his return in 1494 from a military campaign in Naples, the king had the garden redesigned at his residence of Amboise in the Loire Valley.

Shortly afterwards this was emulated by his successor Louis XII at Blois, and by his ministers Georges d'Amboise at Gaillon and Florimond Robertet at Bury. Although those gardens were still modest enclosures hugging the château walls, they had escaped outside the fortifications and were able to expand. They were as yet confined inside walls of their own and independent of each other, but soon they would be interconnected and then linked to the château itself.

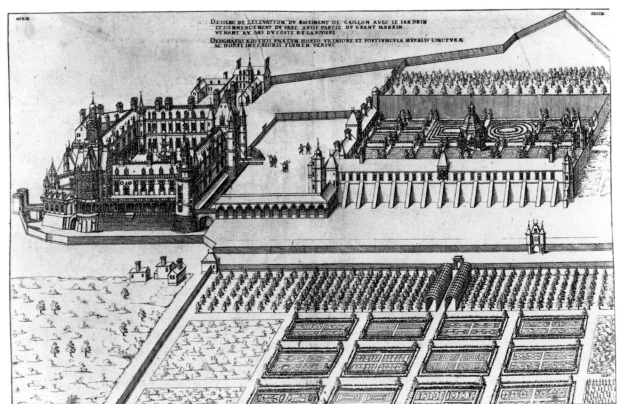

Gaillon

The location of the château of Gaillon, as of Blois, had been dictated by strategic considerations, and the steepness of the site did not lend itself readily to a harmonious garden composition: the different elements were walled, and independent of the château as well as of one another.

Not until some years later, at the completely new residence of Bury, were the gardens directly linked with the building by a double flight of steps.

Fontainebleau

In 1528 François I ordered the transformation of the royal fortress 55 kilometres (34 miles) south of Paris. Fontainebleau has a view to the south over an artificial lake, the Etang des Carpes, and although the different parts of the garden were still separated they were nevertheless organized round this great piece of water. To the west was the Grand Jardin, bordered by canals; to the east lay the Jardin des Pins, which was given a grotto in 1543; to the north an enclosed garden, the Jardin des Buis, was decorated with the first antique casts brought back from Rome – exemplifying the influence of the Italian Renaissance in the choice of ornament.

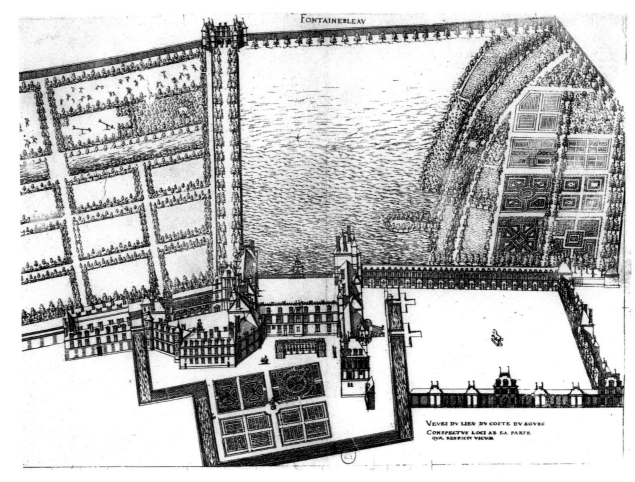

In 1515 François I succeeded Louis XII. Italy held the same fascination for him, but he transferred his interest from the Loire Valley to the Ile-de-France, where his residences of the Château de Madrid near Paris, Saint-Germain-en-Laye, Villers-Cotterêts and Fontainebleau were all in turn altered by Italian artists.

By the mid-century the foreigners had been succeeded by the first French architects, Philibert Delorme and Jacques Androuet du Cerceau the

elder. Starting from Italian principles, they adapted their garden designs to the limitations of the site and incorporated into them the water that was so characteristic of France.

The death of Henri II in 1559 was followed by the troubled period of the Wars of Religion. During this time, against a backdrop of massacres, princes and nobles vied with each other in magnificence as they manoeuvred for power. Their residences became theatres for

Anet

In 1547 the Italian architect Sebastiano Serlio, who had just given Ancy-le-Franc a garden axially aligned with the château, was replaced by Philibert Delorme as Director of the Bâtiments du Roi (the royal building administration).

Delorme was appointed by Henri II, son and successor of François I, to transform the residence of his mistress Diane de Poitiers at Anet. Here he took up Serlio's principle of axiality and integrated the buildings, canals and gardens into a harmonious whole, which he further embellished with an ornamental scheme based entirely on the cult of the goddess Diana.

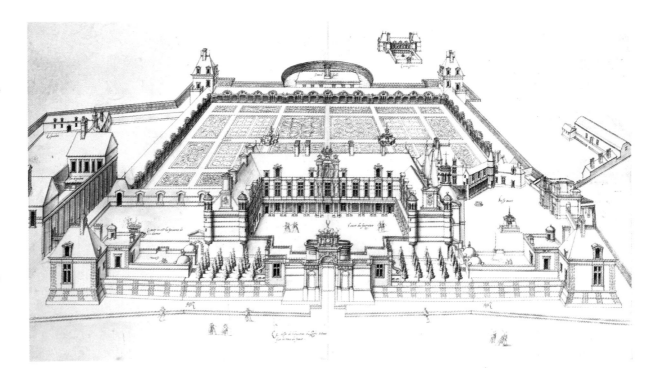

sumptuous fêtes, whose ephemeral staging
gradually crystallized as permanent decoration.
Bernard Palissy gives an idea of the brilliance of
some of these settings in his 'design for a
delectable garden'[11] and his projects for grottos
made of glazed earthenware, with plant and
animal decoration in naturalistic colours. The
scale of these gardens found a new expression
in the '*parterre*', a word coined by Jean
Liébault to describe a flower garden in his 1564
translation of Charles Estienne's *Praedium
rusticum*.[12]

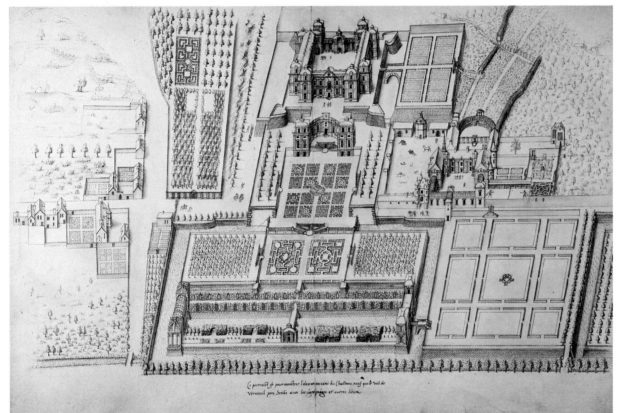

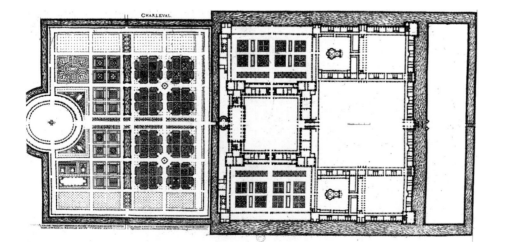

**Verneuil-sur-Oise and
Charleval-sur-Andelle**

These two houses, probably
both designed by Jacques
Androuet du Cerceau the elder
himself, no longer exist, but the
variety in the new gardens can
be judged from du Cerceau's
illustrations.

Verneuil, situated north of
Paris on an escarpment above
the valley of the Oise, was
started in 1558 by Philippe de
Boulainvilliers and continued
for the Duc and Duchesse de
Nemours. A suite of terraces
was centred on the axis of the
house and surrounded by moats
(dry above and wet below); an
upper parterre led to a second,
with flanking bosquets, which
led to transverse walks set
beside two parallel canals.

Charleval, near Rouen, was
built for the second son of
Henri II, the future Charles IX,
after whom it was named. While
it was never finished, the design
– comprising three islands
surrounded by canals, on a level
site – foreshadows the
integration of parterres with the
house characteristic of the vast
compositions of the following
century.

The first Baroque gardens

A T THE END of the sixteenth century Europe
entered the Baroque age. In France Henri
IV succeeded his cousin Henri III, who in turn
had succeeded his brother Charles IX. The
kingdom at last enjoyed a period of peace and
prosperity, favourable to agriculture. In his
Théâtre de l'agriculture et mesnage des champs
(1600), Olivier de Serres extolled the wisdom of
prudent management of landed estates. The
nobility began to turn their châteaux into
'noblemen's houses set in the country',[13] and
they were soon followed by a wealthy merchant
class for whom the purchase of a fief became a
quick road to ennoblement. Around Paris the
countryside began to be marked by a number of
vast estates, in which the pleasure garden was
integrated with the surrounding landscape. But
for the nobility the desire to shine had not been
extinguished.

The source of inspiration for garden
decoration at this time was Mannerism, the
style which in Italy succeeded the Renaissance.
This was expressed in a recherché exaggeration
of the spectacular, described in 1615 by the
French engineer Salomon de Caus in his
*Raisons des forces mouvantes avec diverses
machines tant utiles que plaisantes auxquelles
sont adjoints plusieurs dessins de grottes et
fontaines*. But if the art of hydraulics was now
associated with that of architecture, a new
profession was claiming its place in the
ensemble of the garden: the age of the gardener
had dawned.[14]

Gardeners had had their own guild since
1599, and in a profession which became
hereditary, dynasties were founded. Taking
advantage of the latest developments in the
science of topography and armed with
graphometer and protractor, they had no
difficulty in reproducing their designs on the
ground and became the new masters of the
garden.

In the reign of Louis XIII (1614–43), son and
successor of Henri IV, the first versions of the
French garden began to appear. The new
professional gardeners, who were both freer
than architects in their practice and at the same
time more closely bound to tradition, added to
the achievements of the French Renaissance
garden the extravagances of Mannerism.

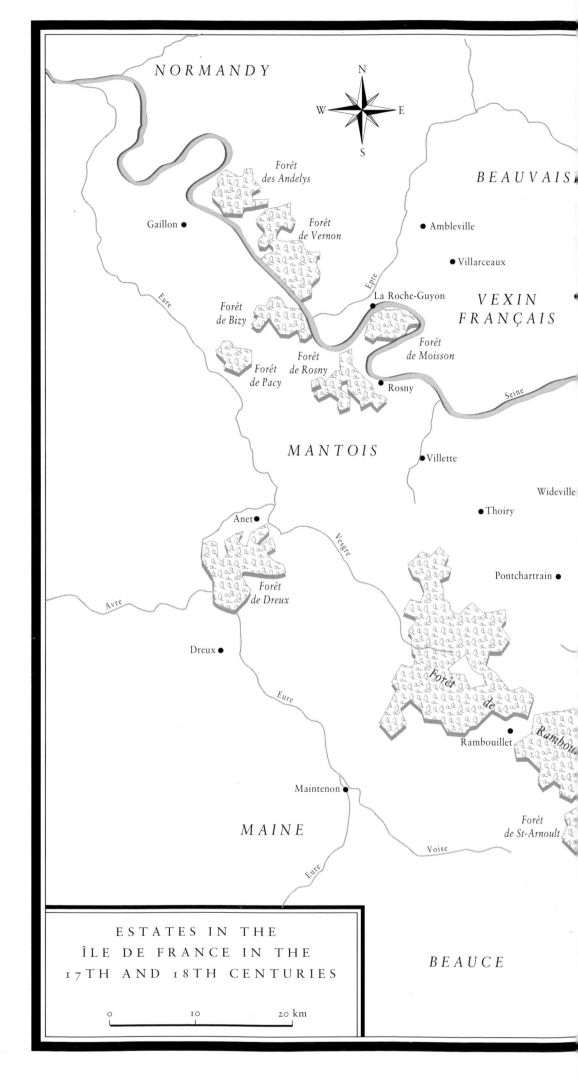

ESTATES IN THE
ÎLE DE FRANCE IN THE
17TH AND 18TH CENTURIES

0 10 20 km

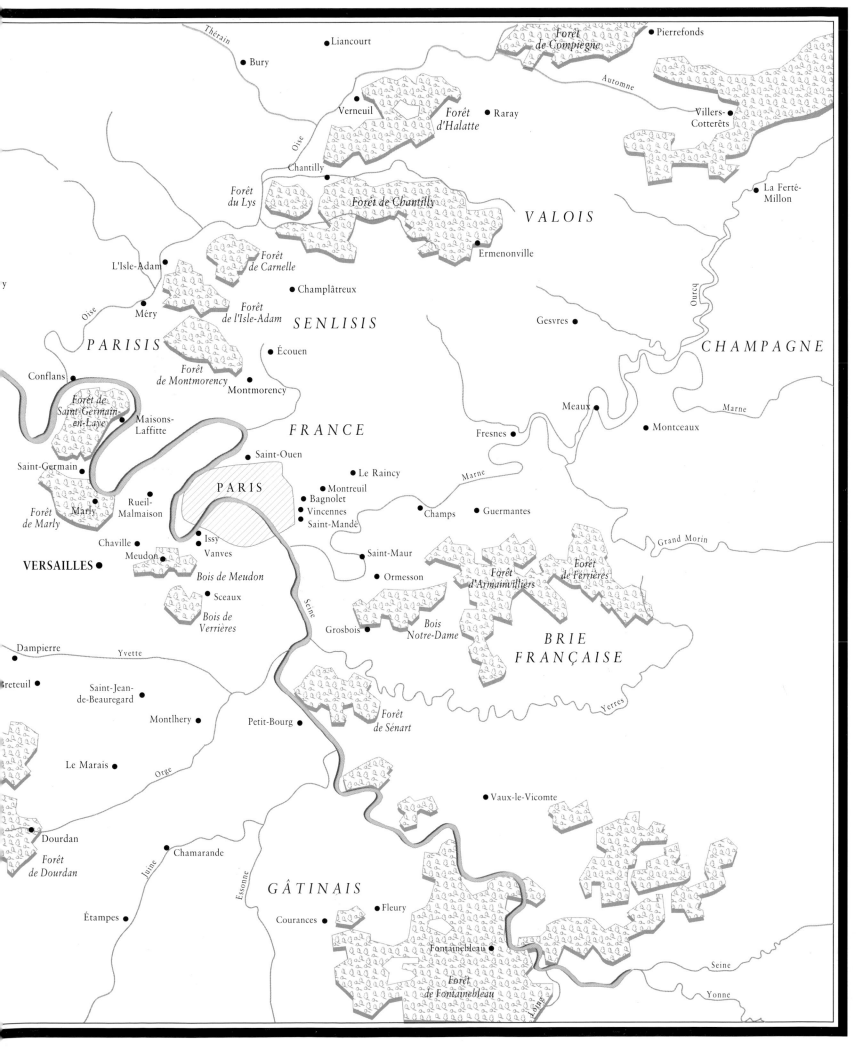

Thérain

• Liancourt

Forêt de Compiègne

• Pierrefonds

• Bury

Oise

• Verneuil

Forêt d'Halatte

• Raray

Automne

• Villers-Cotterêts

Chantilly •

Forêt du Lys

Forêt de Chantilly

V A L O I S

Ourcq

• La Ferté-Millon

L'Isle-Adam •

Forêt de Carnelle

• Ermenonville

y

Oise

• Méry

Forêt de l'Isle-Adam

• Champlâtreux

S E N L I S I S

• Gesvres

C H A M P A G N E

P A R I S I S

• Écouen

Forêt de Montmorency

• Montmorency

• Meaux

Marne

Conflans •

Forêt de Saint-Germain-en-Laye

Maisons-Laffitte

F R A N C E

• Fresnes

• Montceaux

Saint-Germain •

• Saint-Ouen

• Le Raincy

Marne

Forêt de Marly

Marly •

Rueil-Malmaison •

• Montreuil
Bagnolet •
Vincennes •
Saint-Mandé •

• Champs

• Guermantes

Grand Morin

Chaville •

P A R I S

• Issy

• Saint-Maur

Forêt d'Armainvilliers

Forêt de Ferrières

Meudon •

Vanves •

Bois de Meudon

• Ormesson

VERSAILLES •

• Sceaux

Bois de Verrières

Grosbois •

Bois Notre-Dame

B R I E F R A N Ç A I S E

Dampierre •

Yvette

Seine

Breteuil •

Saint-Jean-de-Beauregard •

Yerres

Le Marais •

Montlhery •

Petit-Bourg •

Forêt de Sénart

Orge

Étampes •

• Vaux-le-Vicomte

Dourdan •

Chamarande •

Forêt de Dourdan

Juine

G Â T I N A I S

Essonne

Courances •

• Fleury

Fontainebleau •

Seine

Forêt de Fontainebleau

Loing

Yonne

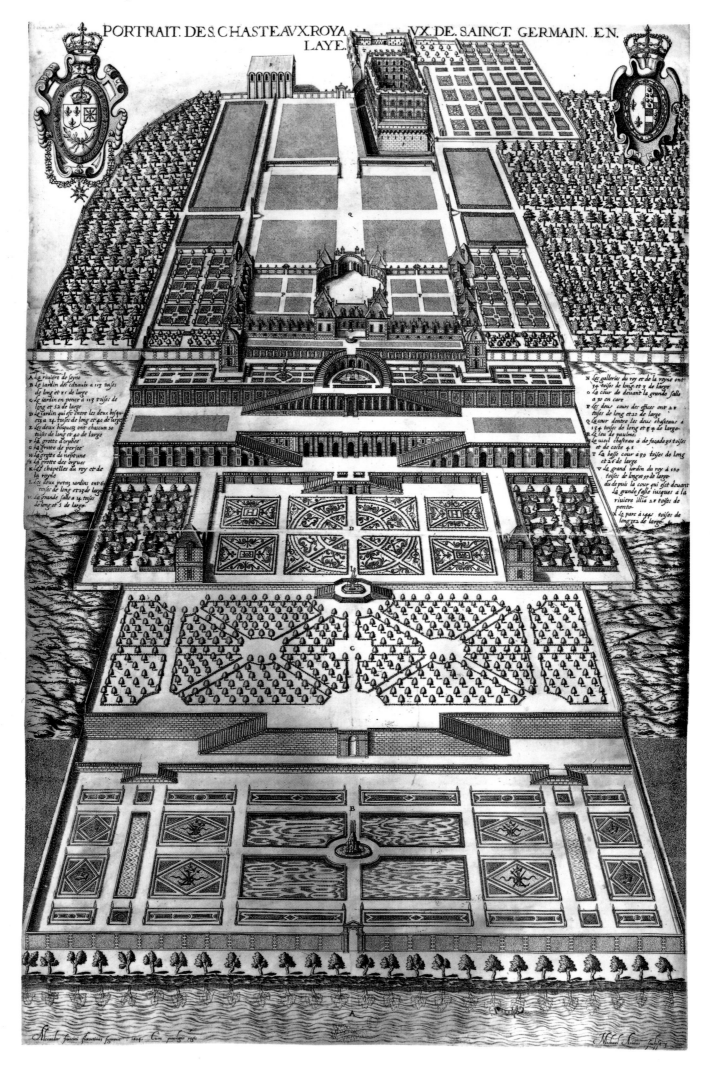

PORTRAIT. DES. CHASTEAVX. ROYA VX. DE. SAINCT. GERMAIN. EN.
LAYE.

Saint-Germain-en-Laye

Looking out from a height above the Seine 20 kilometres (12 miles) west of Paris, Saint-Germain-en-Laye represents the link between the Renaissance garden and the French garden. In 1594 Henri IV appointed Etienne Dupérac to resume a project already started by Philibert Delorme in the reign of Henri II, and build a new château to the east of the old one. The building (of which nothing remains today) crowned a monumental perspective of six terraces, with the retaining walls of the second and third levels pierced by five grottos, given the evocative names of 'Neptune', 'Dragon', 'Maiden playing the organ', 'Orpheus', and 'Perseus and Andromeda'. These were devised in 1598 by the brothers Tommaso and Alessandro Francini, hydraulic engineers or 'fountainers', who had been sent from Italy for the king and whose family name – gallicized as Francine – appears with distinction in the records of the Intendance des Eaux et Fontaines at Versailles. This view was drawn by Alessandro Francini in 1614.

**Jacques Boyceau
de La Barauderie** (*c.* 1560–1636)

Boyceau was not an architect or a gardener, but a gentleman in the service of Louis XIII. He was appointed Contrôleur des Jardins du Roi, and was the first theoretician of the age on the subject of gardens. Two years after his death, in 1638, his nephew and successor Jacques de Menours published his uncle's *Traité du jardinage selon les raisons de la nature et de l'art*, in which Boyceau defined the spirit of the French garden of the future, and drew the first portrait of the ideal gardener: 'Just as we choose young trees for our gardens … so let us employ a young boy, healthy and good-humoured, the son of a good worker … we shall teach him reading and writing, … drawing, … geometry for his plans, … architecture, … and arithmetic for the calculation of expenses which may pass through his hands.' Boyceau also designed the parterre in front of Louis XIII's hunting lodge at Versailles (ill. p. 79 top). (After A. De Vries, 1638)

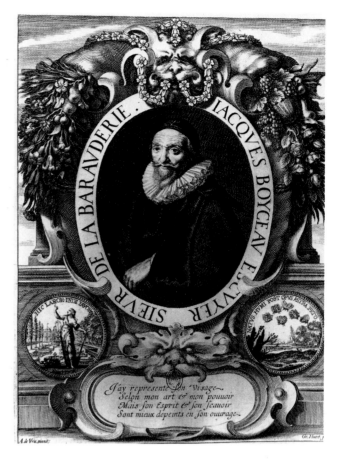

Claude Mollet the elder
(*c.* 1563–*c.* 1650)

Mollet, Boyceau's contemporary, was in charge of the gardens of Saint-Germain-en-Laye, the Tuileries and Fontainebleau. From 1615 he composed his *Théâtre des plans et jardinages*, on a more practical than theoretical level, which complemented Boyceau's work. He was the son of a gardener and marks the transition from practising gardener to designer of gardens, but it was his son André, attached to the Swedish court, who first demonstrated the skill of this new breed in his *Jardin de plaisir* of 1651. (After Michel Lasne, 1652)

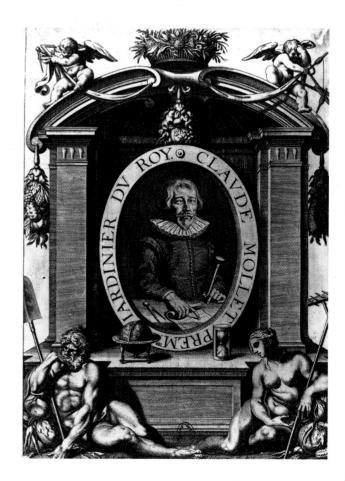

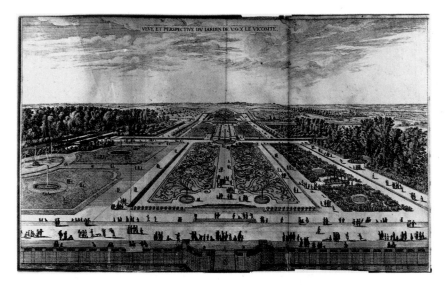

VEÜE ET PERSPECTIVE DU IARDIN DE VAVX LE VICOMTE.

'Jardins à la française'

COUNTRY SEATS multiplied round Paris in the first half of the seventeenth century. Over fifty great houses, most notably Rueil, Wideville, Liancourt, Maisons and Petit-Bourg, displayed their own version of the effect of Italian Mannerism on the tradition of French gardening. Everything was in place for the arrival of the first great *jardin à la française* or truly French garden, Vaux-le-Vicomte.

Vaux was conceived for Nicolas Fouquet, Surintendant des Finances during the regency of Anne of Austria, widow of Louis XIII and mother of the future Louis XIV. In 1656 Fouquet had his residence enlarged and altered by three artists attached to the service of the Bâtiments du Roi: the architect Le Vau, the painter Le Brun and the gardener Le Nôtre. When Louis took power in 1661 Fouquet was imprisoned, and the gardens of Vaux were left in their original state. After a long period of neglect, they were re-created in the nineteenth century by Henri Duchêne, and bear witness to the purest spirit of a French garden.

Vaux: the gardens seen from the château

All the characteristics of the French garden of the age of Louis XIV are already present. Vaux was Le Nôtre's first commission but already bore the marks of his genius: the composition was skilfully adapted to the site, and was of a rich formality which provided a splendid setting for the château while also introducing elements of surprise.

On a slightly sloping site, a great succession of terraces unrolls along a north-south axis which passes through the centre of the building. The vista stretches continuously to the horizon from a vast space in front of the façade of the château (foreground), off which three parterres open out: *de broderie* in the centre, *de gazon* to the east (left) and *à fleurs* to the west. This first section of the garden is closed by a round bassin flanked by two canals on the first of the transverse axes.

Beyond is a great *parterre de gazon* bisected by an *allée d'eau* which leads to a square bassin called the Grand Miroir. Beyond that, the second transverse axis is formed at a lower level by the river transformed into a canal.

The retaining wall on the far side of the canal is ornamented with grottos. Above that is a terrace, decorated with a single jet of water, which leads to an expanse of grass at the end of which stands a colossal statue of the Farnese Hercules. This closes the perspective of the gardens. (Engraving by Israël Silvestre)

Vaux: the château seen from the gardens

The statue of Hercules which closes the view from the château offers the best position from which to look back at the entire layout of the gardens. The prospect in this direction reveals the wall of cascades beyond the canal, while the château appears to float above the parterres. (Engraving by Israël Silvestre)

Marly

Contrary to popular belief, the discipline of design characteristic of the French garden does not entail either uniformity or monotony. Responding to the demands of the site and to his patrons' wishes, Le Nôtre gave individuality to each of his gardens – to the Tuileries as to the Luxembourg in Paris, Saint-Germain-en-Laye, Saint-Cloud, Chantilly, Sceaux, Meudon and indeed to Versailles.[15]

Marly, Louis XIV's new toy after he had finished the great works at Versailles, is one of the last examples of the French garden and in the simplification of its overall layout already foreshadows the English garden of the eighteenth century. Enclosed in a narrow valley between Versailles and Saint-Germain-en-Laye, Marly was built in the 1680s by Hardouin-Mansart, who also supervised the gradual construction of the gardens. They were laid out along a great north-south axis, marked at one end by a monumental cascade built in 1697–99 in the form of water-steps descending almost to the house itself.

The king reserved the central building for his private use, while in front on either side a succession of terraces were framed by twelve pavilions to accommodate guests. The château represented the sun, and the pavilions stood for the twelve months of the year. This view by Pierre-Denis Martin was painted in 1724.

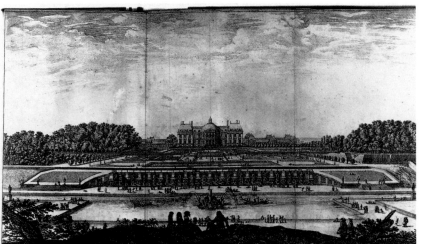

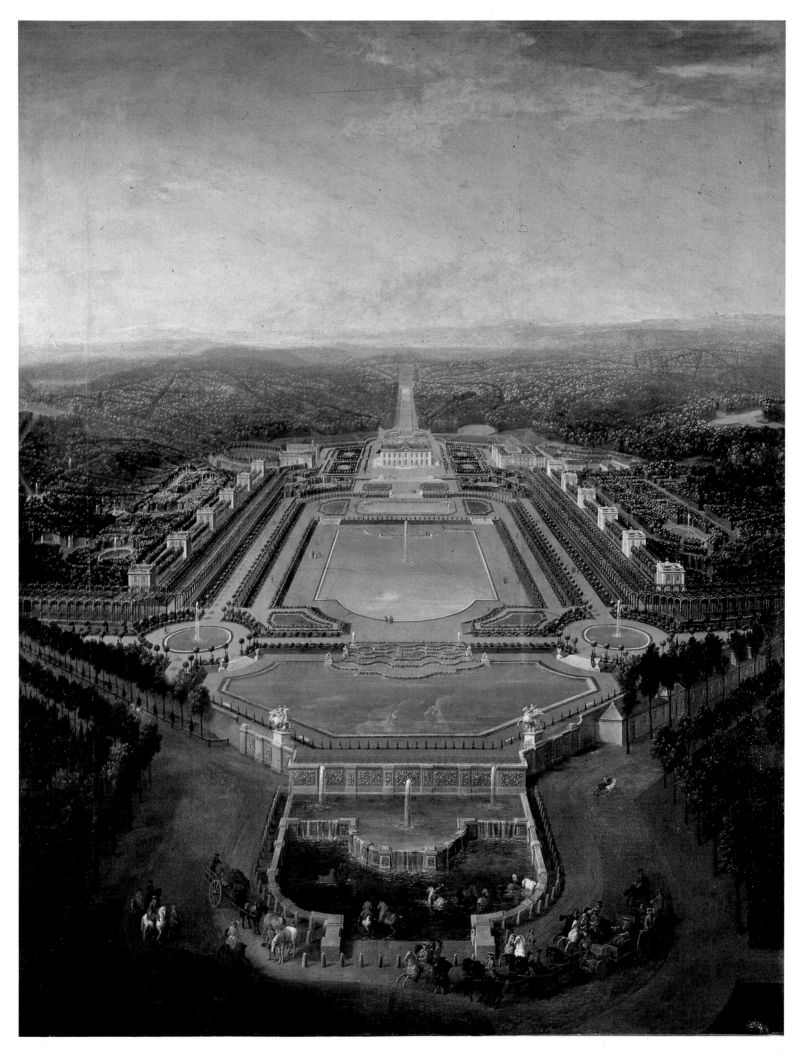

The evolution of Versailles

Versailles-au-Val-de-Galie
The seigneury of Versailles, 15 kilometres (9 miles) west of Paris and 10 kilometres (6 miles) east of Saint-Germain-en-Laye, consisted of a rabbit-warren, meadows, cultivated fields, several marshy ponds and a house north of a village, Versailles-au-Val-de-Galie, which at the beginning of the seventeenth century had only a few hundred inhabitants. This map by Jean Boisseau, of 1643, shows the position of Versailles (lower left) in relation to Paris (centre right).

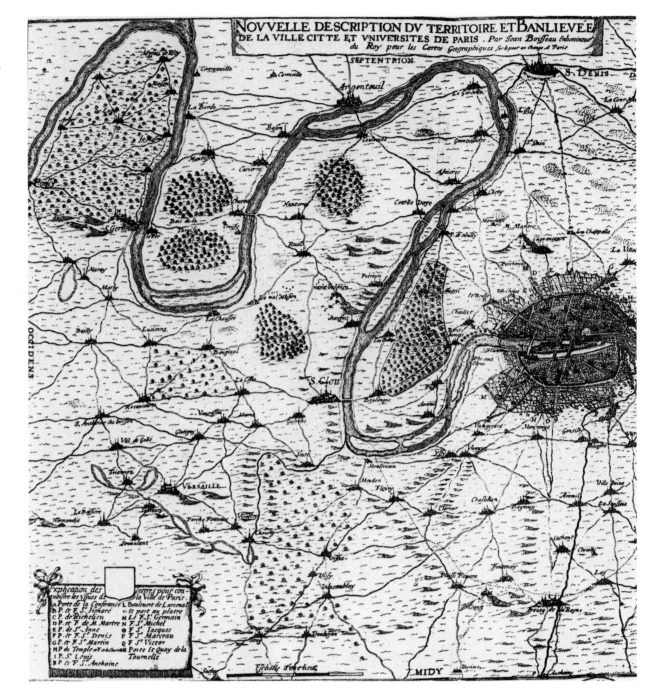

The seigneury of Versailles

VERSAILLES was a latecomer among royal residences. Fontainebleau, Saint-Germain-en-Laye and Villers-Cotterêts had large and often already altered gardens when Versailles was still only a modest seigneury.

The property was acquired in 1561 by Martial de Loménie, Secrétaire des Finances under Charles IX. In 1575 he sold it to the favourite of the Queen Mother Catherine de Médicis, the Maréchal de France Albert de

Gondi, in whose family it remained for sixty years although it was rarely visited.

In 1589 a reception was held there for the King of Navarre, who as Henri IV succeeded Henri III, his cousin and brother of Charles IX. The new king often went hunting at Versailles, which was conveniently close to his residence of Saint-Germain-en-Laye. His descendants inherited his love of the open air, his taste for the hunt, and his interest in Versailles.[16]

Louis XIII's hunting lodge

In 1614 Louis XIII came of age and succeeded his father Henri IV. He had first gone hunting at Versailles in 1607 when he was only six years old and returned there regularly, eventually buying the warren in 1622, followed the next year by some of the surrounding land, paid for from his personal funds.

To the north-west of Gondi's house he built a hunting lodge on a small hill 140 metres (460 feet) high formerly occupied by a windmill. In 1631 the lodge was enlarged by the architect Philibert Le Roy, and in the following year Louis XIII finally acquired the remainder of the domain and became the new *seigneur* of Versailles. In 1636 he surrounded his property with a wall and laid out a park, comprising a simple *parterre de broderie* (ill. p. 79, top) and a large extent of woodland, which covered the same area as the gardens do today. At the king's death in 1643 Versailles became crown property attached to Saint-Germain-en-Laye. Eight years later his son, the future Louis XIV, went hunting there in his turn. He was thirteen and had just come of age.

Versailles appears (at the left) with other royal residences in a detail of a map of 1652 by Jacques Gomboust.

Louis XIV's Versailles

A LTHOUGH he was crowned in 1654, Louis XIV visited Versailles to hunt only once or twice a year before 1661, when he officially assumed power and started to take an interest in his father's residence.

Louis' predeliction for Versailles was opposed by Jean-Baptiste Colbert, who two years later wrote to him, 'Nothing shows the greatness and judgment of princes more than what they build...how sad that the most illustrious of kings should be measured against the yardstick of Versailles...this place is more fit for Your Majesty's pleasure and amusement than commensurate with your glory.'[17] However, the king's attachment did not waver: although Versailles was still only an unassuming country residence, he bought more of the surrounding land, made additions and improvements to the house, and visited it ever more frequently. Scarcely twenty years later he decided to make it his permanent residence and the seat of his government, and in the intervening period he had transformed the modest park into a magnificent French garden. Conceived initially for his personal entertainment and that of his court, it soon evolved into the instrument through which to dispense privilege and wield power.

At first, in line with the tradition of a pleasure garden, it followed the Italian fashion of the previous century by taking its inspiration from classical mythology. Like others before him, Louis XIV chose the sun for his emblem. In the *Mémoires* which he composed for his son, the king wrote that the sun 'by the light which it lends to other stars,...by the just and equal division of that light,...by the good which it does everywhere, ceaselessly and uniformly bestowing life, joy and activity,...by its constant and invariable course from which it never strays nor turns away, is assuredly the most fitting likeness of a monarch'.[18] Having assumed the role of the Sun of France,[19] Louis filled the gardens with images of himself in the guise of the god Apollo, giver of light. The Apollonian mythology of the creation of the world was applied to the reign of Louis XIV by his artists, drawing supplementary imagery from Ovid's *Metamorphoses*.

The second phase of the gardens began on 6 May 1682, when the court was installed at Versailles, with the king and his kingdom at the height of their glory and power. From that moment the iconography reflected the past

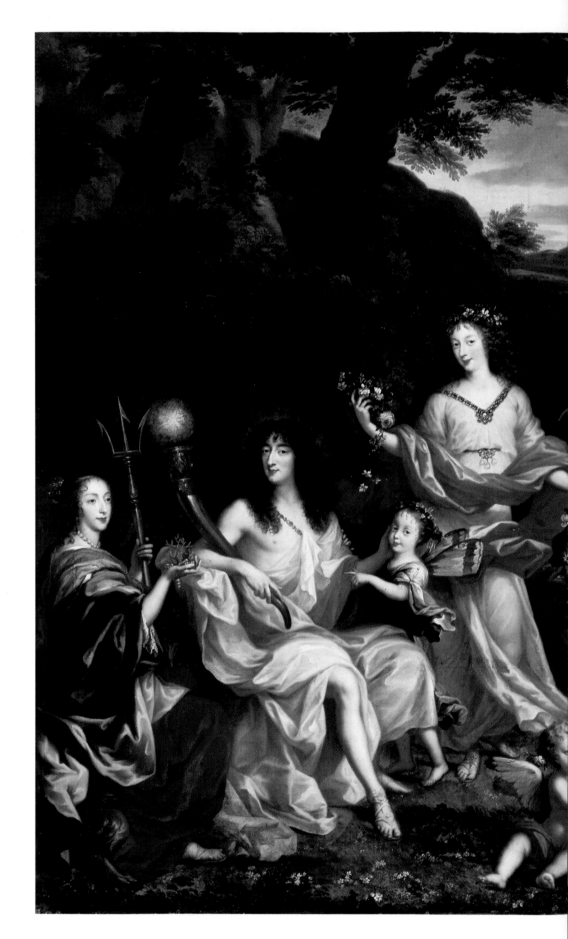

and present achievements of France, and the victorious monarch replaced Apollo and the fables of antiquity. The Sun King had become Louis the Great.[20] After overcoming the military might of Spain and the Austrian Empire, France then took from Italy the artistic supremacy she had enjoyed for so long.

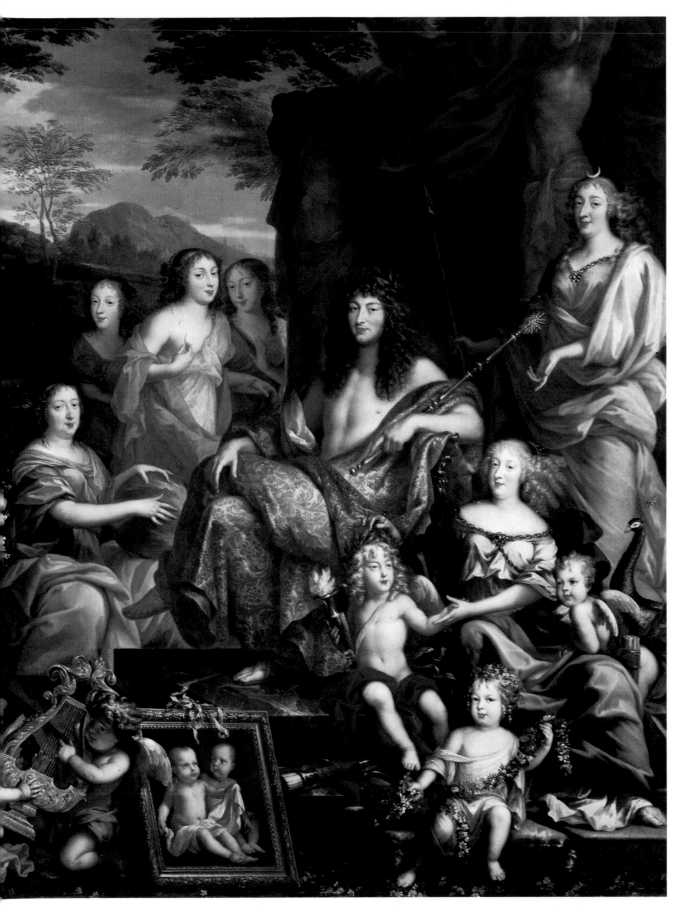

The Assembly of the Gods

This group portrait of the royal family by Jean Nocret (1670), commissioned for Saint-Cloud by Louis XIV's only brother, Philippe d'Orléans, echoes the iconography of the gardens in representing the members of the family as deities of the classical pantheon and in evoking the daily course of time centred on the sun.

Seated in the middle is the Queen Mother, Anne of Austria, in the guise of Cybele, mother of the gods. At the left, Philippe d'Orleans holds the morning star which signals the rising of the sun. (To his right, holding symbols of the sea, is his wife Henrietta, daughter of Charles I of England.) Louis XIV dominates the picture as Apollo, symbolizing the sun. At his feet are his wife, Marie-Thérèse of Spain, as Juno, and their son, the Dauphin Louis, as a laurel-crowned Cupid. Finally on the far right, Louis' cousin Anne-Marie d'Orléans, Duchesse de Montpensier (the 'Grande Mademoiselle'), wears the crescent moon of Diana who brings the day to a close.

Country retreat

In 1661, when Louis XIV assumed control of government and started to take an interest in Versailles, he was in his early twenties. At first he would come over from Saint-Germain-en-Laye or Fontainebleau for short stays to hunt or organize fêtes, but then he brought in the team of artists who had worked on Vaux-le-Vicomte, calling on Le Vau to transform the château and improve its dependencies, Le Brun to devise a fitting decorative scheme, and Le Nôtre to design the gardens. Versailles soon became his favourite country retreat.

Jean-Baptiste Colbert (1619–83)
As Louis XIV's First Minister, Colbert was the driving force behind the politics of the early part of the reign. In 1664 he became Surintendant des Bâtiments, and in that position supervised the gardens. Although he initially reproached the king for neglecting Paris and the palace of the Louvre in favour of Versailles, he subsequently concurred in all Louis's demands to enable him to achieve his extravagant project. (Portrait by Claude Lefebvre, 1666)

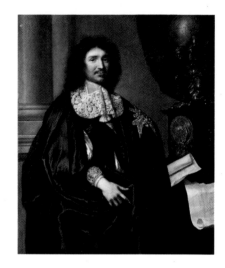

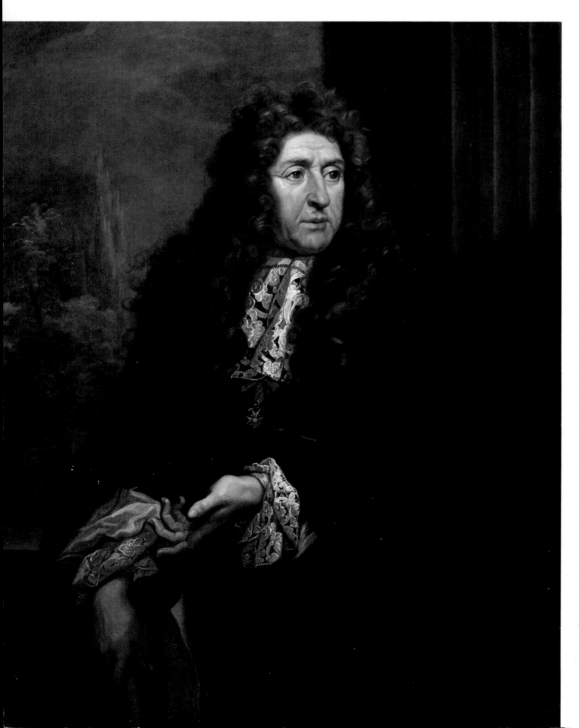

André Le Nôtre (1613–1700)
This most celebrated of garden designers was born into a family of Parisian gardeners. He was appointed head gardener of Louis XIII's brother at the Luxembourg in 1635, and two years later was promised the succession to his father's position as head gardener at the Tuileries. In 1643 he was given the title of Dessinateur des Parterres de tous les Jardins du Roi, and later became Contrôleur Général des Bâtiments du Roi, with responsibility for the buildings, gardens, tapestries and manufactories of France. In 1693 he was honoured by Louis XIV with the Order of St Michael. He was recognized in his own day as the master of the French garden, and after his death his contribution to the art of gardening was celebrated by Antoine-Joseph Dezallier d'Argenville in his *Théorie et pratique du jardinage* of 1709. (Portrait by Carlo Maratta, 1678)

Charles Le Brun (1619–90)
Appointed director of the Gobelins tapestry manufactory in the early years of Louis' reign, and then Court Painter and Life Chancellor of the Académie de Peinture et de Sculpture, the painter Le Brun was the leading authority on the arts. He organized the vast programme for the decoration of Versailles, and provided the designs for the majority of the fountains and statues in the gardens. (Portrait by Nicolas de Largillierre, *c.* 1686)

François Girardon (1628–1715)
The principal collaborator of Le Brun, he directed the sculptors working at Versailles, provided a large number of models, and supervised the casting of the bronze statues. As the king's official sculptor, he himself produced some of the finest pieces in the gardens. (Portrait by Gabriel Revel, 1683)

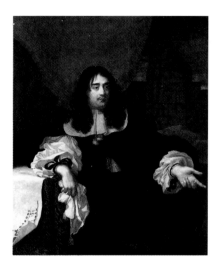

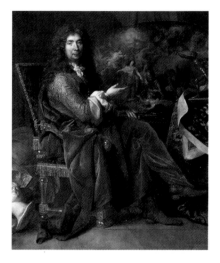

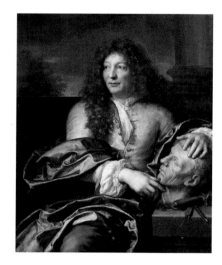

Louis Le Vau (1612–70)
Following the death of Jacques Le Mercier in 1654, Le Vau was given the post of Architecte du Roi, and as such at Versailles designed the Ménagerie, the Orangerie, and the 'Envelope' or new château built round Louis XIII's hunting lodge, which was finally completed by his brother-in-law and colleague François d'Orbay. He left to Le Nôtre all the major decisions on the gardens. (French School, seventeenth century)

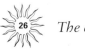

Permanent residence

From 1682 to the death of Louis XIV in 1715, Versailles was the centre of the kingdom. The country retreat had become the permanent residence and seat of government. This second part of the reign opens with the death of Queen Marie-Thérèse and the secret marriage of the king to Françoise d'Aubigny, Marquise de Maintenon, who was the governess of his illegitimate children. The same decisive period saw the death of Colbert, who was succeeded by Louvois, and the gradual fall from favour of Le Brun, replaced by Jules Hardouin-Mansart. Two new wings were added to the château to accommodate the court and the royal family, as well as new service buildings, while the estate was enlarged and the gardens were surrounded by an immense park. The euphoria of the first part of the reign gave way to a period marked by the military expenses of two new defensive wars, when the king spent less time in the gardens and preferred indoor entertainments, or even took refuge at Marly.

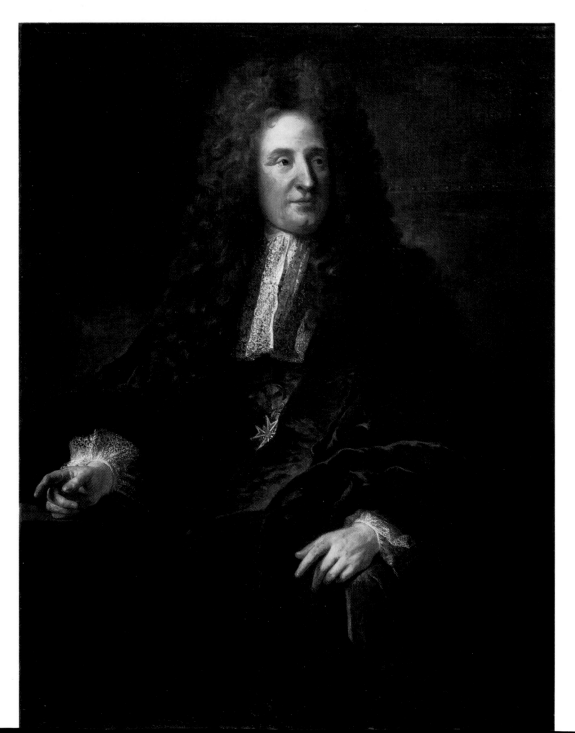

Jules Hardouin-Mansart
(1645–1708)
Builder in 1675 of the château of Clagny, just north of Versailles, for the illegitimate children of Louis XIV, he was appointed court architect by Louvois in 1688 and Surintendant des Bâtiments in 1699. From then on he had under his direction all the building works at Versailles. At his death his brother-in-law Robert de Cotte succeeded him as court architect. (Portrait by François de Troy, 1699)

Michel Le Tellier, Marquis de Louvois (1641–91)
Son of the Secretary of State for War, Louvois inherited his father's post in 1677. First Minister for the second half of Louis XIV's reign, he succeeded Colbert as Surintendant des Bâtiments and in that position was responsible for the new building works at Versailles and also for the enormous undertaking of finding additional water supplies for the gardens. (French School, seventeenth century)

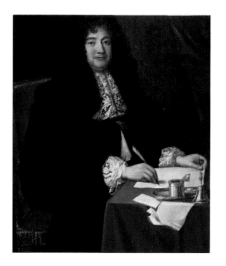

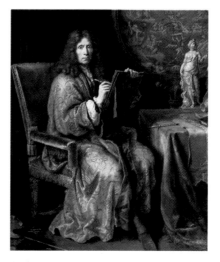

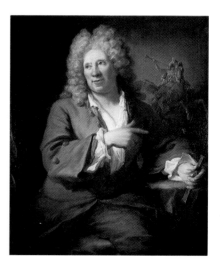

Pierre Mignard (1612–95)
While Hardouin-Mansart was increasingly taking over the direction of operations at Versailles, Le Brun was losing favour and at his death in 1690 the position of Premier Peintre was given to Mignard. Mignard played a secondary role in the gardens, producing only a few designs for statues. (Self-portrait, 1690)

Antoine Coysevox (1640–1720)
Coysevox and Girardon were the two great official sculptors of the reign of Louis XIV. Whereas the style of the latter reflects the Classical attitudes taught by Le Brun, Coysevox tended more to a Baroque spirit, which he shared with the greatest sculptor represented at Versailles, Pierre Puget. (Portrait by Gilles Allou, 1711)

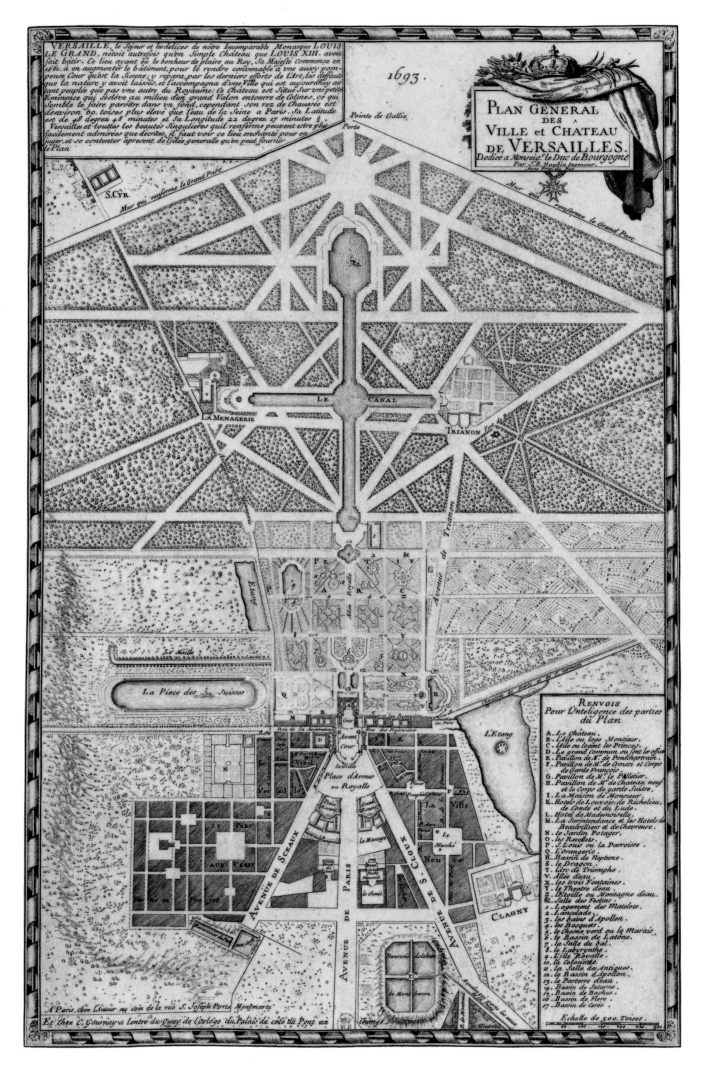

1693.

PLAN GENERAL DES VILLE et CHATEAU DE VERSAILLES.
Dedié a Monseig.r le Duc de Bourgogne
Par J.B.Naudin Ingenieur.
Avec Priv.du Roy.

RENVOIS
Pour l'Inteligence des parties
du Plan

A. Le chateau.
B. L'Isle ou loge Monsieur.
C. L'Isle ou logent les Princes.
D. Le grand commun ou sont les offices
E. Pavillon de M.r de Pontchartrain.
F. Pavillon de M.r de Croisi et Corps
 de Garte François.
G. Pavillon de M.r le Pelletier.
H. Pavillon de M.r de Chateau neuf
 et le Corps de garte Suisse.
I. La Maison de Monsieur.
K. Hotels de Louvois de Richelieu,
 de Conde et du Lude.
L. Hotel de Mademoiselle.
M. La Surintendance et les Hotels de
 Beauvilliers et de Chevreuse.
N. le Jardin Potager.
O. les Recolets.
P. S.Louis ou la Parroisse.
Q. L'Orangerie.
R. Bassin de Neptune.
S. le Dragon.
T. l'Arc de Triomphe.
V. Allée d'eau.
X. les trois Fontaines.
Y. le Theatre d'eau.
Z. L'Estoille ou Montagne d'eau.
&. Salle des Festins.
1. Logement des Matelots.
2. L'encelade.
3. les Bains d'Apollon.
4. les Bosquets.
5. le Chesne verd ou le Marais.
6. le Bassin de Latone.
7. la Salle du bal.
8. le Labyrinthe.
9. L'Isle Royalle.
10. la Colonnatie.
11. la Salle des Antiques.
12. le Bassin d'Apollon.
13. le Parterre d'eau.
14. Bassin de Saturne.
15. Bassin de Bachus.
16. Bassin de Flore.
17. Bassin de Cerés.

Echelle de 500.Toises.

The town, gardens and park of Versailles

The town, gardens and park of Versailles

At the end of the seventeenth century the château and gardens were complete. Their layout is recorded in this plan of 1693 by Jean-Baptiste Naudin. (North is to the right.)

The little township of Versailles-au-Val-de-Galie (bottom) had grown enormously after important concessions were granted in 1670 to new residents.[22] Virtually the new capital of the kingdom, Versailles attracted all the organs of government with the exception of the Parlement and the Archdiocese, which remained in Paris. To the east of the château, three great avenues spread out from the Place d'Armes, while to the west the royal park extended over a much greater area.

At the end of the 1680s the estate comprised 93 hectares (230 acres) of gardens. Beyond them was the walled Petit Parc of some 700 hectares (1,730 acres), containing the Grand Canal, the Ménagerie and Trianon. Surrounding it all was the Grand Parc, more than 6,500 hectares (16,000 acres) in extent, whose wall 43 kilometres (27 miles) long had twenty-two gates.

The royal *potager* lay on the opposite side of the château, to the south-east (labelled 'N'): in the French garden the practical was firmly separated from the ornamental. Created by Hardouin-Mansart between 1678 and 1683 and replacing an earlier *potager* which had lain close to the old house of the Maréchal de Gondi, this new kitchen garden provided the court with fruit and vegetables.

Versailles after Louis XIV

AFTER the death of Louis XIV in 1715 the court went back to Paris during the brief regency of Philippe d'Orléans, and then returned to Versailles when Louis XV – Louis XIV's successor and great-grandson – came of age. While the whole of Europe was copying Versailles and imitating its setting, those gardens had started to evolve towards a more natural style which eventually found its expression in the English garden. That new form of paradise was to be defined in terms of reaction against Versailles, where 'art everywhere seems to restrict and subdue nature'.[21]

Caught between the defenders of the French style and the enthusiasts for the new English fashion, the French garden lived out its last years. Appointed Director of the Bâtiments du Roi in 1751, Abel-François Poisson, Marquis de Marigny (brother of Louis XV's mistress, the Marquise de Pompadour), had great difficulty in attempting to halt the slow dilapidation of the gardens of Versailles, which the king neglected in favour of the château itself and the nearby gardens of Trianon. In 1755 Dezallier d'Argenville was still trying to defend them in his *Voyage pittoresque des environs de Paris*, written in response to the criticism of the Abbé Laugier, who had complained in his *Essai sur l'architecture*: 'Let our feelings be the judge, what do we find as we walk through these superb gardens? Astonishment and admiration at first, then soon afterwards melancholy and boredom.'

In 1774, the year of the accession of Louis XVI, successor and grandson of Louis XV, the publication of *Essai sur les jardins* by Claude-Henri Watelet, echoing Thomas Whately's *Observations on Modern Gardening*, spelt the end of the French garden. Replacing Marigny, Charles Claude de Flahaut de La Billarderie, Comte d'Angiviller, planned to take advantage of the replanting of the gardens of Versailles to simplify some of the bosquets.

At the fall of the monarchy in 1792 work was brought to a halt, and the gardens were dedicated by the First Republic to public enjoyment. Under the First Empire they narrowly escaped being transformed by Napoleon I into a park commemorating his conquests. They were replanted once again in the mid-nineteenth century, and then there was no further change until 1986 when a new replanting programme was undertaken, followed by a concerted project, still under way, to re-create some of the seventeenth-century features.

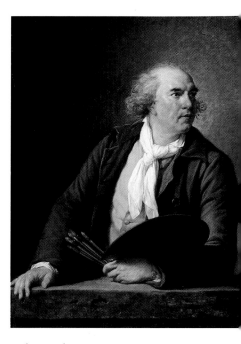

Hubert Robert (1733–1808) Appointed Dessinateur des Jardins du Roi in 1778 – the first time the position had been filled since Le Nôtre – this landscape painter was charged by d'Angiviller with the transformation of the gardens of Versailles. He achieved with remarkable skill the new painterly vision of the English garden, chiefly at Trianon but also in his creation of the Grotte des Bains d'Apollon (ill. pp. 252–53). (Portrait by Elisabeth Vigée-Lebrun, 1788)

The layout of the gardens

THIS PLAN shows the gardens in the state they had reached before recent work began. The château is at the top.

Closest to the château is the Jardin Haut or upper garden, which is arranged on a transverse axis, between the Bassin de Neptune at the north end (left) and the Parterre de l'Orangerie or Parterre Bas at the south. Its design comprises two small bosquets and six parterres. (This is the area that we shall explore first.)

From the château, the Grand Axe or Great Axis leads west past the Bassin de Latone to the Bassin d'Apollon. The latter marks the end of the gardens and the beginning of the park, through which the axis extends along the Grand Canal.

Finally comes the Jardin Bas or lower garden, flanking the axis, beyond the Allée des Trois Fontaines and Allée de l'Orangerie. This consists of an ensemble of bosquets – open-air rooms created in clumps of woodland.

The king's itinerary

Six tours of the gardens were devised by Louis XIV for his guests between 1689 and 1705. One of the existing manuscripts, datable between 1702 and 1704, is entirely in his own hand, while some of the other versions, written by a secretary, were corrected by him. Louis' autograph *Manière de montrer les jardins de Versailles* points out briefly but precisely the various viewpoints or stopping places he considered worthy of interest.[23] That tour is the one which the visitor follows now after seeing the palace: it is shown on the plan below in dotted lines, starting from the château.

There was free access to the gardens with the exception of certain bosquets, which were open or closed to the public according to the king's whim. Even today several are shown only on the occasion of the *grandes eaux*, when on certain days in the year the fountains are switched on.

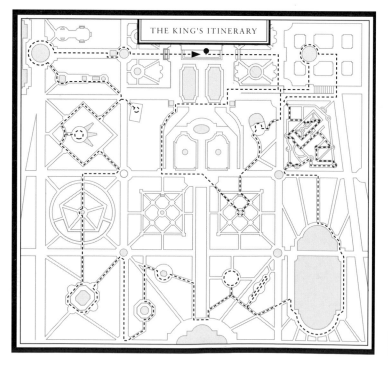

THE KING'S ITINERARY

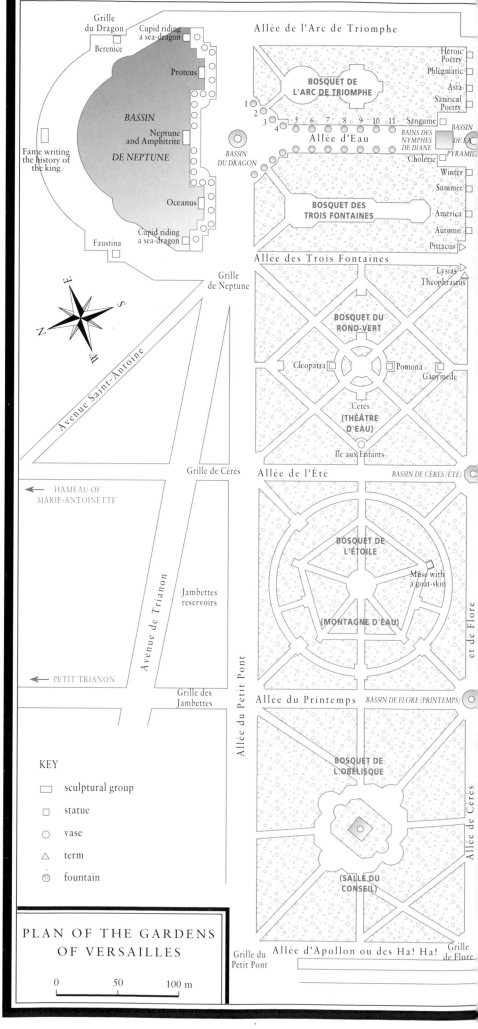

KEY

☐ sculptural group

☐ statue

○ vase

△ term

● fountain

PLAN OF THE GARDENS OF VERSAILLES

0 50 100 m

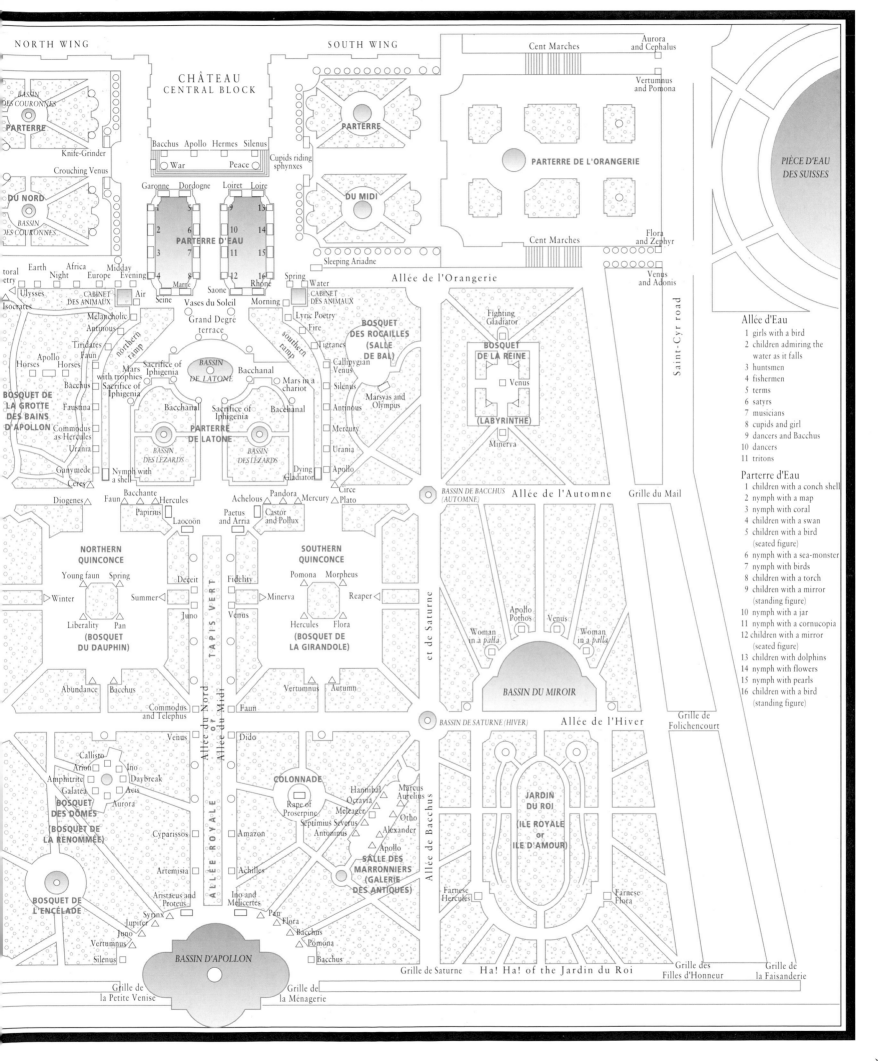

Allée d'Eau

1 girls with a bird
2 children admiring the
 water as it falls
3 huntsmen
4 fishermen
5 terms
6 satyrs
7 musicians
8 cupids and girl
9 dancers and Bacchus
10 dancers
11 tritons

Parterre d'Eau

1 children with a conch shell
2 nymph with a map
3 nymph with coral
4 children with a swan
5 children with a bird
 (seated figure)
6 nymph with a sea-monster
7 nymph with birds
8 children with a torch
9 children with a mirror
 (standing figure)
10 nymph with a jar
11 nymph with a cornucopia
12 children with a mirror
 (seated figure)
13 children with dolphins
14 nymph with flowers
15 nymph with pearls
16 children with a bird
 (standing figure)

'Our Monarch delights in raising Palaces, an Amusement worthy of a King. This likewise is of general Benefit, as it gives Subjects an Opportunity of sharing, with their Sovereign, in his Pleasures; and of admiring Wonders, form'd for his Use only. So great a Number of beautiful Gardens and sumptuous Palaces are the Glory of a Nation. Then, what do not Foreigners say? What Elogiums will not Posterity bestow on these Master-Pieces in all Arts?'

JEAN DE LA FONTAINE
Les Amours de Psyché et de Cupidon (1669)
(First English translation by 'Mr. Lockman', 1744)

This romance by La Fontaine and Madeleine de Scudéry's *Promenade de Versailles*, also published in 1669, are the first printed works directly associated with the gardens of Versailles. They stand at the head of a long list of writings, including *La Manière de montrer les jardins de Versailles* by Louis XIV himself, descriptions by such contemporary observers as André Félibien,[24] commentaries in journals of the time like the *Gazette de France*, the *Muse historique* and the *Mercure galant*, and the celebrated memoirs of the Duc de Saint-Simon.

Yew (*Taxus baccata*)
As closely associated with the
French garden as box, the common
yew shares many characteristics
with it. Slow-growing and long-
lived, yew is tolerant of all soils, as
happy in sun as in shade, and bears
repeated clipping. Walks and
parterres are punctuated by yew
shaped into balls, pyramids, cones,
columns, animals or chessmen
following a technique unchanged
from antiquity and brought back
into fashion by the Renaissance
under the name of the art of
topiary.

II
A WALK IN THE GARDENS

The Jardin Haut

The Great Axis

The bosquets of the Jardin Bas

The gardens

'Versailles is pure harmony. Everything there is part of the unity of a perfect work of art; the construction, the decoration, the most modest detail and the most magnificent ensemble all spring from the same idea, bring it to fruition, glorify it and stay within its bounds. … Although infinitely varied, the individual creations are assembled and set in position following the same rules interpreted by different craftsmen; they obey the laws of balance and moderation, the quintessential laws of that French genius of which they offer one of the most perfect images.'

Behind this harmony of the gardens, superbly described by Pierre de Nolhac in a series of publications at the beginning of this century,[25] lies a process of transformation which started even as they were created following Louis XIV's assumption of power, was pursued throughout his reign, and has continued to the present day.

The early designs of Le Nôtre were conceived in the spirit of the new French garden which had evolved from the Italian tradition. They give full play to imagination and the intellect.[26] Le Nôtre was a fortunate man, privileged to create at Versailles the most prestigious of French paradises and the most complete example of a French garden.

The most notable feature of this first period is the rigorous plan harmoniously adapted to the site, where the open spaces of the Jardin Haut or upper garden and the more thickly planted areas of the Jardin Bas or lower garden are elegantly grouped round the Great Axis, which after passing through the centre of the château opens out on to a wide perspective. An array of bosquets succeed each other, whose traditional presentation as grotto, cascade, labyrinth, or *théâtre de verdure* is enlivened by a constant exercise of imagination. Finally there is an admirable balance in the arrangement of terms, vases, fountains and statues, all combining simultaneously to glorify nature and the king. And all this was due to the impetus of a gardener who, 'constrained by his character or by circumstances to be compliant and unpretentious, was yet very conscious of the fact that his talent was being appealed to to create a theatrical setting'[27] – a task to which he applied himself in complete accord with his royal patron and with his partner Le Brun, creating at Versailles a unique example of a French garden where the variety of invention is never frozen into the cold grandiloquence of which the style is so often accused.

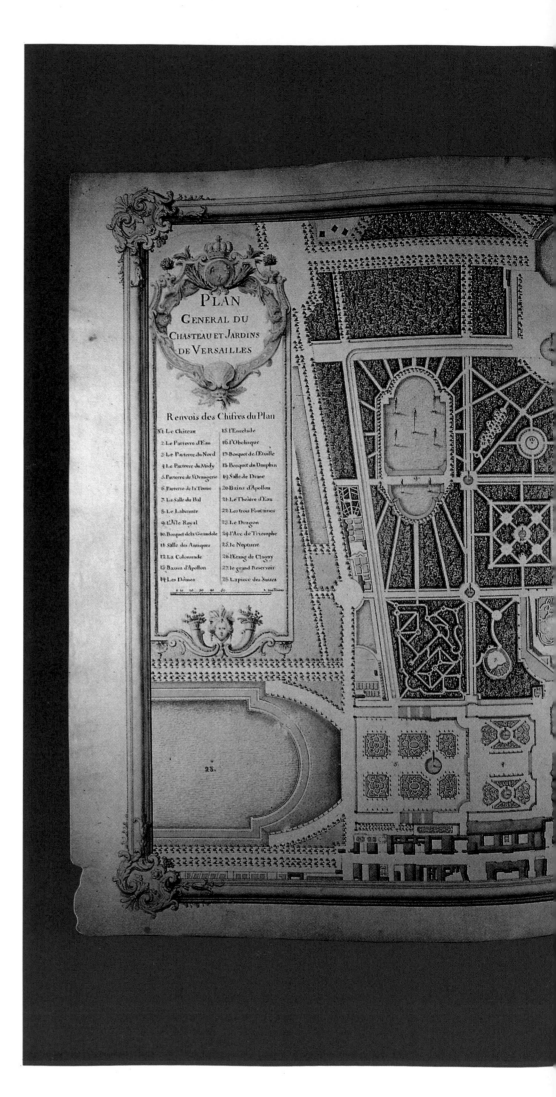

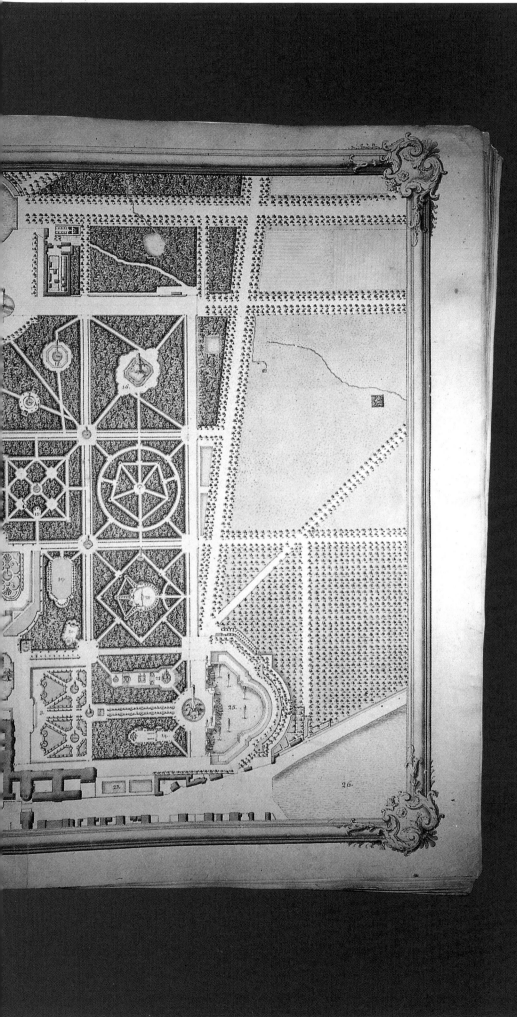

The escutcheon of André Le Nôtre
Following a royal edict of 1696, this coat of arms was granted to Le Nôtre by Charles-Henri d'Hozier, genealogist of the royal house.

Drawing upon the Italian humanist tradition, it has been suggested,[28] the gardens of Versailles could be interpreted as a sort of initiatory journey leading to self-knowledge. The visitor assumed the identity of the equestrian figure of the king at the entrance to the Bassin de Neptune, who revealed to him the mystery of the origin of life, and he then went on to overcome the forces of his own unconscious at the Bassin du Dragon. Led through the stages of the formation of the universe at the Allée d'Eau, the visitor was accorded a new birth at the Bains des Nymphes de Diane, and eventually entered into communication with the world at the Bassin de la Pyramide. His walk finally led him to the Orangerie, image of the Garden of the Hesperides and representation of paradise.

But this vast symbolic poem to the glory of man within the universe, with its gods and heroes liberally represented by statues and fountains, would soon be given a quite different interpretation. In a second phase the gardens, transformed into an allegory of power, became the expression of omnipotence. Gradually Le Nôtre and Le Brun handed over to Hardouin-Mansart, who turned the initiatory journey into an elegant stroll, entirely dedicated to the glory of Louis XIV.

A third and last period then opened, during which the gardens changed little. In the eighteenth century the Rococo fashion, and then the taste for the more naturalistic English garden, gradually evolved and succeeded the decorative style of the end of Louis XIV's reign.

General plan of the gardens
The gardens as such constitute only the smallest part of the estate of Versailles, the area lying closest to the château on the west. In 1732, Louis XV had a survey drawn up by the geographer Jacques Dubois – *Recueil des plans et distributions du château et jardins de Versailles, Trianon et la Ménagerie*. A general plan and detailed plans of the bosquets were executed in watercolour and made into a superbly bound volume. Although drawn more than fifteen years after the death of Louis XIV, these plates show the state of the gardens at the end of his reign, *c.* 1715. The château appears at the bottom; north is at the right.

Stages in the formation of the gardens

IN SPITE of being constantly altered during the fifty-four years of Louis XIV's activity, the gardens retained the overall structure originally given them by Le Nôtre: the Jardin Haut in front of the château, the Great Axis stretching away from the château, and the Jardin Bas consisting of two groups of bosquets flanking the axis.

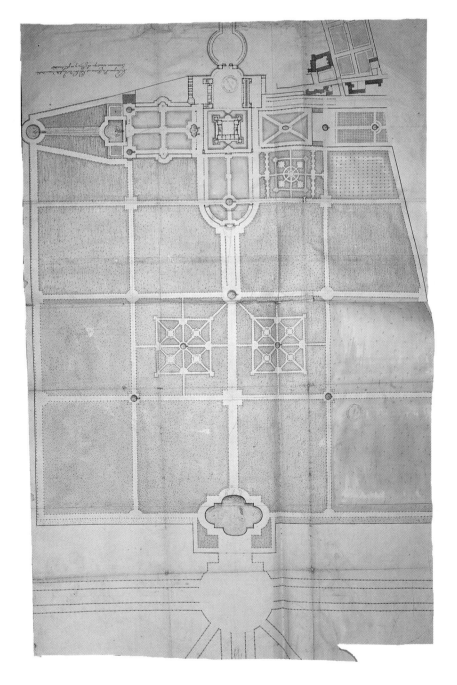

The gardens before Le Nôtre

When Louis XIV assumed power in 1661 the ground which the gardens would later occupy was part of Louis XIII's park. It was enclosed by a wall and was composed of sixteen divisions, some of them wooded, set round a parterre in front of the château, which looked down a grand axis punctuated by three bassins. (Plan du Bus, *c.* 1662)

Le Nôtre's early work

Starting from the existing plan, Le Nôtre laid out the Jardin Haut between 1662 and 1665, absorbing the parterre in front of the château (top) into the design. The remaining space was divided into twenty bosquets, retaining the line of the Great Axis and establishing the foundations of the Jardin Bas. Three of the bosquets had been decorated when this plan was drawn, *c.* 1663: the short-lived Bosquet du Bois-Vert near the château, and the symmetrical Deux Bosquets (ancestors of the Quinconces) further away. Immediately north of the château – left – is the Bassin de la Sirène; beyond that, the Parterre du Nord in its first simple form leads on to the Bassin du Dragon at the garden's edge.

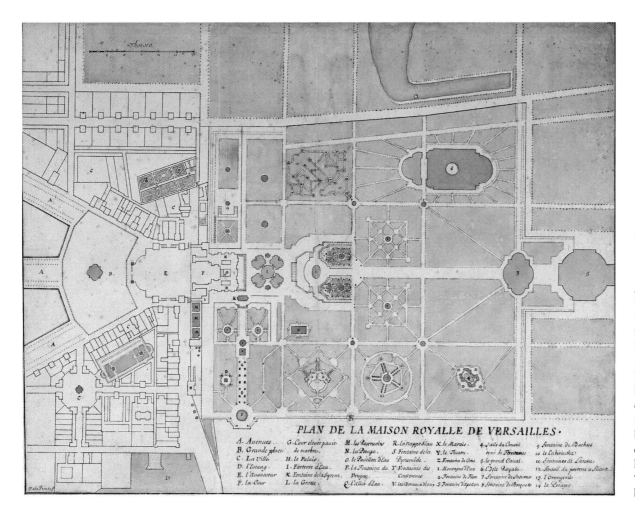

PLAN DE LA MAISON ROYALLE DE VERSAILLES.

A. Avenues.
B. Grande place.
C. La Ville.
D. l'Estang.
E. l'Avantcour.
F. la Cour.

G. Cour eleuée pauée de marbre.
H. le Palais.
I. Parterre d'Eau.
K. Fontaine de la Syrene.
L. la Grotte.

M. les Reservoirs.
N. la Pompe.
O. le Pauillon d'Eau Pyramide.
P. la Fontaine du Dragon.
Q. l'allée d'eau.

R. la nappe d'eau.
S. Fontaine de la
T. Fontaines des Couronnes
V. les Bosques d'eau.

X. le Marais.
Y. le Theatre.
ené de Fontaines
1. Montagne d'Eau
2. Fontaine de Flore
3. Fontaine d'Apollon

4. Salle du Conseil.
5. le grand Canal.
6. l'Isle Royale.
7. Fontaine de Saturne.
8. Fontaine de Bacquets.

9. Fontaine de Bachus
10. le Labirinthe
11. Fontaine de Latone.
12. Partoil du parterre a fleurs
13. l'Orangerie.
14. le Potager.

Further works by Le Nôtre

Between 1666 and 1679 Le Nôtre doubled the size of the Jardin Haut (left) and linked it to the Jardin Bas by a huge horseshoe-shaped ramp. The Great Axis was widened and lengthened to the west (right) by the Grand Canal. Parterres, allées and bosquets were further embellished. At the château (left, in outline), Le Vau had by now remodelled and enlarged Louis XIII's hunting lodge, wrapping the 'Envelope' around it. (Plan by F. Delapointe, 1674)

Alterations by Hardouin-Mansart

After 1680 the gardens changed only in detail. The Jardin Haut was enlarged to the north (left) by the Bassin de Neptune and to the south by the Pièce d'Eau des Suisses. The last bosquets of the Jardin Bas were given more elaborate decoration, even as others were already being simplified. This plan of 1707 (by N. Grandmaison) also shows the town, laid out in front of the château to accommodate courtiers.

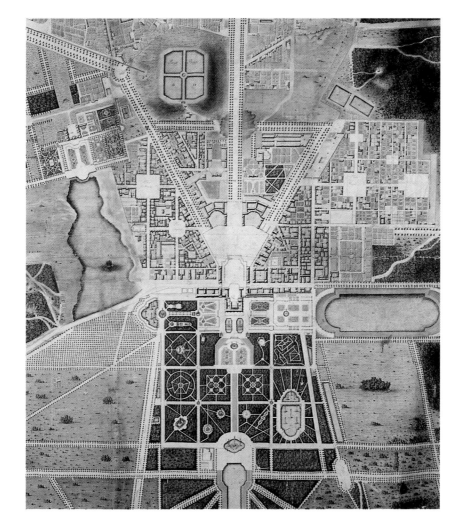

The Jardin Haut

The Jardin Haut from the north
The Parterre du Nord is enclosed to the north and sheltered from cold winds by thickly planted trees. These were separated into two bosquets (Arc de Triomphe on the left and Trois Fontaines on the right) by the Allée d'Eau, which leads to the Bassin du Dragon and Bassin de Neptune (foreground). Whereas on the south side the land was steeply cut away to create the Orangerie, giving extensive views out across the Pièce d'Eau des Suisses to the hills of Satory beyond, here to the north it slopes down gently and allowed the construction of a number of water features. (Painting by Etienne Allegrain, *c.* 1696)

THE JARDIN HAUT is the first part of the gardens reached from the château, and it is the part that underwent most alteration. At first there was only a small parterre immediately in front of Louis XIII's hunting lodge. On the accession of Louis XIV a new parterre was added on either side, prefiguring the Jardin Haut with its transverse axis.

The three parterres, laid out as the fashion of the time demanded to be viewed from the first floor or *étage noble*, created an expansive view parallel to the façade of the building. Each presented a different design: to the north was a *parterre de gazon*, of turf (Parterre du Nord); in the middle was the Parterre d'Eau (or Parterre Central), with mirror pools; and to the south lay a *parterre de broderie* (Parterre du Midi).

Following the lie of the land, the Jardin Haut was extended downhill to the north with two bosquets (Arc de Triomphe and Trois Fontaines) and two bassins (Dragon and Neptune). To the south was the Orangerie, whose Parterre Bas opened on to the large Pièce d'Eau des Suisses.

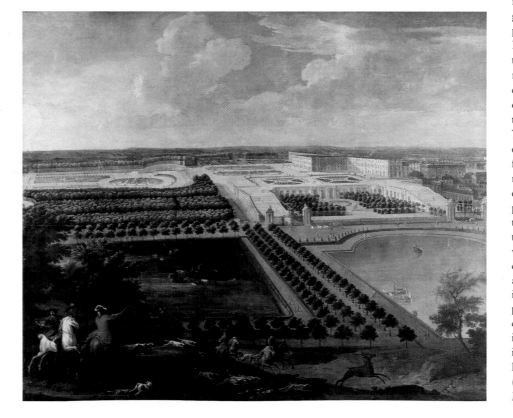

The Jardin Haut from the south
The Parterre du Midi, bathed in sunshine, was open to the south along the terrace forming the roof of the Orangerie, which gave the effect of a monumental plinth for the château. Pierre de Nolhac described the effect in these words: 'Around the royal residence nature is entirely enslaved, everything has been organized to ensure that only the works of man are visible. … The terraces are made almost entirely of earth brought in from elsewhere; the original modest hillock has been expanded to enormous proportions to accommodate the château and its setting … the building is surrounded by a vast platform in which all the decoration has been kept low and as it were squashed down, in order to give greater prominence to the majestic construction which dominates it, and to conceal no detail of it.'[29] In the foreground is the Pièce d'Eau des Suisses. (Painting by Jean-Baptiste Martin, 1693)

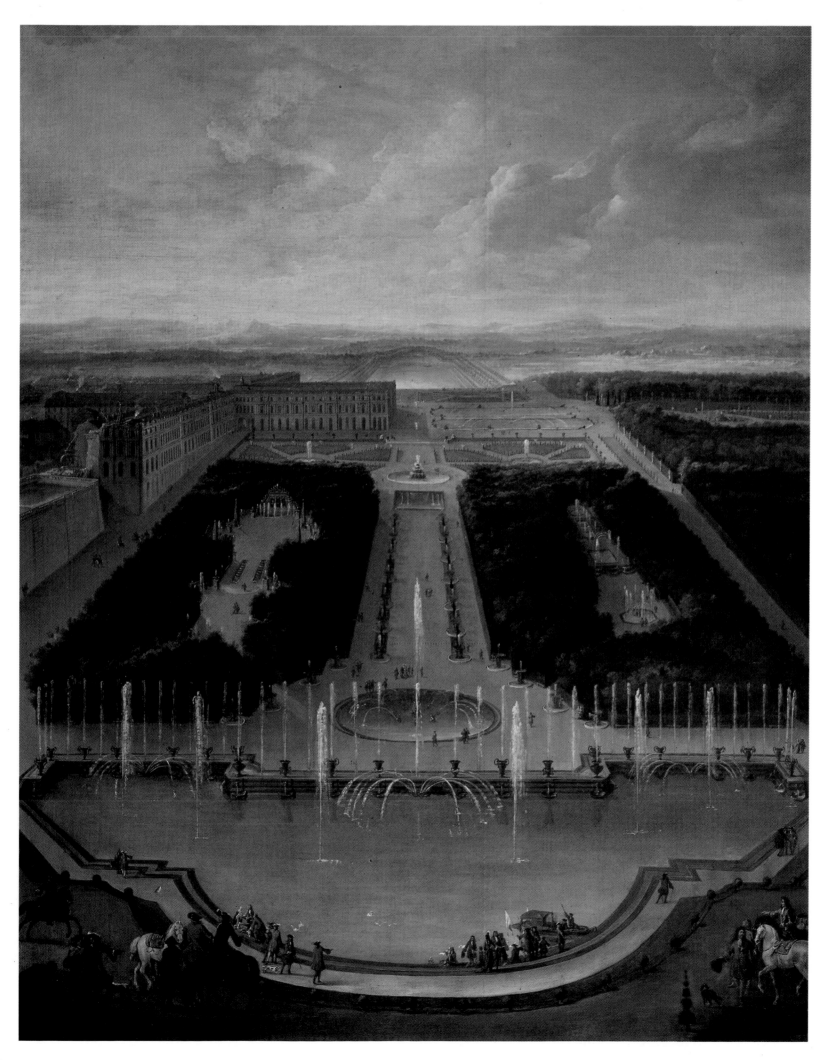

The Bassin de Neptune and Bassin du Dragon

THE GARDENS can be entered from a number of places. Our tour begins at the northern end of the Jardin Haut, looking over a great open space occupied by two bassins: the Bassin de Neptune and that of the Fontaine du Dragon.

The Bassin du Dragon originally stood alone, enclosed to the north by a grille (see p. 37, upper plan) which was demolished when the Bassin de Neptune was built and the site enlarged. These two bassins together allude to the creation of all things, and lie at the beginning of what has been interpreted as a sort of initiatory journey through the gardens. Celebrating the element of water, they remind us that water and sunlight were the source of life on earth. The Bassin de Neptune symbolizes its origin, and the Bassin du Dragon represents the victory over the formless and uncomprehending forces lurking in the abyss that opens the way to the achievement of true human dignity.

The realm of Neptune
One of the twenty-two *métail* vase-fountains on a marine theme that decorate the retaining wall at the southern edge of the Bassin de Neptune.

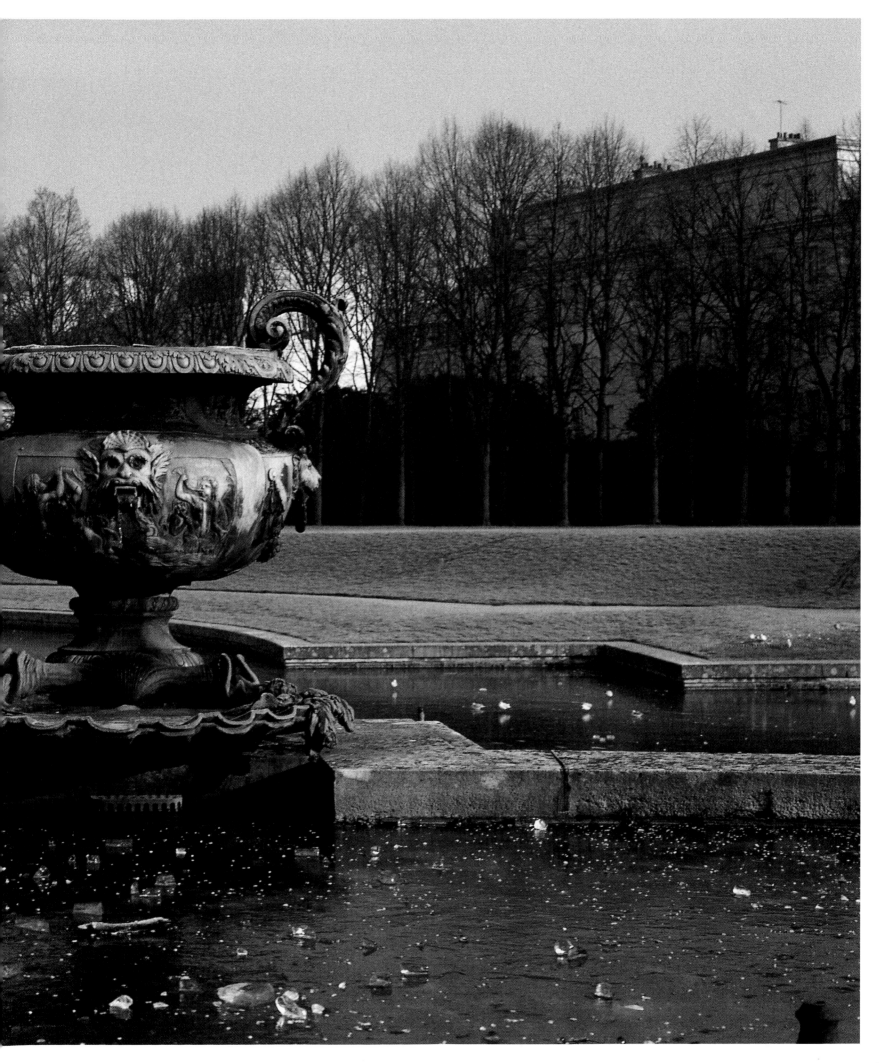

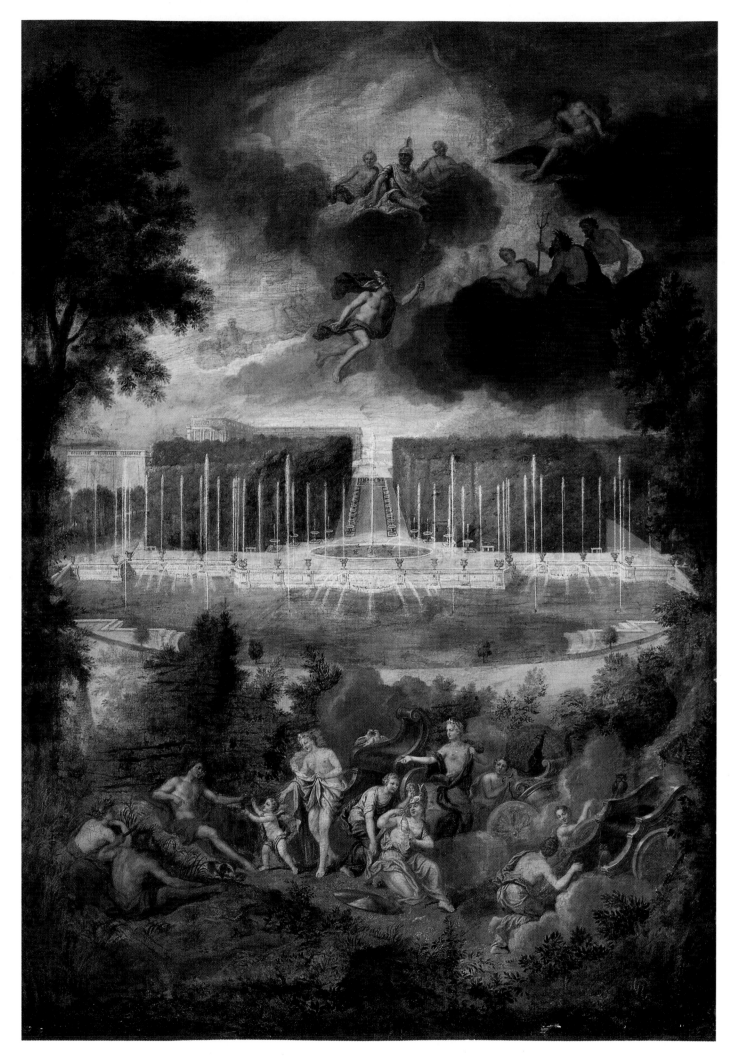

The Bassin de Neptune in the time of Louis XIV

Started by Le Nôtre in 1678 and finished by Hardouin-Mansart in 1682, this bassin is the largest piece of water in the gardens proper, balancing the Pièce d'Eau des Suisses created at the same period beyond the Orangerie.

The decoration, based on marine motifs, was designed by Le Brun and executed in 1683: twenty-four sculptors were employed on the vases, shells and masks of the retaining wall to the south, while eight ornament carvers produced the stalactite motifs on its inner face. A further eight teams of artists were brought in for the sculptural groups. Using the mythological themes of Neptune and Amphitrite, the sculptors – who included Coysevox, Jacques Houzeau and Jean Raon – prepared models which were placed in position for the king to approve on 17 May 1685. France had however just become embroiled in new wars: the final execution of the decorative scheme was twice postponed, and in the end involved different sculptors.

The bassin was first called the Pièce d'Eau sous le Dragon, from its position below the earlier bassin, then Grande Cascade or Pièce des Sapins after the trees which bordered it to the north. Originally its corners were marked by two small round bassins which were probably decorated with two groups of children, complementing the decorative scheme of the Allée d'Eau which adjoined it.[30] At an early date it was given its final name of Bassin de Neptune, although its new mythological decoration was not fully realized until a half-century later under Louis XV (ill. pp. 46–47).

The Bassin de Neptune

The completed bassin was immortalized by Jean Cotelle in one of a series of large views of the gardens commissioned by the king in 1688 for the gallery of the newly built Grand Trianon. With twenty-one other views, it is still in position there.

Some of the canvases include mythological scenes: here, in the presence of Juno and Minerva, the young Trojan hero Paris offers the golden apple to Venus who has promised him the love of Helen.[31]

Bernini's equestrian statue of Louis XIV

The northern edge was briefly the location of an equestrian statue of Louis XIV by the Roman sculptor-architect Gianlorenzo Bernini, a work whose complicated history illustrates the evolution in taste and Louis' desire to see French art triumph over Italian.

Bernini was summoned to France in 1665 in connection with the Louvre, at a time when Italy was still dominant artistically throughout Europe, and commissioned to make an equestrian statue of the king. He began the design in 1670 after his return to Rome, and by 1674 the sculpture was complete, carved from a single block of Carrara marble.

A further ten years passed, however, before it was shipped from Rome, and meanwhile France had seized artistic ascendancy. The equestrian portrait did not find favour with the king, who considered that it was a bad likeness and that it failed to conform to the new canons governing the representation of royalty.[32]

The statue's subsequent fate

Initially in 1685 the statue was housed in one of the galleries of the Orangerie, then a year later put in a prominent position in the adjacent parterre; later in 1686 it was moved to a spot behind the Bassin de Neptune (ill. p. 72).

In 1687 Girardon was called in to alter it into 'Marcus Curtius leaping into the abyss'. To depict the legendary hero of ancient Rome throwing himself into a fiery chasm to save the city, Girardon placed a helmet on the king's head and transformed the rock into flames.

In 1702 the statue was ousted by a marble group representing Fame writing the history of the king and came to rest at the far end of the Pièce d'Eau des Suisses. Its transformation into a Roman hero saved it at the Revolution, when the destruction was decreed of all royal monuments 'raised to pride, prejudice and tyranny'. Replaced by a copy in 1980, the original is now in the museum of the Grande Ecurie in Versailles.[33]

Bernini's design is recorded in this clay model of 1670.

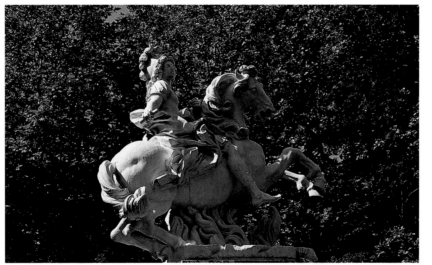

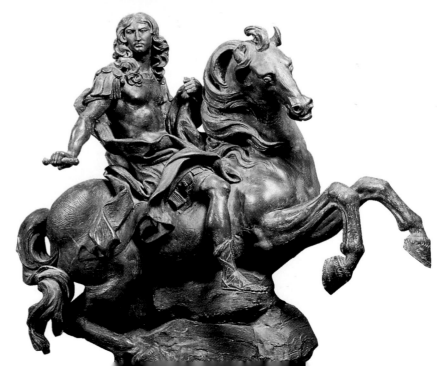

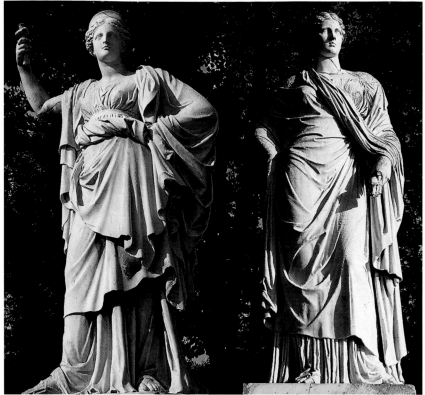

Berenice and Faustina

These two figures of queens flanking the group of Fame (*below*) were carved in marble by the pupils of the Académie de France in Rome, established by Colbert in 1666. The figure of Berenice (*far left*), who for reasons of state renounced her love for the Emperor Titus, was executed by François Lespingola in 1673 on the model of the Cesi Juno. The statue of Faustina (*left*), daughter of the Emperor Antoninus, wife of Marcus Aurelius and mother of the Emperor Commodus, is an enlarged copy by Nicolas Frémery of the Mattei Ceres.

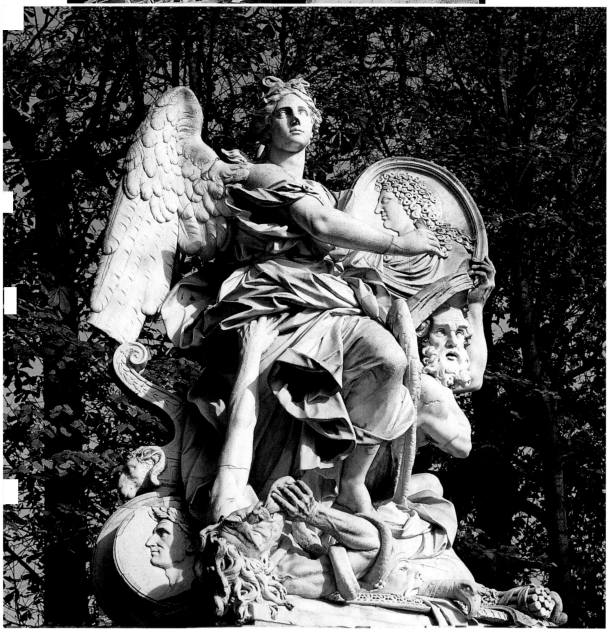

Fame writing the history of the king

This allegorical group (known as *La Renommée du Roi*) replaced Bernini's equestrian statue to the north of the Bassin de Neptune in 1702. Colbert commissioned it from the Italian sculptor Domenico Guidi, who executed it in Rome from a single block of marble, following a drawing by Le Brun. The group arrived in 1686 at Versailles, where at first it supplanted Bernini's statue, then in the Orangerie parterre. In 1691 it was moved to the entrance of the Bosquet de la Colonnade, and from 1699 to 1702 it stood in the Parterre d'Apollon.

The sculpture represents a winged female figure personifying Virtue or Fame writing the history of Louis XIV in a book carried by Time. At their feet Envy tears at a heart with her teeth, surrounded by trophies among which are portrait medallions of the Emperors Alexander, Caesar and Trajan. They are reminders of the greatness of the king, represented in effigy on the medallion held by Fame which was carved by Girardon when the statue arrived in France; defaced during the Revolution, it was recarved by Jean-Pierre Lorta in 1818.

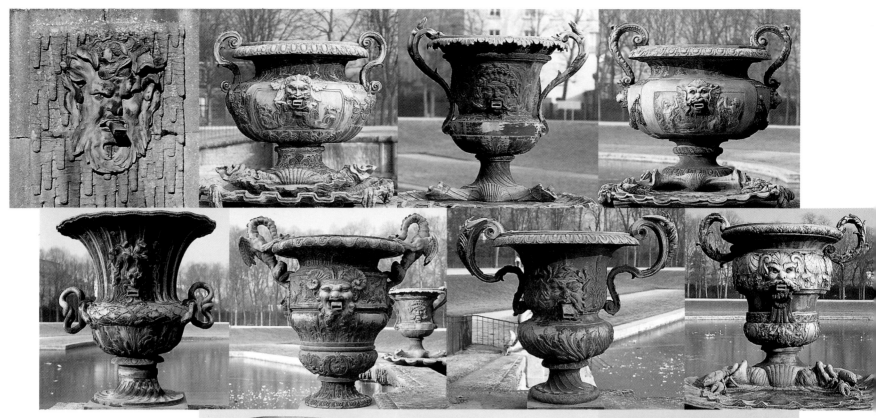

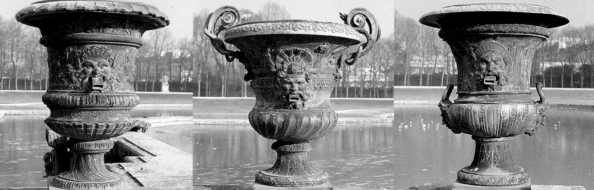

The marine decoration of the bassin

Twenty-four masks of gilded *métail* ornament the southern retaining wall, throwing jets into twenty-two shells from which the water falls in a sheet. On the rim stand twenty-two vases, also of gilded *métail*, arranged symmetrically in pairs. The decorations include lobsters, lizards, dragons, snakes, swans, fauns and reeds, and aquatic scenes such as naiads and putti riding on the backs of dolphins and seahorses, and tritons blowing conch shells. From each of these vases a lance or thin column of water shoots into the air, then falls back inside and spouts out through a mask, either into the shell below or directly into a channel which runs the length of the rim (ill. p. 52). The masks, vases and shells were renewed during restoration work in 1883–88.

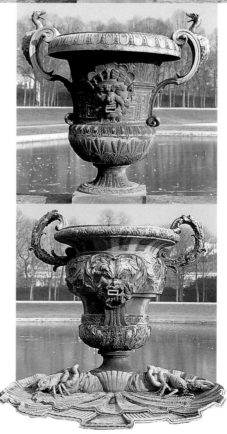

The Bassin de Neptune in the time of Louis XV

In 1733 the design of the bassin was simplified
and three years later Philibert Orry, Director of
the Bâtiments du Roi, took up the project of
decorating it which had been abandoned under
Louis XIV. The retaining wall and the two ends
were ornamented with five groups in *métail*:
in the centre is the Triumph of Neptune;
flanking this are Proteus and Oceanus; while at
the ends cupids ride on sea-dragons. The bassin
was restored in 1785, and again between 1883
and 1888.

**The Bassin de Neptune with its
new sculptural decoration**

Beyond, the eye is led past the
Bassin du Dragon and up the
Allée d'Eau towards the
château. (Painting by André-
Jacques Portail, *c.* 1742)

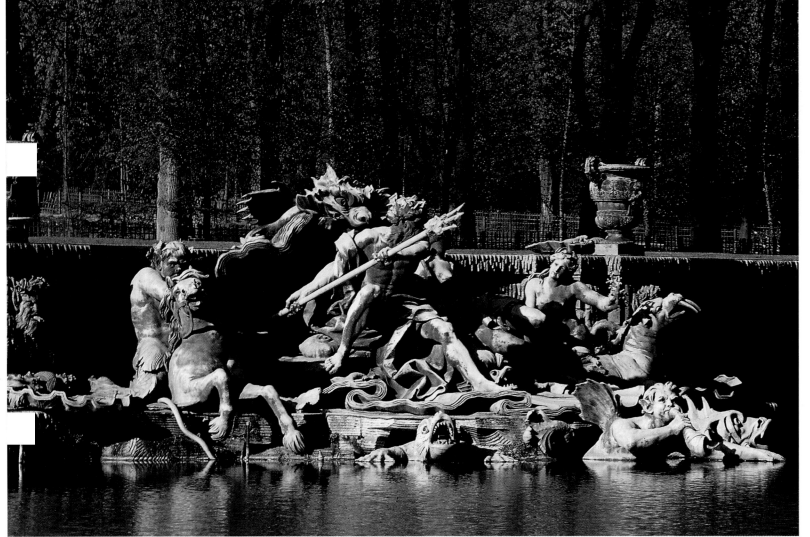

The Triumph of Neptune
Lambert-Sigisbert Adam and
his brother Nicolas-Sébastien
won the competition organized
by the Direction des Bâtiments
for the main sculptural group of
the bassin. Their model for the
Triumph of Neptune was
accepted in 1736, cast in 250
separate pieces, and placed in
position in 1739. Surrounded by
tritons and sea-monsters,
Neptune brandishes his trident
while his wife, the nereid
Amphitrite, accepts the gift
of a branch of coral.

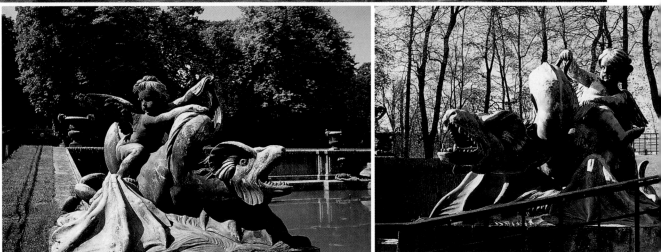

Oceanus

The father of all rivers leans
on a sea-unicorn, and has an
enormous crab at his feet. This
sculpture, balancing Proteus to
the west of the Neptune group,
was created by Jean-Baptiste
Lemoyne the younger between
1737 and 1740.

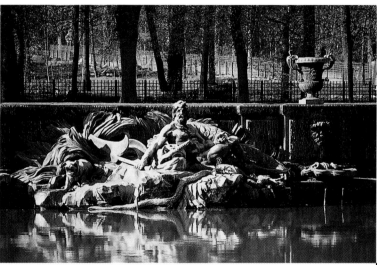

Proteus

The shepherd of Neptune's
marine flocks is depicted to the
east of the main group, lying
on a shell beside a sea-monster.
The sculpture, by Edme
Boucharddon, was executed
in 1739.

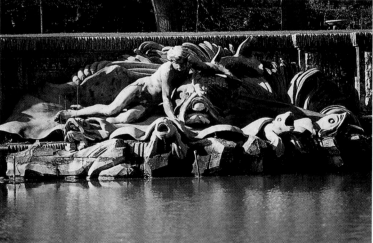

Cupids riding sea-dragons

These two groups, by Edme
Boucharddon, frame the Bassin
de Neptune and form a visual
link with the putti in the Bassin
du Dragon (ill. p. 53).

49

'Grandes eaux' at the Bassin de Neptune

The Bassin de Neptune had two opening ceremonies, first in 1685 by Louis XIV and again in 1741 by Louis XV. Its hydraulic system was the most elaborate in all the gardens, comprising 109 jets of water, including 44 lances on the rim of the retaining wall, 3 sprays, and 6 jets in the pool itself.

When Versailles was the royal residence the fountains played continuously, and depending on whether the king was present or not, the water was at full pressure (the *grande manière*) or reduced (the *petite manière*). Now, the fountains are seen as their designers conceived them only on the special days of the *grandes eaux*.

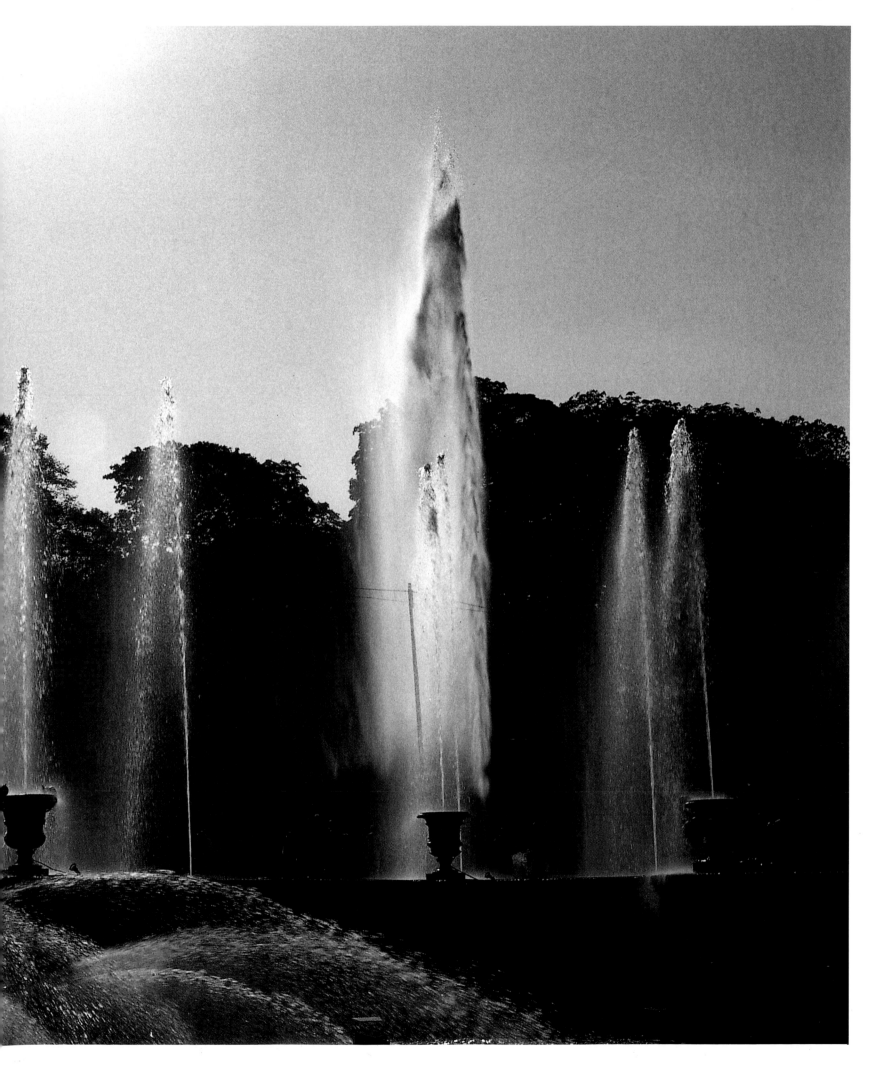

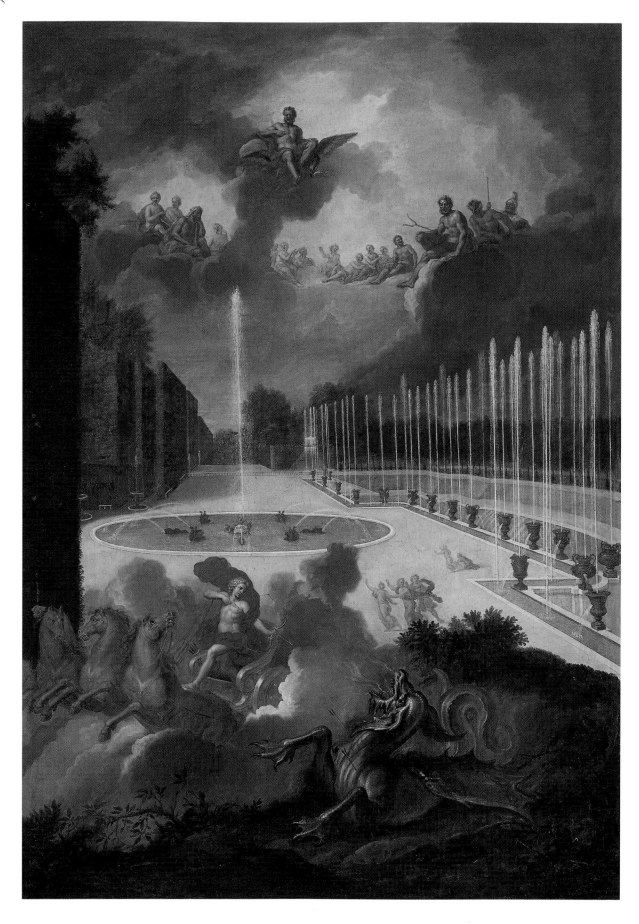

The Fontaine du Dragon in the seventeenth century

Jean Cotelle's painting (commissioned in 1688) shows the effect of the fountain at its most splendid – the *grande manière* – when Louis XIV was present and the lance of water from the dragon's mouth rose to nearly 27 metres (some 85 feet). When the king was absent it was reduced to about 11 metres (36 feet). The jets of the Bassin de Neptune shoot up at the right.

The foreground scene shows the mythological encounter between Apollo and the Python. By recalling the victory of the sun god over the forces of darkness, embodied by the Python, Louis XIV was reminding his nobility of his own victory over the forces of disorder and over their disloyalty to the crown during the Fronde.

The fountain seen from afar

The traveller approaching Versailles from the north saw the town on the left and the château on the right, across the large pond of Clagny. (The pond was a source of water for the fountains, managed by the combined pump and water-tower visible left of centre.) To the right of the château, the end of the Jardin Haut was marked by the great jet of water from the Fontaine du Dragon. (Engraving by Israël Silvestre, 1674)

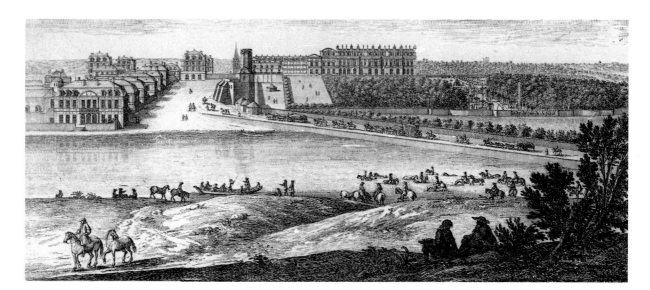

The Bassin du Dragon

FROM 1664 until the Bassin de Neptune was made, the northern perspective of the Jardin Haut was closed by a round pond, called the Grand Rondeau du Nord and then the Bassin du Grand Jet. In 1668 this was given a fountain which marked one of the first appearances of the Apollo theme in the gardens of Versailles. Thereafter that theme was further developed in the Great Axis, from the Grotte de Téthys to the Fontaine de Latone and right up to the Parterre d'Apollon. Here, the 'dragon' is the Python, which was pursued and killed by Apollo to avenge his mother Latona for the insult paid her by Juno.

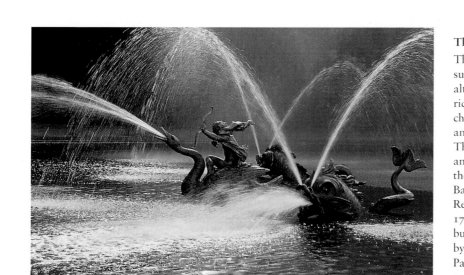

The dragon group

The wounded dragon is surrounded by four dolphins alternating with four swans ridden by children. Two of the children shoot arrows at him, and two turn away in terror. The ensemble, cast in *métail* and then gilded, was made by the brothers Gaspard and Balthazar Marsy in 1667. Restored for the first time in 1737, it was later dismantled, but in 1883–88 it was re-created by the sculptor Edme Antony Paul (Tony-Nöel) using the surviving fragments.

The Allée d'Eau and flanking bosquets

L OOKING SOUTH from the open space of the Bassin de Neptune and Bassin du Dragon, the view is closed by woodland, bisected by an avenue which forms the transverse axis of the Jardin Haut. This is the Allée d'Eau, which leads up to the Parterre du Nord; only at the top of the slope does the château come into full view. The allée is composed of a central path and two side paths separated by bands of turf originally punctuated with clipped yews (no longer extant) and the fourteen fountains which give it its name. Seven separate designs of trios of children, facing in various directions, give the impression that all the fountains are different. The avenue is also known as the Allée des Marmousets.

On either side of the allée a bosquet was created within the woodland, initially (in 1672) with a simple layout of a *pavillon d'eau* on the east – left, here – and a *berceau d'eau* on the west. Then in 1678 they were reworked in a far more elaborate style, with an allegorical décor on the east, the Bosquet de l'Arc de Triomphe, and on the west a design relying only on planting and water, the Bosquet des Trois Fontaines (ill. p. 39).

Conceived by Le Nôtre, as were the earlier ones, these two bosquets showed the scope of his originality. The Bosquet des Trois Fontaines displayed the lack of ostentation of which he was capable, in the limitation of the decoration to jets of water, while the Bosquet de l'Arc de Triomphe demonstrated his ability to use ornate detail in a highly elaborate allegorical programme.

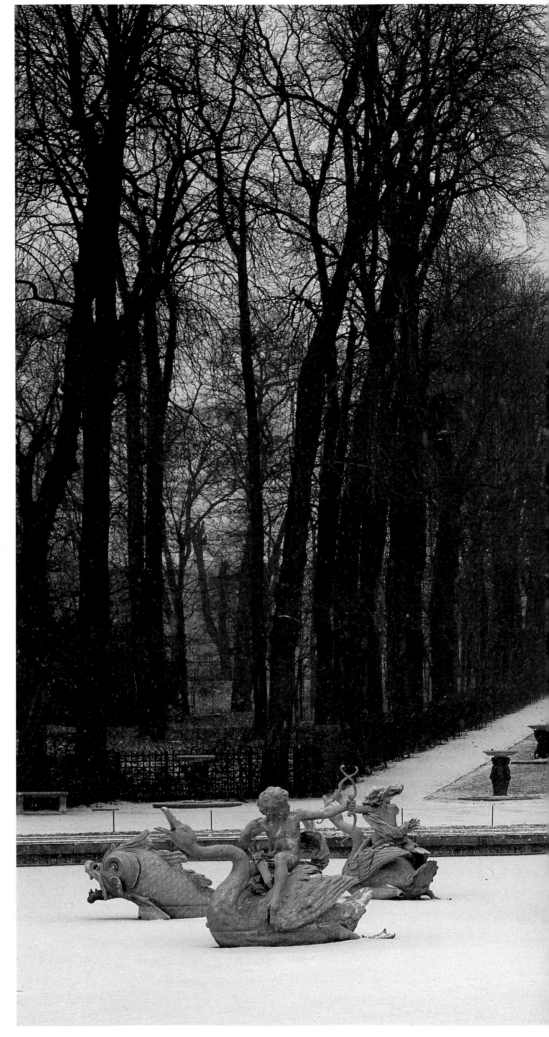

The Bassin du Dragon and perspective of the Allée d'Eau
The entrance to the Allée d'Eau was at first flanked by statues: these were replaced by further fountains with trios of children. In the distance are the Bains des Nymphes de Diane and the Bassin de la Pyramide, at the edge of the Parterre du Nord.

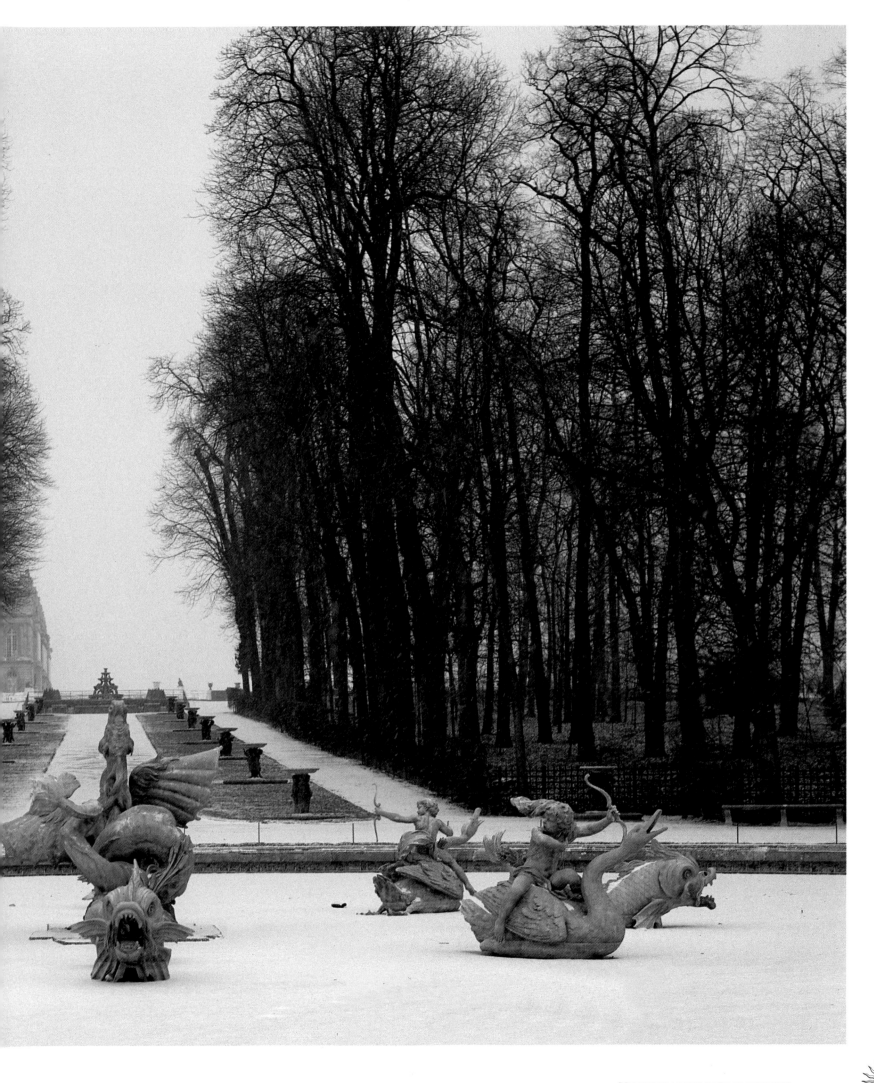

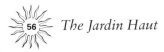

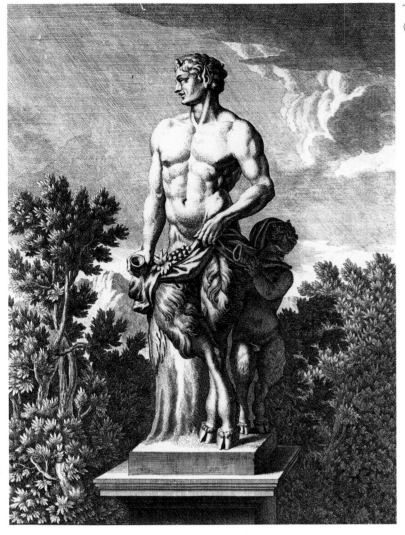

Two satyrs
(Philippe De Buyster)

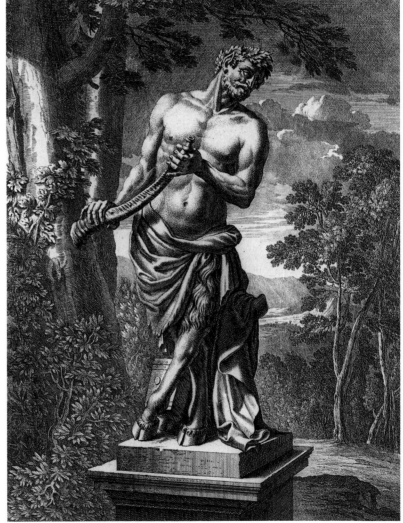

Pan holding a goat's horn
(Louis Lerambert)

The statues originally at the entrance to the Allée d'Eau

Eight stone statues, carved in 1665, were placed around the
entrance to the allée. They were among the earliest sculptures in
the gardens, and belong to the period before marble was being
used. Four were by Philippe De Buyster and four by Louis
Lerambert, both master craftsmen of the first generation of
sculptors at Versailles. Recorded by Jean Le Pautre in 1672 and
1675, they were removed in 1678 to the Parterre d'Apollon and
replaced in the 1680s by eight bronze groups of 'Marmousets'
(see pp. 54–55, 59).

Bacchante and little satyr
(Philippe De Buyster)

Bacchante and cupid
(Louis Lerambert)

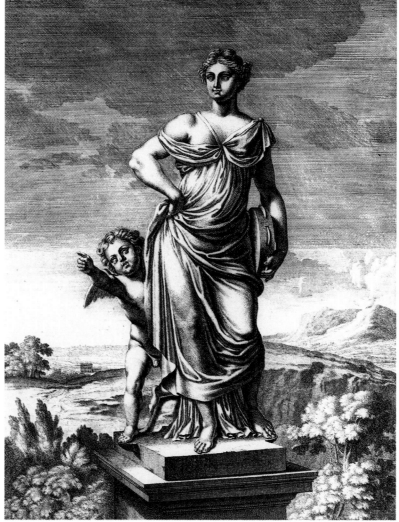

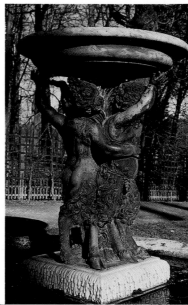

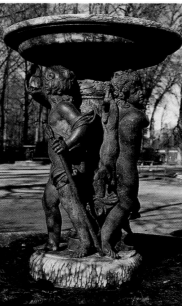

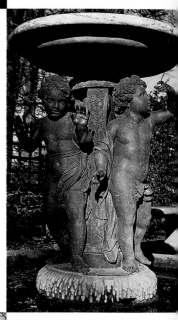

Three little terms
(Louis Lerambert)

Three little satyrs
(Pierre Legros the elder)

Three children admiring the water as it falls
When the fountains are playing, the water flowing from the bowl completes the ornamental effect intended by the designer.

Three young huntsmen
(Pierre Legros the elder)
One of the fountains at the entrance.

Three children admiring the water as it falls
(Pierre Legros the elder and Benoît Massou)

Compare *far left* – the same fountain (one of those at the entrance) during the *grandes eaux*.

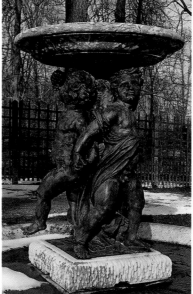

Two cupids and a little girl
(Etienne Le Hongre)

Two dancers and the young Bacchus
(Pierre Legros the elder)

The 'Marmousets of the Allée d'Eau

Seven groups of figures known as 'Marmousets' (a familiar term for little boys), rejoicing in creation and life itself, decorate the Allée d'Eau and illustrate the evolution of matter: from mineral to vegetable, then from the marine world to the animal and human kingdoms. Designed by Le Brun, they were originally cast in *métail* in 1669–70 by three artists. Lerambert was here bidding farewell to Versailles, while two sculptors of the new generation, Pierre Legros the elder and Etienne Le Hongre, were making their first appearance.

Each group initially supported a shallow bowl of fruit or flowers, executed by Benoît Massou; from the middle of the bowl a jet of water rose and then fell in a sheet into a stone basin, alternately round or square (see Jean Le Pautre's illustration of 1673, *below*).

When the groups were cast in bronze in the 1680s, each was given a round pink marble bowl and placed in a round white marble basin. At the same time, four new pairs of 'Marmouset' fountains were designed and cast in bronze to replace the stone statues originally at the entrance to the Allée.

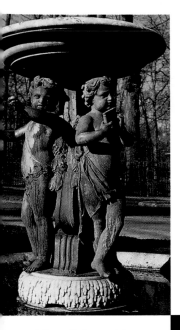

Three little musicians
(Louis Lerambert)
Compare the engraving
below right.

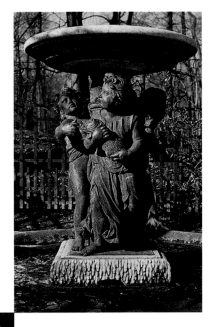

Three young fishermen
(Pierre Mazeline)
One of the fountains at the entrance.

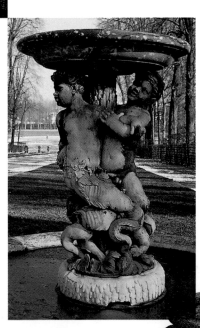

Three little girls and a bird
(Pierre Legros the elder and
Benoît Massou)
One of the fountains at the entrance.

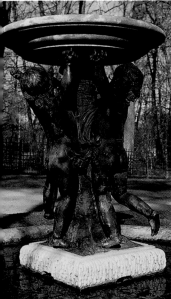
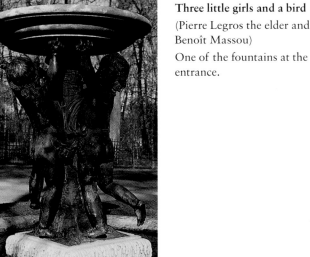

Three little dancers
(Louis Lerambert)

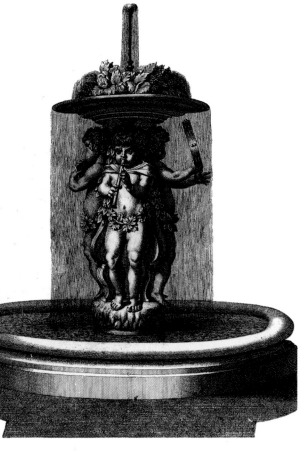

Three little tritons
(Pierre Legros the elder)

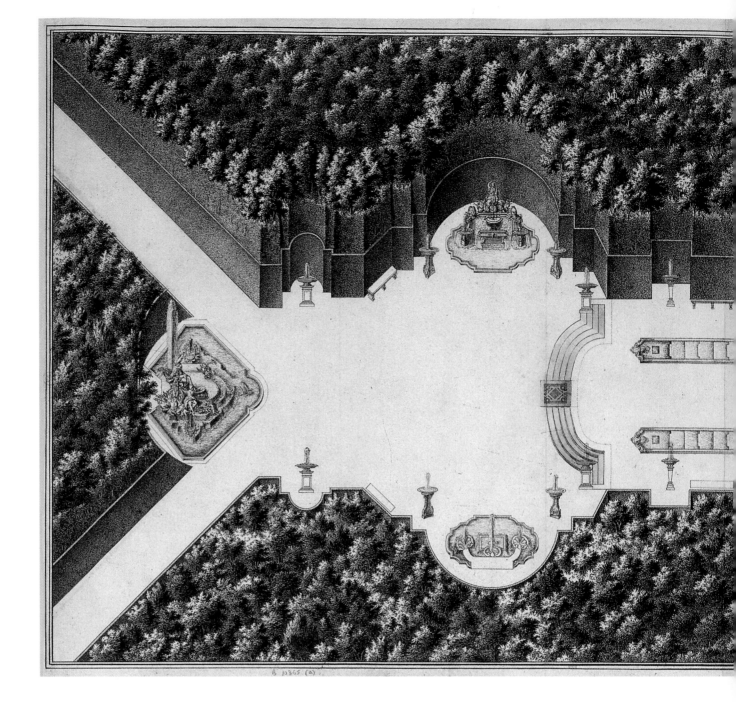

B 10365 (a).

The Bosquet de l'Arc de Triomphe

THE ARC DE TRIOMPHE and the Trois Fontaines, the only bosquets in the Jardin Haut, were given a highly unusual elongated form in which the rise in the land gave scope for their arrangement in several *salles* (rooms) and for a masterly use of water features.

This bosquet, situated to the east of the Allée d'Eau, was created in 1672 as a *pavillon d'eau*. Originally two paths led diagonally through the clump of woodland to a round *cabinet de verdure* with a square pool in the middle (see the plan p. 37, top). From each corner a *métail* dolphin threw a jet towards the centre of the bassin, where a lance of water rose into the air. In the clipped hornbeam hedges lining the bosquet were four vases, each supporting a bowl from which a jet rose vertically and fell back into the vase. The water then spouted from a mask in the side of the vase into a shell-shaped bassin.

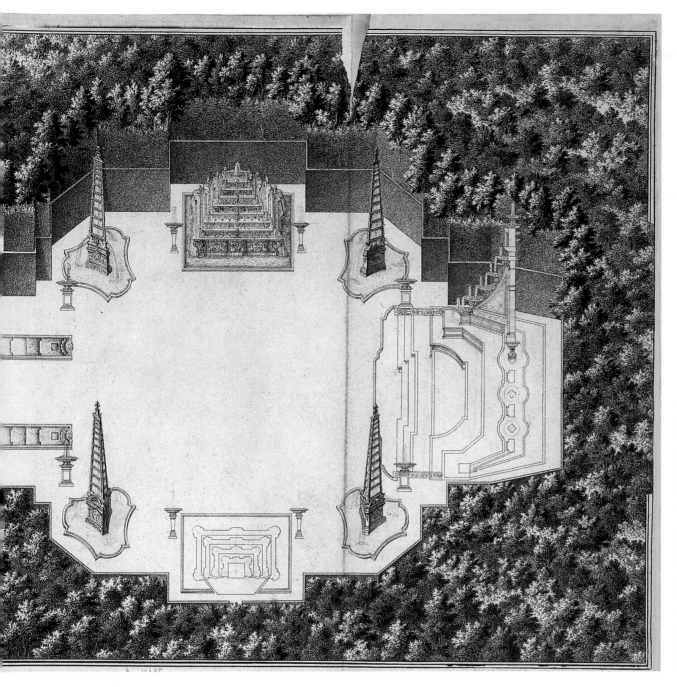

The completed bosquet

In this drawing the upper, southern, salle appears on the right. Each pair of obelisks flanks a marble *buffet d'eau*. It had been intended that a monumental cascade crowned by an eagle should complete the décor at the right, but instead a triumphal arch was created by Pierre Mazeline in 1677 (hence the bosquet's name). In 1678 the connecting passage to the lower salle was given two rows of white marble water-steps and a flight of five curved steps.

In the lower salle, facing the triumphal arch in the higher salle, a fountain celebrated the Victory of France. That was soon moved to one side and balanced on the other side by a similar fountain with the theme of Glory, and a new central fountain was installed representing France Triumphant.

In 1676 the design was altered, and the vases were replaced by two pairs of obelisks. Another clearing was later opened at a lower level, linked by a short connecting passage (ill. p. 39), and the two salles were given decoration on a political theme.

The final scheme well illustrates how, after France's victories over Spain and the Austrian Empire, when the Sun King had become Louis the Great, there was a change of emphasis in the decoration of the gardens, away from the mythological and towards allegorical references to contemporary events.

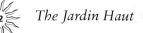

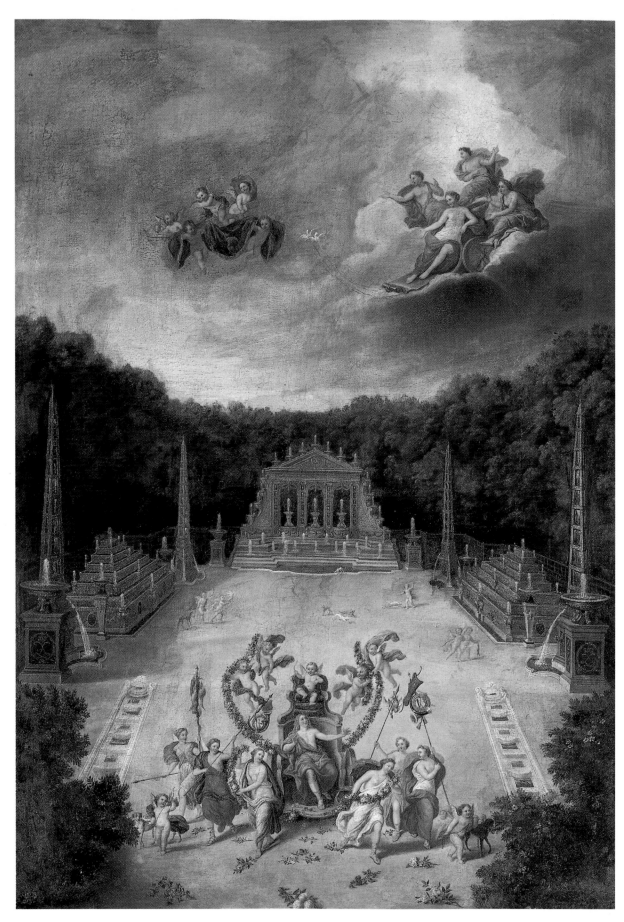

The upper salle

Jean Cotelle's painting shows
the southern part of the
bosquet, with the vista towards
the triumphal arch framed by
water-steps, obelisk fountains
and *buffets d'eau*. In the
foreground is Adonis returning
in triumph from the chase,
watched by Venus in the clouds.

Like the image opposite, this
picture is part of the set ordered
in 1688 by Louis XIV, who
wished to decorate the gallery
in the Grand Trianon with
views of the bosquets in his
gardens.

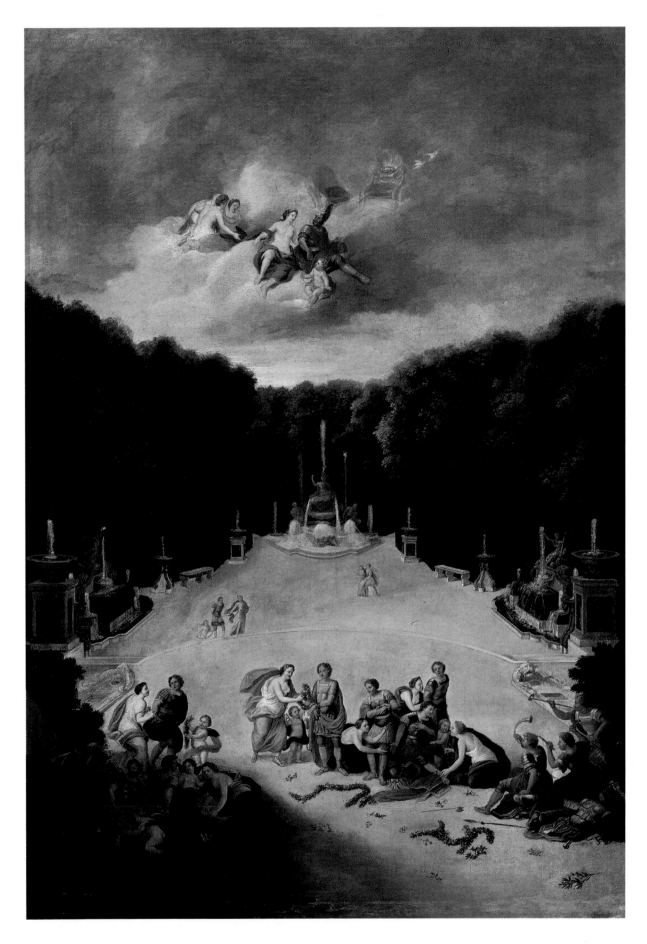

The lower salle

This painting shows the other end of the bosquet, with its central fountain of France Triumphant flanked by the Victory and Glory of France. Warriors are received by cupids and nymphs below figures of Mars and Venus.

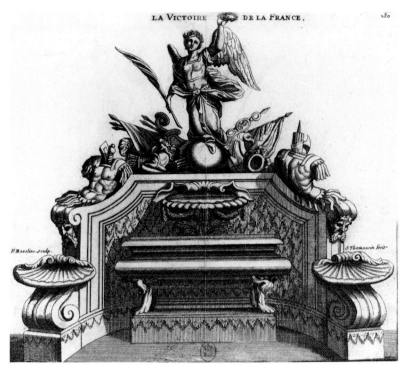

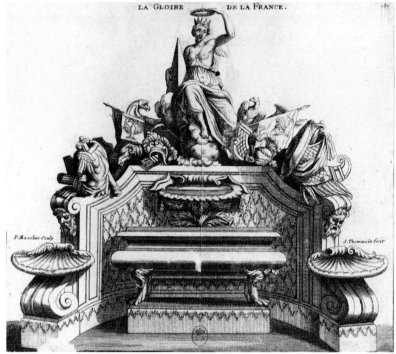

The Victory and Glory of France

These marble fountains surmounted by allegorical figures in gilded *métail* were made by Mazeline with the collaboration of Houzeau and the Blanchard brothers. They do not survive, but were engraved by Simon Thomassin in his *Recueil des figures, termes, fontaines, vases et autres ornements tels qu'ils se voient à present dans le château et parc de Versailles* (1694).

Victory (made in 1678) kneels on a globe and holds a palm and a laurel wreath. Glory (made in 1681) is seated on a star-spangled globe: she crowns herself with one hand and in the other clasps a pyramid, symbol of the sovereign's greatness.

France Triumphant

Jean-Baptiste Tuby produced a model for this allegorical fountain in 1677, after designs by Le Brun, and in 1680–83 he supervised its execution by Prou and Coysevox. The figure of France sits on a triumphal chariot shaped as a shell; she holds a spear and a shield decorated with the royal fleurs-de-lis, and on her helmet perches the cockerel of Gaul. At her feet a young captive and a lion symbolize the defeat of Spain; turning his back to her, an older captive with an eagle refers to the defeat of Austria. They are separated by a three-headed dragon writhing in agony representing the disarray of the Triple Alliance, formed by the other states involved in the war against France.

The group is at present being restored, and the photograph here was made at the beginning of the twentieth century by Eugène Atget, who also took many other views of the gardens.

The Bosquet des Trois Fontaines and Bains des Nymphes de Diane

Wᴴɪʟᴇ the Bosquet de l'Arc de Triomphe has the appearance of a grand reception room, that of the Trois Fontaines has the charm of a natural space. In 1671 this bosquet, crossed by a simple 'elbowed' path (see the plan p. 37, top), was laid out as a *berceau d'eau* or water arbour. The effect of the *berceau* was produced by numerous jets springing from the raised bands of turf running the length of the allée, and arching over to form a vault of water without wetting the walker. Between 1677 and 1678 the bosquet was transformed by Le Nôtre who made use of the different levels to create a series of linked salles, also containing a number of water features. In this form it became the Bosquet des Trois Fontaines.

Depending on whether it was approached from the north (left) or south, two quite different perspectives opened out: seen from the north, as the land rose, the view narrowed; from the south it widened. In the centre of the lowest and largest salle, which was octagonal, was a rocaille fountain echoing the shape of the clearing. Access to the middle salle, smaller and square in shape, was by a set of steps flanked by two little rocaille cascades. Here the central bassin was also square. The space narrowed and rose again, and a cascade flanked by two flights of steps led to the highest and smallest of all the salles, which contained a circular fountain. The bosquet was restored at the end of the eighteenth century but disappeared in the 1830s.

The fountain known as the Bains des Nymphes de Diane, which closes the view south along the Allée d'Eau between the two bosquets of the Jardin Haut (ill. p. 39), creates a subtle link by the elegance and delicacy of its décor.

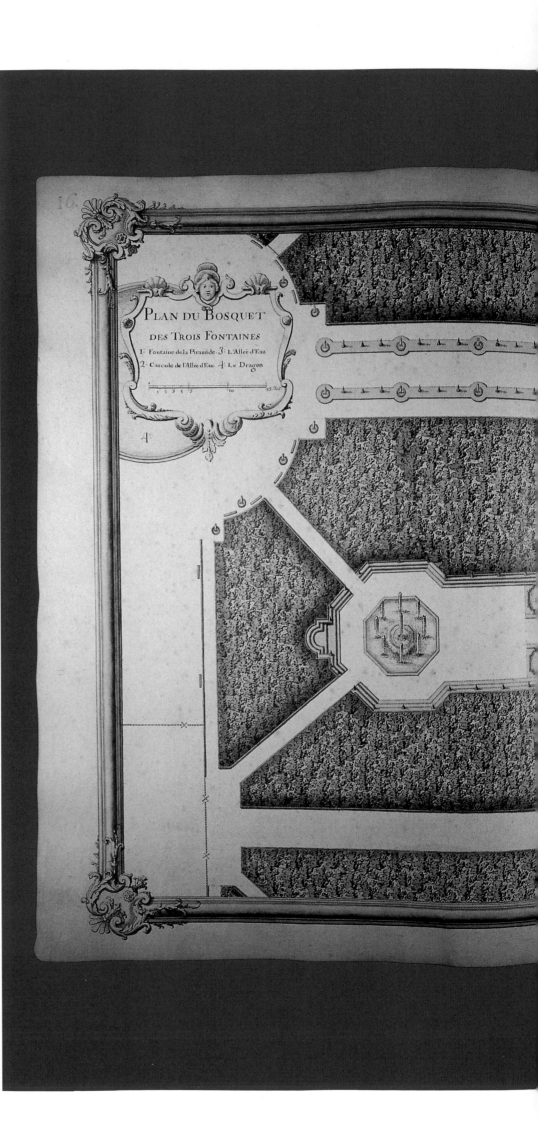

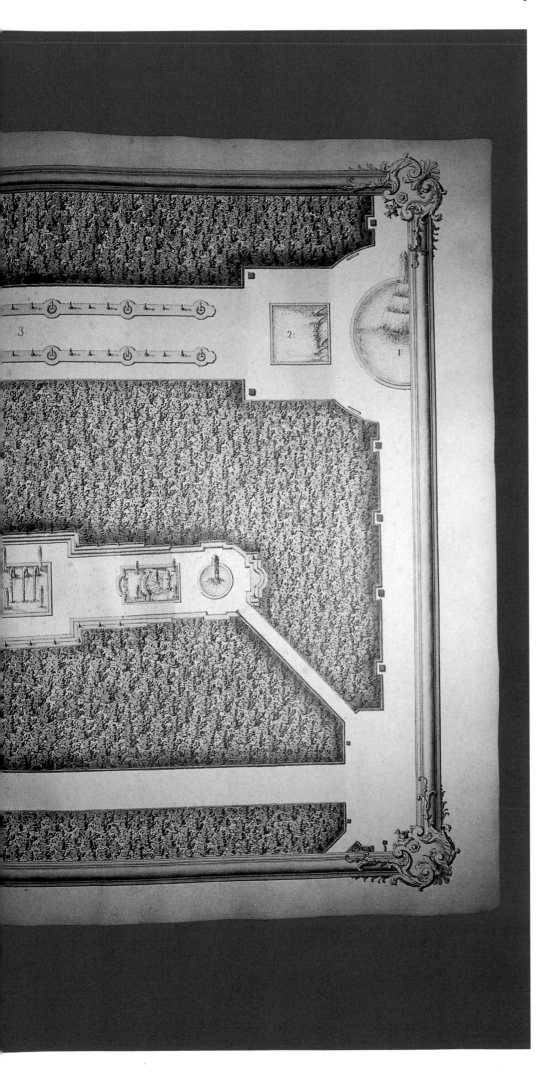

Plan from the album of Jacques Dubois

Dubois' plan shows the Bosquet des Trois Fontaines as it appeared *c.* 1715, together with the Allée d'Eau (above) and the Bains des Nymphes de Diane at the end of the allée (top right).

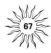

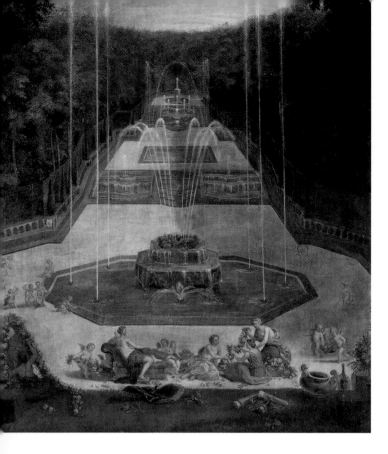

The Bosquet des Trois Fontaines

LOOKING southward down the bosquet, the space narrowed and the ground level rose. In the foreground of Jean Cotelle's painting (commissioned in 1688) is the octagonal salle, with a three-tiered rocaille fountain decorated with painted metal flowers; it was surmounted by eight jets that fell in a crown into the bassin, from which rose eight lances of water.

Beyond, you climbed a flight of steps between rocaille cascades, each with three bubbling jets, to reach the square central salle. Here ten jets – six forming a water vault, and four lances – rose from a square bassin. You changed level again, up steps flanking a cascade, to reach the final salle, with a circular fountain in which 140 jets formed a cluster.

Around the perimeter, clipped yews stood on a raised border of three turfed steps, set close against the enclosing hornbeam hedge.

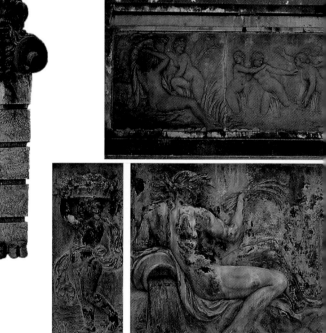

Relief of a putto
(Nicolas Legendre)

Relief of a young sea-god
(Etienne Le Hongre)

Reliefs on the eastern side wall
(Etienne Le Hongre)

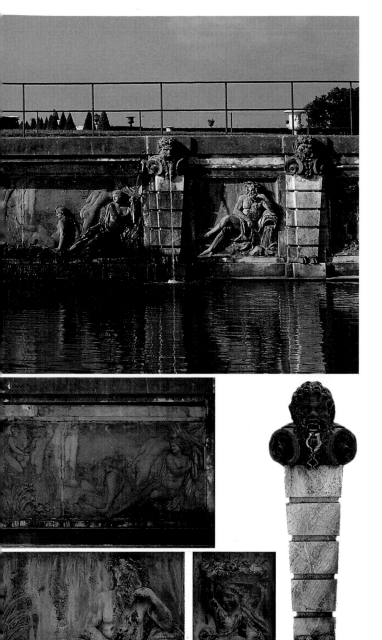

The Bains des Nymphes de Diane

The end wall of the fountain
The central relief of nymphs is flanked by two river-gods. Visible above the retaining wall is the Pyramide d'Eau, which marks the entrance to the Parterre du Nord.

The relief of Diana's nymphs
The commission for this relief in *métail*, 6.15 metres (20 feet) long and 2.25 metres (7 feet 5 inches) high, was given to Girardon in 1668. It was finished in 1670 and gilded the following year.

Satyr terms
The heads of the four terms which back on to the retaining wall of the bassin were fashioned by De Buyster, Legendre and Magnier.

THIS FOUNTAIN, originally called 'La Nappe' (the sheet of water), was made as part of the initial decoration of the Allée d'Eau. It stands at the south end, and its form is adapted to the rise in the level of the ground. Scenes of bathing nymphs and other water deities cover the end wall and sloping side walls; the end wall has in addition four satyr terms with cloven feet, whose mouths serve as water-spouts. The fountain takes its name from the relief of eleven nymphs of Diana – goddess of the chase and sister of Apollo – whose nakedness is half hidden and half revealed.

The decoration was produced in 1670–71 by six sculptors: Nicolas Legendre and De Buyster were master craftsmen, while Girardon, Laurent Magnier, Le Hongre and Pierre Legros the elder were members of the first generation of artists trained in the new Académie Royale de Sculpture.

Relief of an aged river-god
(Laurent Magnier)

Relief of a putto
(Laurent Magnier)

Reliefs on the western side wall
(Pierre Legros the elder)

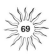

The three parterres of the Jardin Haut

This was the starting-point for the gardens of Versailles. These three parterres grew out of the design laid out in the time of Louis XIII – a single *parterre de broderie* in front of the west façade of the hunting lodge (see the plan p. 36, top). Louis XIV added two new parterres for the north and south façades. Once the lodge was turned into a palace, the three parterres were made into a single ensemble. A vast *parterre d'eau* in the centre of the composition was complemented by a *parterre de gazon* to the north and a *parterre de broderie* to the south, bringing together the three main varieties of parterre associated with the French garden.

The two side parterres, at first separated from the central parterre by rows of trees, were soon united with it. Their size was doubled (ill. p. 119) and they were given the names of Parterre du Nord and Parterre du Midi by which they are still known today.

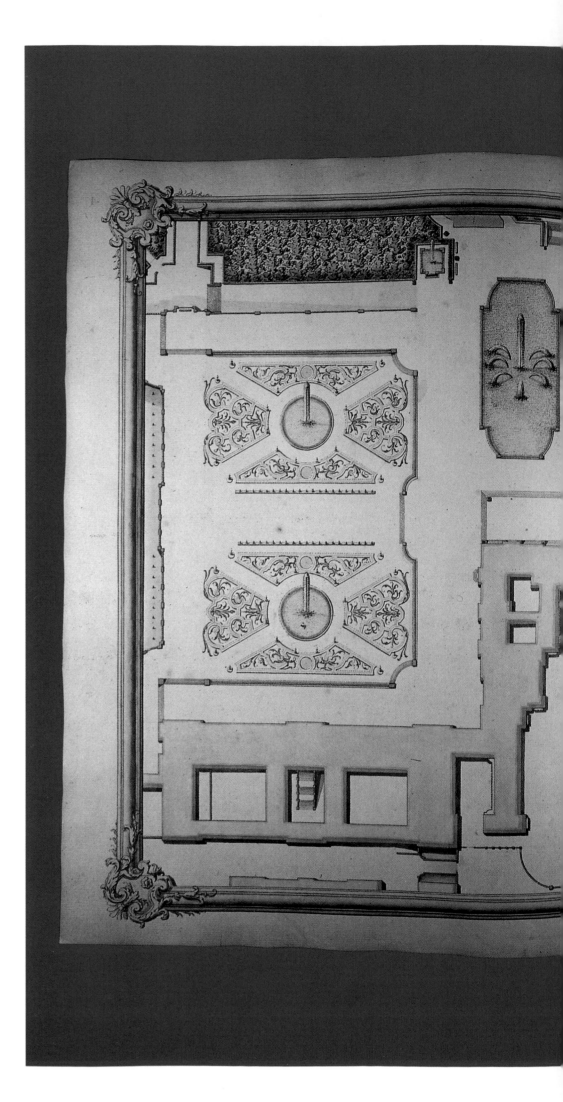

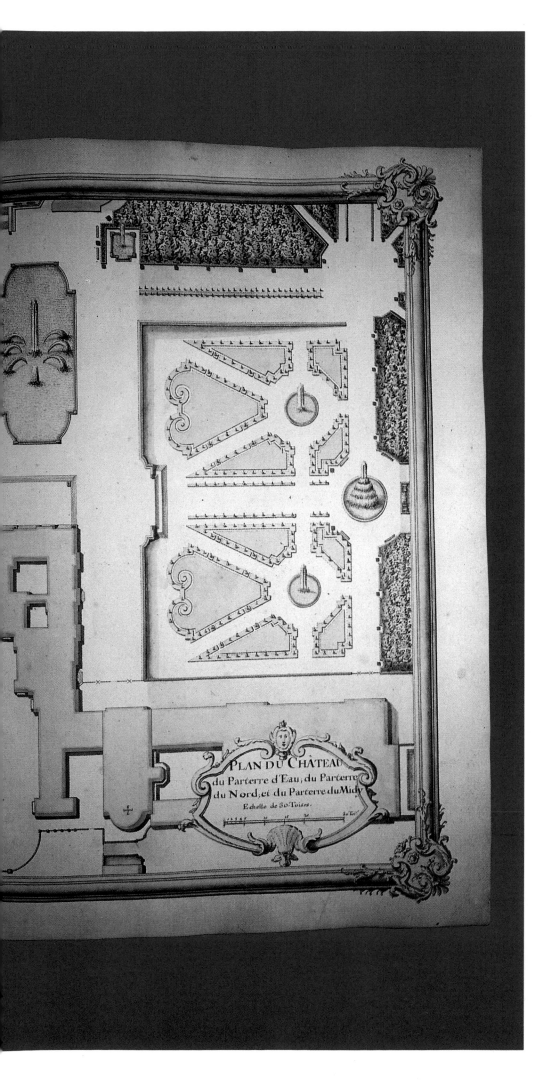

Plan from the album of Jacques Dubois

The Parterre du Nord is on the right, the Parterre d'Eau in the centre (in its final state; the plan shows the parterres *c.* 1715) and the Parterre du Midi on the left. The château, with its two wings, is at the bottom.

The Parterre du Nord

A S DESIGNED by Le Nôtre in 1663, the parterre extended north of and aligned with Louis XIII's hunting lodge. At that time three bassins – two small to the north, one large to the south – framed four compartments of turf (see the plan p. 36, below).

In 1666 the parterre was doubled in size to the west. Its new layout consisted of ten turf compartments bordered with plates-bandes in which the planting was punctuated by clipped yews and marble vases. The two small bassins were relocated and became the Bassins des Couronnes. A larger third bassin was constructed at the north to balance the original large bassin to the south, relocated on the new axis (see the plan p. 37, top): the former soon housed the Fontaine de la Pyramide, the latter the Fontaine de la Sirène.

At first called the Jardin de la Grotte after the grotto built to the north of Louis XIII's hunting lodge, whose reservoir supplied the first water features in the gardens, it then became the Parterre du Nord (ill. p. 119). The aquatic theme of its decoration, devised by Le Brun, echoed that of the Bassin de Neptune, the Bassin du Dragon, and the Allée d'Eau.

The Parterre du Nord in its enlarged state

This painting by Etienne Allegrain depicts the view looking north, *c.* 1689. The parterre is shown with the symmetrical Bassins des Couronnes and central Fontaine de la Pyramide d'Eau. By this time the Fontaine de la Sirène (ill. p. 78) had been removed: it stood near where the artist has depicted the king and his entourage.

The axis of the Jardin Haut crosses the parterre and becomes the Allée d'Eau, leading to the Fontaine du Dragon, the Bassin de Neptune, and finally to Bernini's equestrian statue of Louis XIV which at this date closed the vista.

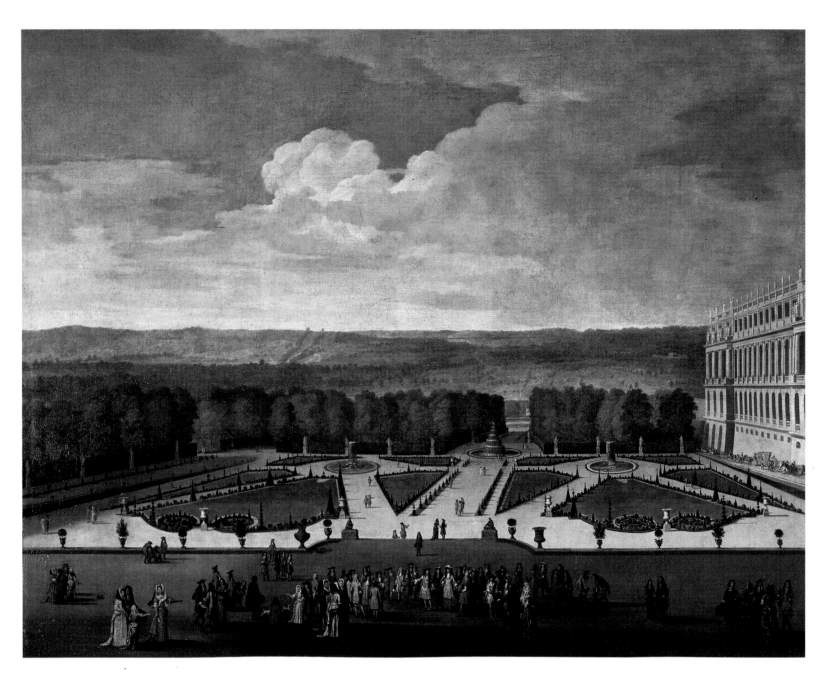

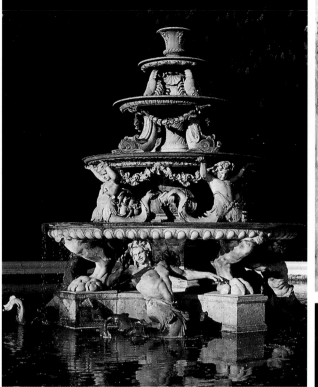

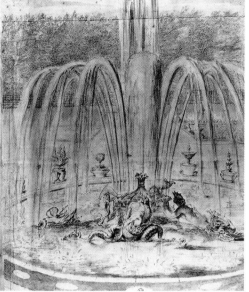

The Bassins des Couronnes

The fountains of these two bassins, nearly identical in design, have a spray of eleven jets of water springing from a crown held by group of tritons and mermaids. They were made of *métail* in 1669–72. In 1686 Pierre Mazeline and Noël V Jouvenet replaced the large central crowns (recorded in a drawing, *left*) by smaller crowns decorated with bay leaves.

The Fontaine de la Pyramide d'Eau

Executed in *métail* by Girardon in 1668, at the same time as the relief of the Bains des Nymphes de Diane, the fountain consists of four superimposed shallow bowls supported at the base on four lion's paw consoles, with four tritons sporting between them. The higher bowls are held up by four young tritons, four dolphins and at the top four crayfish. At the apex, water gushes out of a vase decorated with satyr heads. After being gilded in 1671 by Jacques Bailly, the fountain looked like a golden pyramid when water flowed over it. The bassin was subsequently altered in the 1680s.

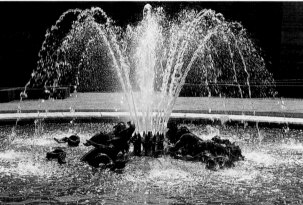

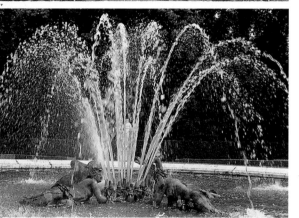

The eastern Bassin des Couronnes

(Jean-Baptiste Tuby)

The western Bassin des Couronnes

(Etienne Le Hongre)

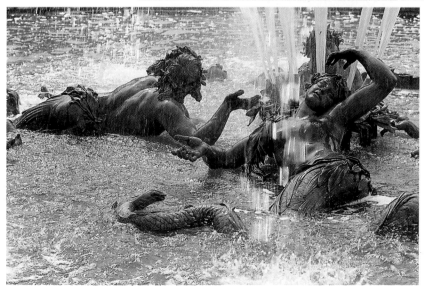

The Rond-Point des Philosophes

The opening in the north-west corner of the parterre was decorated
in 1688 with five marble terms depicting sages of ancient Greece.
They had been commissioned five years earlier by Louvois and the
designs for them made by Pierre Mignard. In the Parterre du Nord
they joined fifteen statues from the series intended for the Grand
Parterre d'Eau (see the plan pp. 30–31, and ills. pp. 84–87).

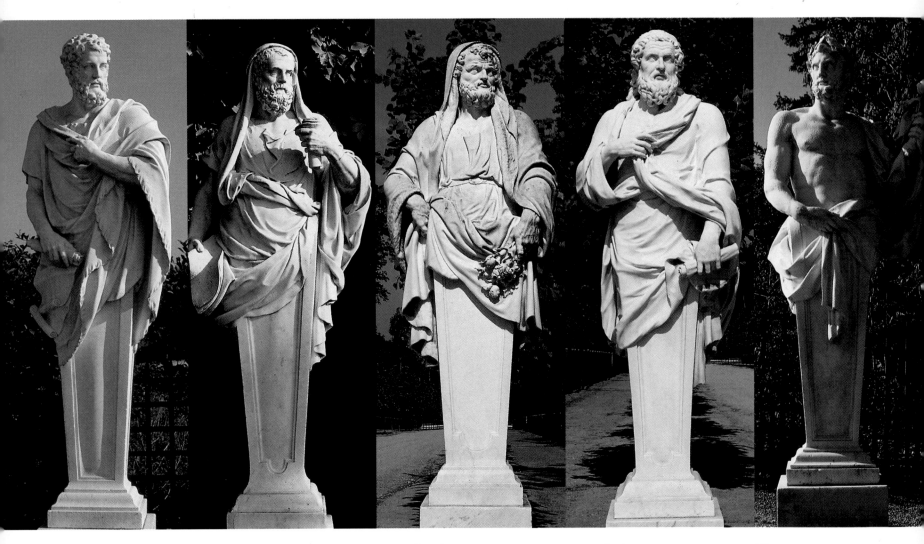

Pittacus

Barthélemy de Mélo)

This term is also identified as
Apollonius, master of Greek
grammar and tutor to the
Emperor Marcus Aurelius.

Isocrates

(Pierre Granier)

Isocrates and Lysias were
among the great orators of
ancient Greece.

Theophrastus

(Simon Hurtrelle)

Theophrastus, a disciple of
Aristotle, is holding a bunch of
poppies symbolizing sleep,
which he resented as time
wasted away from study.

Lysias

(Jean Dedieu)

Ulysses

(Philippe Magnier)

Ulysses, the hero of Homer's
Odyssey, is shown holding the
flower with which he freed his
companions who had been
turned by Circe into swine.

The vases of the parterre

Originally there were eight large white marble vases (ill. p. 72): now there are six. At the northern end of the central allée were a pair by Rousselet; flanking its southern end were a pair by Girardon; further to the east and west at the shaped ends of the beds were two more pairs, probably those by Cornu and Bertin still in the parterre.

Girardon's vases, commissioned by Colbert and carved in 1683, showed the Triumphs of Venus and Galatea. They went in 1706 to Trianon (and thence to the Louvre), and were replaced by Cornu's pair. In 1817 Rousselet's were moved to the Bosquet du Jardin du Roi in the Jardin Bas (ill. p. 196); they were replaced by a new pair of vases with putti. Bertin's may still be in their original position, at the outer edges of the beds. The middle positions are now vacant.

One of the pair of vases with oak wreaths

These were made in 1684 by Jean Cornu, who three years later, with Joseph Rayol, carved the statues on the façade of the the new north wing of the château. They occupy the position of Girardon's vases.

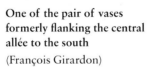

One of the pair of vases formerly flanking the central allée to the south

(François Girardon)

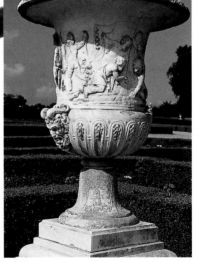

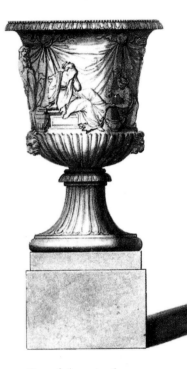

One of the pair of vases formerly marking the entrance to the allée at the north

(Jean Rousselet)

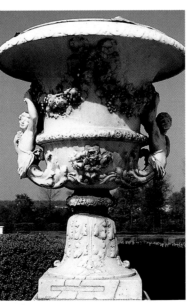

One of the pair of vases with vine garlands

These were made by Claude Bertin, together with eighteen other vases distributed throughout the gardens, between 1687 and 1705. They are symmetrically placed to balance a pair decorated with flower garlands in the Parterre du Midi (ill. p. 107, below right).

Pair of vases with putti

Carved by pupils of the Académie de France in Rome, these replaced the vases by Rousselet at the north. The subjects are scenes of the chase to the east (*right*), and games to the west (*above*).

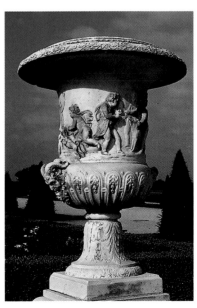

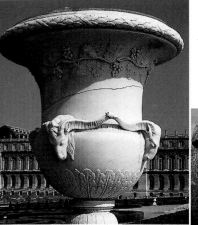

White marble vase
Decorated with a vine wreath and rams' heads, this vase stands on the western section of the parapet above the parterre.

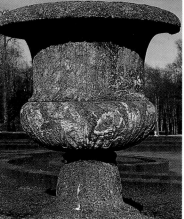

One of a pair of green marble vases

These vases, executed in Egyptian marble by Simon Mazière and Simon Hurtrelle in 1685, flank the two statues at the top of the steps.

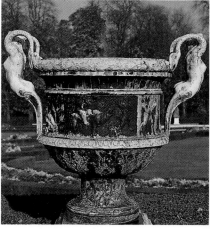

The bronze vases

Made in 1665 to designs by the royal goldsmith Claude Ballin, they stand in a row along the parapet wall, seven on each side of the steps. Those by François Anguier and Nicolas Legendre were cast in bronze by Ambroise Duval, while those by Laurent Magnier and Jean-Baptiste Tuby were cast by Denis Prévost and François Picart. Some have figurative handles, like the mermaids *above*.

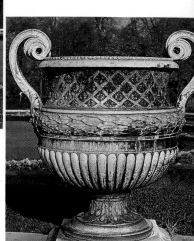

Volute handles and a laurel wreath

Vases and statues of the parapet of the terrace

At the southern end of the Parterre du Nord, a retaining wall with a short central flight of steps marks the separation from the Parterre d'Eau, at a higher level. (The same is true, in reverse, for the Parterre du Midi.) The parapet was decorated with fourteen bronze vases, three large marble vases, and two marble statues facing each other at the top of the steps (ill. p. 72). The latter were cast in bronze by the Keller brothers in 1688 to match the bronze groups in the new Parterre d'Eau. (The originals were moved first to the Tuileries and then in 1871 and 1873 to the Musée du Louvre.)

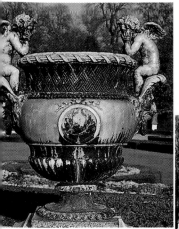

Pensive cupids

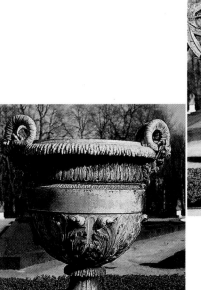

Wolf heads

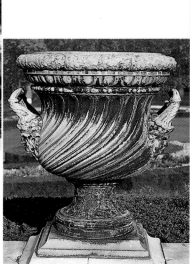

Faun heads

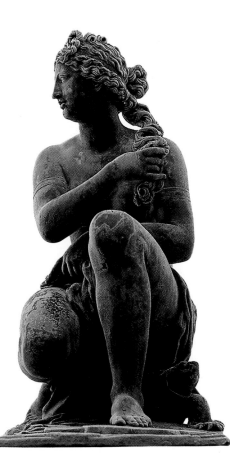

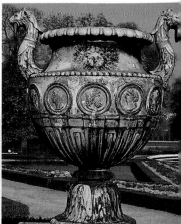

Lion heads

Swirls

The Knife-Grinder

This statue on the east side of the steps is a cast by the Kellers of a copy of an antique work (now in the Uffizi Gallery in Florence) made in 1684 by the Italian Giovanni Battista Foggini for Versailles. In Louis XIV's time it was described as the slave Milichus, sharpening for his master Scaevinus the knife that was to kill the Emperor Nero, and listening attentively to the conspirators whose plot he foiled.

Crouching Venus

The original figure of Venus facing the Knife-Grinder was created in 1683 by Coysevox, also after an antique model but more freely adapted. She represents Modesty, indicated by the tortoise at her feet which is taken from Cesare Ripa's *Iconologia*, a work much used by contemporary artists to supply their themes: 'Chaste women should move from their house no more than this animal moves from beneath the roof where nature has confined it.'[34]

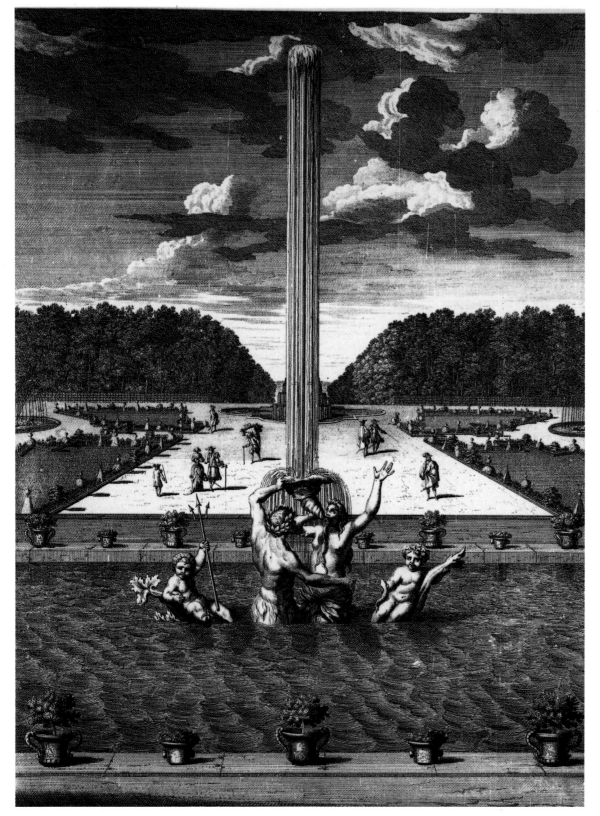

The Grand Parterre d'Eau

In 1668, when Le Vau was working on the 'Envelope' around the old château, the area in front of it became a *parterre d'eau*, composed at first of four small circular pools grouped round a large central bassin decorated with nine tritons. Le Brun then extended the theme of universality informing the new façade to a new design for the parterre. His Grand Parterre d'Eau, seen in a drawing from his studio showing four variant schemes (*opposite*), was begun in 1674 but never fully completed. The area was completely remodelled in 1683.

The composition of a large central bassin and four corner bassins, flanked by two small oval pools, was intended to represent 'the union or interrelation of all that makes up the universe.'[35] There was to be a rock in the middle of the large bassin and a fountain in each of the corner bassins, and four marble groups were to have decorated the corners of the parterre (see pp. 82–83). Twenty-four statues would have punctuated the plates-bandes surrounding the bassins (see pp. 84–87).

The Fontaine de la Sirène

This bassin lay on the level of the Parterre d'Eau, above the Parterre du Nord. When the latter was doubled in size it was moved to the new axis (compare the plans p. 36, below and p. 37, top).

The fountain, on a marine theme, was made in 1667 of *métail* by Gaspard and Balthazar Marsy and gilded the following year by Jacques Bailly. It took the form of a mermaid blowing into a conch shell held by a triton, from which rose a lance of water. During the first alteration of the Parterre d'Eau, a second bassin symmetrically positioned on the other side of the château was planned but then abandoned, and at the same time this bassin and fountain were destroyed.

Jean Le Pautre's engraving of 1679 shows the view from the Fontaine de la Sirène across the Parterre du Nord towards the Fontaine de la Pyramide.

The Parterre d'Eau and its setting

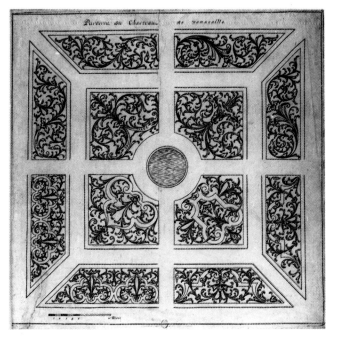

THIS PARTERRE in front of the château, where the Great Axis meets the transverse axis of the Jardin Haut, is the hub of the gardens. Laid out as a *parterre de broderie* under Louis XIII, then as a *parterre de gazon* at the accession of Louis XIV, and subsequently turned into three versions of a *parterre d'eau*, it serves as an illustration of the main forms of parterre of the seventeenth century (see the plans pp. 36–37).

The early parterre

The square parterre designed for Louis XIII by Boyceau de La Barauderie and executed by his nephew Jacques de Menours was divided into twelve compartments *de broderie* round a circular bassin. This engraving of its plan (*above*) comes from Boyceau's *Traité du jardinage* (1638).

In 1663 it was enlarged and closed to the west by a hemicycle, built up with earth from the excavations for the Orangerie; it then consisted of four compartments of turf with a bassin at the crossing of the walks (see the plan p. 36, below).

Three years later, when the Jardin Haut was doubled in depth, the hemicycle was reversed to give the first form of the horseshoe terrace looking over the Jardin Bas. The parterre was then simplified to two compartments of turf (ill. p. 100, top).

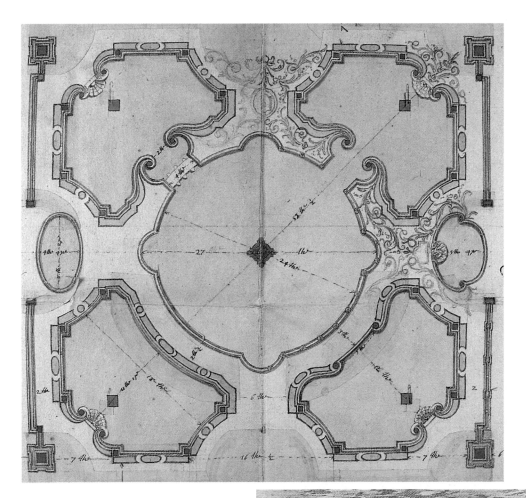

The Grand Parterre d'Eau in 1682

In Israël Silvestre's engraving the château is shown with its new south wing and as yet unbuilt extension to the north. In the foreground is the Grand Degré flanked by cupids riding sphinxes (ill. pp. 102–3). Le Brun's parterre was soon to be destroyed.

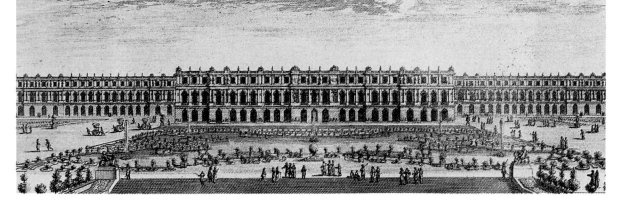

April/Taurus
March/Aries
(Benoît Massou and Jean Raon)
April was restored in 1898 by
Pierre Aubert and March
replaced by a copy.

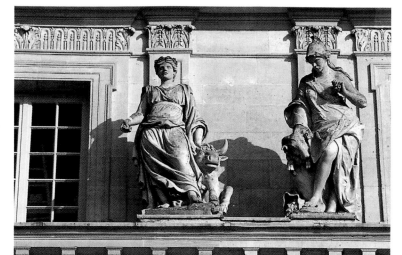

June/Cancer
May/Gemini
(Benoît Massou and Jean Raon)

July/Leo
August/Virgo
Gaspard and Balthazar Marsy)

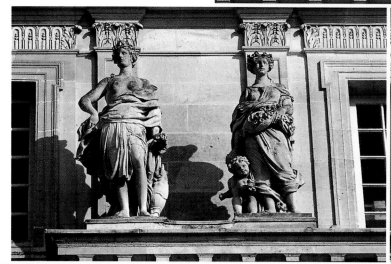

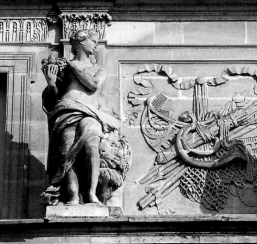

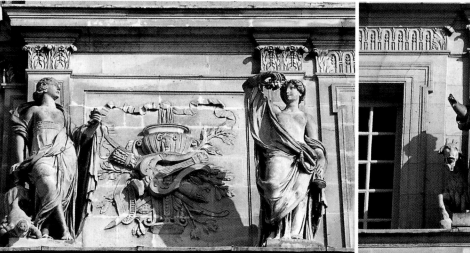

October/Scorpio
September/Libra
(Gaspard and Balthazar Marsy)

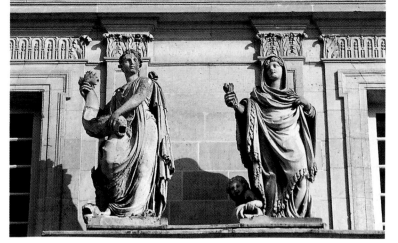

December/Capricorn
November/Sagittarius
(Gaspard and Balthazar Marsy)
The originals have been
replaced by copies.

February/Pisces
January/Aquarius
(Gaspard and Balthazar Marsy)
February was restored in 1895
by Charles Jonchery and
January replaced by a copy.

Ornamentation of the garden façade

The façade of the central block of the château rises from an arcaded ground floor and is articulated by three projecting sections. When Le Vau built the 'Envelope' around Louis XIII's château, his design had a recessed central portion with a raised terrace. Hardouin-Mansart later filled that in for the Galerie des Glaces, but the principle remained the same.

Directly above the columns of the projecting bays are twelve stone statues, nearly 2.5 metres (over 8 feet) high. Depicted as female figures, each with her sign of the zodiac, they illustrate the twelve Months, arranged according to the ancient Roman calendar in which the year opens with the beginning of spring and closes at the end of winter. They start from the south and so read from right to left.

The keystones of the ground-floor arches represent the Ages of Man.

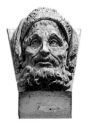
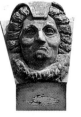

The Ages of Man

The keystones of the ground-level arcade were decorated with twenty-five masks, alternately male and female, depicting the Ages of Man from early childhood to extreme old age. They were carved in 1674 by the Marsy brothers and Benoît Massou. When the façade was altered by Hardouin-Mansart, their number was reduced to twenty-three, of which twenty-one are shown here.

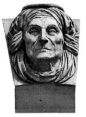

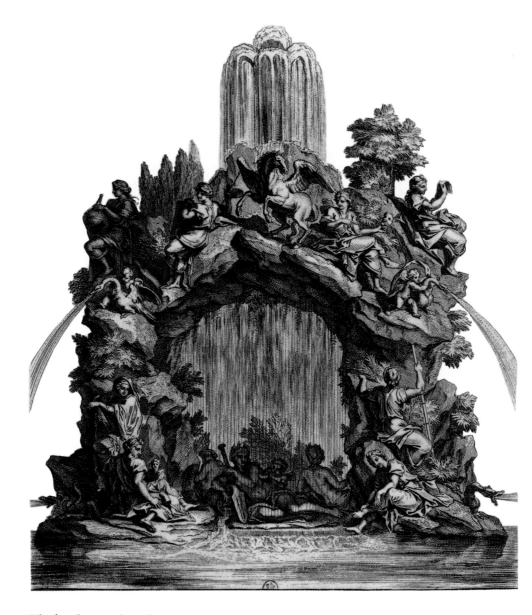

The four large sculptural groups

These were ordered for the corners of the parterre and symbolized the four elements in the form of four famous abductions: Fire, or the Rape of Proserpine by Pluto; Earth, or Cybele being carried off by Saturn; Air, or the abduction of Orithyia by Boreus; and Water, or Coronis and Neptune (*below left*). Only the first three were executed, of which Fire was sent to the Bosquet de la Colonnade and the two others to the Parterre Bas de l'Orangerie (ills. p. 112). The fourth group was commissioned from Tuby but never executed.

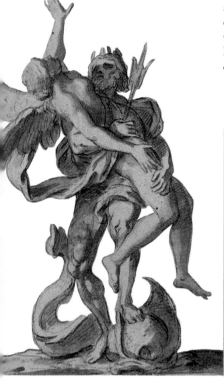

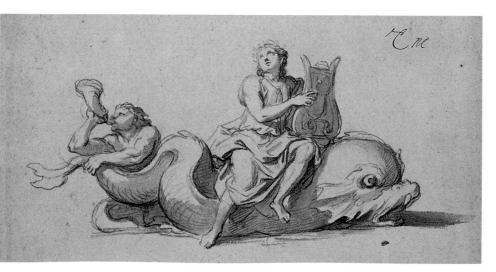

The fountains of the corner pools

The theme of these fountains was the elements in motion, again represented by scenes from classical mythology. Air was shown as Arion borne away by a dolphin; Fire as Phrixus and his sister Helle who fled sacrifice on the back of a ram; Earth as Europa ravished by Zeus in the guise of a bull; and Water as Melanippe carried off by Neptune in the form of a dolphin.

The Rocher des Muses et des Arts

This fountain consisting of four open rocaille arches was designed for the middle of the large central bassin. On one side (*right*) the arch was decorated with Apollo and the Muses whose song made the river Helicon lying at their feet break its banks.

On the other side (*opposite*), the winged horse Pegasus brought the river back to its normal course, and made the spring Hippocrene gush from beneath his hoof to flow round the four sides of the rock

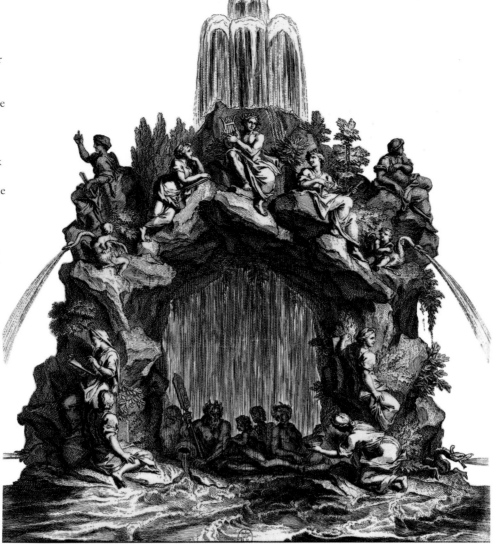

Decoration of the Grand Parterre d'Eau

Even before the ornamentation of the parterre was complete (see p. 79), the decision was taken to alter it. Some of the decorative pieces remained as designs, while others that had been executed were dispersed round the gardens. They are shown here in drawings by, and engravings after, Le Brun.

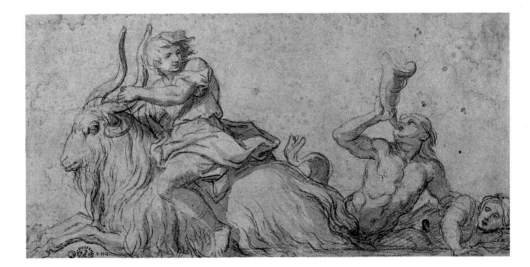

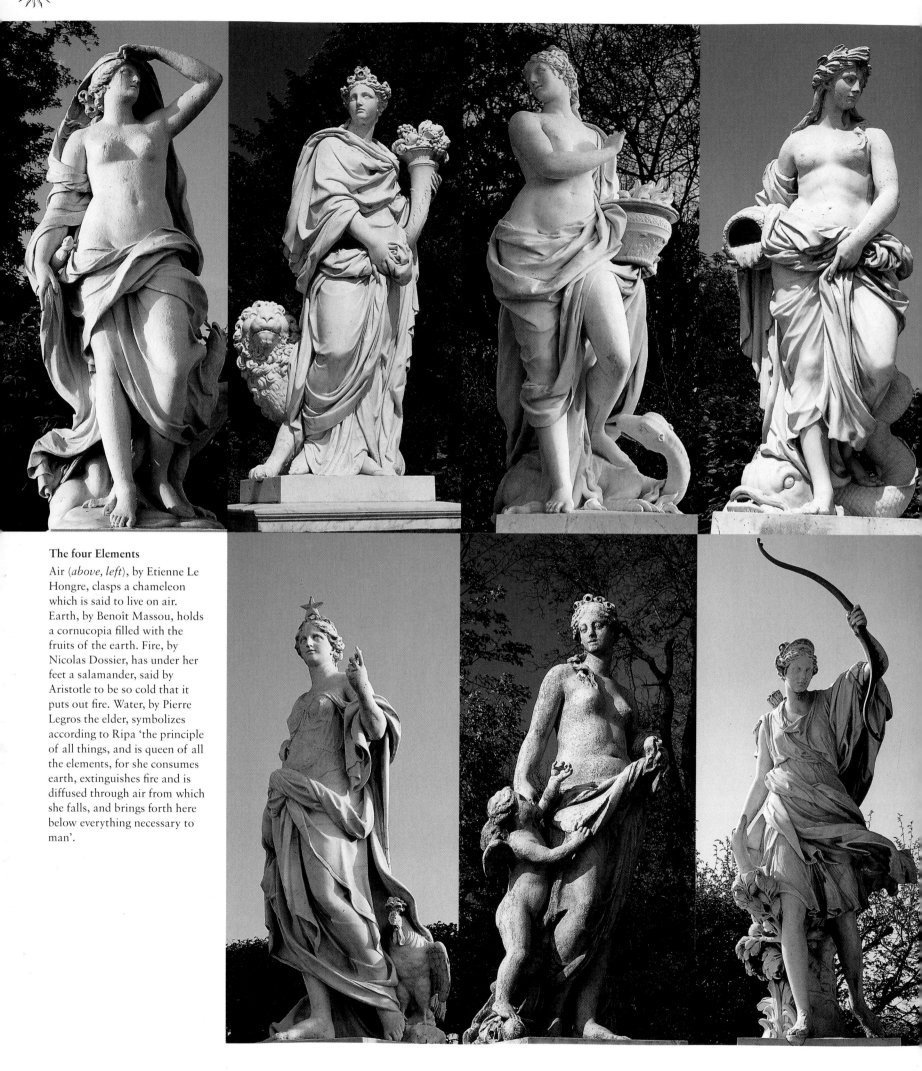

The four Elements

Air (*above, left*), by Etienne Le Hongre, clasps a chameleon which is said to live on air. Earth, by Benoît Massou, holds a cornucopia filled with the fruits of the earth. Fire, by Nicolas Dossier, has under her feet a salamander, said by Aristotle to be so cold that it puts out fire. Water, by Pierre Legros the elder, symbolizes according to Ripa 'the principle of all things, and is queen of all the elements, for she consumes earth, extinguishes fire and is diffused through air from which she falls, and brings forth here below everything necessary to man'.

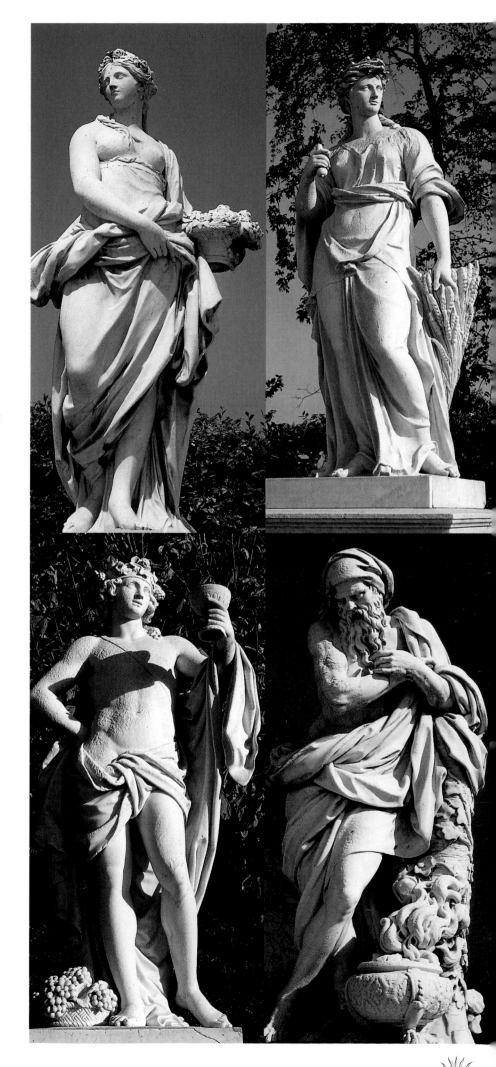

The twenty-four statues for the Grand Parterre d'Eau

Six groups of four marble statues were planned to stand around the edges of the bassins (see the plan p. 79). They were derived from the *Iconologia* of Cesare Ripa, many of whose illustrations were used as models by Le Brun: 'the four elements, by whose composition natural generation is effected, share in a sovereign degree with the four essential qualities, in consideration of which are found also in man four humours, four virtues, four principal sciences, the four noblest arts, four seasons of the year, four cardinal points, four winds, four parts of the world, and four causes or subjects of human knowledge.'

Work on the statues, commissioned by Colbert, began in 1674. In the spring of 1682, seventeen had been put in place. When the series was complete, however, in 1687, Le Brun's parterre had been destroyed, and they were eventually set up on the north and west edges of the Parterre du Nord, in front of the Cabinets des Animaux, and along the ramps of the Parterre de Latone (see the plan pp. 30–31).

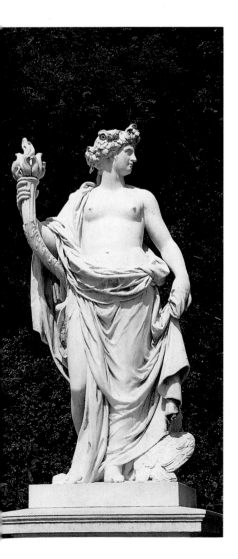

The four Seasons

Spring or Flora (*right, top left*) is by Laurent Magnier; Summer or Ceres, by Pierre Hutinot the elder and younger, held a sickle in her hand; Autumn or Bacchus is by Thomas Regnaudin; and Winter is by Girardon.

The four Times of Day

Morning (*far left*) and Midday are the work of Gaspard Marsy, the only sculptor to execute two statues in this series. Morning is crowned with the morning star. Midday is shown as Venus who, according to Ripa, 'with her son Cupid both burns and wounds those whom she attacks with flames or with arrows, working her strongest effects in the hearts of animals as they reach the age of maturity; so is the sun never so ardent as when at midday, directly over our heads, it casts at everything here below its burning darts.' Evening by Martin Desjardins appears as Diana, for there is no time of day more favourable to hunters. Night by Jean Raon holds a torch and wears a star-studded mantle.

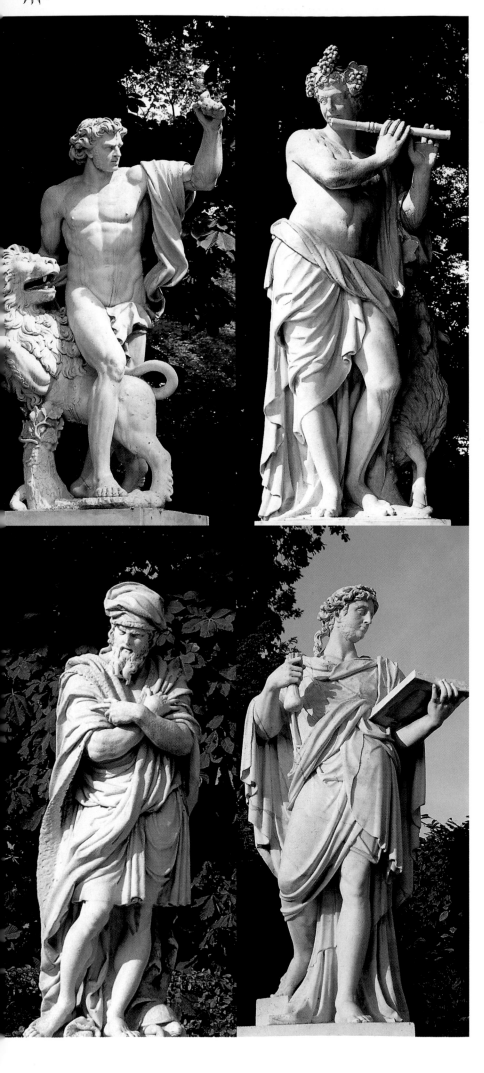

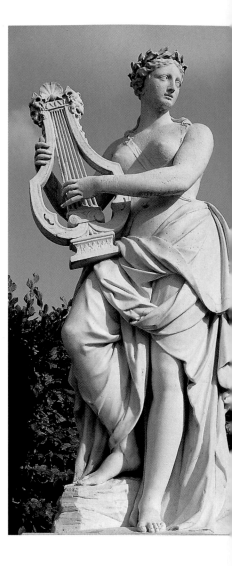

The four Humours of Man

The Choleric (*top left*), by Jacques Houzeau, is depicted with a lion, indicating anger but also a warm-hearted and generous character. The Sanguine, by Noël V Jouvenet, is accompanied by a goat which by its fecundity denotes a character inclined to love. The Phlegmatic, by Matthieu Lespagnandelle, has beside him a tortoise to suggest his slow heavy gait. The Melancholic, by Michel de La Perdrix, is by nature cold and dry.

The four Continents

Asia (*opposite, far left*) is by Léonard Roger. The model for Africa was made by Gaspard Marsy but the statue was begun by Georges Sibrayque and finished by Jean Cornu. Europe is the work of Jean Mazeline. America, by Gilles Guérin, has a severed head at its feet to indicate that its savage peoples eat human flesh.

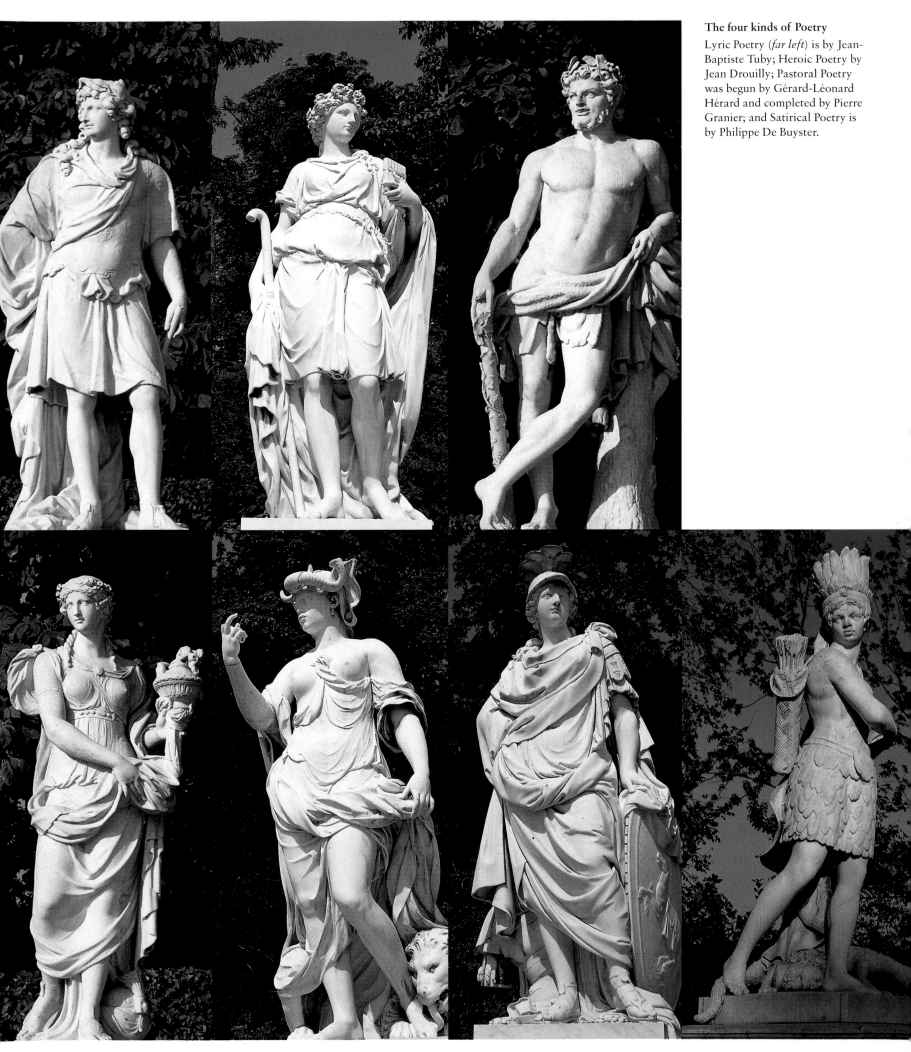

The four kinds of Poetry
Lyric Poetry (*far left*) is by Jean-Baptiste Tuby; Heroic Poetry by Jean Drouilly; Pastoral Poetry was begun by Gérard-Léonard Hérard and completed by Pierre Granier; and Satirical Poetry is by Philippe De Buyster.

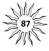

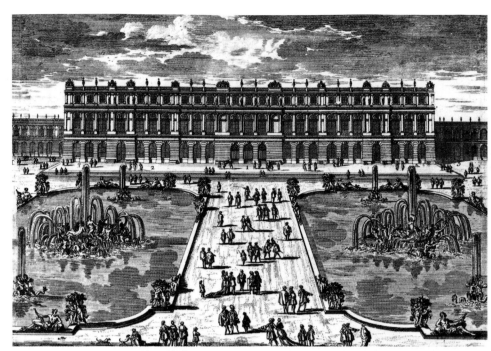

The new Parterre d'Eau
This engraving by Adam Pérelle shows the remodelled parterre in front of Hardouin-Mansart's new façade, with an unrealized design for the fountains (cf. p. 97).

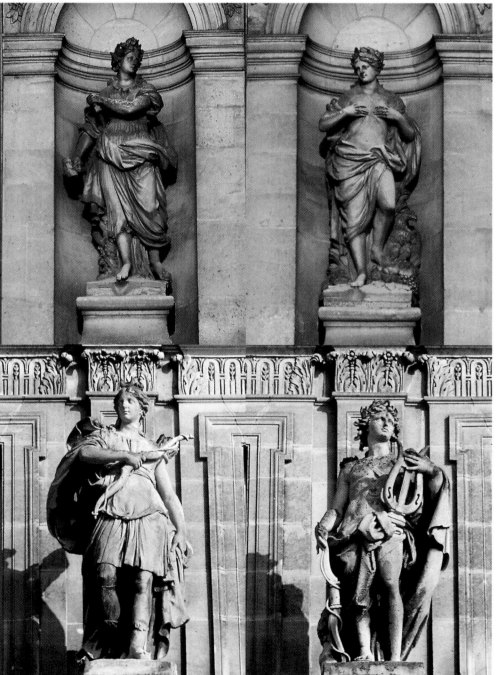

Ornamentation of the façade of the Grande Galerie
On the new central section of the façade two niches were filled with statues made in 1680 by Louis Leconte, summarizing the aesthetic doctrine of the time: the reconciliation of Art and Nature. In the northern niche Art holds the hammer and chisel of the sculptor – the tools with which to imitate Nature, according to Ripa. In the southern niche Nature presses the milk from her breasts, a gesture which, again according to Ripa, displays 'the wondrous fecundity of the earth-mother, nurse of all the world's creatures'.

Two stone statues in the centre completed the ensemble of the Months (see p. 80). They illustrate the alternation of day and night, with the Moon represented by Diana (probably by Girardon) and the Sun by Apollo (by Coysevox).

The new Parterre d'Eau and Grand Perron

In 1678 Hardouin-Mansart replaced the terrace which had occupied the recessed central section of the garden front of the château with the Grande Galerie, or Galerie des Glaces. In 1683, he remodelled the Parterre d'Eau as two canals or rectangular bassins. The centre of each was to have a figural fountain, with the Triumph of Thetis (mother of Achilles) to the north and the Birth of Venus to the south, and the rims were to be decorated with twenty-four bronze statues and groups. All the models were put in place in 1685 but in the end the fountains consisted only of jets.

In front of the main block of the château, the Grand Perron – a terrace with a great flight of steps leading down to the Parterre d'Eau – provided a stage for further works of sculpture (ill. p. 97). At the top of the steps stand two monumental marble vases, ordered in 1684. They owe their name to the Salon de la Guerre (War) and Salon de la Paix (Peace) built at either end of the Grande Galerie, whose ceilings painted by Le Brun were echoed in the friezes with which the vases are decorated, above a lower part carved with acanthus leaves and handles in the form of grimacing fauns.

The Vase de la Guerre

(Antoine Coysevox)

The body of the vase is covered with reliefs illustrating symbolically two events which confirmed the authority of France over the Austrian Empire and Spain. One side shows the victory of Louis XIV in 1664 at the Battle of St Gothard, although he had sent only a small military contingent to help Austria against the Turks. France, with the eagle of Austria perched on her shield, is assisted in the struggle by Hercules who symbolizes Heroic Virtue. The other side illustrates the quarrel over precedence which took place in 1662, when the king of Spain was obliged to accept that his ambassadors yielded rank to those of Louis XIV. Flanked by Heroic Virtue and Justice, France is here shown as the warrior goddess Minerva receiving the submission of Spain and the Castilian lion.

The Vase de la Paix

(Jean-Baptiste Tuby)

This vase alludes to the Treaties of Aix-la-Chapelle in 1668 and Nijmegen in 1678–79 which ended the first two wars of the reign. Louis XIV is seated like a Roman emperor under a canopy with Hercules at his side, while Victory hangs trophies on a palm tree. The king receives the homage of Peace represented by a procession of women carrying the appropriate attributes – cornucopias, an olive branch, pike and caduceus.

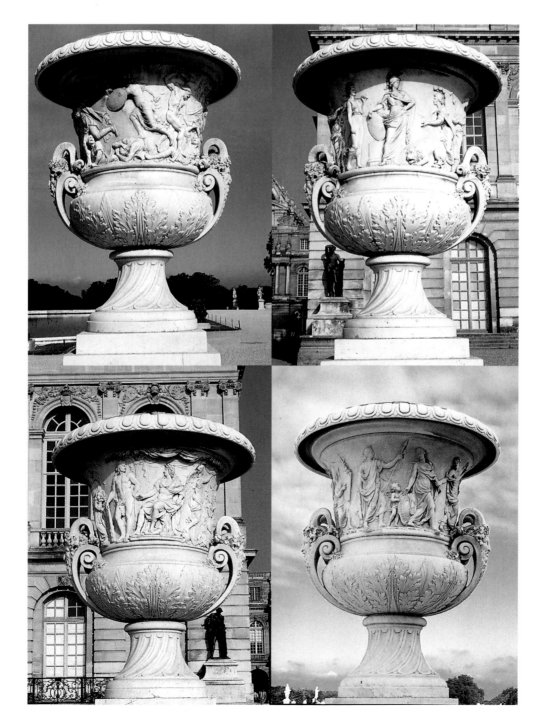

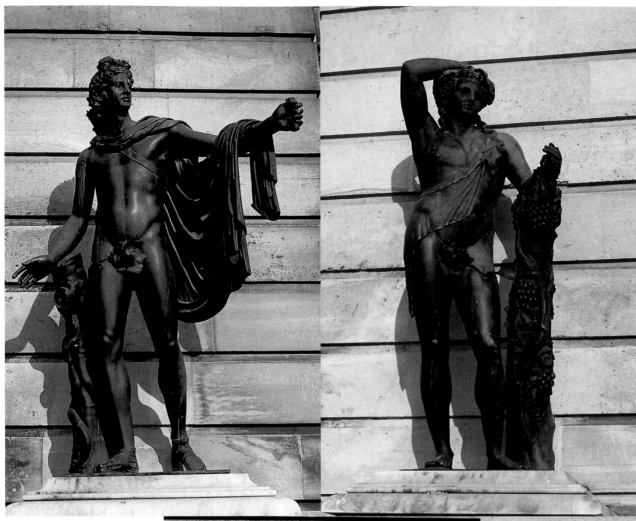

The bronzes of the Grand Perron

The decoration of the Grand Perron was completed after 1701 by four bronzes brought from the Parterre du Midi. They had been made in 1685, copying antique statues regarded as examples of perfection: Apollo and Antinous (*far left and below left*), already cast once before under François I, from the originals in the Vatican Belvedere; the so-called Versailles Bacchus (*left*); and Silenus with the infant Bacchus, after a marble in the Borghese collection, now in the Louvre (*below right*).

These were the first castings made by the brothers Jean-Jacques and Jean-Balthazar Keller, who had come from Zurich to the Arsenal in Paris to make pieces of artillery, and who were commissioned in the 1680s to cast in bronze a number of statues for the garden.

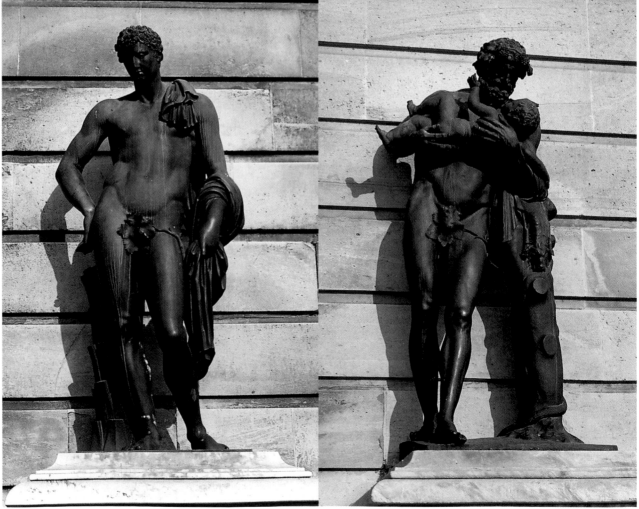

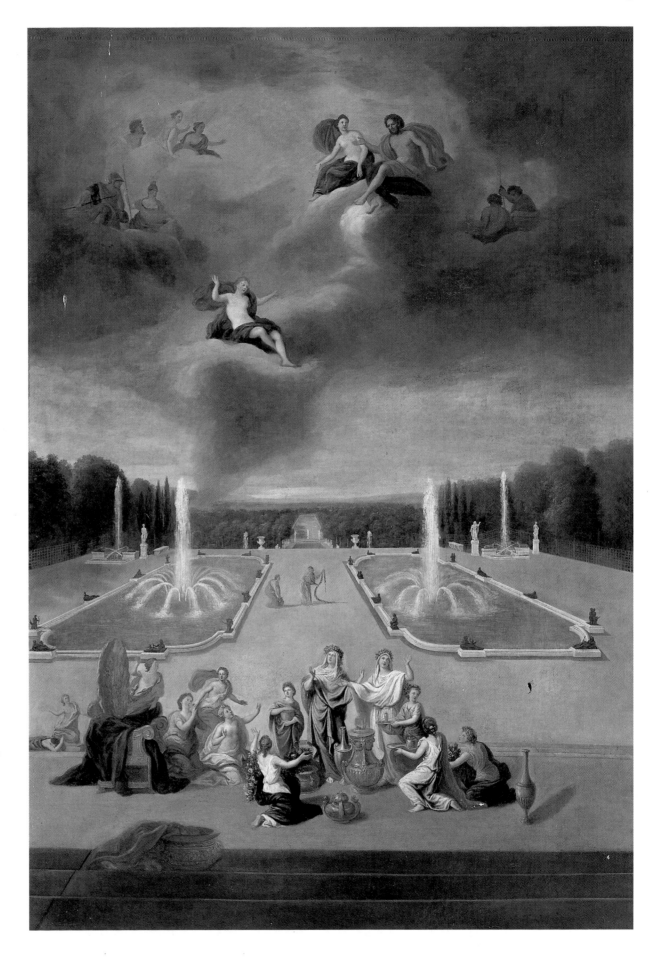

The new Parterre d'Eau

There are now two elongated
bassins. Bronze statues rest on
their rims: there are reclining
figures representing the rivers of
France at the sides and nymphs
at the ends, while at the corners
eight groups of putti refer to the
four elements, symbolizing the
prosperity of the kingdom.

Like the vases celebrating
war and peace, this ensemble
shows how the décor of the
second half of the reign had
passed from mythological
themes to glorification of the
kingdom. (Painting by Jean
Cotelle, from the series
commissioned in 1688 for the
Grand Trianon)

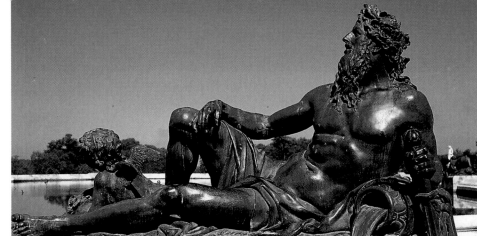

The Garonne and the Dordogne
(Antoine Coysevox)

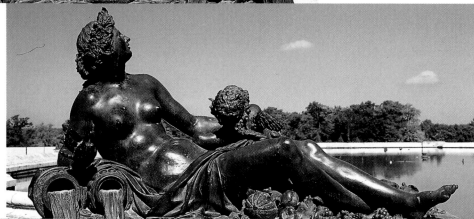

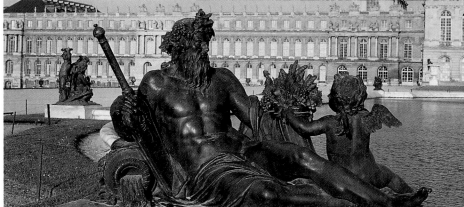

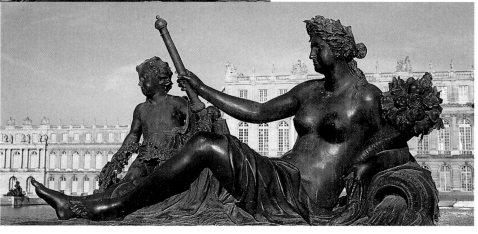

The Seine and the Marne
(Etienne Le Hongre)

The rivers of France

In the new Parterre d'Eau, four male figures representing rivers and
four female figures for the associated tributaries are arranged in
couples on the rims at the east and west ends of the two bassins.
The tradition of antiquity is followed by portraying them in a
reclining position, and is further reinforced by the allusion to the
four great rivers of the world, here replaced by the principal
watercourses of France. Four sculptors worked on the models, which
were then cast in bronze by the Keller brothers under the supervision
of Girardon. They were placed in position in 1691.

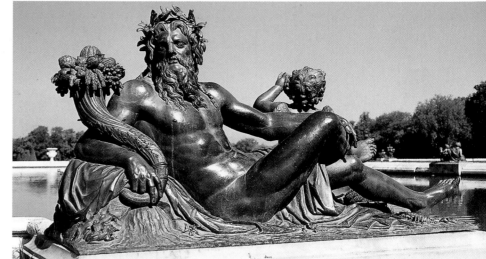

The Loire and the Loiret
(Thomas Regnaudin)

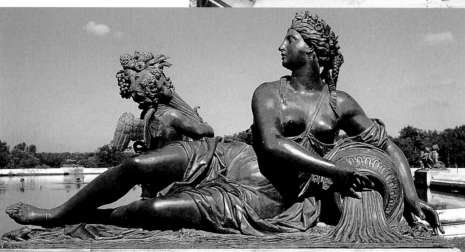

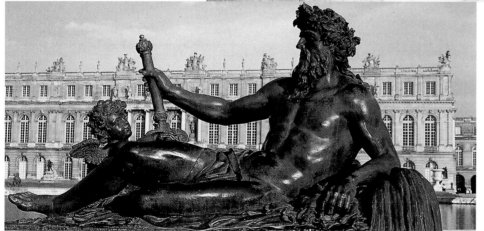

The Rhône and the Saône
(Jean-Baptiste Tuby)

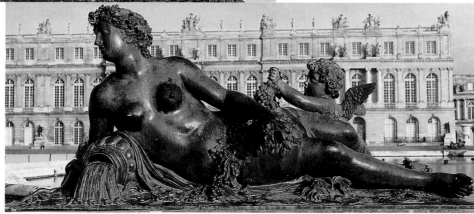

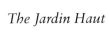

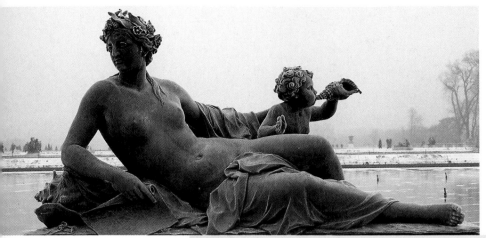

**Nymph with a map and
nymph with coral**
(Philippe Magnier)

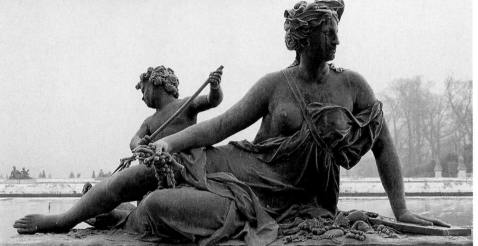

**Nymph with a sea-monster
and nymph with birds**
(Pierre Legros the elder)

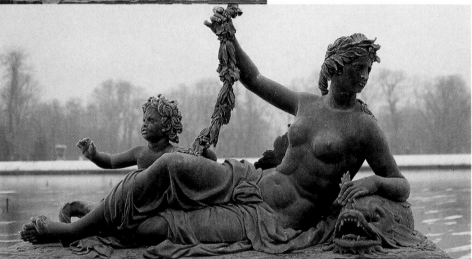

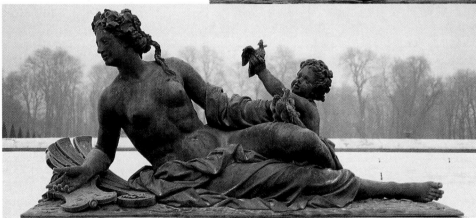

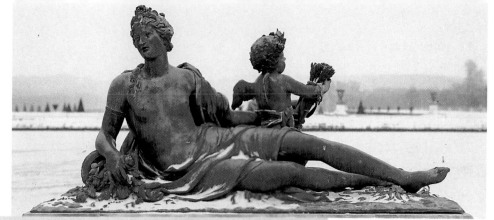

Nymph with a jar and nymph with a cornucopia
(Jean Raon)

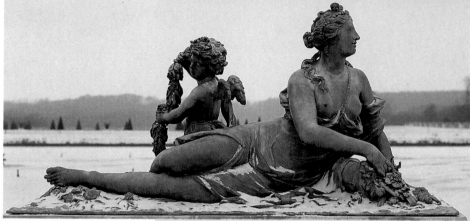

Nymph with flowers and nymph with pearls
(Etienne Le Hongre)

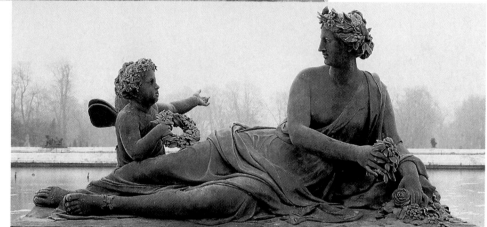

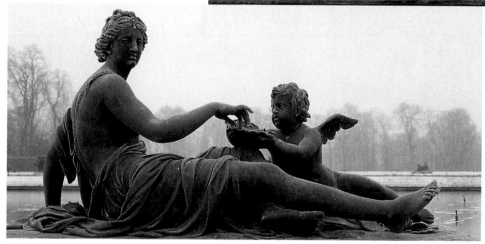

The nymphs

Eight figures of nymphs, accompanied by a putto, a cupid, a triton or a sprite, are set in pairs on the north and south sides of the bassins. The models were made between 1685 and 1687, and they were cast in bronze, also by the Keller brothers, between 1688 and 1690.

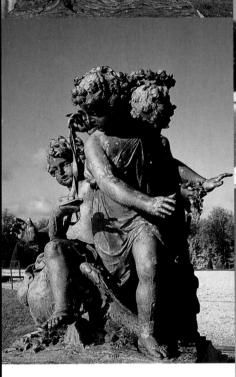

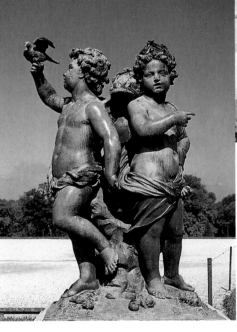

Group with a torch
(Pierre Granier)

Group with a swan
(Jacques Buirette and François
Lespingola)

**Group with seated figure
and bird**
(Jean Dugoulon)

**Group with standing figures
and bird**
(Simon Mazière)

Group with dolphins
(François Lespingola)

**Group with seated figure
holding a mirror**
(Pierre Laviron, finished
after his death by Pierre Legros
the elder)

**Group with standing figure
holding a mirror**
(Jean Poultier)

**Group with figure blowing into
a conch shell**
(Cornelius van Cleve)

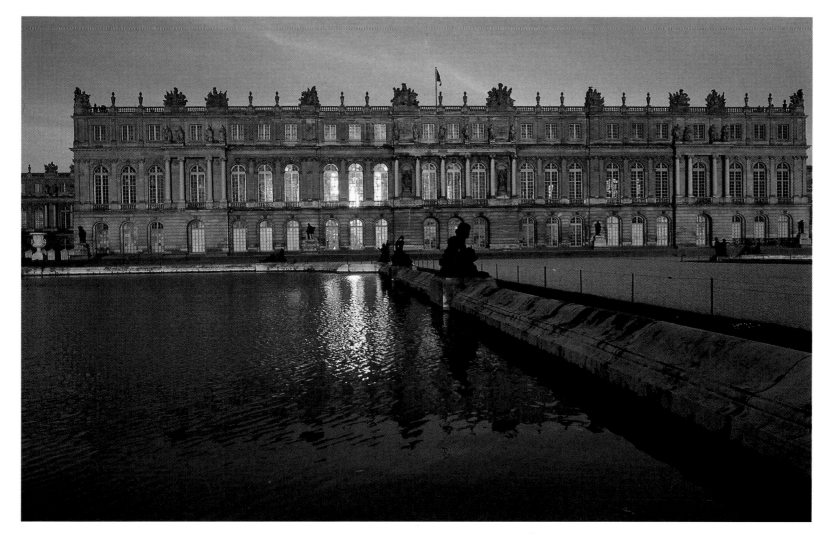

The groups at the corners

Eight groups of twenty-four lively children and cupids arranged in threes (as at the Allée d'Eau) mark the corners of the bassins and contribute references to the elements of Earth, Air, Fire and Water. The models were made between 1685 and 1688 and cast between 1687 and 1690 by Aubry, Bonvallet, Roger Scabol and Taubin.

The garden front at sunset
The last rays strike the mirrors on the back wall of the west-facing Galerie des Glaces and are reflected in the waters of the Parterre d'Eau, where their brilliance contrasts with the dark bronze sculptures on the rim – nymphs on the long sides, rivers at the ends, and groups of children at the corners.

A backdrop to the parterre is provided by the Grand Perron, stretching between the white marble Vase de la Guerre and Vase de la Paix and accented by four bronze copies of antique statues, while sculpture on the façade evokes further themes – the Months and the Ages of Man, the Sun and the Moon, and Art and Nature.

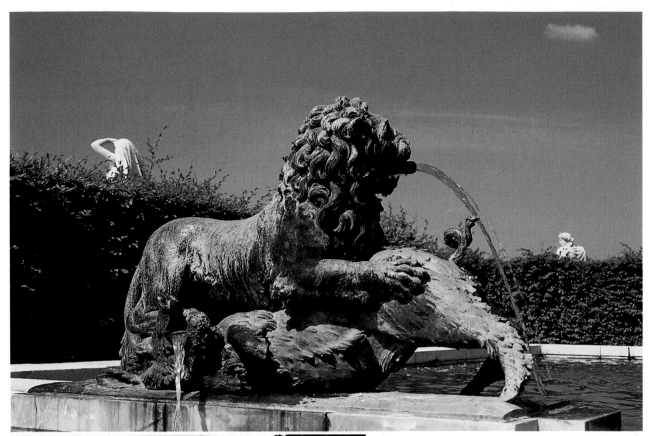

Fighting animals in the Cabinet du Nord (also known as the Cabinet de Diane or Cabinet du Soir)

The lion bringing down a wild boar was modelled by Jean Raon; the lion attacking a wolf by Cornelius van Cleve.

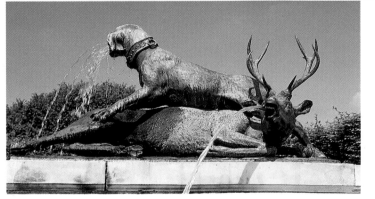

Fighting animals in the Cabinet du Sud (also known as the Cabinet du Point du Jour)

The tiger overcoming a bear and the hound bringing down a stag were modelled by Jacques Houzeau.

The Cabinets des Animaux

Two small *cabinets* (enclosures) complete the décor of the new Parterre d'Eau and flank the Grand Degré or great stairway leading down to the Parterre de Latone. The cabinets contain two fountains designed by Hardouin-Mansart, decorated with examples of the seventeenth-century art of animal portrayal. On either side of each fountain is a pair of fighting animals, begun in 1684 and finished in 1687, and subsequently cast in bronze by the Keller brothers.

'Grandes Eaux' in the Cabinet du Sud

The five jets of the fountain act as an unspoken commentary on the struggles: the victors throw a jet towards the lance of water in the upper pool, while the jets of the vanquished fall into the lower pool.

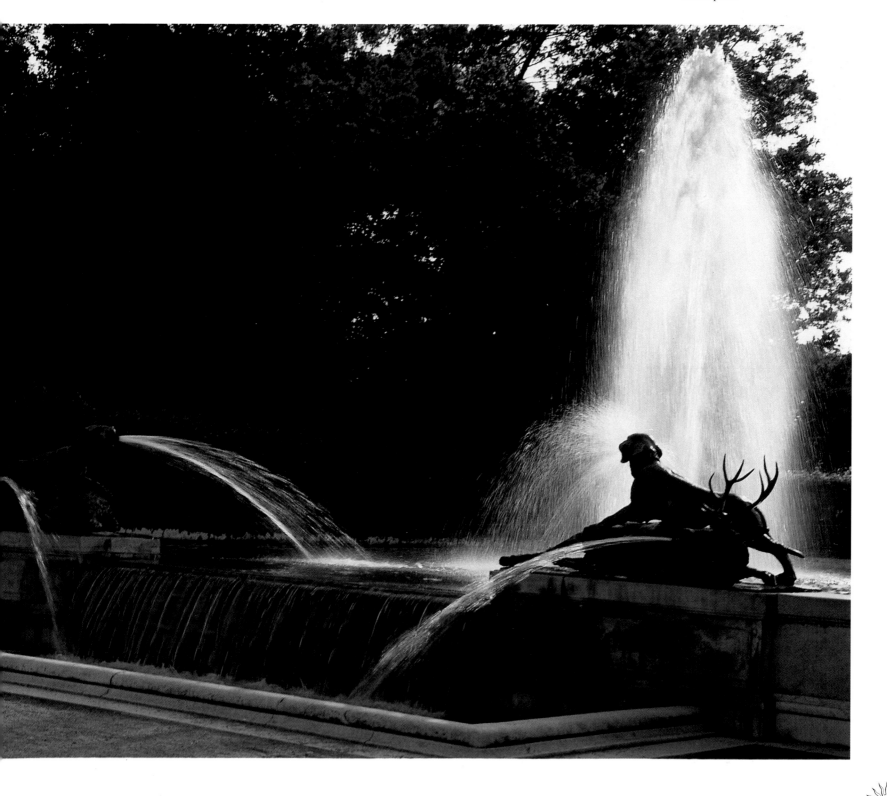

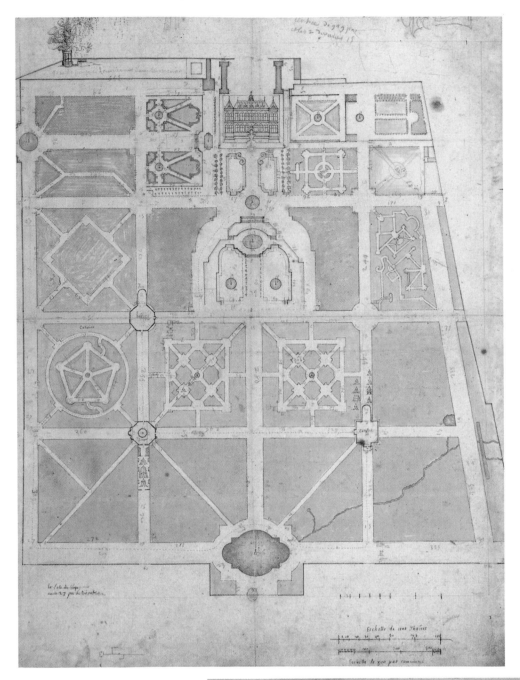

The terms of the grille

In 1664 the parterre was enclosed to the north by a grille supported by double-sided stone terms representing mythological figures – here Jupiter and Juno – executed by Louis Lerambert, Jacques Houzeau and Thibaut Poissant. Grille and terms were demolished in 1685 during alterations to the parterre. (Engravings by Jean Le Pautre, 1674)

Jardin du Roi, Jardin des Fleurs, Parterre de l'Amour

The first state of the Parterre du Midi, which was called the Jardin du Roi (king's garden) or Jardin des Fleurs (flower garden), was a small parterre of four compartments round a circular bassin in front of the south façade of the château; it was closed in by a grille on two sides, and on the west was bordered by a bosquet of *salles de verdure* known as the Bois-Vert.

In the plan by Delapointe of 1668 (*above*) it appears to the right of the château; a detailed drawing (*right*) shows it when it had become the Parterre de l'Amour (see *opposite*).

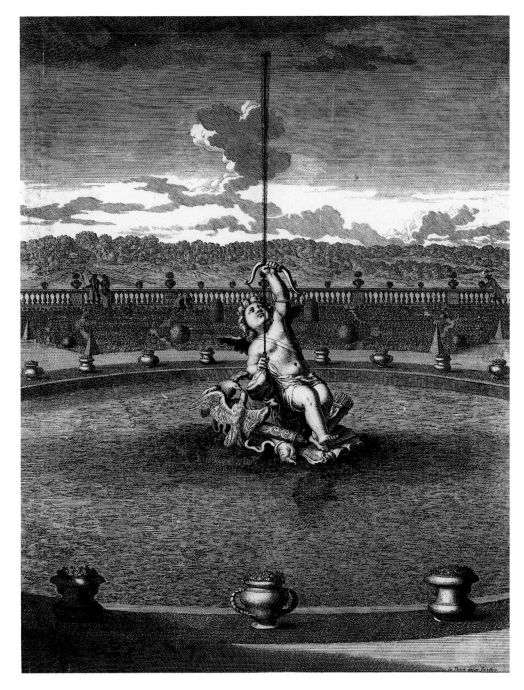

The Fontaine de l'Amour
In 1667 the bassin in the middle of the first parterre was given a fountain in *métail* by Louis Lerambert in the form of Cupid sitting on a shell, with two turtle-doves perched beside him, shooting an arrow of water into the air. From the subject, the area was called Parterre de l'Amour. (Engraving by Jean Le Pautre, 1677)

The Parterre du Midi

THIRD AND LAST large parterre of the Jardin Haut, the Parterre du Midi is bounded to the south by a balustrade overlooking the Parterre Bas de l'Orangerie, with a view extending to the wooded hills of Satory.

Its evolution is linked to that of the Orangerie. In 1663 it was a modest parterre as wide as the château was deep (ill. p. 119). In 1672 the Bosquet du Bois-Vert was destroyed to make way for its westward enlargement, but only in 1682, with the building of the south wing of the château and the start of work on the new Orangerie, did it take its final form. It was doubled in area and the design of four compartments was repeated on the other side of the new walk which crossed it. The Fontaine de l'Amour was replaced by two new bassins.

The sphinxes at the entrance to the Parterre du Midi These were the first pieces of sculpture designed for the gardens of Versailles. Models were made by Jacques Sarazin in 1660, the year of his death; the cupids were then cast in bronze by Ambroise Duval in 1668, and the sphinxes on which they sit were carved in marble by Louis Lerambert and Jacques Houzeau.

Their first position in 1670 was at the top of the Grand Degré of the Parterre de Latone (ill. p. 128, above), but in 1685 they were moved to the entrance of the enlarged Parterre du Midi and the cupids were stripped of their gilding to harmonize with the statues of the nearby Parterre d'Eau.

The groups represent religious revelation and philosophical enquiry, indicating that knowledge of the divine is achieved through knowledge of nature. The cupid on the eastern pier (*below*) points to the ground, signifying *hic et nunc* (here and now): only the present moment is real. The cupid on the western pier (*opposite*) holds his hand open, palm downward, in a gesture signifying *festina lente* (make haste slowly): only a combination of impulse and reflection will lead to knowledge.

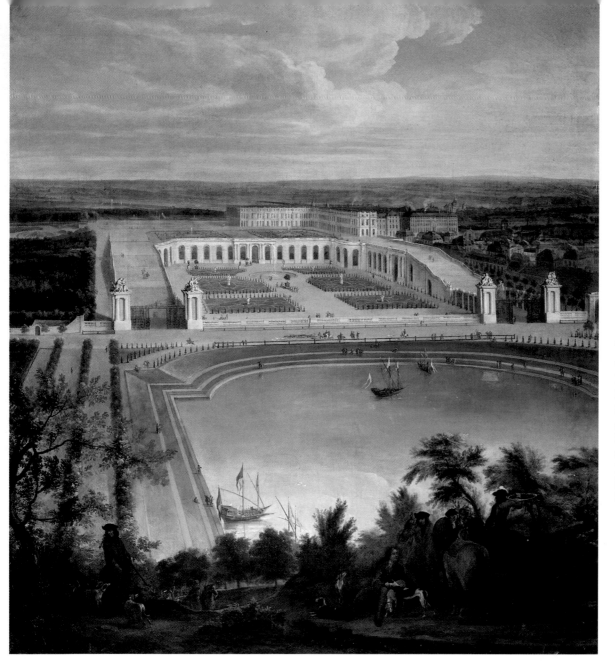

The Orangerie and Parterre du Midi in 1693
In the foreground of Jean-Baptiste Martin's view is the Pièce d'Eau des Suisses. The new Orangerie and its Parterre Bas lie beyond, framed by the two broad flights of the Cent Marches that lead up to the level of the Parterre du Midi in its extended form.

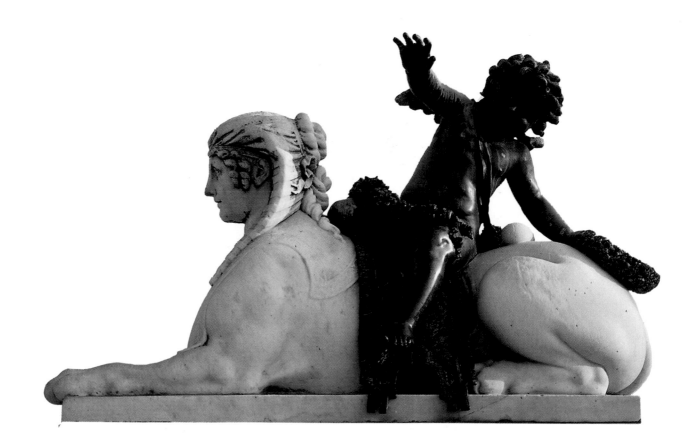

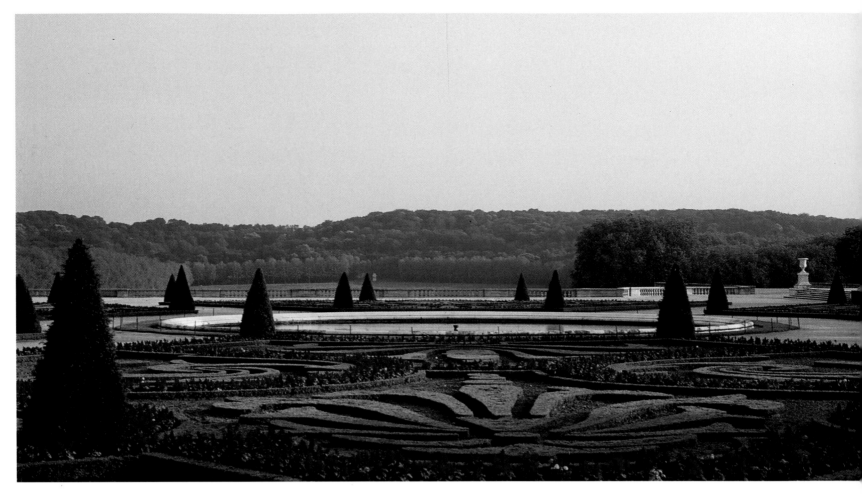

The Parterre du Midi

The design of this *parterre de broderie* illustrates the
third of the main categories of parterre. As designed by
Le Nôtre, it consisted of compartments with a ground of
sand and other coloured material, on which a pattern was
traced in box. The present planting includes flowers.

The sleeping Ariadne
This statue is placed at the entrance to the allée on the west side of the Parterre du Midi that leads on via the Cent Marches to the Orangerie. It is a copy of a bronze made by Primaticcio for Fontainebleau after a marble sculpture in the Vatican. Carved by Cornelius van Cleve in 1684, it was known until the nineteenth century as Cleopatra because of the serpent twined round the arm of the reclining figure.

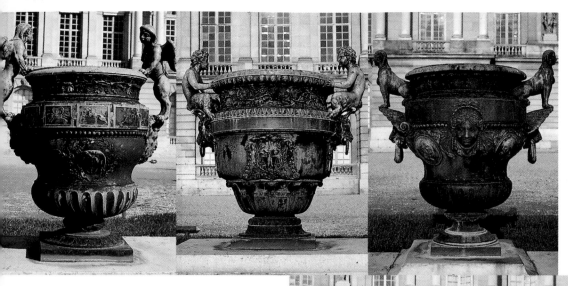

The bronze vases of the perimeter

In 1687 the mason Deschamps enclosed the parterre by low retaining walls on the north, east and west. The north side received six pairs of bronze vases at the time, and in 1852 eighteen further vases were placed along the east and west sides. They were cast by Calla who copied the earlier vases and added three more patterns from the vases in the Parterre du Nord.

The six original patterns
Claude Ballin devised designs different from those he made for the Parterre du Nord (ills. pp. 76–77), with handles featuring chimaeras, satyrs, sphinxes, lion heads, Janus heads and dragons.

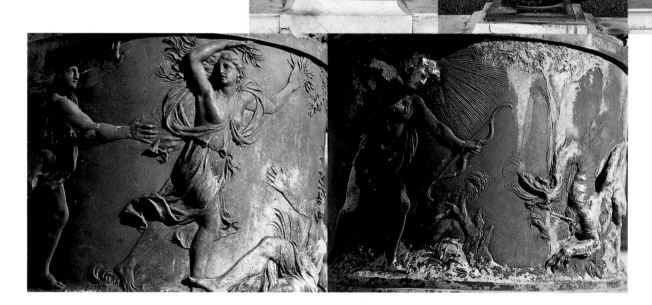

Apollo pursuing Daphne and killing the Python
The sides of the two vases with dragon handles (*centre row, right*) are decorated with scenes from the myth of Apollo, connected with the rewards accorded to heroes. The oak garland is associated with the Pythian games founded by Apollo in memory of his victory over the Python, and the laurel wreath is linked with the nymph Daphne who, as she was pursued by Apollo, implored her father to save her and was transformed into a laurel or bay tree.

The marble vases at the entrances to the parterre

After 1701 four pairs of large marble vases were placed at the entrances to the corners of the parterre.

Vases on the south-east and south-west

Four vases executed by Claude Bertin replaced bronze statues which were moved to the Grand Perron in front of the château (ill. p. 90). The first two (*right*) are decorated with themes from Antiquity: Numa Pompilius entrusting the sacred flame to the Vestal Virgins, and a sacrifice to Bacchus. The two others (of which one is shown *below*) are decorated with military trophies and dolphins framing the royal cipher, obliterated during the Revolution.

Vases on the north-west
Made by Jean-Baptiste Tuby and Guillaume Hulot, they were part of an order of twelve for Marly, commissioned from six two-man teams of sculptors in 1697.

Vases on the north-east
Made by Claude Bertin, this pair is decorated with garlands of ivy.

The Orangerie

A N ORANGERY, like a grotto, was a feature of the decoration of a garden in the seventeenth century. Versailles had both, and both were built soon after Louis XIV had assumed power, reflecting his early interest in his new country residence.

The Orangerie was positioned at the southern end of the Jardin Haut, facing into the sun to take advantage of the strongest light and heat. It was built below the Parterre du Midi, with its back forming the retaining wall of the terrace, giving it protection from the north winds. It was invisible from the château although so close to it, and only came into sight from the balustrade of its terrace, from which the view included the Parterre Bas below, the Pièce d'Eau des Suisses further away, and the wooded hills of Satory in the distance.

The first Orangerie was built in 1662. Twenty years later, when Versailles had become the permanent residence of the king, it was doubled in width and a new parterre created (compare the plans p. 36, below, and p. 37, below).

The Parterre de l'Orangerie
The parterre is framed between the two long sets of steps and landings known as the Cent Marches (hundred steps), which lead down from the Parterre du Midi. Their line is continued by grilles between stone piers decorated with sculpture.

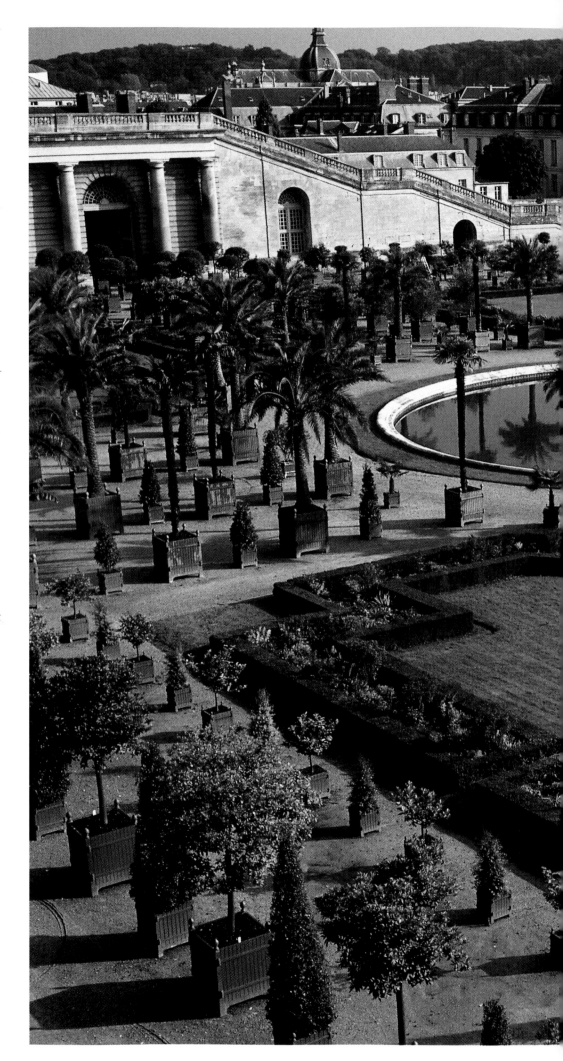

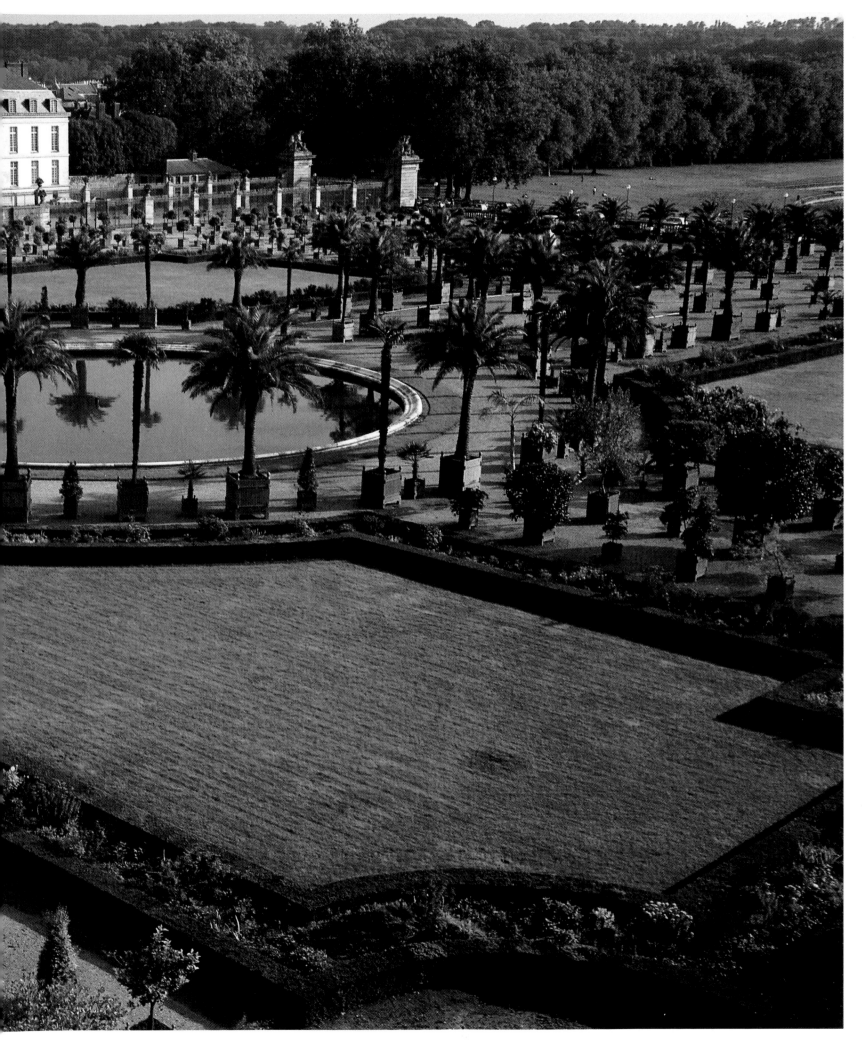

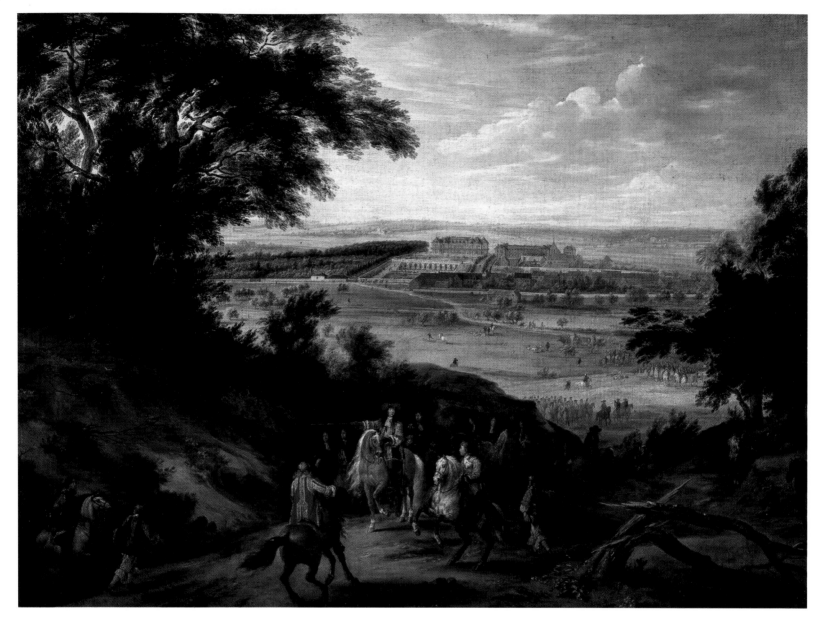

The first Orangerie

Started by Louis Le Vau in 1662, shortly after the
Ménagerie, the first Orangerie was flanked by two single
flights of steps. Its façade with eleven round-headed
openings, built of brick with stone dressings like the
hunting lodge of Louis XIII, looked over the Parterre Bas
which sloped gently south. The soil excavated for its
construction was used in the formation of the original
hemicycle of the central parterre in front of the château
(see the plan p. 36, below). At this stage the Pièce d'Eau
des Suisses was still marshy ground, known as 'the
stinking pond'. (Painting by Adam-Frans van der Meulen,
c. 1664)

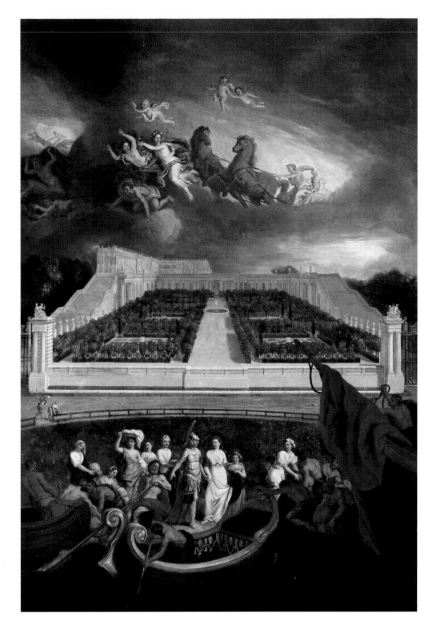

The new Orangerie

Construction was begun in 1683 by Hardouin-Mansart, who had just finished the orangery at Chantilly, and completed in 1686. The new stone-faced Orangerie was twice as wide as the first one, and it was built twice as high, by excavating the slope of the Parterre Bas down to the level of the Saint-Cyr road, which separated it from the newly created Pièce d'Eau des Suisses.

The central projection of the façade – now, with the return wings, thirty-five bays long – looks down an allée which visually prolongs the transverse axis of the Jardin Haut. On either side are the grand Cent Marches.

The view painted by Jean Cotelle (reversed in this reproduction) illustrates in the foreground an episode from the Trojan War: Paris flees with Helen on the Pièce d'Eau des Suisses.

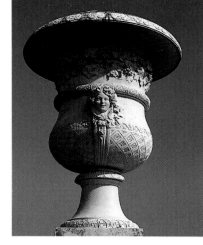
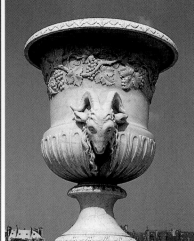

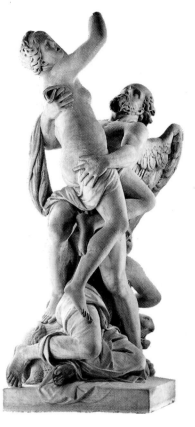

Vase with female heads and ivy-wreath

This is one of two vases in the southern compartments made by Jacques Buirette and Jean Raon to the design of Hardouin-Mansart. They formed part of a commission by Louvois in 1687 for the Allée Royale. The two vases in the northern compartments, carved with flower garlands by Pierre Legros the elder and Jean Robert, were moved in 1722 to the gardens of the Tuileries.

Vase with vine-wreath and goat heads

This is one of ten marble vases, ordered in 1688 by Louvois from Claude Bertin, which stood on the parapet of the Orangerie. In 1692 they were moved to Marly, and from there to the Tuileries, where they remain.

The rape of Cybele by Saturn

In Thomas Regnaudin's group, Saturn, personifying the Earth, captures Cybele – the power of vegetative growth.

The Orangerie

The plants of the Orangerie were placed under the responsibility of Jean-Baptiste de La Quintinye, Director of the Potager du Roi. Over three thousand exotic trees were housed here, of which two thirds were 'orange trees', a term which included all other citrus fruits – lemons, Seville oranges, mandarins, citrons – as well as sweet oranges. More than five hundred tubs came from Vaux-le-Vicomte, and others were sent from all over France. The trees were used to decorate the Grande Galerie in the château or, in season, to add interest to the parterres, the bosquets and the surrounds of the bassins. The most famous of them was the orange tree of the Connétable, also called the Grand Bourbon or Grand Condé. This bitter orange tree was the first introduced to France: planted in Spain in 1421, given to the Connétable de Montmorency for Chantilly and then to the king for Fontainebleau, it was transported in 1687 to Versailles where it survived until 1895.

The Parterre Bas

At present the trees are taken out of the Orangerie and displayed in the Parterre Bas from May to October. The 960 tubs include 530 orange trees, 60 pomegranates, bay trees, date palms, *Trachaecarpus camerops* (an exotic palm), *Eugenia ughi* (an exotic myrtle), and two araucarias or monkey puzzles, one of which was a gift to Marie-Antoinette.

The decoration of the Parterre Bas of the new Orangerie

The new parterre, designed by Le Nôtre, like that of the first Orangerie, was closed to the east and west by grilles, and defined to the south by a balustrade beyond which the view extended across the Pièce d'Eau des Suisses. It was composed of six compartments of turf (ill. p. 103, *top*).

The centres of the four compartments nearest the building were each occupied by a round bassin with a column of water. Round the edges of the parterre stood bronze statues: Diana with a stag (cast by the Keller brothers from the marble original in the Grande Galerie), Hercules fighting the Hydra, and Pandora seized by Mercury.

In the centre of the middle two compartments were marble groups, originally intended for the Grand Parterre d'Eau, which were placed here when they were finished in 1687. (In 1716 they were moved to the Tuileries, before going finally to the Louvre, where they are today.)

The outer compartments contained single vases, also in marble, and there were further vases along the parapet above the Orangerie.

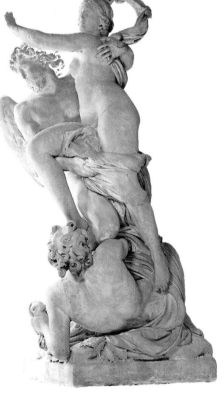

Orithyia carried off by Boreas

The model was by Gaspard Marsy, but the statue was executed by his pupil Anselme Flamen. Orithyia, an allegory of Air, is carried off by Boreas who represents the violence of the north wind.

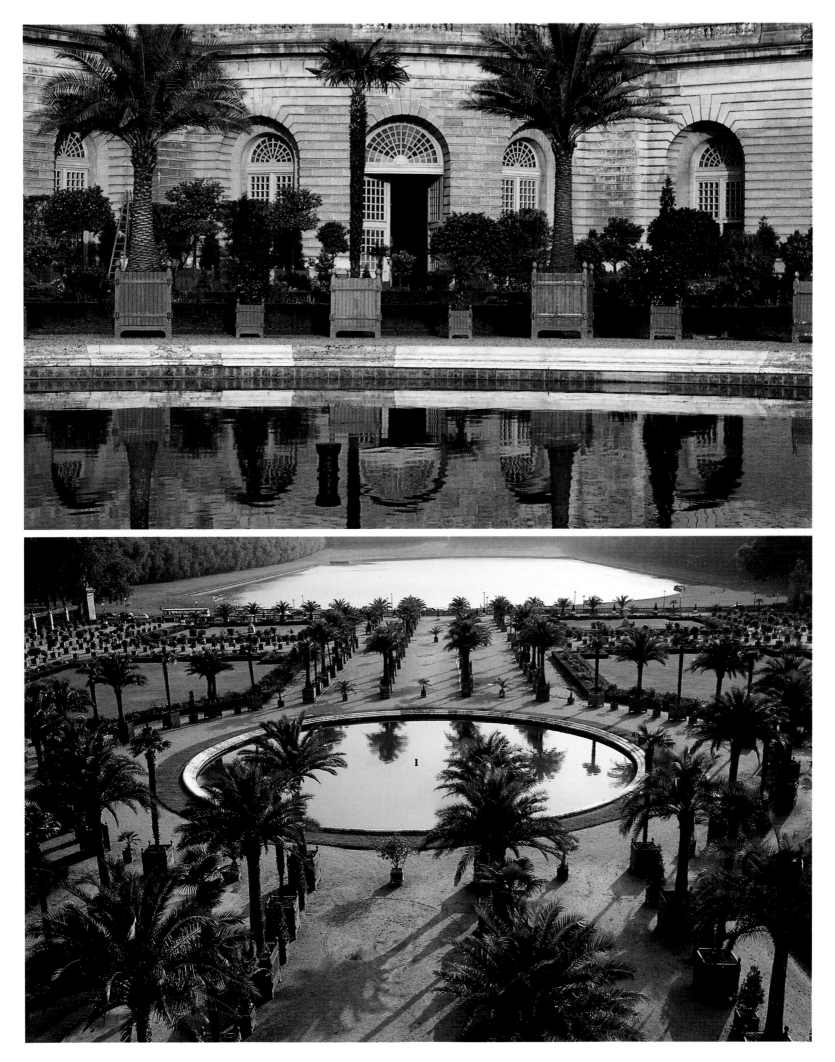

The Cent Marches and stone baskets by the grilles

Two marble stairways of three flights each flank the Orangerie and act as buttresses for the Parterre du Midi on the higher level. They are called the Cent Marches, although in fact there are 103 steps in the east flight and 104 in the west.

The piers of the grilles are surmounted by baskets of flowers and fruit, carved in Troussy stone by Jean-Baptiste Pineau and François Lespingola after models by Pierre Legros the elder.

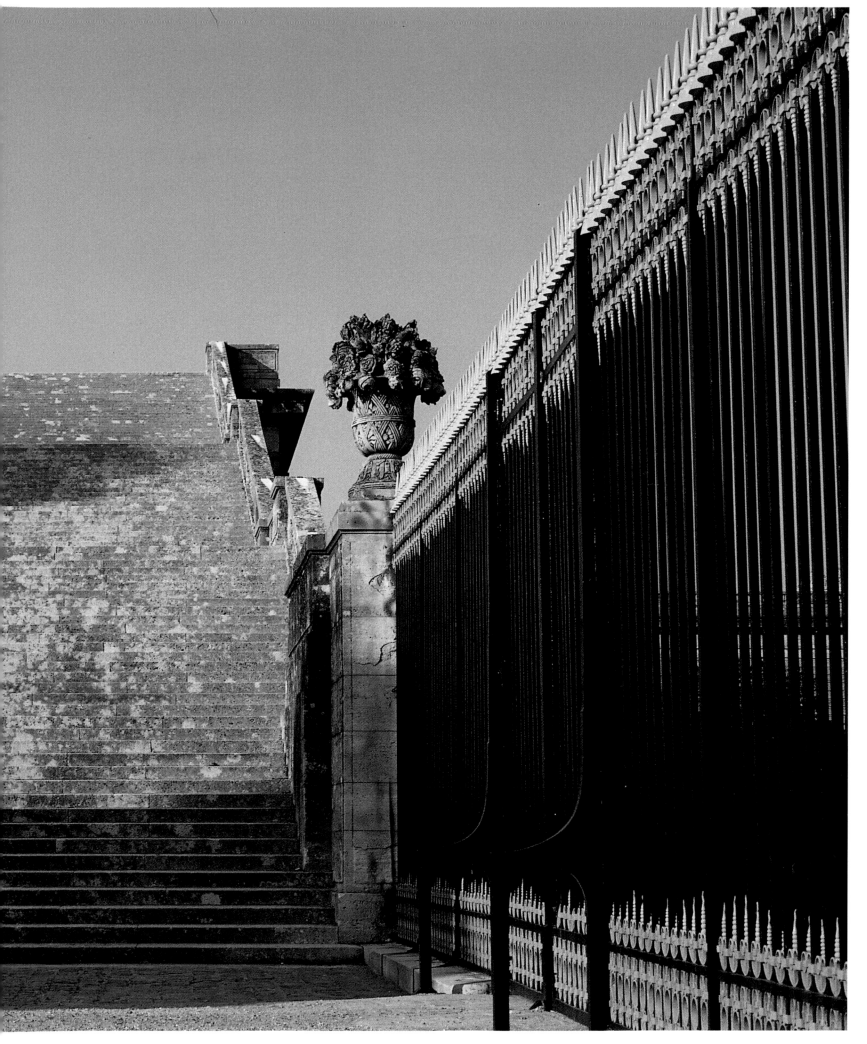

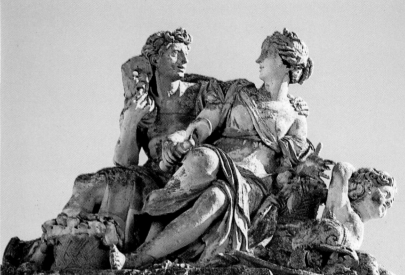

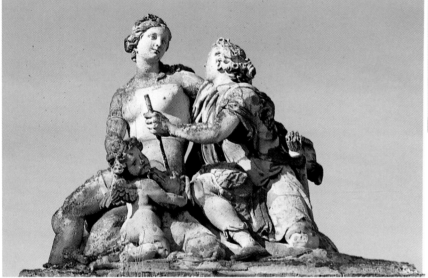

**Aurora and Cephalus and
Vertumnus and Pomona**

(Pierre Legros the elder)

On the eastern gate-piers,
Aurora is depicted restraining
Cephalus, the life-giving wind
of dawn (*left*), while Vertumnus,
god of the harvest, removes the
mask of an old woman that he
had worn to seduce Pomona,
goddess of orchards (*above*).

The sculptural groups of the Orangerie grilles

In 1686 the line of the monumental stairways flanking the Orangerie
was continued by grilles enclosing the Parterre Bas to the east and
west. They terminate in wrought-iron gates made by Michel Hasté
the elder, between piers surmounted in 1687 by groups carved of
stone from Saint-Leu-d'Esserent.

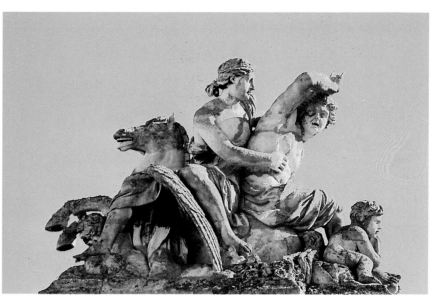

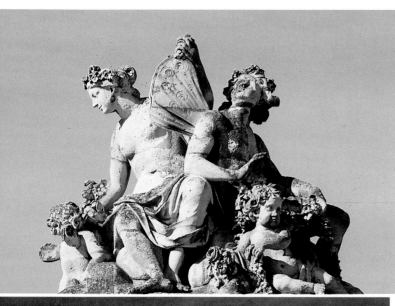

Flora and Zephyr and Venus and Adonis

(Louis Leconte)

On the western gate-piers, Zephyr carries off Flora and gives her dominion over flowers (*left*), while Venus tries to hold back Adonis, who has been condemned to spend a third of the year with her, a third with Proserpine, and a third in solitude (*above*).

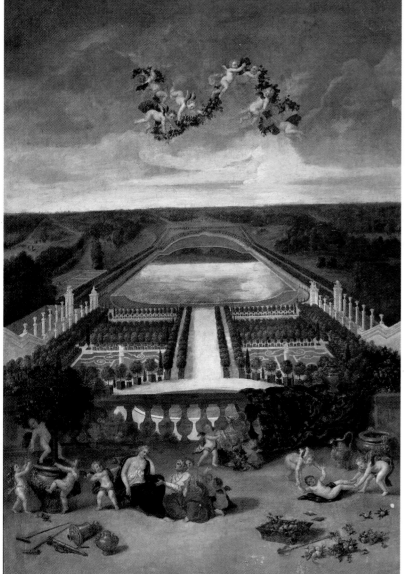

The Parterre Bas and Pièce d'Eau des Suisses

The parterre appears clasped by the Cent Marches and the grilles with ornamented gate-piers. Aligned with its central axis is the large Pièce d'Eau des Suisses. Although planned as early as 1668, that was not excavated until 1679, when a regiment of Swiss guards undertook the work – hence its name. In 1702 Bernini's equestrian statue was moved here.

Repeating one of the themes of the groups on the gate-piers, Cotelle's painting commissioned in 1688 shows Vertumnus seducing Pomona.

The Great Axis

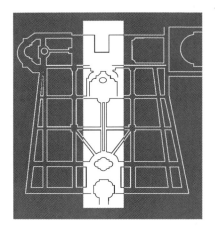

A symbolic axis

In Louis XIV's day, the sun set on the line of the Great Axis on 25 August, the feast day of St Louis.

The line of the Great Axis

Already in 1665 the line of the Great Axis had been fixed, and it appears clearly in a painting by Pierre Patel of 1668 *(opposite)*. Originally the three avenues radiating out to the east on the town side (foreground) were balanced at the far end of the garden by a similar goose-foot of avenues. To complete the Apollo group symbolizing the setting sun at the Grotte de Téthys – the rectangular building to the north (right) of the château, with a water-tank on its roof – a group illustrating the morning ascent of the god was placed in the Pièce d'Eau des Cygnes (which thus became the Bassin d'Apollon) at the end of the central avenue; and that, given the name of Allée Royale, was widened to open out the view over the Grand Canal which was begun on the site of the goose-foot in 1668.

(Note also, in this painting, the Parterre du Midi on the left in its original size, with the Bosquet du Bois-Vert beyond, whereas the Parterre du Nord on the right, beyond the reservoirs, has been doubled in depth.)

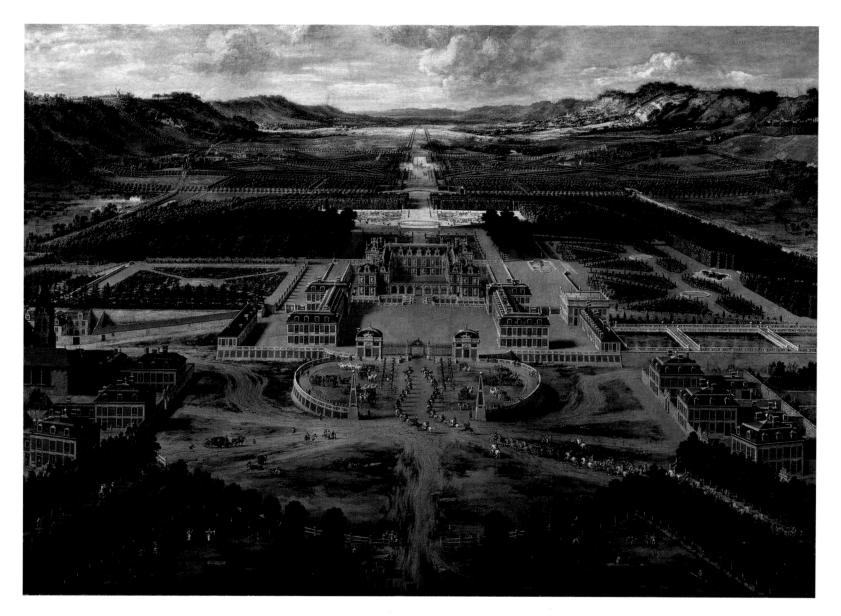

Following the principle common to all great gardens in the French style, that of Versailles was laid out around a main axis which, as at Vaux-le-Vicomte and Marly, passed through the centre of the château (see the plan p. 28). On the east side, adjoining the town, it radiated into three avenues; on the west or garden side it took the form of a long avenue (the Allée Royale), extended as far as the eye could see by a long mirror pond (the Grand Canal).

Versailles has been called 'the palace of the Sun',[36] and the orientation of the Great Axis supports that description: it runs from east to west, parallel to the daily course of the sun, and the entire thematic decoration of the gardens is linked to it. The birth of Apollo takes place in the Parterre de Latone, his rise into the heavens at the Bassin d'Apollon, his descent at the end of the day in the Grotte de Téthys, and the turning circle of the year is represented in the Bassins des Saisons.

When the king became Louis le Grand, the Great Axis reflected his greatness. This was emphasized by a rich collection of antique statues bought by Colbert in Italy,[37] by copies made in the Académie de France in Rome, and by the monumental vases set round the Parterre de Latone, the Allée Royale and the Parterre d'Apollon.

The entrance to the grotto

Charles Perrault in his *Mémoires de ma vie* pointed out that the theme of the grotto was a reference to Louis XIV: 'Apollo comes to seek rest with Tethys when he has made his round of the earth, just as the king seeks relaxation after labouring for the good of all.' In this painting Louis is shown at the entrance to the grotto, below the radiant sun on the gilded grilles, surrounded by his courtiers. (In the distance is the tower that pumped the water of the reservoirs.)

The Grotte de Téthys

GROTTOES, which had come back into fashion in the Renaissance, were at first associated with the mysterious origins of life. The one at Versailles belonged to the tradition of grottoes in French sixteenth- and seventeenth-century gardens, such as those at Fontainebleau, Meudon, the Tuileries, Saint-Germain-en-Laye and Rueil. In 1664 it was still only a reservoir, constructed by Le Vau and the engineer Denis Jolly to supply water to the first fountains in the garden.

In 1665 the interior was decorated as a marine grotto, then as the palace of Tethys. Here the goddess who symbolized the bounty of the sea welcomed the Sun (Apollo) at the end of his daily course through the sky. Charles Perrault, appointed to the Surintendance des Bâtiments and member of the Petite Académie which defined the cultural politics of the kingdom, claimed that the idea had come from him and his brother Claude, the doctor-architect.

The grotto was considered by the contemporaries of Louis XIV as one of the first important achievements in the gardens, and in 1672 Félibien devoted to it a *Description de la grotte de Versailles*, to which twenty engraved plates were added in 1679. However, five years later the grotto was demolished to make way for the new north wing of the château.[38]

Plan of the grotto

Passages paved with marble led from the three openings through the three bays of the vestibule to the three large bays at the back, terminating in alcoves. In the middle of the central bay of the vestibule, a jet so powerful that it reached the ceiling sprang from a table of figured marble. A hydraulic organ, sent from Montmorency in 1666, stood in a separate room at the back of the grotto.

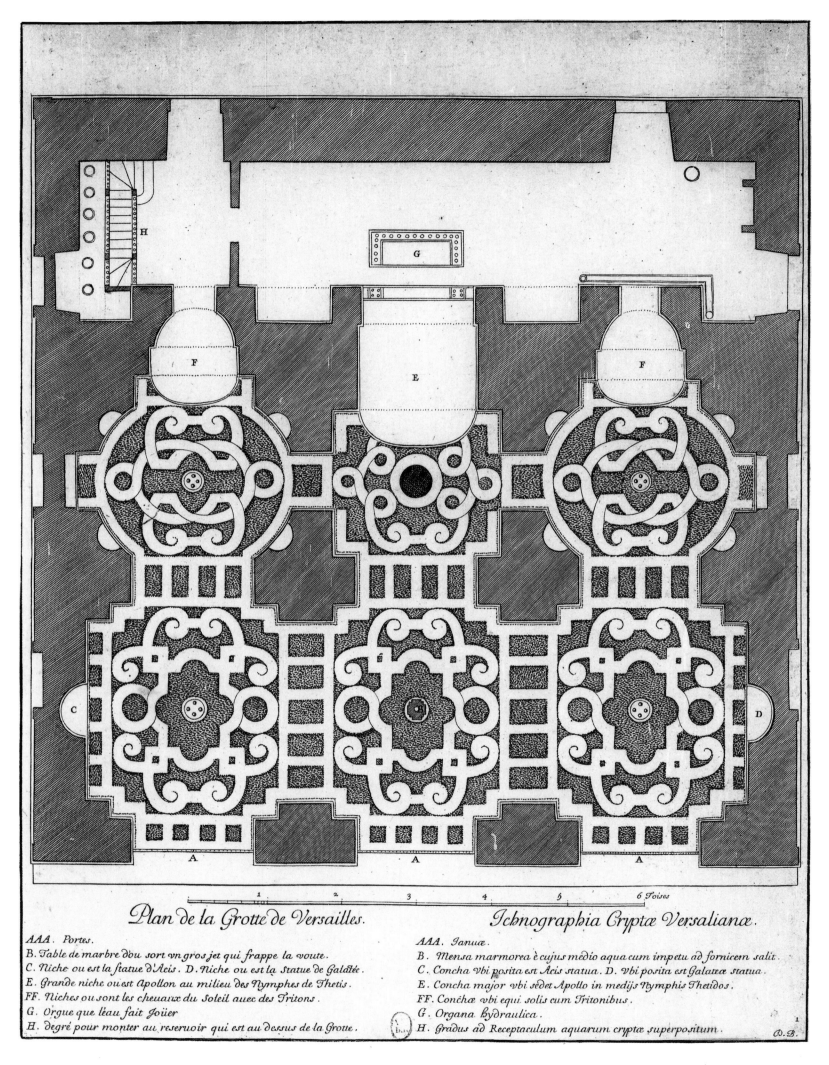

Plan de la Grotte de Versailles.　　　　*Ichnographia Cryptæ Versalianæ.*

AAA. *Portes.*

B. *Table de marbre d'ou sort vn gros jet qui frappe la voute.*

C. *Niche ou est la statue d'Acis.* D. *Niche ou est la Statue de Galatée.*

E. *Grande niche ou est Apollon au milieu des Nymphes de Thetis.*

FF. *Niches ou sont les cheuaux du Soleil auec des Tritons.*

G. *Orgue que l'eau fait Joüer.*

H. *degré pour monter au reseruoir qui est au dessus de la Grotte.*

AAA. *Januæ.*

B. *Mensa marmorea è cujus medio aqua cum impetu ad fornicem salit.*

C. *Concha vbi posita est Acis statua.* D. *vbi posita est Galatæ statua.*

E. *Concha major vbi sedet Apollo in medijs Nymphis Thetidos.*

FF. *Conchæ vbi equi solis cum Tritonibus.*

G. *Organa hydraulica.*

H. *Gradus ad Receptaculum aquarum cryptæ superpositum.*

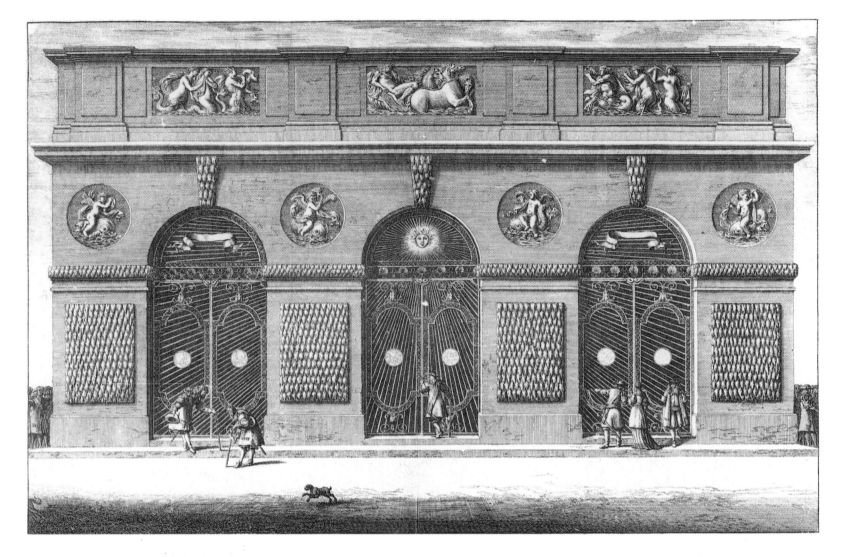

The façade of the grotto

The strictly architectural façade took the form of a tripartite triumphal arch, ornamented with panels of carved stalactites and surmounted by an attic masking the reservoir. The decoration also included three reliefs and four medallions made in 1666 by Gerard van Obstal, showing the sun sinking into the sea, tritons, mermaids and cupids riding on dolphins.

The three grilles covering the arched openings were wrought by the smith Mathurin Breton. They symbolize the course of the sun, whose rays, spreading across the three arches, reach all the corners of the earth, represented by the six discs on the doors. After the grilles had been gilded in 1667 by Claude Goy, the evening sun set them ablaze and filled the entire grotto with light, penetrating even to the back wall and lighting up the groups of Apollo and the Horses of the Sun.

(This and the other engravings of the grotto are by Jean Le Pautre, of 1672 and 1675.)

The fountains of the vestibule

The three sections of the vestibule were decorated with fountains and half-fountains reflected in mirrors that lined the walls. Each fountain had a mask with water gushing from its mouth into a shell basin, and bore the royal cipher framed by a triton and a mermaid.

At either end in two niches stood marble statues of Acis and Galatea, made by Jean-Baptiste Tuby between 1667 and 1674. When the grotto was demolished the statues went to the Bosquet de la Renommée or Bosquet des Dômes in the Jardin Bas, where they remain (ills. pp. 222, 224).

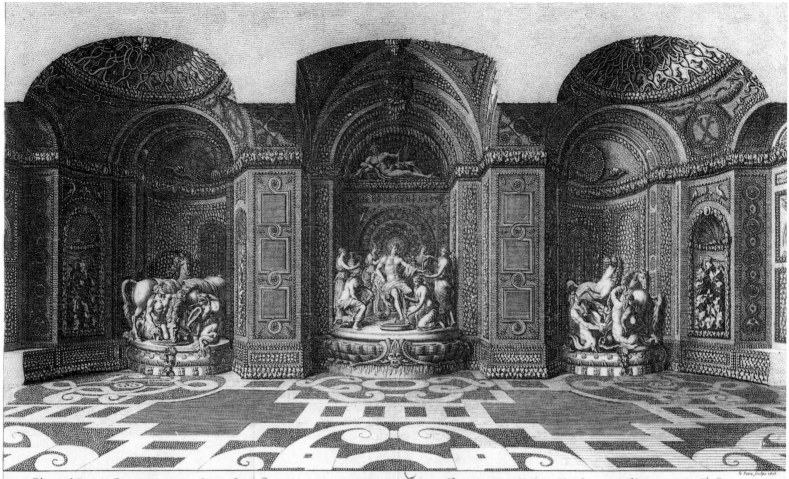

Veüe du fonds de la Grotte de Versailles, orné de trois Grouppes de marbre blanc, qui representent le Soleil au milieu des Nymphes de Thetis, et ses cheuaux pensez par des Tritons.

Prospectus Cryptæ Interioris Versaliarum, ubi sol inter Nymphas Thetidis, et ejus equi cum Tritonibus, statuis marmoreis exhibentur

The alcoves at the back of the grotto

The walls of the grotto were incrusted with stones, shells and coral, arranged in 1665 by the *rocailleur* Jean Delaunay, and accented with masks. From the vaulted ceiling, also covered in rockwork, hung chandeliers made of shells with jets of water taking the place of candles.

In 1676 three marble groups were placed in the alcoves at the back, facing the entrance. The central group, of Apollo attended by the nymphs of Tethys, was made between 1666 and 1675 by Girardon and Thomas Regnaudin. In the side niches, the first two Horses of the Sun were the work of Gilles Guérin, while the two others were by Gaspard and Balthazar Marsy, who took over the commission given to Guérin and Thibault Poissant. The later fate of the three groups was not lacking in incident: moved at first to the Bosquet de la Renommée (ill. p. 222), they were then used to remodel the Bosquet du Marais (ill. p. 250), and ended up in a new grotto setting by Hubert Robert (ill. pp. 246–47).

In this engraving Le Pautre has made it easier to see all the decoration by depicting the room as a single space, without the two massive piers (shown as dark crossses on the floor) that supported the vaults and the reservoir above.

The Parterre de Latone

THE PARTERRE DE LATONE is situated below the Parterre d'Eau where the Jardin Haut meets the Great Axis, and only becomes visible from the edge of the terrace between the Cabinets des Animaux. From the top of the steps, the perspective opens out down the Great Axis which from the parterre leads to the Allée Royale and continues through the Grand Canal.

The king in the guise of Apollo is glorified in this parterre, which is decorated with a fountain celebrating the god's mother Latona and his birth. Further mythological themes are introduced by marble statues and vases.

Plan from the album of Jacques Dubois

The parterre is laid out on a slope westward from the level of the Parterre d'Eau (top). An encircling horseshoe ramp, here grassed, originally allowed carriages to drive from one level to the other (see the plan p. 37, top). Within that, a central flight of steps – the Grand Degré – and a terrace, lateral steps and ramps surround the Fontaine de Latone and two ornamental beds.

Sculptural features are marked in red: the statues at the outer edge of the ramp, the Nymph and Dying Gladiator at the foot of the ramp, the terms at the west, and three sets of vases – flanking the Grand Degré, on the terrace below, and at the upper ends of the two beds.

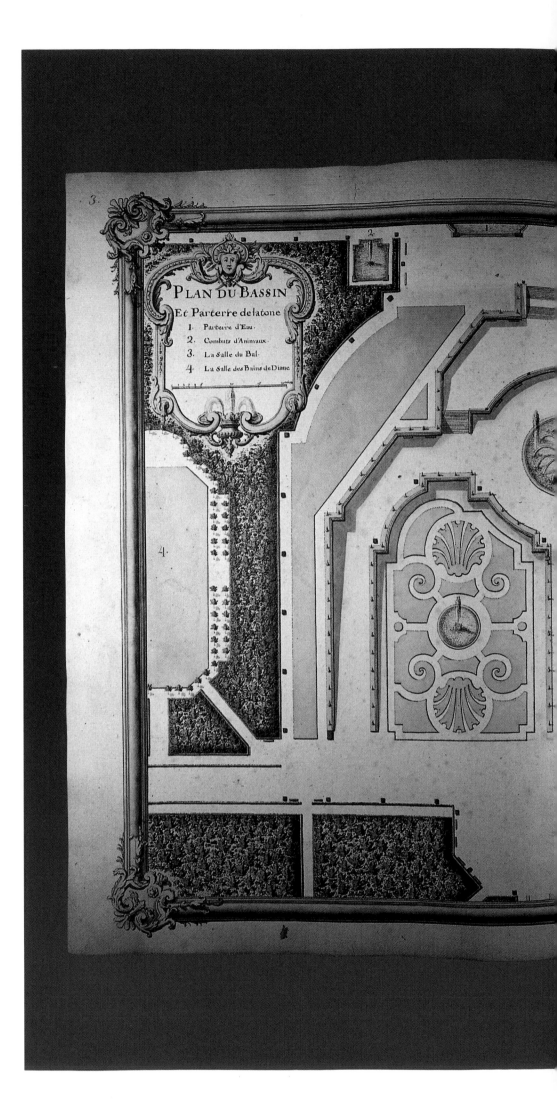

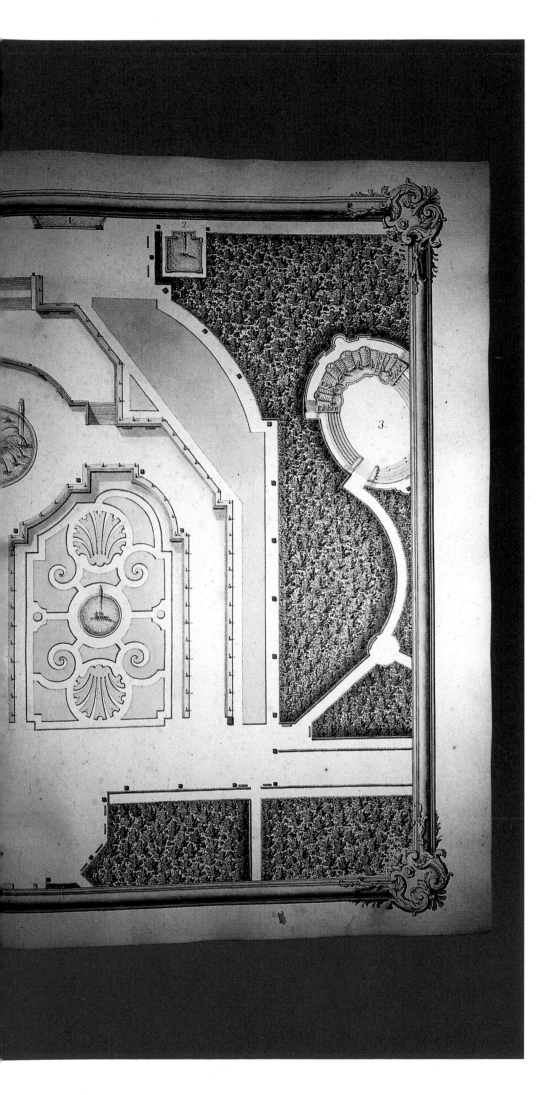

Latona or the birth of the Sun

The myth of Latona relates the birth of Apollo, god of the sun. Seduced by Jupiter and pursued by the wrath of his wife Juno, Latona had to take refuge on the isle of Delos where she gave birth to Apollo and Diana.

Sheltering later on the banks of a pond in Lycia and hounded by the peasants living there, she cried, 'May you live for ever in your pond!'[39] Her wish was granted by Jupiter, who changed them into frogs. She is depicted with her two infant children at the top of the fountain in the parterre.

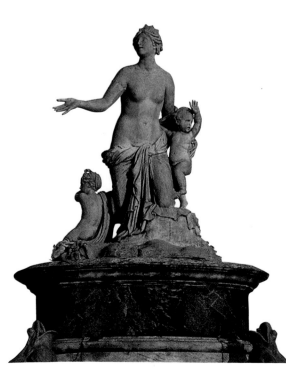

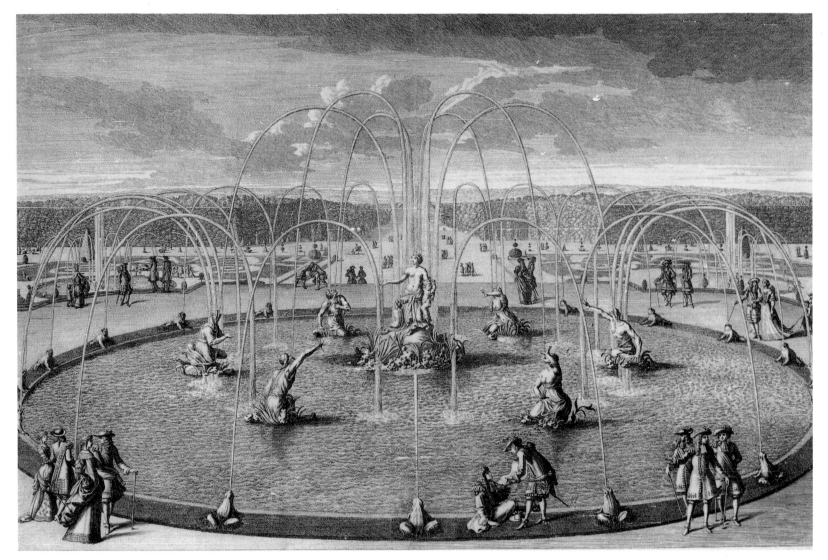

From the Bassin de l'Ovale to the Bassin de Latone

In 1665 the parterre in front of the château was altered and the hemicycle which defined it to the west, with a bassin which marked the beginning of the Allée Royale, was inverted (compare the plans p. 36, below, and p. 37, top). The sloping allée which had led from the parterre to the Jardin Bas was replaced by a flight of steps and a horseshoe ramp with a gentle gradient surrounding an oval bassin.

This new bassin lay at the head of a *parterre de gazon coupé* with two smaller circular fountains. The parterre was decorated with yews clipped into pyramids, boats and pawns, and with stone terms carved by Thibault Poissant and Jacques Houzeau.

In 1666 the oval bassin was given a central jet and six secondary jets. A fountain on the subject of Hercules and Antaeus was proposed but rejected, and in 1668 the Fontaine de Latone began to be installed. At the top of the steps leading down to the parterre were placed the two sphinx groups which were later moved to the Parterre du Midi (ills. pp. 102–3). The fountain itself was given its final form in 1687 by Hardouin-Mansart.

The first Fontaine de Latone
Gaspard Marsy executed the group of Latona and her children, while his brother Balthazar worked on the figures of the Lycian peasants turned into frogs. The composition was completed in 1670. A rock of coral with reeds of tin rose from the water in the centre of the bassin; on this Latona had taken refuge and was protecting her children from six peasants in the water – some already turning into frogs – and twenty-four frogs placed on a band of turf around the rim. Two peasant couples decorated the two small bassins in the parterre.
(Engraving by Jean Le Pautre, 1678)

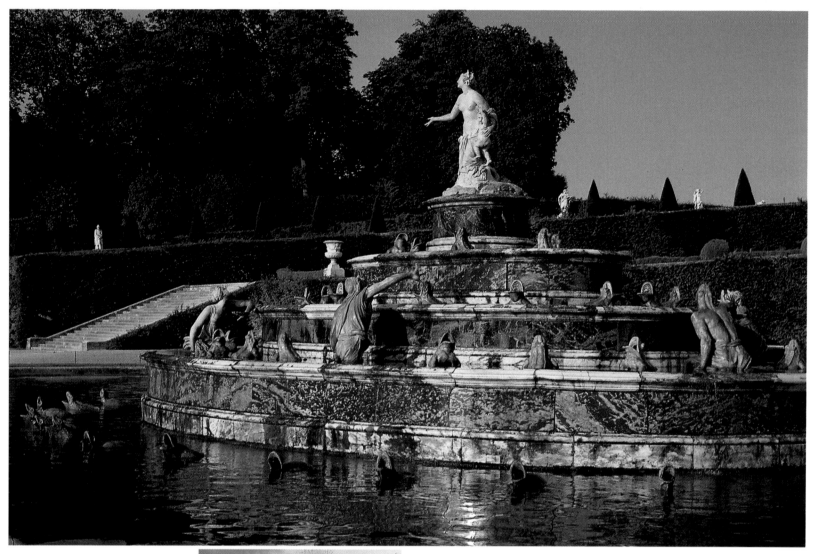

The new Fontaine de Latone

In 1687 the fountain was remodelled by Hardouin-Mansart. The white marble group of Latona and her children was placed on top of three superimposed bowls of pink and white marble, and instead of facing the château was turned to look down the Great Axis (ill. pp. 138–39). Below, peasants, lizards, turtles and frogs, including new frogs of gilded *métail* by Claude Bertin, aim their jets at the mother of Apollo.

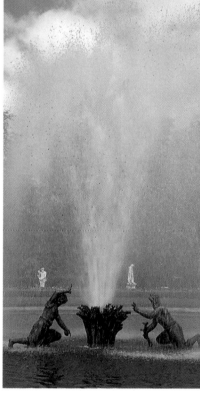

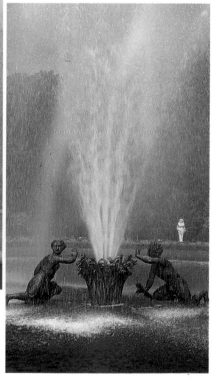

The Fontaines des Lézards

The two round bassins on the north and south of the parterre were decorated in 1670 with figures of tortoises and lizards, and then with Lycian peasants in gilded *métail* by Balthazar Marsy. Each couple faces a clump of reeds, from which a jet of water rises.

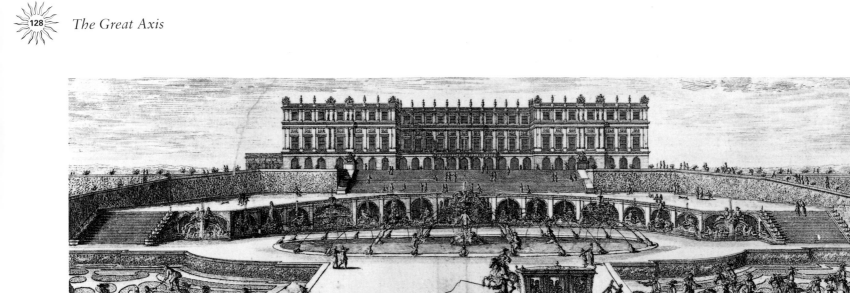

The project for the retaining wall

While he was working on the décor of the bassin, Le Brun was also planning a vast allegorical programme to decorate the retaining wall of the terrace above with seventeen niches holding fountains illustrating the story of Latona. The project was abandoned due to new military expenses, and the wall was instead concealed by a hornbeam hedge. An engraving of 1674 by Israël Silvestre (*above*) shows how the scheme would have looked. The designs for the fountains were engraved by Louis de Chastillon in his *Recueil de divers dessins de fontaines et de frises maritimes inventées et dessinées par M. Le Brun.*

Fountain of Saturn

On a chariot drawn by two winged deer Saturn, husband of Cybele and father of Zeus, intercedes for Latona and calls on Fate to reverse the decree.

Fountain of Juno

Standing in a chariot drawn by two peacocks, Juno commands Python to pursue Latona and prevent her giving birth. The goddess is framed by two fountains in which the figures represent the rivers crossed by Latona in her flight.

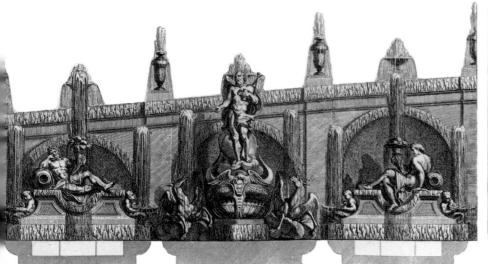

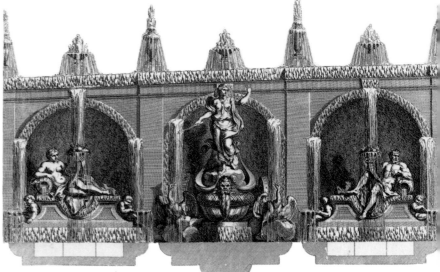

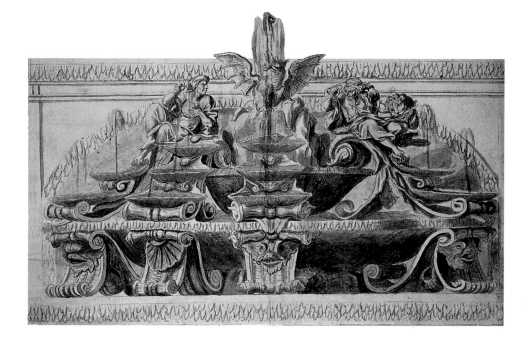

Project for the central fountain

Two variant designs exist for this central feature. In the first, seen here, two female figures representing the Fury and Jealousy of Juno flank the serpent Python, which was sent by the goddess in pursuit of Latona. The second design depicts the creation of Python from the silt left by the waters of the Flood.

Fountain of Neptune

Standing in his chariot drawn by two sea-horses, Neptune challenges Juno and causes the island of Delos to rise from the sea, on which Latona gave birth to Apollo and Diana.

Fountain of Cybele

On a chariot drawn by two lions Cybele, the mother of Jupiter, calls on the gods to save Latona.

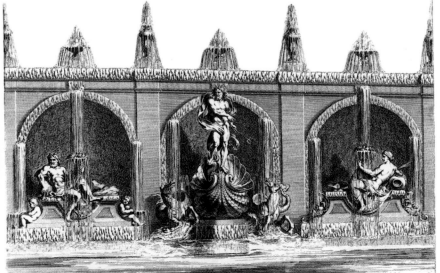

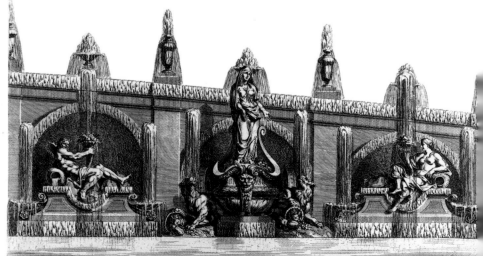

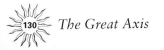

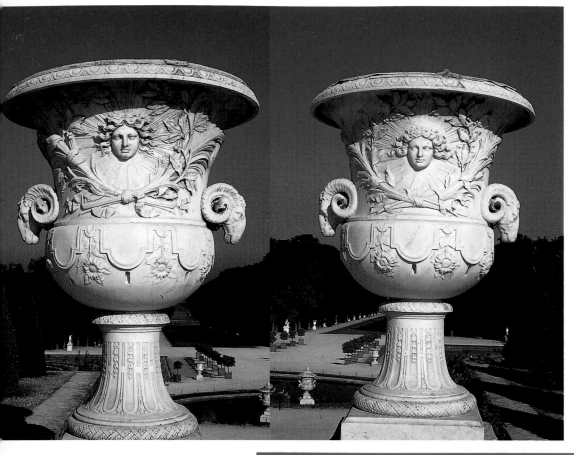

The Vases du Soleil
These vases on the plinths flanking the Grand Degré were designed by Hardouin-Mansart, ordered in 1684 from Jean Dugoulon and Jean Drouilly, and put in place after 1688. (From 1670 to 1685 the spaces had been occupied by sphinx groups: see ills. pp. 102–3.) The vases are carved with radiant heads of Apollo, palm leaves recalling the tree he was born under, laurel, and sunflowers, which turn towards the sun.

The vases on the terrace
The four vases of which two are shown here were made before 1673 by Jacques Grimault and other pupils of the Académie de France in Rome, copying antique models. They are carved with satyr heads, garlands of ivy and vine trails.

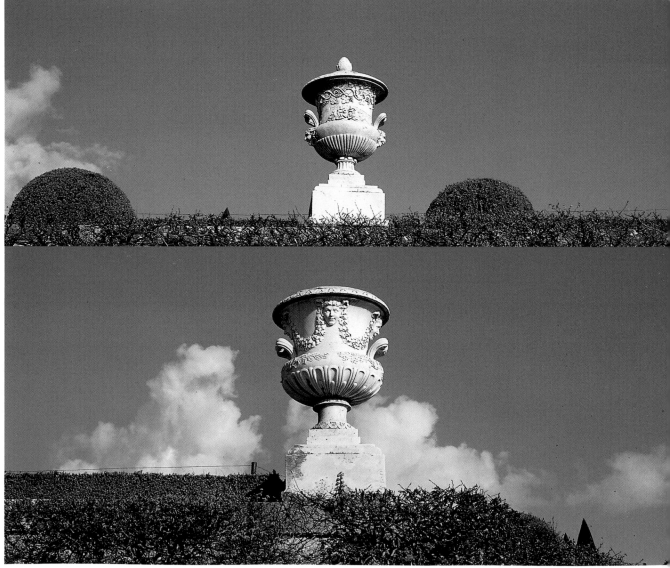

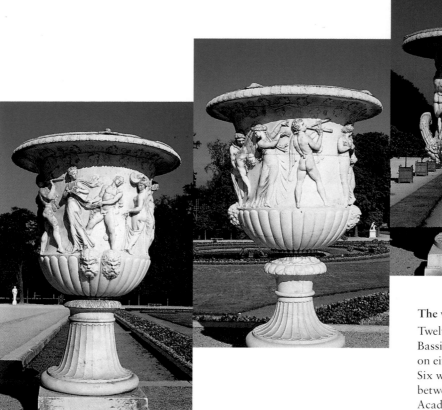

The marble vases

Three sets of marble vases stand in the Parterre de Latone: the two great Vases du Soleil framing the Grand Degré, four at the edge of the terrace overlooking the Bassin de Latone, and a further eight at the upper ends of the two compartments of the parterre.

The vases of the parterre

Twelve vases surround the Bassin de Latone and extend on either side below the ramps. Six were ordered by Colbert between 1679 and 1682 from the Académie de France in Rome, whose director, the painter Charles Errard the younger, suggested two famous antique models: the Borghese Vase, with its distinctive ribbed base (*above, left and centre*), and the Medici Vase, with its handles sprouting from satyr masks (*above, right, and below, left*). Those models had already been used in Rome for three other vases that became part of the set – one by Simon Hurtrelle (1673) and two by Pierre Laviron. After 1683, Jean Cornu and Louis Leconte completed the series in Paris. Three vases show bacchanalian processions (*above*), while another three depict a sacrifice to Diana (*far left*).

Two further vases made between 1684 and 1688 celebrate Louis XIV's victories over Austria and Spain, in the guise of the triumph of Mars, enacted by putti. On the north, the vase by Jean Hardy shows Mars in his chariot drawn by two wolves (*centre*), while on the south, the vase by Jacques Prou the younger depicts him surrounded by trophies (*right*).

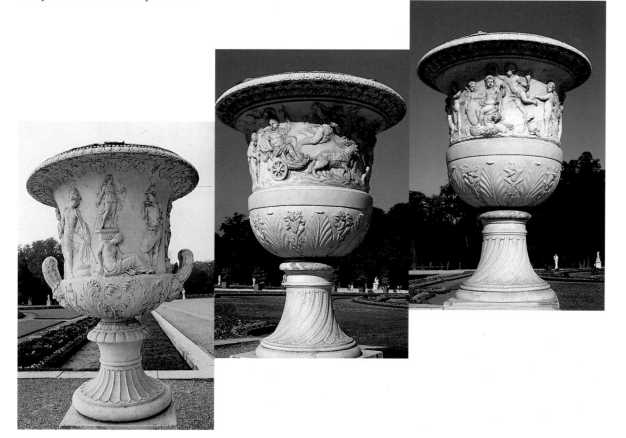

| Tiridates, king of Armenia | Urania | Ceres | Callipygian Venus | Tigranes, king of Armenia |
| (Antoine André) | (Martin Frémery) | (Thomas Regnaudin) | (Jean-Jacques Clérion) | (Matthieu Lespagnandelle) |

The statues along the ramp

The two arms of the ramp enclosing the parterre were decorated from 1687 onwards with eighteen marble statues, silhouetted against a row of clipped yews. The first three form part of the set commissioned in 1674 for the Grand Parterre d'Eau, while the others are copies of antique statues, ordered in 1683 by Louvois from fifteen different sculptors and executed in Italy by pupils of the Académie or made in Paris from casts. Some subjects are repeated.

In the cause of modesty, most of the nudes were soon adorned with a leaf, a fold of drapery or a conveniently placed branch by Claude Bertin and François Fontelle, the sculptors in charge of maintenance and restoration of the statuary in the gardens.

Two further reclining figures were placed on plinths at the bottom of the ramp.

Commodus as Hercules
(Nicolas Coustou)

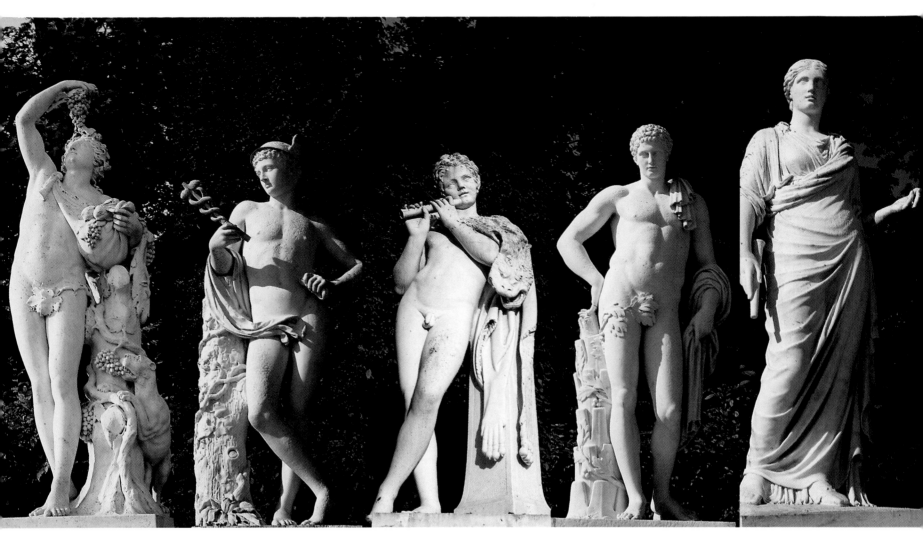

Bacchus with a panther
(Pierre Granier)

Mercury
(Barthélemy de Mélo)

Faun playing a flute
(Simon Hurtrelle)

The Belvedere Antinous
(Lacroix)

Urania
(Martin Carlier)

Silenus and the infant Bacchus
(Simon Mazière)

The Belvedere Antinous
(Pierre Legros the elder)

Nymph with a shell

This statue, placed at the bottom of the northern arm of the ramp, represents the nymph Castalia, daughter of Achelous. Pursued by Apollo, she threw herself into a spring which thereafter conferred the gifts of poetry and divination on all who drank there. It is a replica by ·Auguste-Edme Suchetet of Coysevox's original, itself a copy of an antique statue (commissioned at the same time as the Crouching Venus in the Parterre du Nord: ill. p. 77), which was sent to the Louvre in 1891.

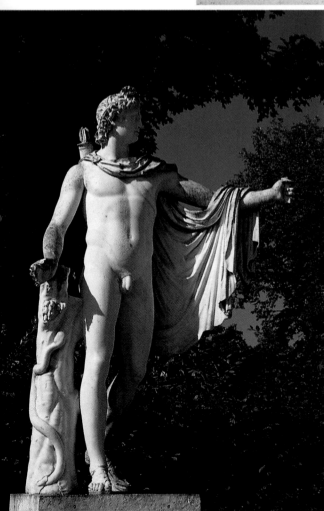

The Belvedere Apollo
(Pierre Mazeline)

Ganymede
(Pierre Laviron)

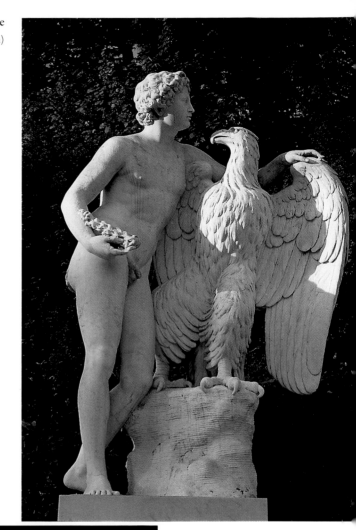

The Dying Gladiator

This statue faces the Nymph, at the bottom of the
southern arm of the ramp. It was executed in Rome
between 1672 and 1681 by Michel Monier, after a figure
of a captive warrior from the monument to Attalus I,
king of Pergamon.

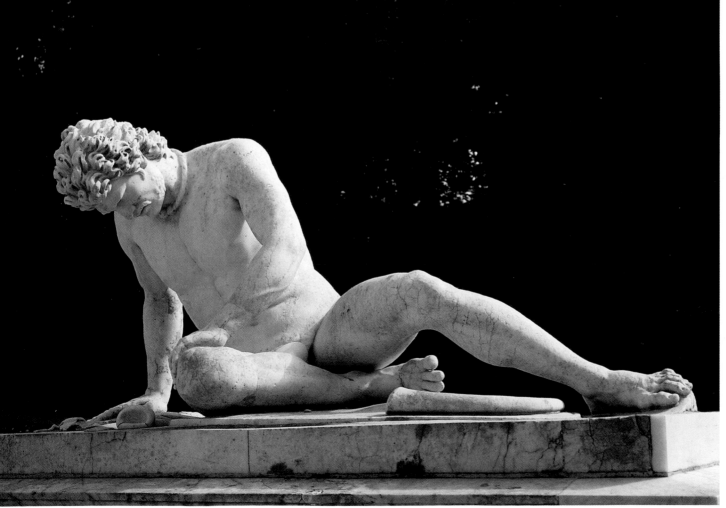

135

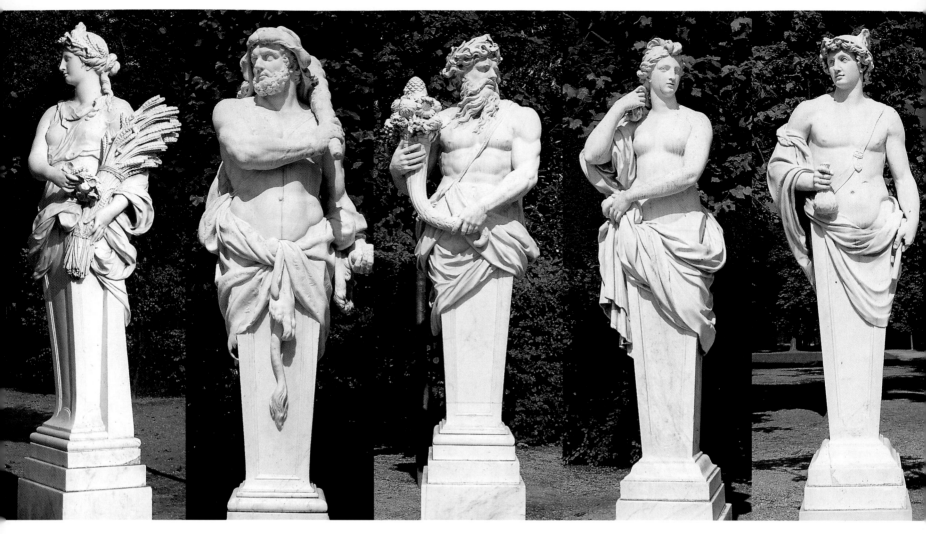

Ceres

Carved by Jean-Baptiste Poultier and placed in position in 1694, this figure of Ceres personifying Summer was part of a commission for terms of the Seasons designed by Girardon. (Spring and Autumn were put in place in the Parterre d'Apollon after 1695; Winter, which was not finished until after 1707, went straight to the Tuileries.)

Hercules and Achelous

These figures, made by Simon Mazière and Louis Leconte, stand on either side of the entrance to the Allée Royale. Achelous, god of the greatest river of Greece and father of all springs, was vanquished by Hercules in a combat to win the hand of Deianeira, daughter of the king of Calydon.

Pandora and Hermes

The term of Pandora was carved by Pierre Legros the elder from a design by Pierre Mignard, and that of Mercury by Cornelius van Cleve. According to Hesiod, Pandora was the first woman to be created and was endowed with every gift, but Mercury planted falsehood and deceit in her heart. She is holding the box which she opened out of curiosity, thereby letting out all the ills that beset mankind.

The terms

From 1690 onwards the stone terms at the lower end of the parterre were replaced by versions in marble. They are grouped thematically in pairs.

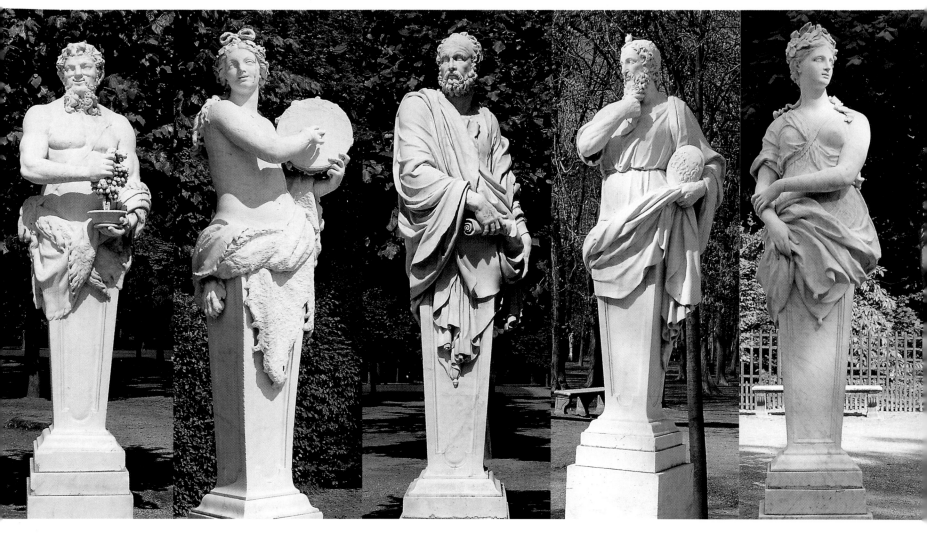

Satyr and bacchante

(Jacques Houzeau and Jean Dedieu)

Diogenes and Plato

These two terms, placed at the ends of the cross-axis opposite Ceres and Circe, were part of an order intended for the Rond-Point des Philosophes in the Parterre du Nord (see p. 74). Diogenes is the work of Matthieu Lespagnandelle to a design by Mignard, while Plato is by Joseph Rayol. The flame on Plato's forehead signifies his supreme genius; the medallion in his hand bears the effigy of his master Socrates.

Circe

Mignard was also responsible for the design of this term, carved by Laurent Magnier. It represents the sorceress in the Odyssey who turned the companions of Ulysses into swine. (The wand which she once held in her left hand has disappeared.)

The Point de Vue and the Bassins des Saisons

IN HIS *Manière de montrer les jardins de Versailles*, Louis XIV recommended a pause at the 'viewing point below Latona'. From here there was a wide perspective over the gardens: looking east, the visitor could admire 'the steps, the vases, the statues, the lizards, Latona and the château', and on turning round to the west could see 'the Allée Royale, Apollo, the canal, the fountain sprays in the bosquets, Flora, Saturn, Ceres on the right, Bacchus on the left'.

These four statues of deities representing the Seasons were placed where the walks of the Jardin Bas converged in crossroads. They were part of the ornamental theme of the Great Axis, and illustrated symbolically the yearly course of the sun, whose rise from the sea was celebrated in the Bassin d'Apollon, and whose setting was depicted in the Grotte de Téthys. The statues are turned towards the Great Axis and gaze in the direction of the Point de Vue.

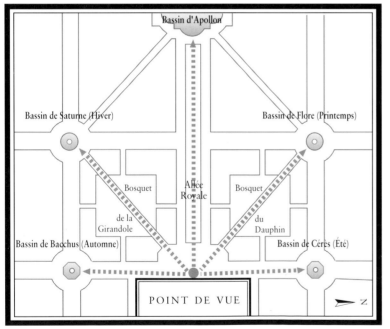

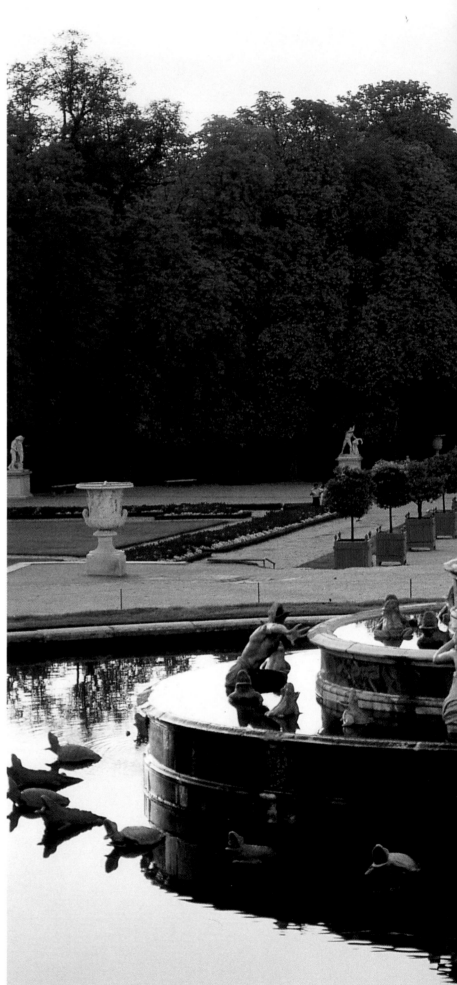

The view from above the Fontaine de Latone

From here, the Allée Royale, Bassin d'Apollon and Grand Canal are clear. From the Point de Vue at the bottom of the parterre, vistas opened up to the Bassins des Saisons.

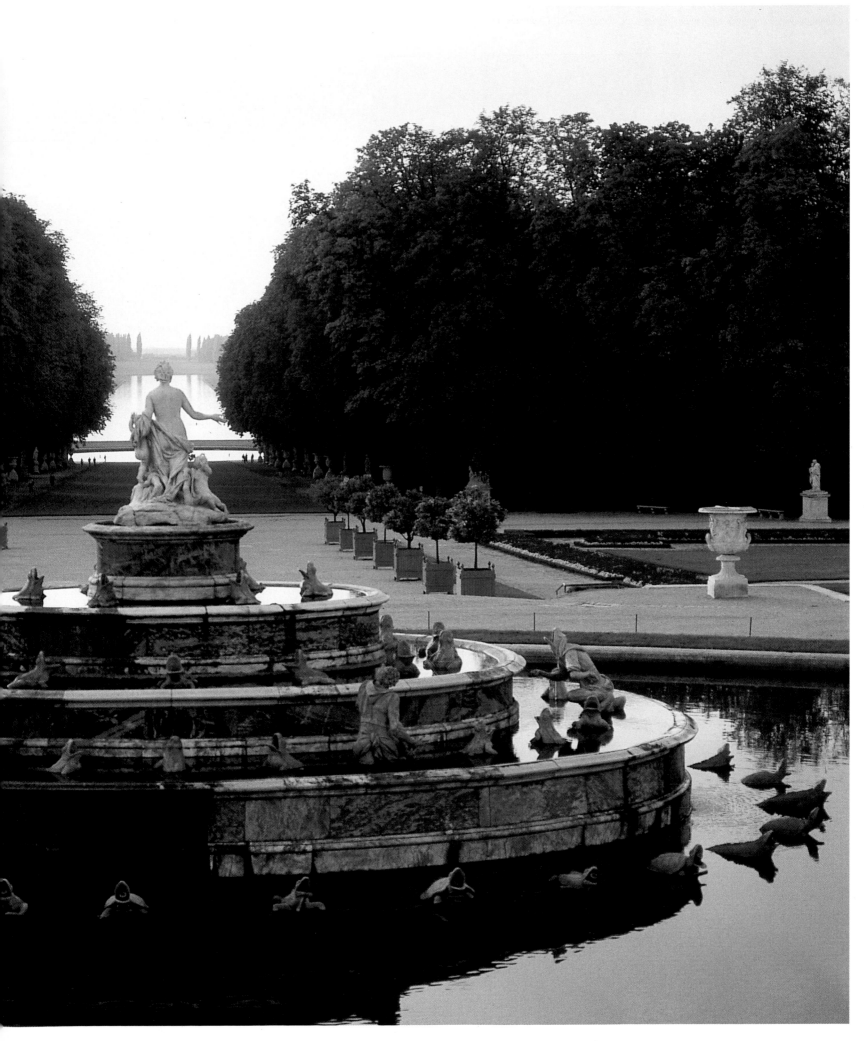

Fontaine de Flore or allegory of Spring

This fountain, at the north-western intersection, was made by Jean-Baptiste Tuby in 1674. Flora, surrounded by zephyrs wearing wreaths of wild roses, sat on a bed of flowers painted in naturalistic colours -- roses, anemones, cornflowers and sunflowers – beside a basket spouting a jet of water. Sixteen other jets rose from secondary motifs around the central group: one ensemble was of four cupids linked by garlands; a second was formed by four cupids alternating with baskets of flowers. The rim of the bassin was decorated with further flowers.

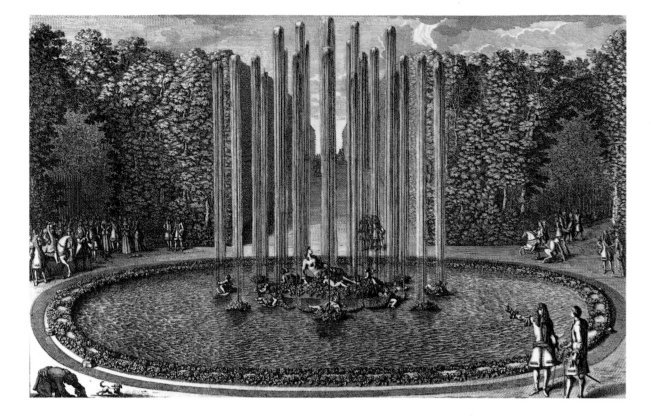

The first allegorical Fontaines des Saisons

As early as 1663 two round bassins marked the crossing of the walks of the Jardin Bas on either side of the Great Axis (see the plan p. 140). Complemented in 1672 by two octagonal bassins at crossings to the east, they were all shortly afterwards given fountains on the theme of the Seasons. These were designed by Le Brun and executed in gilded *métail* by four artists of the first generation trained in the Académie de Sculpture. Spring and Summer were represented in the north of the Jardin Bas by goddesses, while Autumn and Winter in the south of the garden were gods. The original appearance of the fountains before their remodelling in 1681 was recorded by Adam Pérelle.

Fontaine de Bacchus or allegory of Autumn

This fountain, at the south-eastern intersection, was made by Gaspard and Balthazar Marsy in 1674. Crowned with vines and surrounded by satyrs, Bacchus reclined on a bed of bunches of grapes and leant on a wine-jar from which a jet of water rose. Four other jets rose from secondary groups of satyrs, detached from the main group, while grapes and vine-leaves decorated the rim of the bassin.

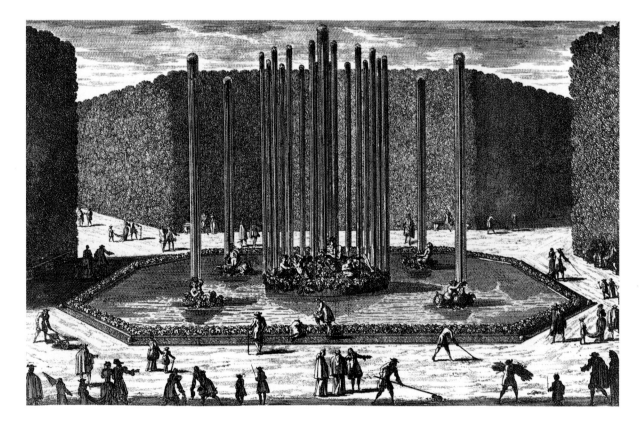

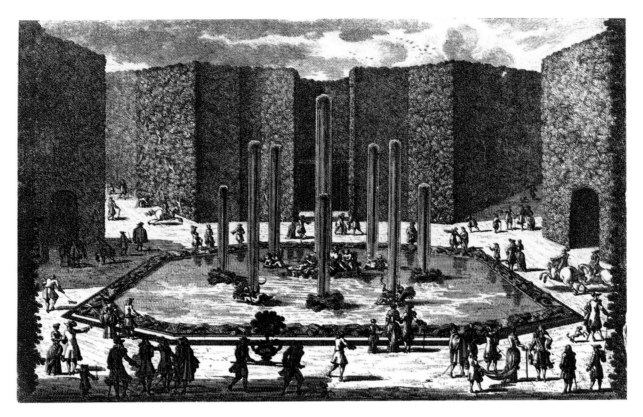

Fontaine de Cérès or allegory of Summer

This fountain, at the north-eastern intersection, was made in 1673 by Thomas Regnaudin. Ceres lay on a bed of wheat, with cupids and wheatsheaves around her. A jet of water rose from the central sheaf, while eight others sprang from detached groups of cupids alternating with crossed sheaves. The rim was decorated with sheaves, pigeons, rats and ants.

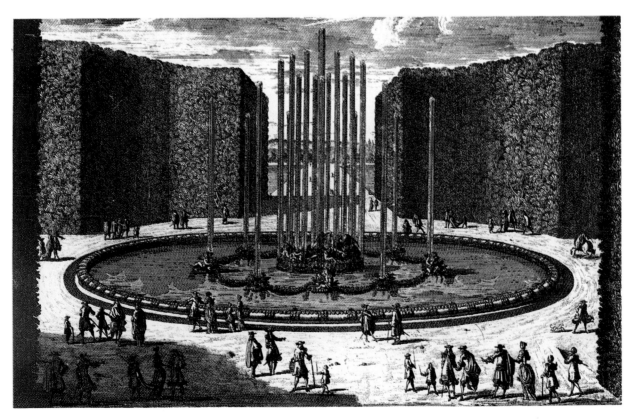

Fontaine de Saturne or allegory of Winter

This fountain, at the south-western intersection, was created by Girardon in 1677. Saturn, sitting on a bed of shells and surrounded by cupids, was shown leaning against the sack which he thought contained his son Jupiter whom he wished to kill (the child had in fact been replaced by a stone). A jet of water spouted from the mouth of the sack, and eight other jets rose from secondary motifs of cupids alternating with wild boar, linked by garlands of shells. The rim was decorated with carving imitating stalactite incrustations.

Elements from the Fontaine de Flore (Spring)

Four of the secondary motifs were placed in the Salle des Marronniers at Trianon; a fifth, now replaced by a copy, in the Bassin du Plat-Fond at Trianon; and two more were sent to Meudon.

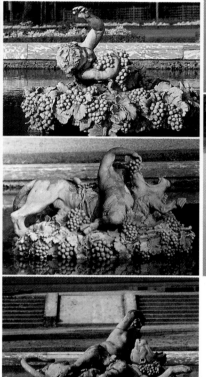

Elements from the Fontaine de Bacchus (Autumn)

Three now decorate the Parterre Bas at Trianon.

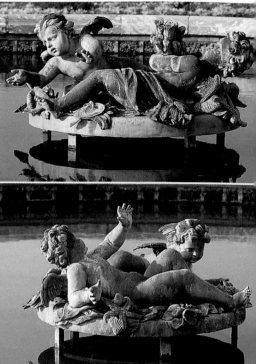

Elements from the Fontaine de Saturne (Winter)

Two are in the Parterre Haut at Trianon.

The Fontaines des Saisons today

Flora, Bacchus, Saturn and Ceres occupy the centre of simple bassins.

The fountains remodelled

In 1681 Hardouin-Mansart moved the secondary ornaments to the Bosquet de la Salle des Festins (ill. p. 232). Three years later the principal motifs were cast in bronze and the decorated rims replaced by plain marble.

When in 1706 the Salle des Festins was transformed into the Bosquet de l'Obélisque, the secondary elements from the fountains of Spring, Autumn and Winter were moved again. The smaller elements of Summer had already been sent in 1697 to the château of Meudon.

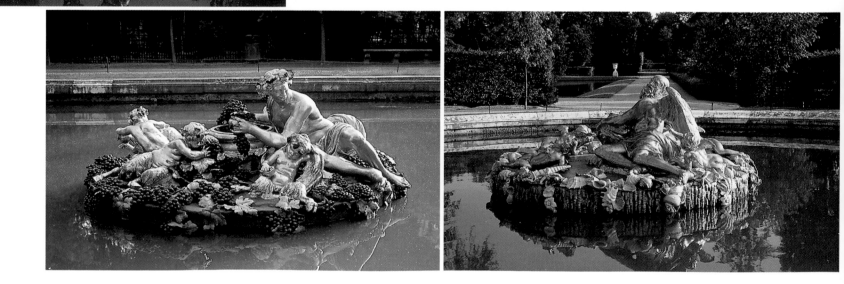

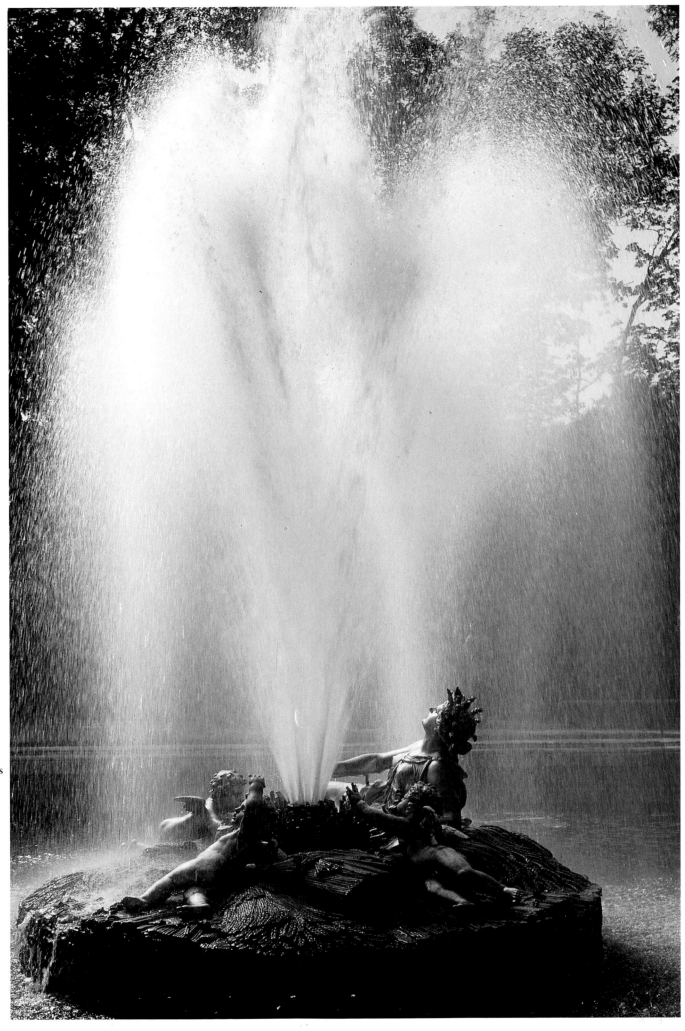

The Fontaine de Cérès
during the
'grandes eaux'

The Allée Royale or Tapis Vert

THIS ALLÉE, which marks the centre of the great axis, was already present in the earliest layout of the gardens (see the plans pp. 36–37). Two bassins at first punctuated its length – one on the west (the Pièce d'Eau des Cygnes, later Bassin d'Apollon) and the other closer to the château, at the meeting of eight walks in a star. During the transformation by Le Nôtre the latter was destroyed and replaced by another, positioned to the east at the entrance to the axial walk. This in its turn disappeared in 1667 when that walk was widened to become the Allée Royale. The Pièce d'Eau des Cygnes at that time looked beyond the gardens over a goose-foot, which was to be replaced by the Grand Canal.

In 1680 the Allée Royale was divided in two by a *tapis vert*, a 'green carpet' of turf, which gave it its new name. Originally bordered by fir trees, it was later given a high hornbeam hedge in front of which stood clipped yews.

The allée was at first lined with stone terms, and then with marble statues and vases commissioned in 1684 and 1687 by Louvois.

The Allée Royale replanted
After the accession of Louis XVI in 1774, the enclosing wall of hornbeam and yew was replaced by a row of sweet chestnuts (themselves replanted after 1870). Hubert Robert recorded the effect of work in process in the winter of 1775. Note the statues of Castor and Pollux on the left, and, on the right, Milo of Crotona. The latter marks the entrance to the Allée Royale, which is itself lined with statues and urns. The Colonnade stands out in the left background, and the vista leads on to the Grand Canal.

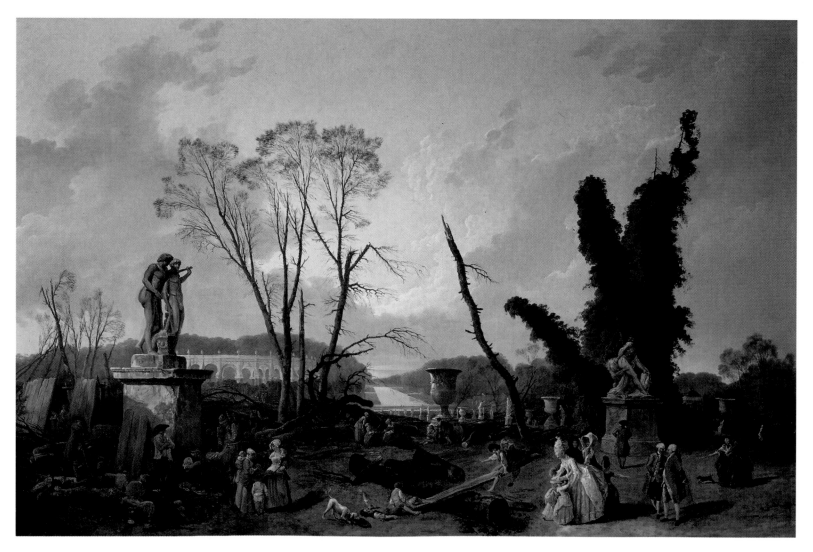

Perseus delivering Andromeda

This group, started by Puget in 1675 and finished in 1684 with the help of his nephew Christophe Veyrier, was brought to Versailles in 1685 in the same consignment as Bernini's equestrian statue of Louis XIV. Two years later it was placed at the entrance to the Allée Royale. Perseus is here breaking the chains that bind Andromeda, who had been promised to him if he could rescue her from a dragon. The hero personifies the king – whose name in Latin, 'LUDOVICO MAGNO', is incised on a scroll at the bottom of the group – while Andromeda symbolizes France.

After 1848 the group was replaced by Tuby's Laocoön.

The sculptures originally at the entrance to the allée

Two marble groups formerly marked the entrance to the Allée Royale. They were by Pierre Puget (1620–94), who is regarded as the greatest French sculptor of the seventeenth century but never fully belonged to the Versailles team. In 1670 he received royal authorization to carve two blocks of Carrara marble deposited at the Toulon Arsenal, and produced Milo of Crotona and Perseus and Andromeda, which were transported to Versailles.

The only major examples of the French Baroque style in the gardens, these two sculptures, which were to have been cast in bronze, were ultimately sent to the Louvre and replaced by other groups (see pp. 146–47).

Milo of Crotona

This group was begun in 1672 and completed in 1682, arriving at Versailles the following year. It shows Milo, whose hand is trapped in a treestump, struggling to free himself, as he is devoured by a lion. Whereas Perseus symbolizes human glory, he embodies human vanity.

Milo was replaced at the entrance to the Allée Royale by Paetus and Arria.

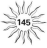

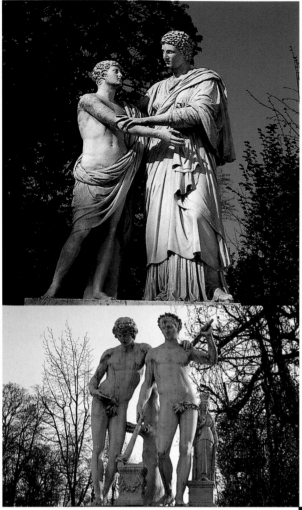

Papirius and his mother

This sculpture was comissioned first from Benoît Massou and then from Martin Carlier and Michel Monier, and executed between 1685 and 1688. Originally called 'Peace between the Greeks and the Romans', it was later taken to show the young Papirius Praetextatus, who had attended a session of the Roman Senate with his father, teasingly frustrating his mother's curiosity by telling her that the debate had centred on the question whether it was in the best interest of the State that a man should have two wives or a woman two husbands.

The group was installed in 1738 in the Bosquet des Rocailles, and then in the nineteenth century took the place of Paetus and Arria when that group was moved across to replace Milo of Crotona.

Paetus and Arria

François Lespingola carved this group in 1684–88. The seventeenth century interpreted the couple as Caecina Paetus, accused of conspiracy and forced to commit suicide, and his wife Arria who set him an example by saying, 'It does not hurt, Paetus.'

The sculpture originally stood on the north side of the clearing; when Puget's Milo of Crotona was taken to the Louvre this was put in its place, balancing Laocoön and next to Castor and Pollux.

Castor and Pollux

This group was sculpted by Coysevox between 1687 and 1707, copying a cast sent from Rome to France in 1670 for the instruction of the pupils of the Académie, and was placed at the entrance to the Allée Royale in 1712 (ill. p. 144). It was thought at the time to represent Castor and Pollux, twins born from the egg laid by Leda after her union with Jupiter in the guise of a swan. At the death of his brother, Pollux refused the immortality offered him by Jupiter if Castor remained in the underworld, and Jupiter accordingly allowed each to dwell in turn among the gods.

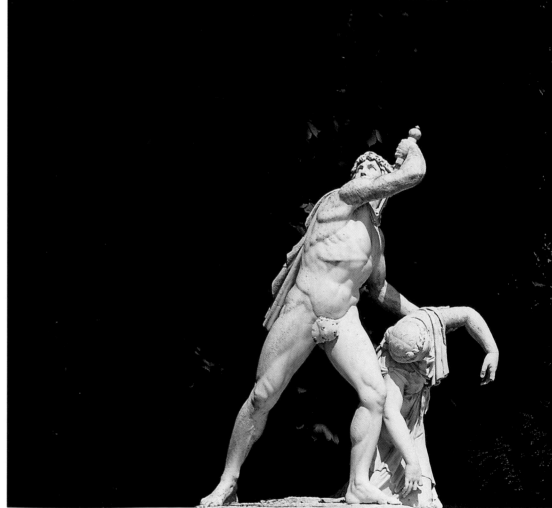

The sculptures now at the entrance

The four sculptural groups now at the entrance formed part of a commission by Louvois for copies of antique works executed from casts. Two stood here from the beginning; the two central ones were brought from

One of the two vases formerly at the entrance

Two vases stood at the entrance: part of a set commissioned in 1687 to designs by Hardouin-Mansart (ills. pp. 148–49), they were executed by Louis-Jacques Herpin and Jean Robert, with carved decoration of musical instruments and garlands of flowers. They were subsequently moved to the Allée du Printemps and Allée de l'Hiver, opposite the western exits from the two Quinconces in the Jardin Bas.

Laocoön and his sons

The original of this group was considered in the seventeenth century, together with the Belvedere Apollo, to be one of the finest achievements of antique art. This marble copy from a cast was executed by Jean-Baptiste Tuby, Philibert Vigier and Jean Rousselet and was completed in 1696. It was brought from Trianon in the nineteenth century to replace Puget's Perseus and Andromeda.

The Trojan Laocoön, a priest of Apollo, was punished for having married Antiope and begotten children against the will of the god; two fearsome serpents were sent to attack his sons, whom Laocoön tried in vain to save.

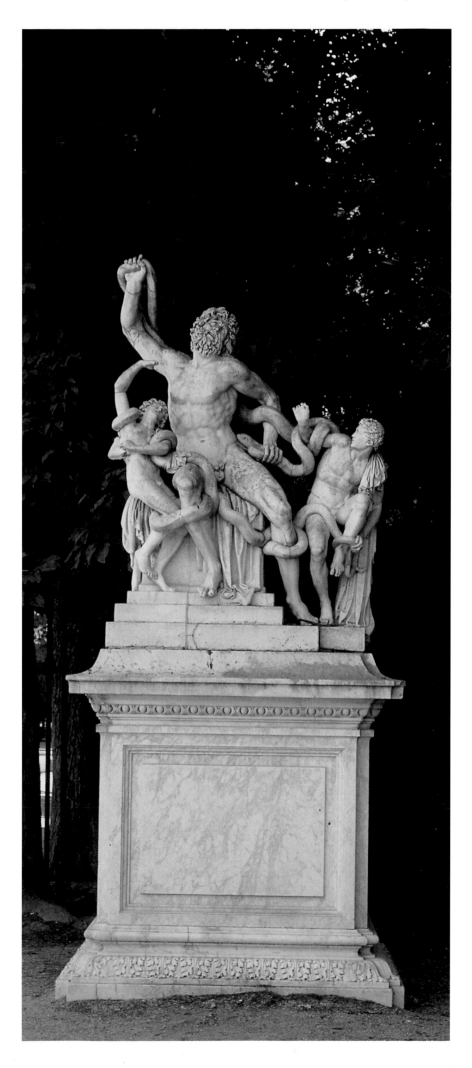

The vases and statues flanking the Tapis Vert

The paths beside the strip of turf known as the Tapis Vert were adorned by twelve statues and by sixteen monumental vases, all in white marble. (Of the set of twenty vases commissioned by Louvois in 1687 to designs by Hardouin-Mansart, four went directly to the Parterre Bas de l'Orangerie.)

The vases, whose decoration is based on solar themes or royal attributes, were placed in symmetrical pairs on either side of the central lawn. Their number eventually dropped to twelve when new allées had been formed leading out of the bosquets lining the Allée Royale, and when, between 1701 and 1707, the ivy-wreath vases by Drouilly and Mélo were repositioned by the Bassin du Miroir in the Bosquet de l'Ile Royale.

The statues are copies of celebrated antique sculptures or original works commissioned by Louvois in 1684.

Vases with cornucopias
(Joseph Rayol and
François Barois)

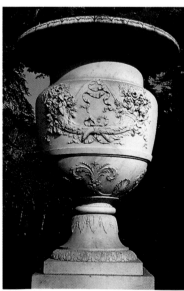

Vases with ivy wreaths
(Jean Drouilly and
Barthélemy de Mélo)
This is one of the pair that now
stand in the Bosquet de l'Ile
Royale.

Vases with fleurs-de-lis
(Jean-Baptiste Poultier and
Louis-Jacques Herpin)
The carvings of fleurs-de-lis on
these two vases were effaced
during the Revolution by
sculptors employed to do
maintenance work in the
gardens. An engraving by Bertin
(*right*) shows their original
appearance.

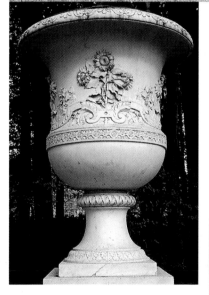

Vases with the royal cipher
(Armand Lefebvre and
Jean Hardy)
The branches of bay and oak
framed the royal cipher, which
was also effaced at the
Revolution.

Vases with sunflowers
(Marc Arcis and
Sébastien Slodtz)

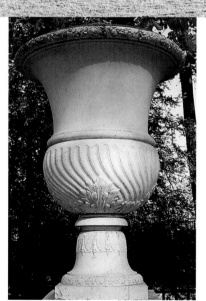

Vases with lilies and sunflowers
(Jean Dugoulon and
Jean Legeret)
These were moved up from a
position lower down the allée to
replace the vases with ivy
wreaths.

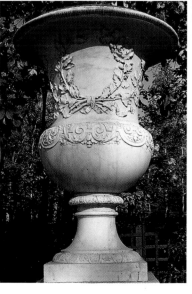

Vases with acanthus leaves
(Philibert Vigier and Jean Joly)

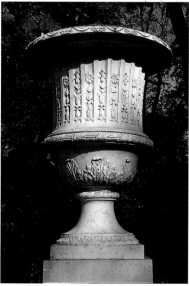

Deceit

The first statue on the north side of the Allée Royale, this female allegorical figure holds a mask denoting flattery, while beside her is a fox symbolizing cunning. The sculpture was executed in 1685 by Louis Leconte to a design by Mignard.

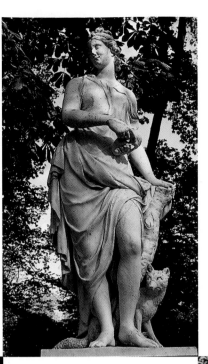

Amazon

Carved in 1693 by Jacques Buirette, after a cast from the antique.

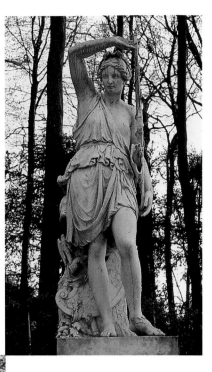

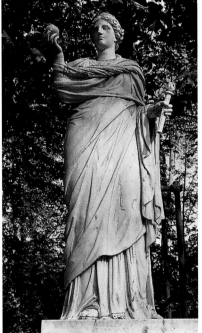

Juno

This statue of Juno is the only actual antique sculpture in the Allée Royale. It was discovered in Smyrna in 1680, with a Jupiter, by an archaeological mission charged with enriching the royal collections. After a first restoration by Simon Mazière in 1687 it was moved to the Parterre d'Apollon in 1696; Lorta restored it again in 1821, and it returned to the Allée Royale in 1829 where it took the place of Jupiter. (The latter, restored by Pierre Granier in 1686–87 and put in position in 1696, was later taken to the Louvre.)

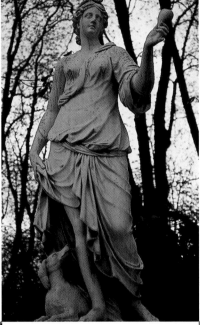

Fidelity

This figure, which forms a pair with Deceit on the other side of the allée, holds a heart while a faithful dog lies at her feet. The statue was carved by Armand Lefebvre in 1684, also to a design by Mignard.

Venus Anadyomene

Begun by Sarazin then taken over by Le Hongre and finally by Pierre Legros the elder, this copy of an antique torso from the château of Richelieu was completed in 1696, and replaced the antique statue of Juno (*above*) when that was initially moved to the Parterre d'Apollon.

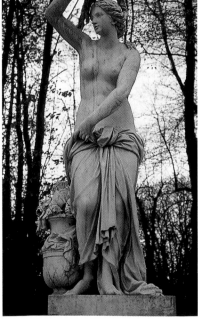

Hercules and Telephus

A copy made in 1685 by Noël V Jouvenet from a cast of an antique statue representing the Roman Emperor Commodus as Hercules with his son Telephus on his arm.

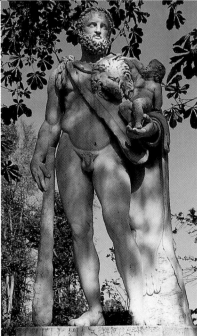

Artemisia

Begun in 1687 by Armand Lefebvre and finished by Martin Desjardins in 1696, to a design by Mignard. The figure portrays Artemisia preparing to quaff the drink made from the ashes of her husband Mausolus, in whose memory she had built the famous Mausoleum at Halicarnassus.

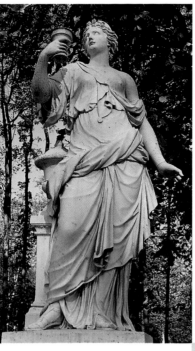

Achilles at Scyros

Executed in 1687–95 by Philibert Vigier after a model by Girardon, this statue illustrates an episode in the Trojan War. To save Achilles from his predicted fate, his mother sent him to Scyros to hide in disguise among the maidens of the court, but he betrayed himself by choosing the sword that Ulysses had planted in a pile of gifts.

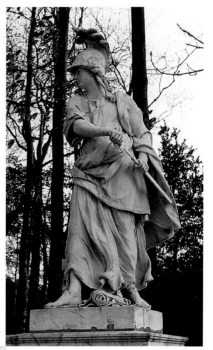

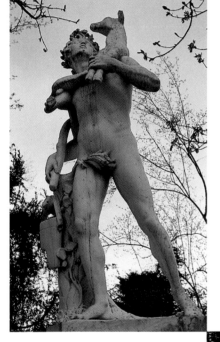

Faun with a kid

Copy of an antique statue from the collection of Queen Christina of Sweden, made by Anselme Flamen in 1686.

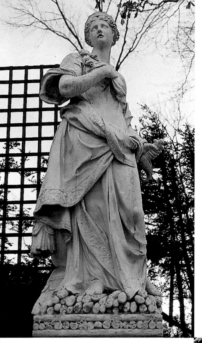

Dido on the funeral pyre

Executed in 1689 by Pierre Poultier from a model by Girardon. This statue alludes to a passage in Virgil's *Aeneid* where Dido, seduced then abandoned by Aeneas, destroys herself in the flames of her own funeral pyre.

The Medici Venus

This copy from a cast of the famous antique statue was begun in 1684 by Michel Monier and finished in 1686 by Martin Frémery.

Cyparissus and his deer

Carved in 1688 by Anselme Flamen from a model by Girardon, this statue illustrates a passage in Ovid's *Metamorphoses*, where Cyparissus, the favourite of Apollo, caresses the pet deer that he later accidentally kills. Then, filled with despair, he implored the gods to make his mourning eternal, and was turned into a cypress, the tree of death and grief.

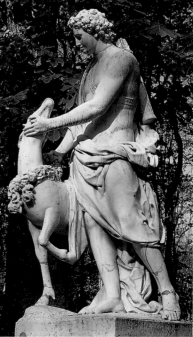

The Parterre d'Apollon

SITUATED at the end of the Allée Royale on the line of the Great Axis and equidistant from the château and the furthest point of the Grand Canal, the Parterre d'Apollon forms the link between the gardens and the park. The separation between those two elements is marked by a concealed ditch or ha-ha. (One of the explanations for the name of this type of view-extending ditch is that the courtiers encouraged their mounts to jump across by shouting, 'Ah! Ah!')

The parterre constitutes the hub of the domain. From the bassin – visible from the first floor of the château – the chariot of Apollo surges out of the water at the start of his daily course which will lead him to the other end of the Great Axis and the Grotte de Téthys.

The ascent of Apollo

The group forming the Fontaine d'Apollon was executed in *métail* by Tuby to a design by Le Brun. It was started in 1668, finished and placed in position in 1671, and then gilded by Jacques Bailly. Apollo, with a cupid at his feet, seems to rise out of the night in his chariot drawn by four horses. He is surrounded by four dolphins and four tritons who blow their conch shells to announce the beginning of the day.

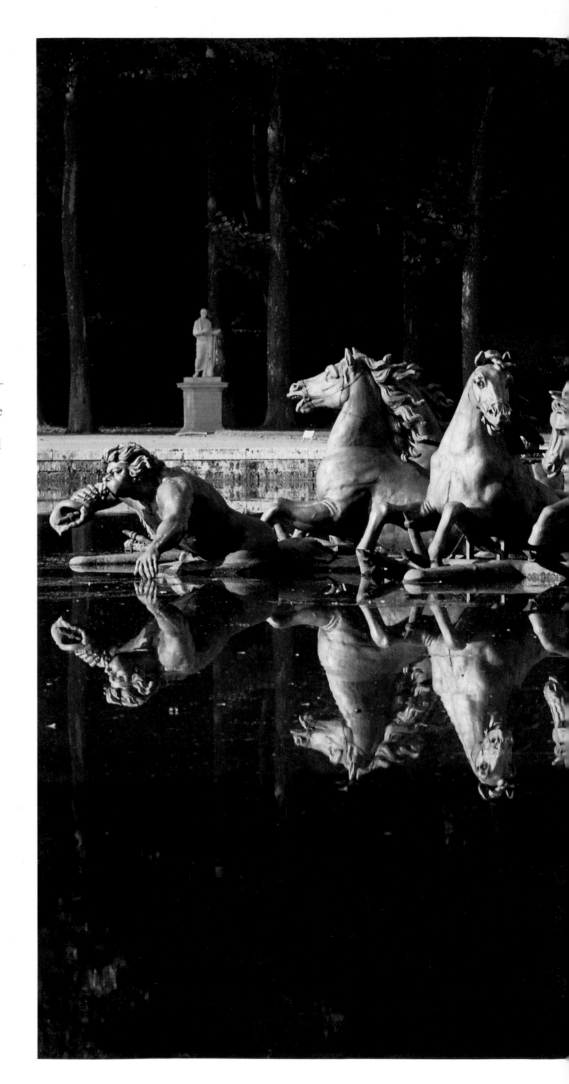

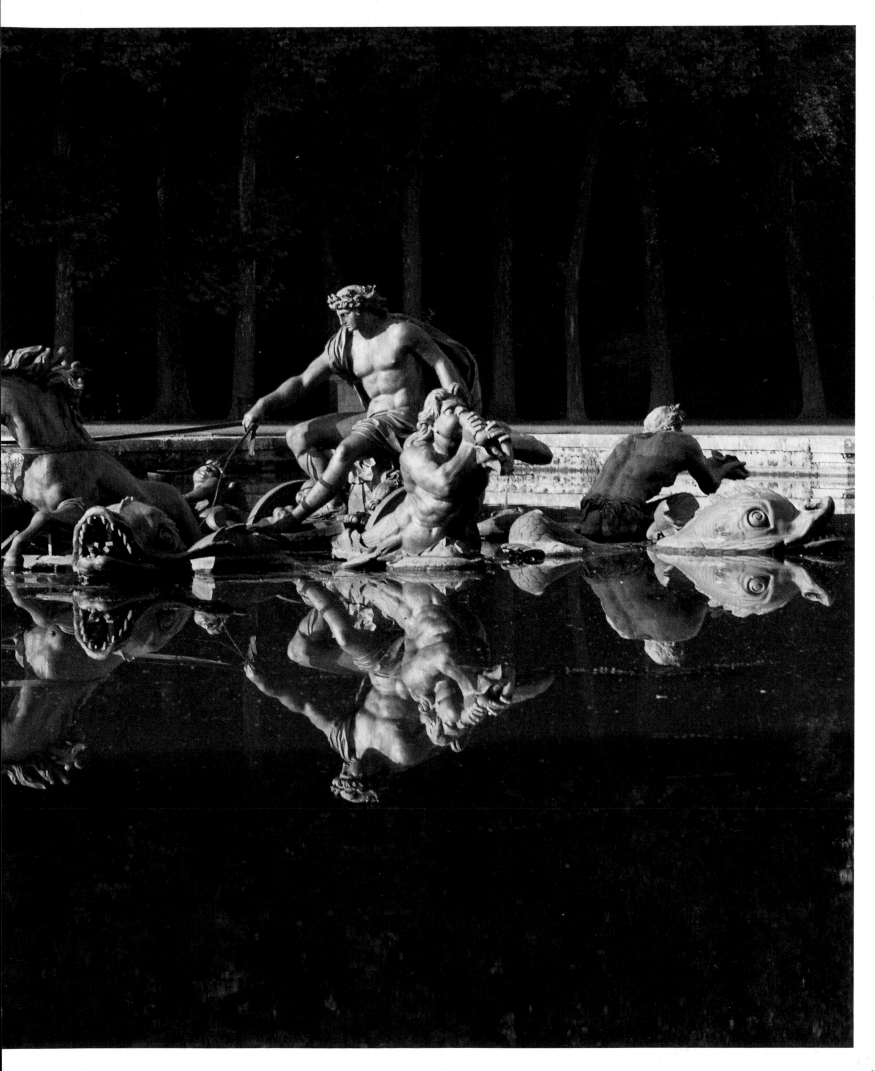

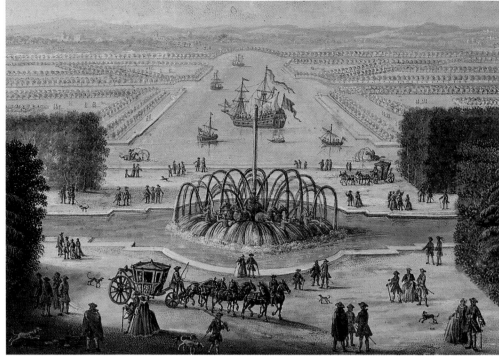

The new Parterre d'Apollon

Between 1705 and 1707 the Parterre d'Apollon was connected to the Parterre de la Tête du Grand Canal to form a single ensemble taking the eye right to the horizon. Pierre-Denis Martin recorded the scene in 1713. Note the statues framing the former Parterre de la Tête du Grand Canal (ills. pp. 159–61).

The first Parterre d'Apollon and Parterre de la Tête du Grand Canal

In 1671 the bassin was decorated with the group of Apollo, and then in 1678 eight stone statues removed from the entrance to the Allée d'Eau (see pp. 56–57) were placed round the edge of the parterre.

In honour of the French navy, Colbert presented small-scale models of warships to sail on the Grand Canal. A galley, galliots and brigantines mingled with the gondolas for the entertainment of the court, while an entire crew was lodged in a nearby building, La Petite Venise, on permanent call to convey the court to Trianon or the Ménagerie, situated at opposite ends of the transverse arms of the canal.

This painting shows the Parterre d'Apollon still distinct from the Parterre de la Tête du Grand Canal beyond, the two separated by blocks of trees.

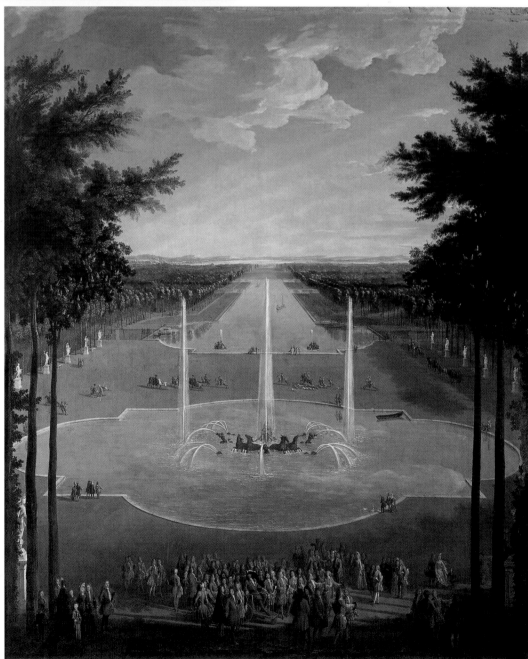

The Parterre d'Apollon and Grand Canal

A bassin at the end of the main axis was created at an early stage – either during the reign of Louis XIII by the Surintendant des Bâtiments, Sublet des Noyers, or by Le Nôtre when he took up his appointment in 1661. Then called the Pièce d'Eau des Cygnes, it was given a cluster of waterspouts in 1665, and the perimeter of the parterre was decorated with terms. With the installation of a new fountain on the theme of Apollo in 1671, this became the Parterre du Bassin d'Apollon.

The separate Parterre de la Tête du Grand Canal was established in 1668. In 1672 it was given two fountains, designed by Le Brun and made in gilded *métail* by Tuby, in the form of seahorses ridden by cupids, which complemented the Fontaine d'Apollon, and in the 1690s it was decorated with antique statues. The two parterres were eventually merged.

Work on the Grand Canal began in 1668. It is 1,500 metres (4,921 feet) long and 62 metres (203 feet) wide, with broader ends to allow boats to turn, and two arms 600 and 400 metres (1,969 and 1,312 feet) long forming a transverse axis.

The Bassin d'Apollon
The gilded horses – seen here during the *grandes eaux* – seem to spring out of the water toward the axis of the Allée Royale leading to the château.

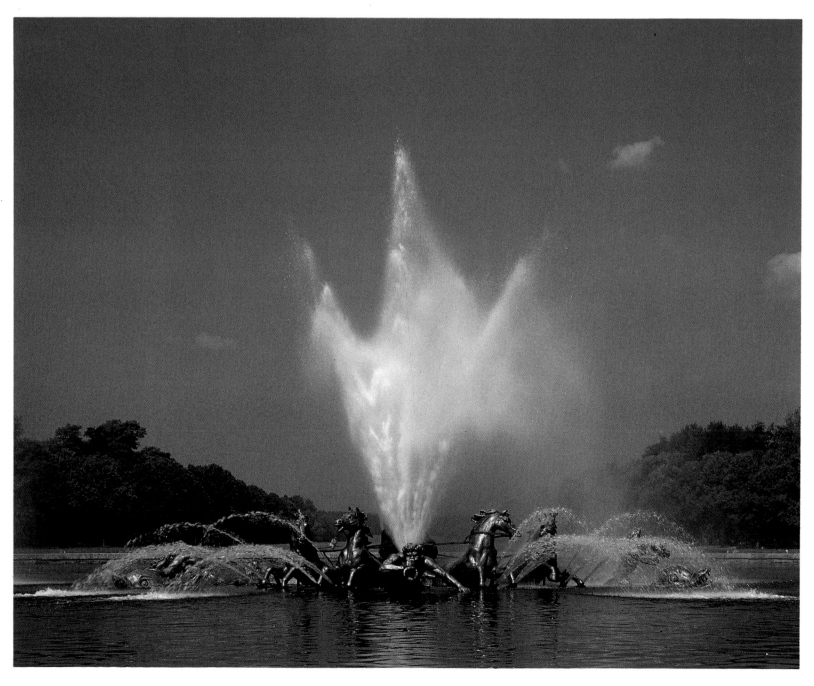

Jupiter and Juno

These terms representing the
two most important divinities
on Olympus were executed in
1686–87 by Jean-Jacques
Clérion to designs by Mignard.

Pan and Syrinx

This pair, made by Simon
Mazière in 1686–89 after
models by Girardon, illustrate
the origin of the panpipes. On
the point of being caught by
Pan, the naiad Syrinx was
metamorphosed into a reed to
escape him. Her plaint mingled
with the moan of the wind in
the reeds and inspired the god
with the idea of the musical
instrument, composed of pipes
of different lengths, which
became known as a syrinx
or panpipes.

The new terms in the parterre

Eight marble terms, commissioned between 1684 and 1686 like those
of the Parterre de Latone (pp. 136–37), border the Parterre d'Apollon
to the east. They are arranged in an arc, designed as couples with
male and female figures alternating.

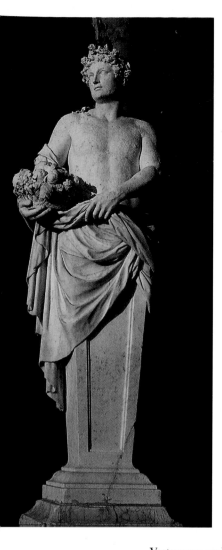

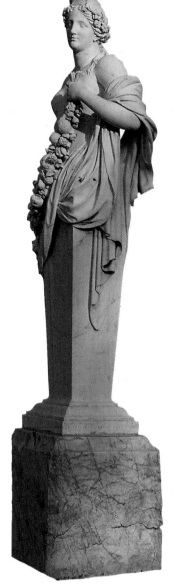

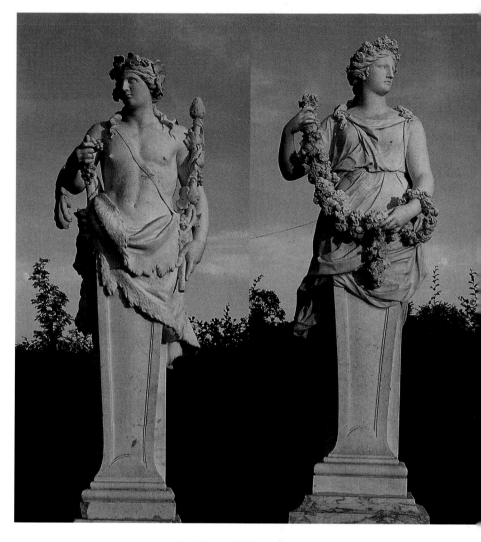

Vertumnus and Pomona

This couple (also represented at the Orangerie: see p. 116) was carved by Etienne Le Hongre in 1684–89.

Bacchus and Flora

These two terms, made after models by Girardon, were part of a commission for figures of the Seasons intended for the gardens of Trianon. Bacchus or Autumn was begun in 1687 by Jean Dugoulon and completed in 1693 by Jean-Melchior Raon. Flora or Spring was started by Marc Arcis in 1688 and finished by Simon Mazière in 1702.

The statues on the east side of the Parterre d'Apollon

Here at the western end of the Allée Royale it was decided to make a composition similar to that at the eastern entrance from the Parterre de Latone. The group of Fame had been brought to the Parterre d'Apollon in 1699 (see p. 44). Now, in 1702, it was removed. The new plan was to frame the western entrance to the allée with a statue of Hannibal by Sébastien Slodtz on one side and Julius Caesar by Nicolas Coustou on the other. However, those statues were sent directly to the Tuileries and then to the Louvre, and the positions were eventually occupied by the two groups of Proteus and Aristaeus and Ino and Melicertes.

Two statues, of Silenus and Bacchus, were added to continue the line of the terms and provide a link with the statues edging the Parterre de la Tête du Grand Canal, by then merged with the Parterre d'Apollon.

Ino and Melicertes

This group, situated on the south side of the entrance to the allée, was made by Pierre Granier between 1686 and 1691 after a model by Girardon.

Ovid recounts in the *Metamorphoses* that when Athamas, visited with madness by Juno, killed one of his sons, his wife Ino in an attempt to save the other, Melicertes, threw herself with him into the sea.

Proteus and Aristaeus

The marble group on the north side of the entrance was designed by Girardon and commissioned first from Cornelius van Cleve and then from Slodtz. It was started in 1688 and completed in 1714, but was not put into position until 1723.

The subject comes from Virgil's *Georgics*, where Aristaeus is described tying Proteus to a rock to force him to reveal the causes of his misfortunes.

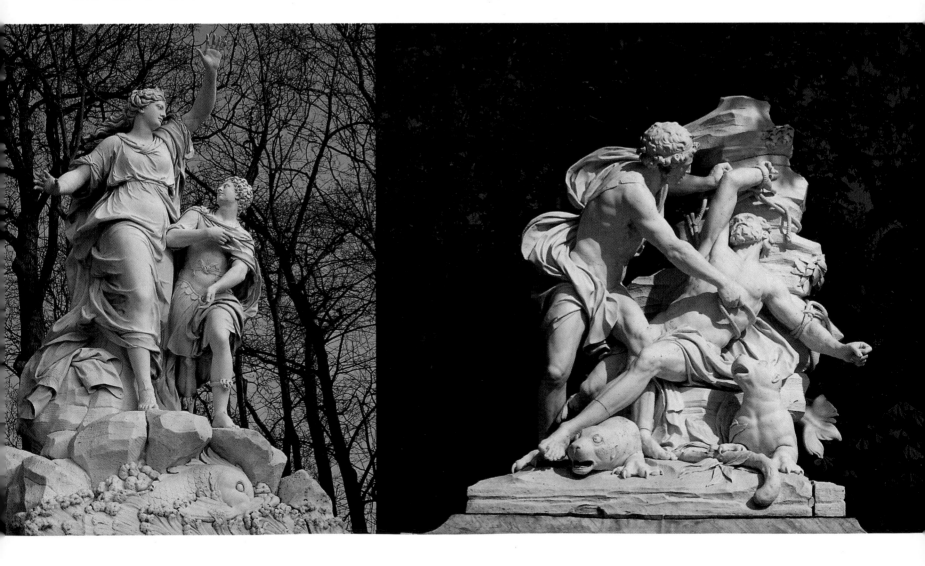

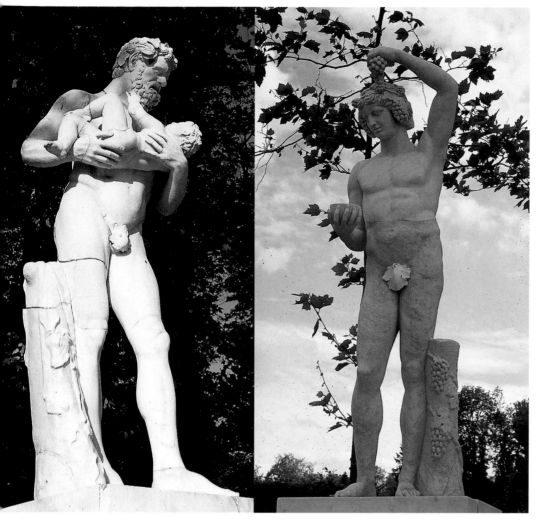

Silenus and the infant Bacchus

This antique statue of Silenus and Bacchus (*far left*), brought from Marly, was installed in 1695 at the end of the series of terms to the north of the parterre. The space had previously been occupied by an antique statue known as the Langres Senator, which had itself been moved from the former Parterre de la Tête du Grand Canal.

Bacchus

This statue (*left*), like the Silenus an antique work brought from Marly, was set up to the south of the parterre in 1795. It replaced a statue of Brutus, which had come from the Bosquet de l'Ile Royale.

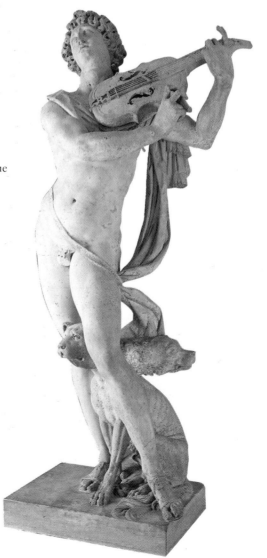

Orpheus
Pierre de Francheville's statue (now in the Louvre) shows Orpheus playing to charm Cerberus, guardian of the underworld, depicted at his feet.

The statues of the former Parterre de la Tête du Grand Canal

Twelve marble statues were placed on either side of the parterre when it was still separate from the new Parterre d'Apollon. All these were restored antique pieces, with the exception of a statue of Orpheus by Pierre de Francheville (1554–1615), which had come to Versailles from the Paris house of Jérôme de Gondi: it was the only example in the gardens of French sculpture dating from the beginning of the seventeenth century.

The statues were frequently moved about; some were taken away at the Revolution and then replaced in the 1820s after the Restoration of the Monarchy by new figures or by other antique statues, restored by Jean-Baptiste Beaumont and Jean Lorta.

Cleopatra

A late sixteenth-century copy after the antique, installed in 1827 to replace an antique statue of Titus, which had taken the place of another antique female figure.

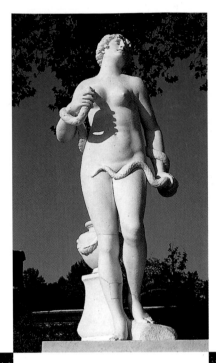

Light

This seventeenth-century statue by the Italian sculptor Baldi was set up in 1795. The first statue to occupy this position was the antique Langres Senator. In 1707 that had been moved to the north of the new Parterre d'Apollon and replaced by an antique figure of Abundance.

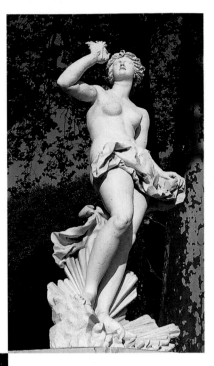

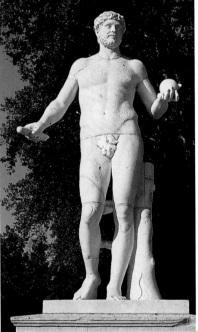

Roman emperor

An antique statue, installed in 1820 in place of a statue of the Emperor Augustus removed at the Revolution.

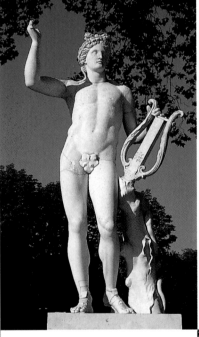

Apollo with a cithara

An antique statue from the château of Richelieu, which replaced another antique figure of Apollo carrying a bow.

Roman with his arm against his chest

An antique statue, set up at the beginning of the twentieth century in place of the Farnese Hercules, which was moved to the south side of the parterre. Before 1826 the position had been occupied by an antique Antinous, which itself replaced Abundance.

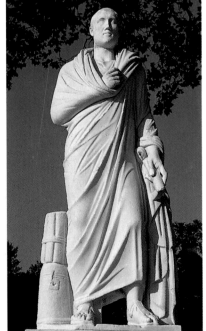

Bacchus

A modern statue by René Grégoire installed at the beginning of the twentieth century in place of an antique statue of Bacchus, in a position previously occupied by Orpheus.

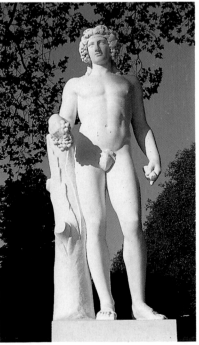

Hercules

A modern replacement of 1893 by René Grégoire for an antique statue of Hercules from the château of Richelieu. That had been set up in 1826 to replace an antique statue of Messalina carrying Britannicus, also known as Agrippina, which had been removed at the Revolution.

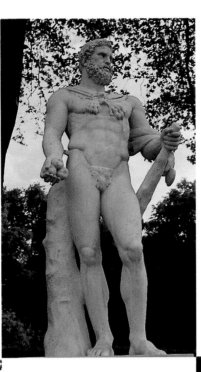

Roman with outstretched arm

An antique statue, which replaced an antique statue of Hercules in 1828.

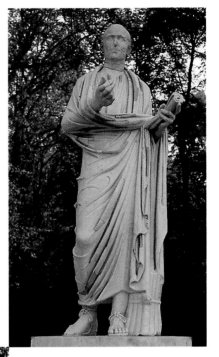

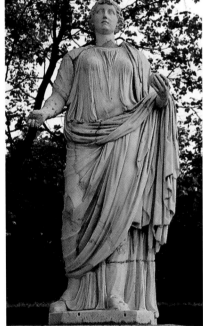

Juno

A copy after the antique. In its initial position, this figure replaced another antique Juno moved to the Allée Royale. It was in turn displaced by the antique statue of a woman holding a child (*below*), then set up again at the Restoration, in a position previously occupied by an antique statue of a Roman senator.

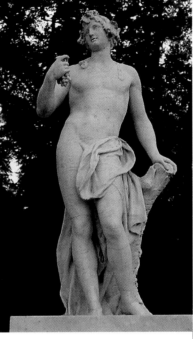

Bacchus

Copy after the antique by Robert Le Lorrain, brought from the Bosquet de l'Etoile. In 1863 this replaced an antique statue from the château of Richelieu, which had taken the place of an antique statue of Titus.

Woman holding a child

An antique statue from the château of Richelieu, set up in 1829. This replaced a copy of an antique Juno (*above*).

The Farnese Hercules

This antique statue was brought from the north side of the parterre at the beginning of the twentieth century. It replaced a statue of Faith by Clodion. Faith had been installed in 1828 in place of an antique statue of a Roman lady, which after the Revolution had taken the place of an antique statue of Victory.

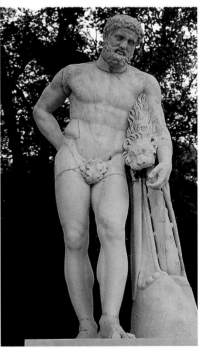

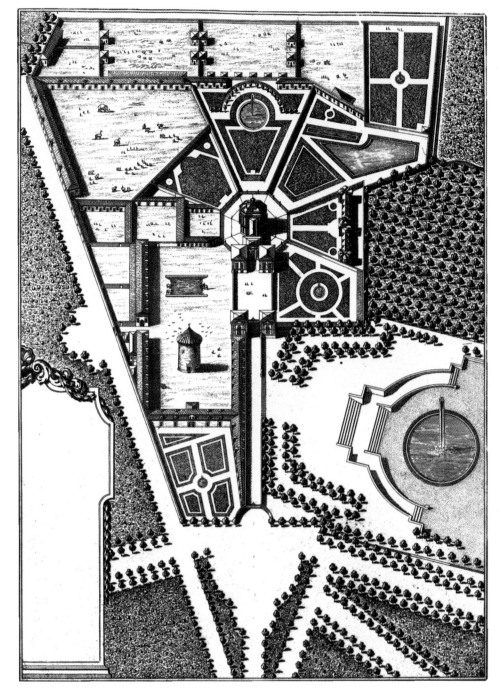

The Ménagerie and Trianon

T HE TRANSVERSE ARMS of the Grand Canal led southwards to the Ménagerie and northward to Trianon, where Louis XIV successively built first the Trianon de Porcelaine and then the Trianon de Marbre or Grand Trianon.

The Ménagerie

This complex was built in 1663 by Le Vau at the same time as the first Orangerie. An octagonal pavilion opening on to a fan of seven courtyards housed storks, African birds, sultan hens, exotic pigeons and other rarities presented to the king by foreign rulers or sent back to France from the colonies. The Ménagerie was demolished in the nineteenth century.

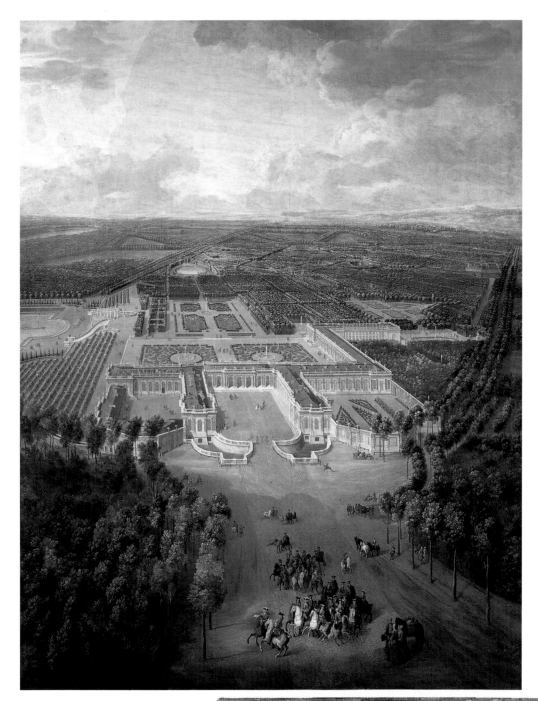

The Grand Trianon

The Grand Trianon was built on the site of the Trianon de Porcelaine (*below*), demolished in 1687. The new building, six times larger, was the work of Hardouin-Mansart and Robert de Cotte. In Pierre-Denis Martin's painting, of 1724, the end of the transverse arm of the Grand Canal is just visible on the left.

The Trianon de Porcelaine

In 1664 the king bought the lands of the seigneury of Trianon and razed the village and church to the ground. In 1670 he commissioned Le Vau to build, at the end of the recently dug northern arm of the Grand Canal, the Trianon de Porcelaine, a pavilion which owed its name to its decoration with blue and white Delft tiles. Its gardens were laid out by Le Nôtre's nephew, Le Bouteux. This engraving by Adam Pérelle situates it in relation to the château and Grand Canal (in the distance, upper right).

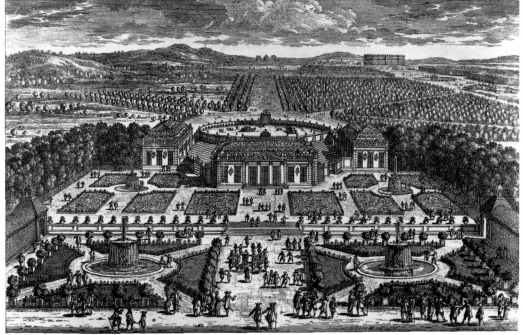

The bosquets of the Jardin Bas

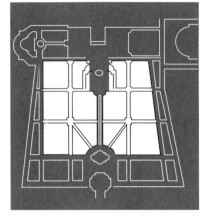

The bosquets

With the exception of the Bosquet du Bois-Vert and the two bosquets of the Jardin Haut (Arc de Triomphe and Trois Fontaines), the main collection of bosquets occupied the wooded area of the Jardin Bas. Conceived as an ensemble by Le Nôtre in 1663, their number varied only slightly during the reign of Louis XIV. Seven lay to the the north of the Allée Royale and six to the south, supplied with water by an extensive network of underground conduits. (In this plan by Girard, *right*, of 1714, the château is at the bottom, not at the top as it is in the diagram, *left*. North is to the right.)

Our tour will begin in the centre, with the two matching square-plan bosquets that became the Quinconces; at this date they were known as the Bosquet de la Girandole on the south and Bosquet du Dauphin on the north. From there, we will explore the other bosquets in a clockwise direction.

Starting on the south, we will return towards the château for the Salle de Bal, and then move through the Labyrinthe downhill to the Ile Royale (which occupies two compartments) before ending at two bosquets within one compartment: the Salle des Marronniers and the Colonnade.

Continuing on the north, again there are a pair: the Bosquet des Dômes and Bosquet de l'Encélade. Next comes the Obélisque, then the pentagonal Etoile, and complex Théâtre d'Eau. We end in the compartment nearest the château. In 1714 it contained the small upper Bosquet des Bains d'Apollon and a larger, lower space still in course of arrangement. The two would eventually be merged for Hubert Robert's Grotte des Bains d'Apollon.

THE FRENCH GARDEN extended the style of the interior of the château out into the open. Parterres were carpets, allées were lined with walls of greenery, and bosquets were arranged as outdoor rooms, with even their names reflecting this concept: ballroom, banqueting room, theatre, sculpture gallery. Decorated with tables, sideboards, lampstands and vases, the gardens of Versailles soon became the best-appointed open-air museum of French statuary of the seventeenth century. The statues were at first executed in stone and in a slightly rustic style by simple craftsmen, but soon they were superseded by works of art in métail, marble and bronze, classical in style and allegorical in inspiration, produced by three generations of artists trained in the Académie de Sculpture in Paris and Rome.[40]

However, even more than the statues, parterres and walks, it was the bosquets that gave the gardens their particular charm. They were vital elements of the jardin à la française and counterbalanced the rigidity of the style by their fantasy. At Versailles there were no fewer than fourteen in the Jardin Bas, each with a different arrangement.

Some were already modified under Louis XIV, others disappeared or were simplified, others again were transformed in the English taste, but the richness of invention that they all showed can still be clearly seen in surviving engravings, paintings and plans.

The layout of a bosquet

A development in the concept of the French garden was already under way during the reign of Louis XIV. These two plans of a bosquet serve to suggest the difference between the style of Le Nôtre and that of Hardouin-Mansart. The former sought the effect of surprise, with angled paths: in the design on the left, of the five paths only two run straight through. The latter was more concerned with the decorative grandeur conferred by a greater number of straight allées: in the design on the right, two more straight vistas have been created. (The Bosquet de l'Obélisque, seen here, in fact acquired these new transverse paths during replanting in the 1770s.)

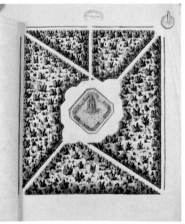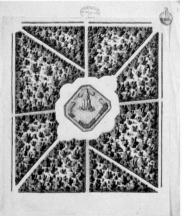

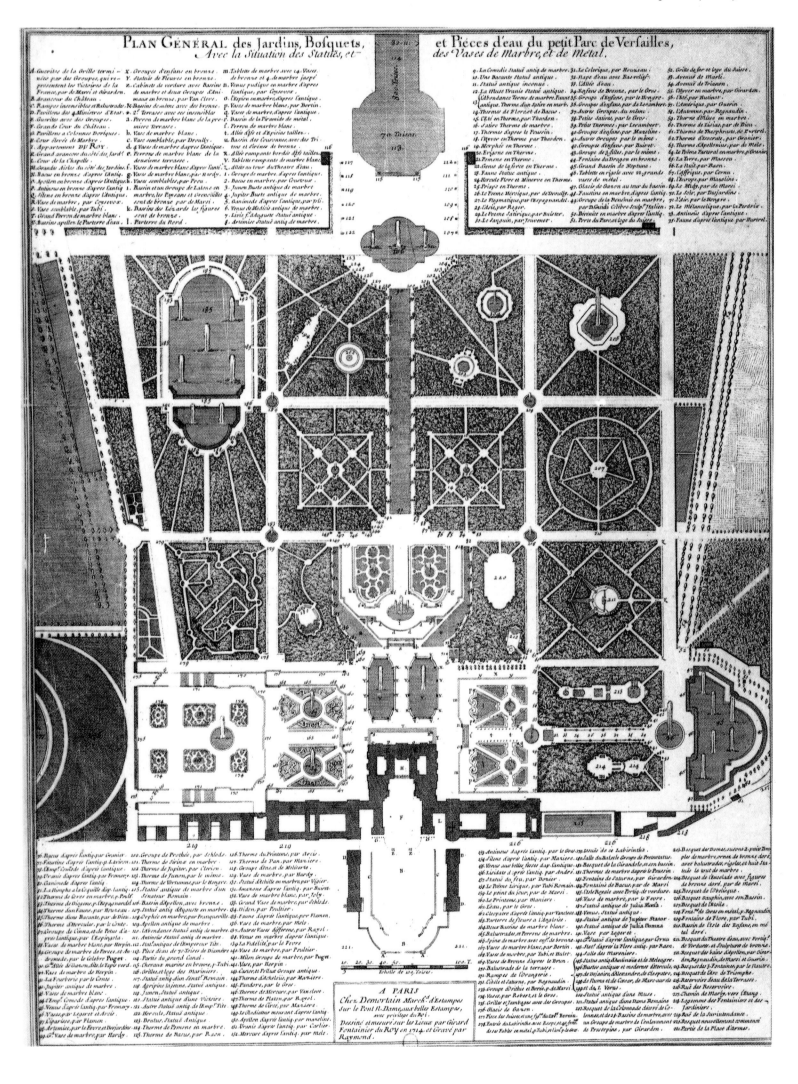

From Deux Bosquets to Quinconces

THE FIRST TWO bosquets to be decorated by Le Nôtre, apart from the short-lived Bois-Vert in the Jardin Haut, were situated on either side of the Great Axis at the beginning of the future Allée Royale. Laid out in 1663, they were at first simply called the Deux Bosquets. Each was composed of four *salles de verdure* crossed by a network of paths converging on a fifth salle with a bassin and jet (see the plan p. 36, below). Later their layout was simplified and the eight converging paths were reduced to four, while the central bassin was decorated with a fountain (see the plans p. 37).

Eventually each was given an individual décor with fountains and statues, and they became known as the Bosquet de la Girandole on the south and the Bosquet du Dauphin on the north.

With the replanting of the gardens by Louis XVI in 1775, the two were filled with lime trees in an identical way. Thereafter, they were known as the Quinconces (quincunxes).

Plan from the album of Jacques Dubois

At this stage, *c.* 1715, the southern Quinconce was still the Bosquet de la Girandole. Sculptures, in the alcove to the east – right – and in one of the salles de verdure, are indicated by red dots. (North is at the top.)

The Bosquet du Dauphin
The central salle of this bosquet contained a fountain
decorated with the dolphin from which its name derived.

From Bosquet de la Girandole and Bosquet du Dauphin to Quinconces

In 1682, the bosquet on the south became the
Bosquet de la Girandole and in 1696 that on the
north was given the name of Bosquet du
Dauphin. The allée leading to each of them
from the east was decorated with an alcove of
trelliswork round a fountain with a statue of
a faun, and their salles were ornamented
with terms.

Between 1761 and 1768 the bassins were
destroyed. In 1775 each bosquet was radically
transformed: around a central open space,
lime-trees were planted in alternate blocks of
symmetrical and staggered (quincunx-based)
rows. The terms were repositioned.

The Quinconces
Symmetrical rows of lime trees in the main directions lead
to a central green surrounded by terms.

The Bosquet de la Girandole

This bosquet gained its name from its fountain which was likened to a girandole, or firework consisting of multiple motifs arranged in a horizontal wheel. Jets round the edge of the bassin converged on the centre, where a column of water rose from a basket of metal flowers painted in naturalistic colours.

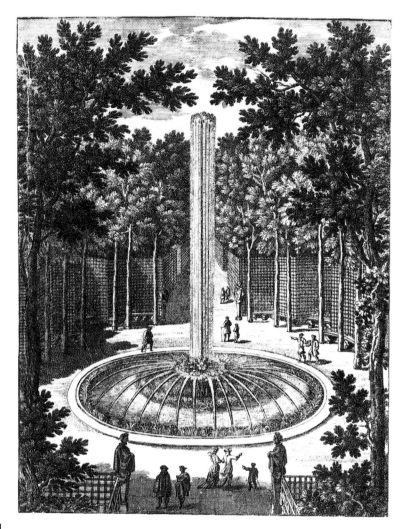

The terms

Twelve of the sixteen terms (*overleaf*) were brought here from Vaux-le-Vicomte in 1684. They had been designed for Fouquet in 1655 by the painter Nicolas Poussin, on the model of antique terms.

The other four were commissioned by Colbert and made in Rome between 1679 and 1690. They represent the Seasons: Lacroix sculpted Spring, Pierre Laviron Autumn, and Jean Théodon Summer and Winter.

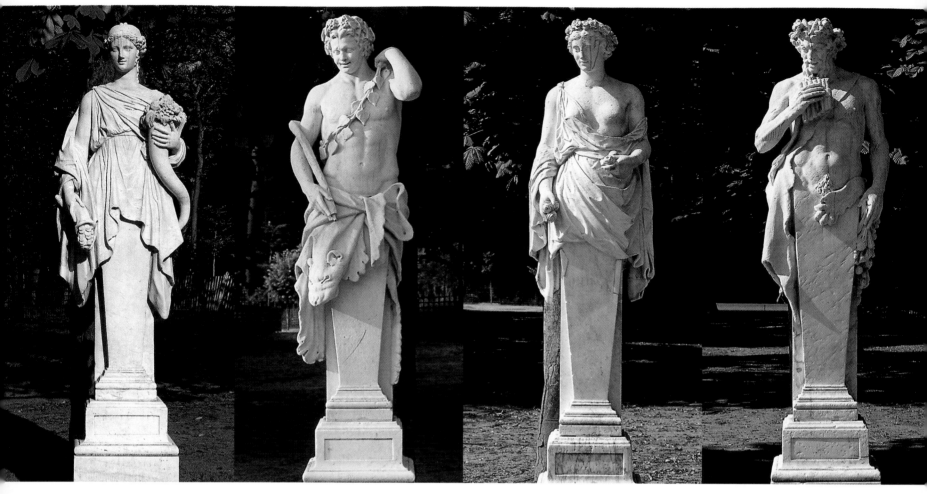

Liberality

A faun

Flora

Pan

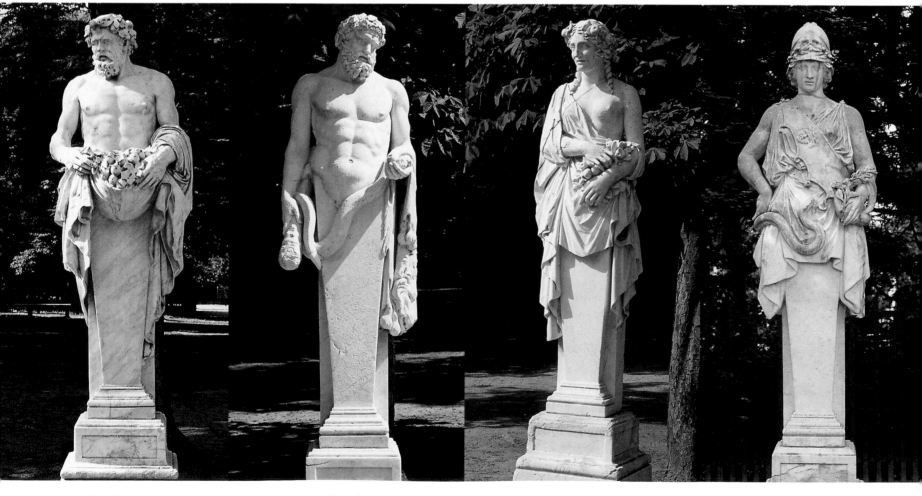

Bacchus

Hercules

Pomona

Minerva

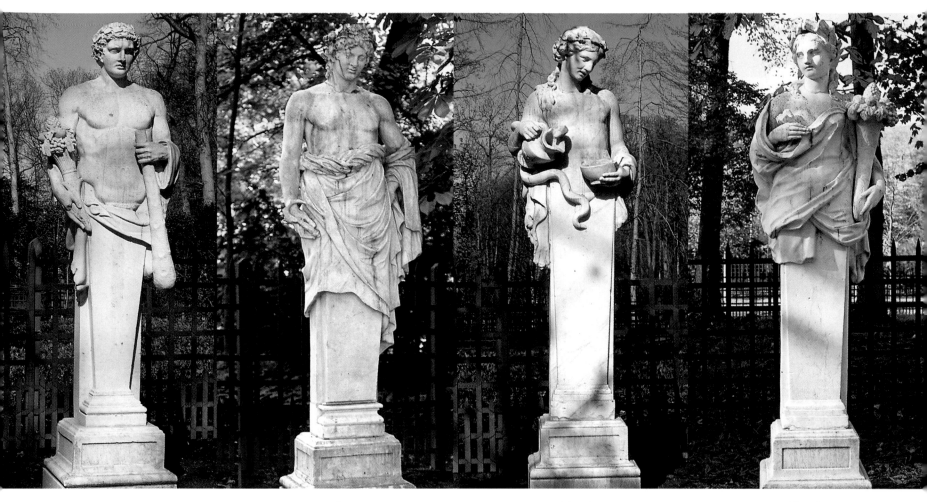

Vertumnus A reaper Morpheus Abundance

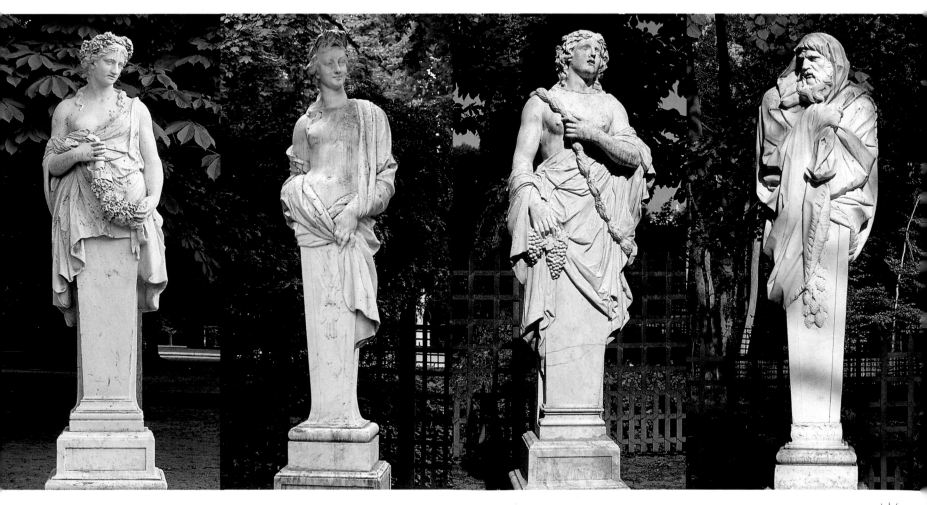

Spring Summer Autumn Winter

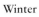

From Salle de Bal to Bosquet des Rocailles

THE BOSQUET to the west of the Parterre du Midi and south of the Parterre de Latone contained the only real cascade at Versailles. A decorative motif held in high esteem in the French garden, the cascade usually occupied an open space where its effect could be appreciated. Here, however, it was completely enclosed in an almost secretive arrangement. It served as the backdrop to a bosquet devoted to music and dance which had the evocative name of Salle de Bal (ballroom). This was the last bosquet of the Jardin Bas to be laid out – designed before the king took up permanent residence in 1682, and inaugurated in 1685 by the Dauphin with a grand supper.

Access was from the west (left) via two short paths leading into a circular clearing, out of which another path approached the bosquet in a wide arc, preventing a view of it until the last minute. At the beginning of the eighteenth century a second entrance was made, taking the place of a lateral *cabinet*, or large alcove, of trelliswork.

Hardouin-Mansart simplified it in 1707, retaining the rocaille cascade, from which it eventually assumed the name of Bosquet des Rocailles.

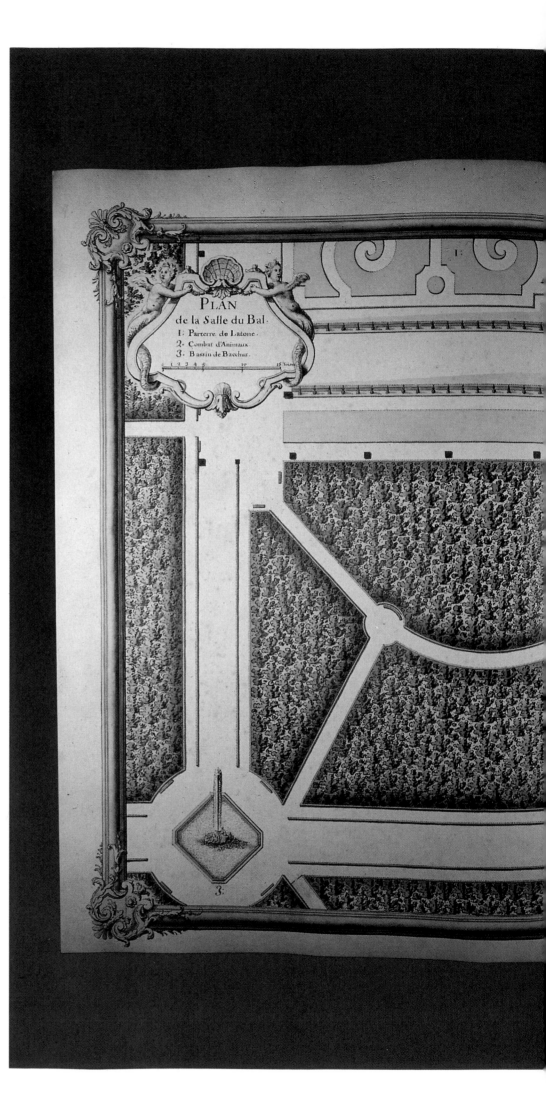

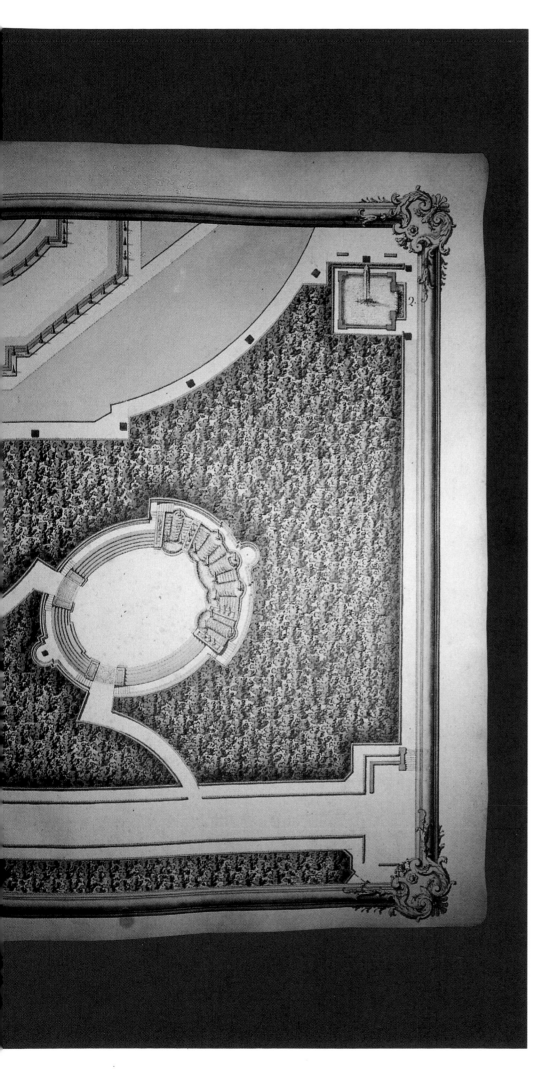

**Plan from the album of
Jacques Dubois**
By the end of Louis XIV's reign
the bosquet was still called the
Salle de Bal but the central
space had been cleared. (North
is at the top.)

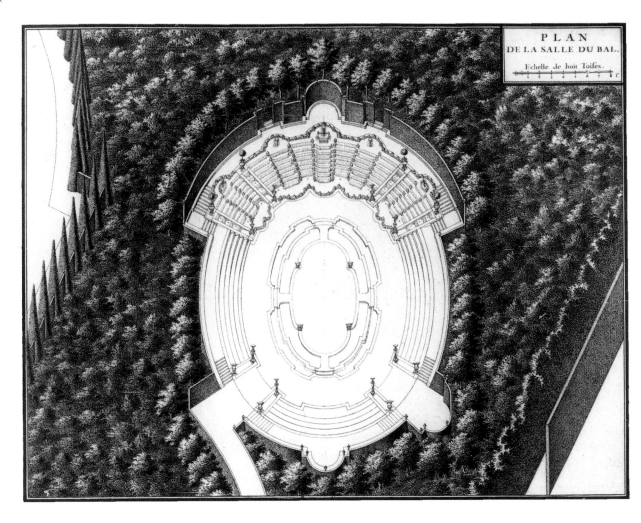

PLAN
DE LA SALLE DU BAL.
Echelle de huit Toises.

The original form of the bosquet

Only one path leads in through the surrounding woodland. The entrance is balanced by a *cabinet* of trelliswork (later destroyed for a second path). A gallery with a sandy floor, reached by steps, runs round the top of the turf seating of the amphitheatre, and, via more steps, behind the cascade. In the centre, on an island, is the dance floor.

The Bosquet de la Salle de Bal

The bosquet was laid out as a salon by Le Nôtre, who took advantage of the slope between the Jardin Haut and the Jardin Bas to give it a fairytale aspect with the creation of a rocaille cascade. This monumental Mur d'Eau or wall of water, which was extended into the form of an amphitheatre by curving rows of turf seats, provided the backdrop to an oval arena whose centre was a large dance floor.

The Salle de Bal

Four footbridges over a canal led to the central oval of the dance floor, marked out by four vases in *métail* decorated with musical instruments, executed in 1682 by François Fontelle. Other vases and torchères, grouped in pairs at the top and bottom of ramps, ornament the amphitheatre and cascade: those still survive. (Painting by Jean Cotelle, c. 1690)

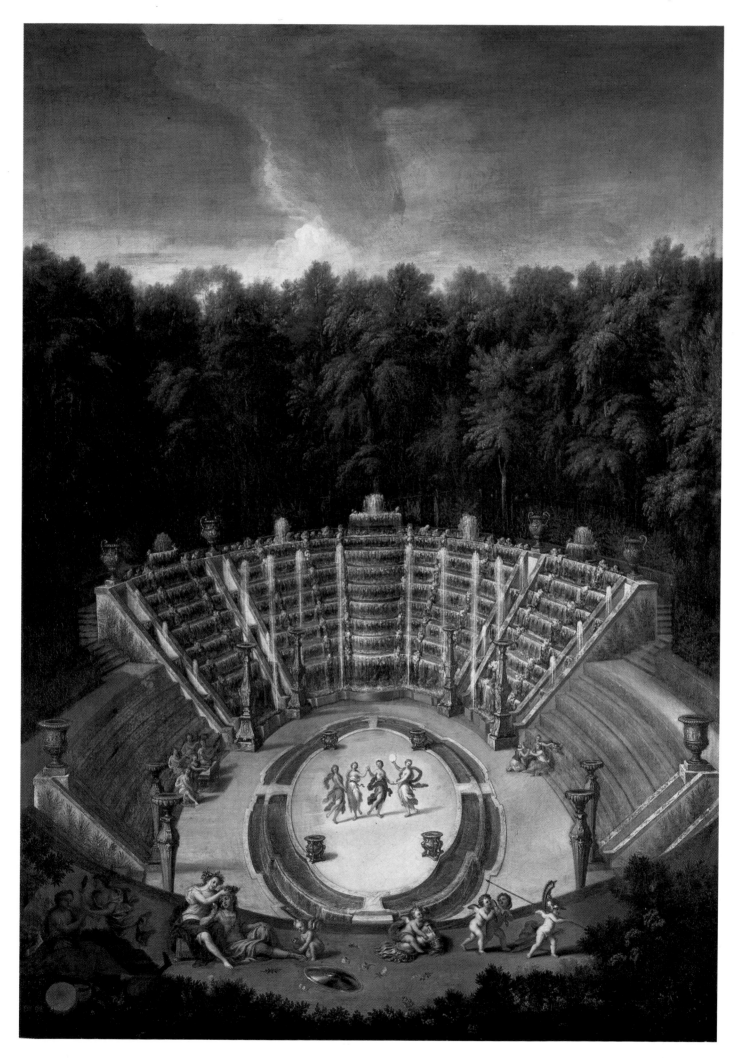

The Mur d'Eau

The 'wall of water' is composed of a wide central cascade flanked by two smaller ones, all decorated by the *rocailleur* Berthier with mussels from Grosrouvre and shells from Madagascar. Water gushes out at the top and flows in sheets down to three pools, framed by four torchères at the foot of pink marble ramps. Within these ramps, smaller columns of water rise from each of three rocaille steps.

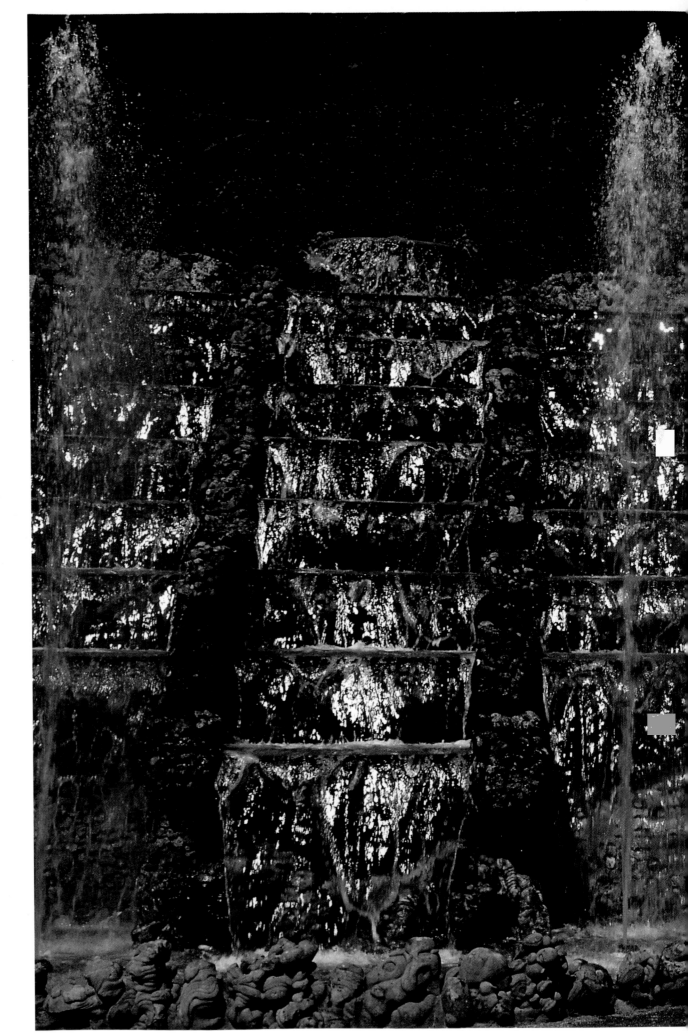

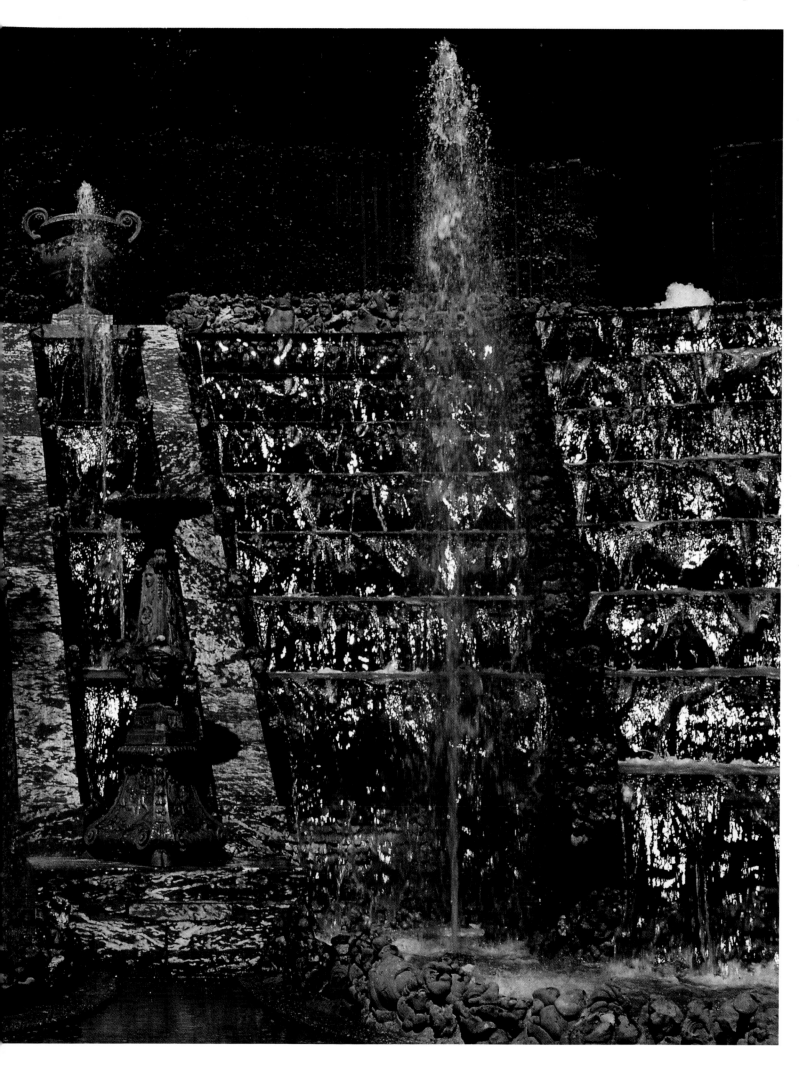

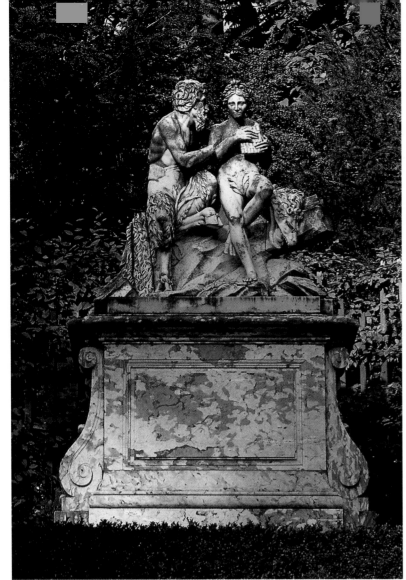

Marsyas and Olympus
This group now occupies the central trelliswork niche opposite the cascade. It was carved in Rome in 1680–84 by Jean-Baptiste Goy, who modelled it on a copy of an antique work believed at the time of Louis XIV to represent the Greek satyr Marsyas teaching his son Olympus the art of the panpipes.

The niche had previously, since 1738, been occupied by the marble group of Papirius and his mother (ill. p. 146). After that had been moved to the Allée Royale, Marsyas was brought here in 1912 from the Théâtre d'Eau.

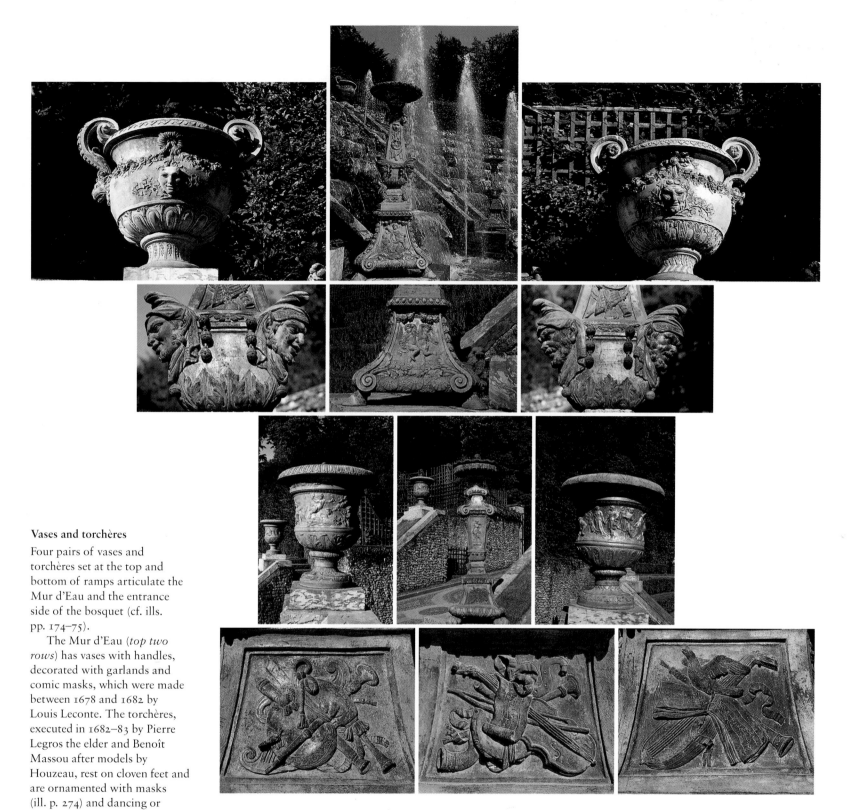

Vases and torchères

Four pairs of vases and torchères set at the top and bottom of ramps articulate the Mur d'Eau and the entrance side of the bosquet (cf. ills. pp. 174–75).

The Mur d'Eau (*top two rows*) has vases with handles, decorated with garlands and comic masks, which were made between 1678 and 1682 by Louis Leconte. The torchères, executed in 1682–83 by Pierre Legros the elder and Benoît Massou after models by Houzeau, rest on cloven feet and are ornamented with masks (ill. p. 274) and dancing or music-making cupids.

The amphitheatre side (*lower two rows, and opposite*) has vases decorated with scenes of dancing and marine subjects, made in 1682–83 by Etienne Le Hongre. The torchères, executed in 1681–83 by Noel V Jouvenet and Pierre Mazeline, maintain the theme of music and dance, with reliefs of instruments on their bases and dancing nymphs on the sides.

From Labyrinthe
to Bosquet de la Reine

LABYRINTHS were popular in medieval and Renaissance gardens and had become a feature of the French garden. Thus, just as it had a grotto and a cascade, Versailles had to have its labyrinth.

The original design by Le Nôtre in 1665 was for a traditional and unadorned maze of paths. Between 1672 and 1677 it was transformed, in a scheme inspired by Charles Perrault which was intended to be part of the education of the Dauphin.[41] Symbolizing the quest for wisdom, the Labyrinthe marked the stages in this progress by illustrating the fables of Aesop in thirty-nine fountains placed in settings of rock- and shellwork. No fewer than eighteen sculptors worked on the fountains, which incorporated 333 animals in *métail*, all painted in naturalistic colours by Jacques Bailly. The result was the largest collection of seventeenth-century *animalier* art in France.

However the fountains were difficult to maintain, with their numerous intricate creatures, and they gradually fell into decay. In 1778 the Labyrinthe disappeared to give way to a bosquet in the new English taste. At first known as the Bosquet de l'Ancien Labyrinthe, it was then called the Bosquet de Vénus, and finally in 1835 the Bosquet de la Reine.

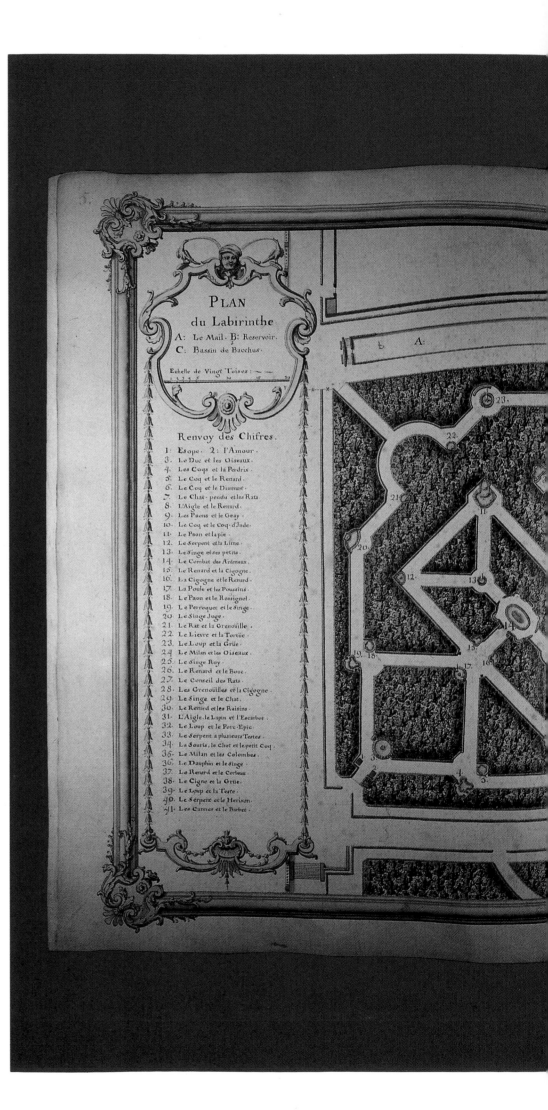

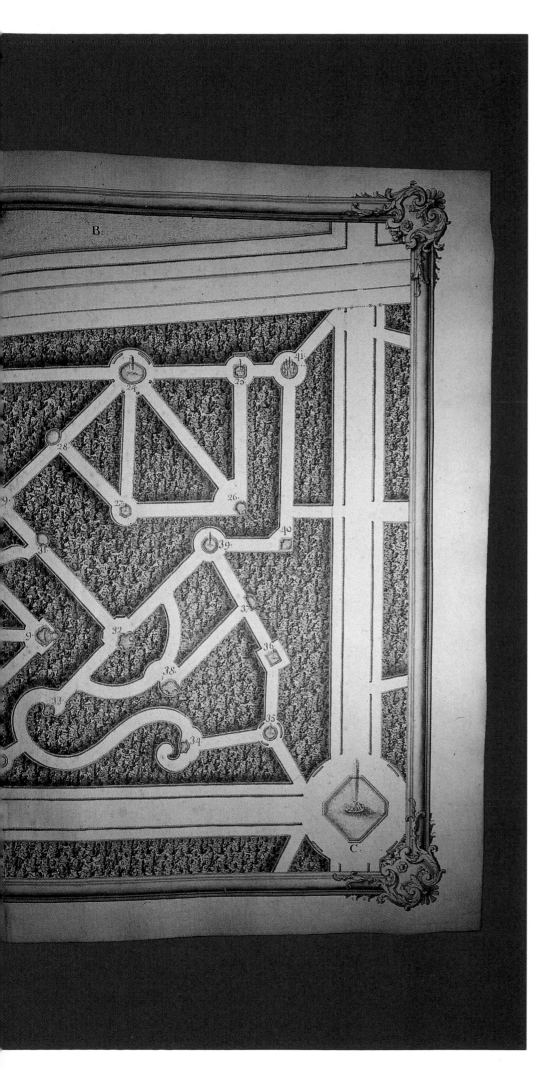

Plan from the album of Jacques Dubois

A key signals the fables represented and the statues of Aesop and Cupid flanking the entrance, below left. (North is at the bottom.)

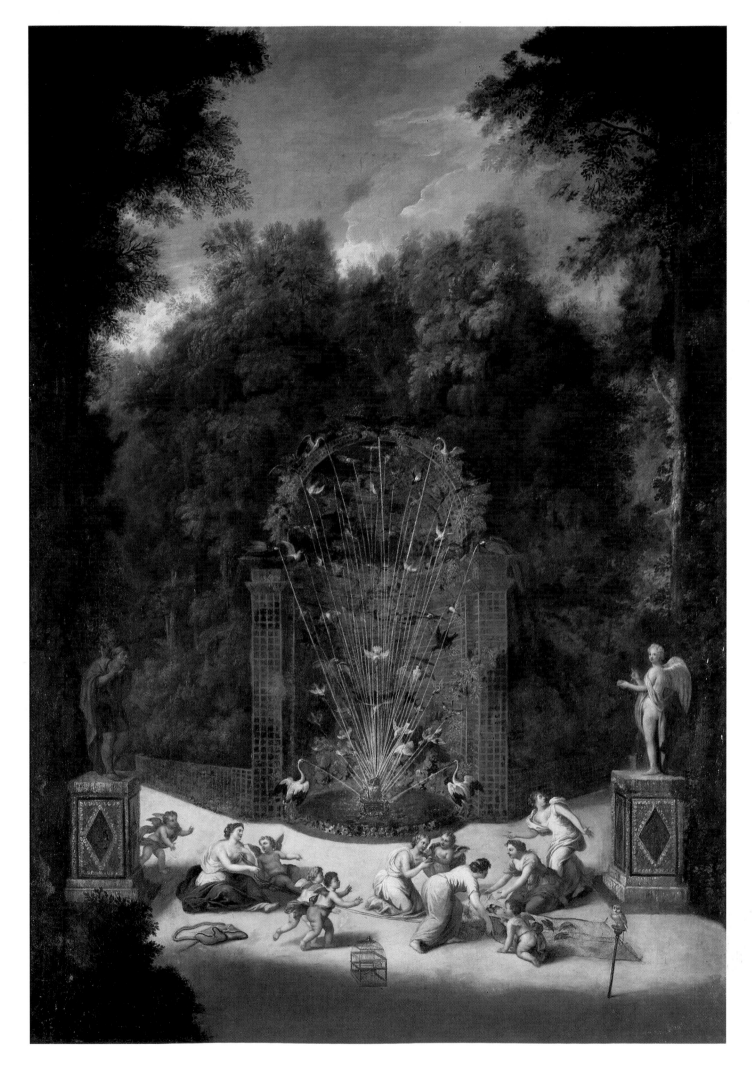

The entrance and the fountain of the Owl and the Birds

The way into the Labyrinthe was in the north-east corner of the bosquet, near the door leading from the Orangerie to the gardens. Framing the entrance were two statues, of Aesop and Cupid, fashioned in métail painted in naturalistic colours and set on rocaille pedestals.

Aesop, made by Pierre Legros the elder between 1672 and 1676, symbolized wisdom and prudence, while Cupid, created by Jean-Baptiste Tuby between 1672 and 1674, personified enthusiastic enquiry. Under the figure of Cupid, depicted holding the thread that Ariadne gave Theseus so he could escape from the Labyrinth after killing the Minotaur, was the inscription, 'Yes, I can shut my eyes and laugh; this skein will guide me safely'; and under Aesop was written, 'Love, with that slender thread you may lose your way; it might break at the slightest tug'. (After the transformation of the bosquet, these two statues were moved to the Bosquet de l'Arc de Triomphe. Finally they joined the surviving forty-three fragments of the Labyrinthe now displayed in the museum of the Grande Écurie at Versailles.)

At the end of a short path the visitor saw an arbour of trelliswork over the first of the thirty-nine fountains, which was also the first of the six attributed to the sculptor Jacques Houzeau: 'The Owl and the Birds'. Fifty-five birds spouted water on to an owl; on the tablet set into the pedestal was a quatrain with the message: 'The birds, catching sight of the owl in broad daylight, all swooped upon him, jeering at his ugliness. However perfect one may be, who is without his detractors?'

Jean Cotelle's painting shows the entrance c. 1690.

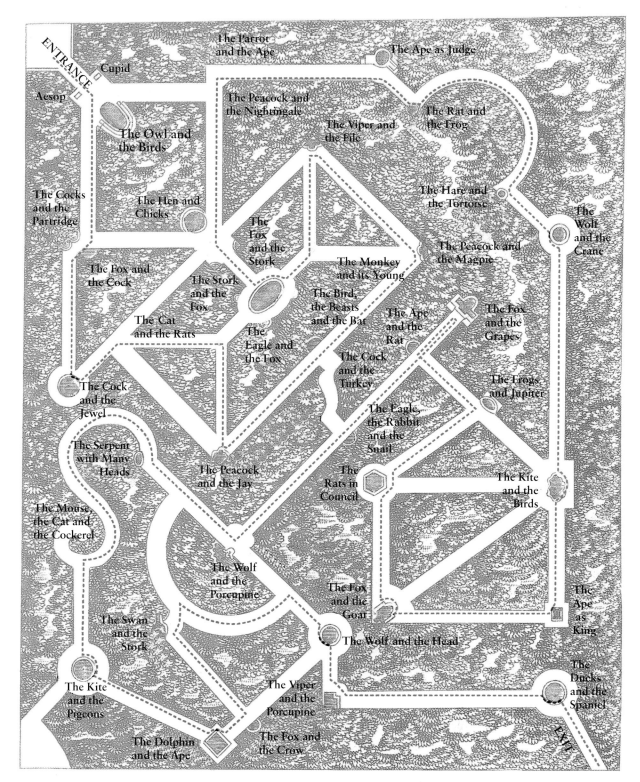

The Labyrinthe

This plan of the Labyrinthe gives the position of the thirty-nine fountains, and shows the circuit of 750 metres (820 yards) by which every fountain could be seen without ever passing the same one twice. Each was accompanied by a tablet on which a quatrain summarizing the story, by the court poet Isaac de Benserade, was written in gilded letters.

The Cat and the Rats

Enclosed in an alcove of greenery (*left*) is a feature formed of two consoles with at the top a cat hanging by its feet, surrounded by ten water-spouting rats. The tablet reads: 'A cat feigned death and caught many rats, then floured his face as a disguise. One of the more cunning rats said: "Even if you were a whole sack of flour I would not come near."' This is one of the four fountains attributed to Pierre Legros the elder.

Sébastien Le Clerc's engravings seen here were hand-coloured for Louis XIV by Jacques Bailly, who had painted the fountains themselves.

The Ape and its Young

In a round clearing (*below*), three apes support a bowl in which a fourth, with a jet rising from it, hugs its young in its arms: 'The ape caused the death of its young by squeezing it too hard in its embrace. By applauding one's own acts, one destroys the merit in them.' The sculptors involved were Etienne and Jacques Blanchard.

The Cocks and the Partridge

In this composition (*above*), jets spout from two cocks, while a third jet shoots up from the beak of a partridge: 'The partridge belaboured by the cocks resented their ungalant treatment of her; but seeing that their behaviour was no better to anyone, took comfort in the thought that they fought each other too.' This is one of the five fountains attributed to Etienne Le Hongre.

The Cock and the Turkey

A cock confronts a turkey (*right*), each sending up a jet of water, while two lances also rise from the bassin surrounded by rockwork, coral and shells: 'The cock was jealous of the turkey and thought him a rival, but he was mistaken, for the turkey swaggered and strutted simply for the pleasure of doing so.' This is the earliest of nine fountains attributed to Pierre Mazeline.

The centre of the Labyrinthe

Jean Cotelle's painting (*c.* 1690) records three of the fountains: two in the foreground on the theme of the Fox and the Stork and one in the distance illustrating the Bat, Birds and Beasts.

The latter was considered the finest piece in the Labyrinthe; together with the two sculptures of goats ridden by apes flanking it, it is attributed to Legros and Benoît Massou. It was set in an open pavilion of trelliswork. The rim of the centrally placed bassin was decorated with shells and animals, and the jets made a vault of water under which one could pass and remain dry. In the middle of the bassin, animals attempted to climb the rock on top of which a bat with outspread wings hovered, spewing a jet towards the top of the trellis dome which was entwined with honeysuckle and climbing roses. From the cornice, peacocks, storks and other birds spouted jets of water towards the bassin: 'Bloody battle between the birds and the beasts, where neither side would admit defeat; but the bat betrayed her own kind, and was condemned never to see daylight again.'

The fountains of the Fox and the Stork and the Stork and the Fox are attributed to Desjardins. On one was written: 'The fox invited the stork to a feast, and dinner was served on a flat plate. The fox ate heartily, quite at home, while the stork with her long beak had hardly a crumb.' The other was inscribed: 'When the fox in turn went to the stork to dine, a tall narrow vase was placed on the white cloth. Beak triumphed over tongue. Is it not natural to take one's revenge?'

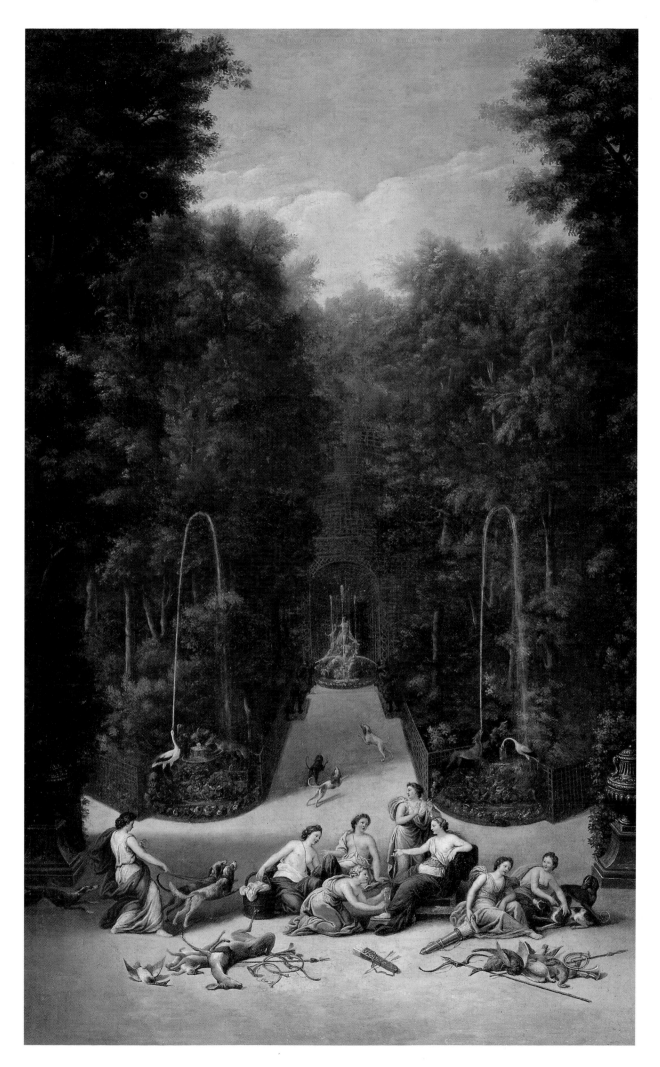

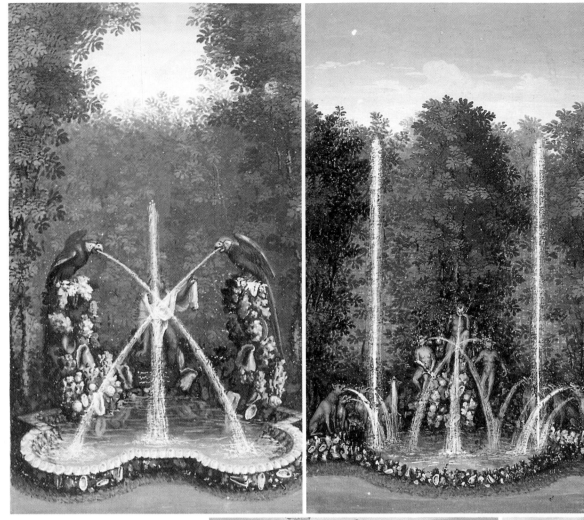

The Ape as Judge

This scene (*left*) shows four foxes and four wolves round the edge of the bassin spewing jets of water; above, an ape sits in judgment between two others, who act as the clerk of the court and usher. 'The fox took the wolf to court, and the ape as judge heard their evidence. At the end he said, "I cannot fail to find two such vicious beasts guilty."' The fountain is one of four attributed to Jacques Houzeau.

The Hare and the Tortoise

A hare and a tortoise spurt jets into the air, in front of a cascade forming the background of the fountain (*below*): 'The hare and the tortoise agreed to race for a wager. Who would have thought that the hare would be second off the mark? Nevertheless, I know not how, in the end the tortoise arrived first at the finish.'

The Parrot and the Ape

Here (*above*) an ape entangled in a shirt he is trying to put on spews a jet of water into the air, while on either side of him two parrots flap their wings and project jets into the bassin: 'The parrot tried to imitate man by his squawking, but still remained a parrot, while the ape dressed as a man remained an ape under the clothes.'

The Ape as King

In this fountain (*right*) ten animals, including a leopard, a rabbit, a young bear, a fox and dogs, project jets towards a rock in the centre of the bassin, on which stands an ape holding over his head a crown with a lance of water passing through it: 'The ape was made king by the other animals because of his gambols in front of the company; but he was caught in a trap like any other beast, and the fox said to him, "Sire, what really counts is intelligence."'

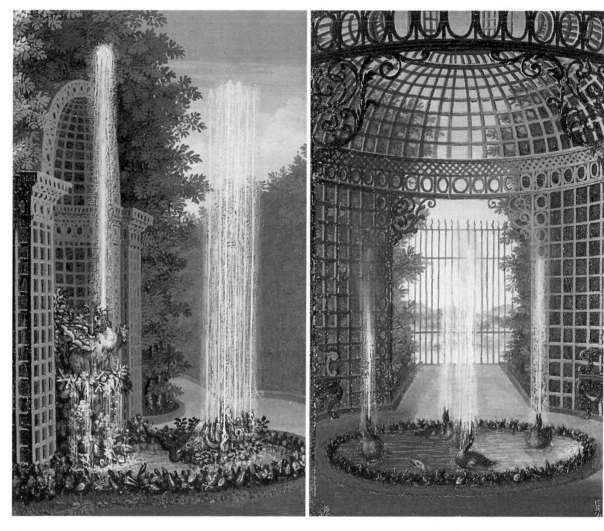

The Serpent with many Heads

This fountain was set against a large semi-domed trellis alcove. A serpent in the foreground spews water from all of its many heads, while a dragon behind, with several tails but a single head, sends up a lance of water which falls back into the bassin in a sheet. The quatrain puns on the French word *chef*, which means both 'head' and 'leader': 'A plurality of heads is disadvantageous. One serpent had seven, another only one, and the first experienced much inconvenience. One chief is absolute, many are not.'

The Ducks and the Spaniel

This fountain, also known as the Goufre (whirlpool) or the Dôme, stood at the centre of a round clearing. From a circular bassin, a lance of water rises to the dome of the trellis pavilion, while four ducks swim round, pursued by a dog which through a hydraulic device makes a barking noise. 'This spaniel has designs on these ducks, but they are teaching him a lesson. Sometimes desires are as vain as they are improper, and one does not always gain by force that which one pursues.'

The Bosquet de la Reine

Maintenance was neglected during the reign of Louis XV, and the Labyrinthe and its fountains were destroyed when the gardens were replanted by Louis XVI. Under the influence of Marie-Antoinette, the bosquet was soon redesigned in the new English taste.

The Borghese Gladiator
This statue, based on a famous Roman copy of a Greek original and executed in bronze by Nicolas Coustou in 1683, was placed in the eastern part of the central salle of the bosquet.

Minerva
This white marble figure in a purple marble robe stands in the western part of the bosquet. An inscription reads: '*Nec forte, nec fato*' (Neither by chance nor by fate).

Marie-Antoinette
An Austrian princess, daughter of the Empress Maria Theresa, she was married to the future Louis XVI in 1770. She was attracted by the new style of the naturalistic garden: for her the gardens of the Grand Trianon were transformed and the Hameau was built in its grounds, while in the main gardens she employed Hubert Robert to remodel the Labyrinthe.

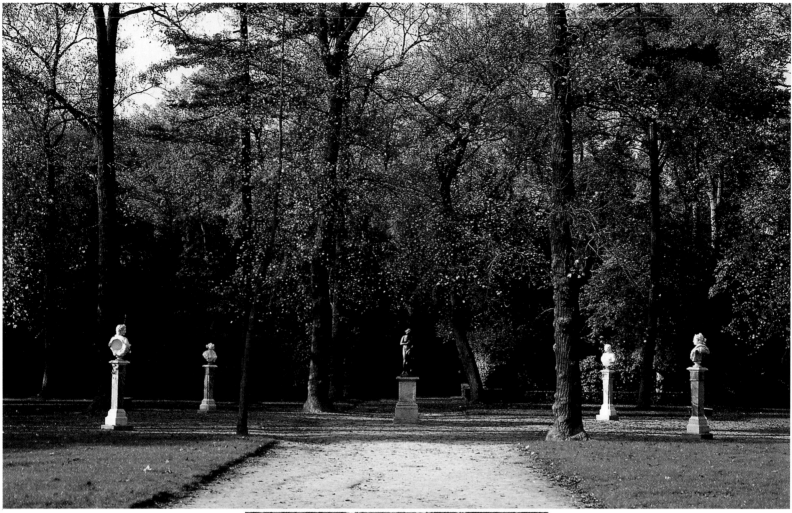

View of the Bosquet de la Reine
As redesigned, the bosquet was
girdled with recently introduced
exotic trees – sequoia, cedar of
Lebanon, Corsican pine, black
walnut from America, and red
buckeye. The central salle was
planted with ten tulip trees and
decorated with vases, which
were later replaced by four busts
of young men and women.

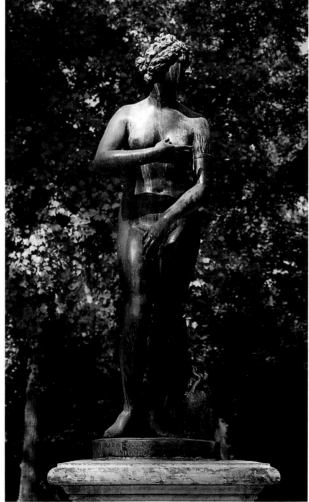

The Medici Venus
The centre of the salle is
occupied by a copy of the
Medici Venus, cast in bronze by
the Keller brothers. It replaces a
Nymph of Diana by Flamen,
which had come from the
gardens of Marly.

From Ile Royale to Jardin du Roi

THE EXTREME western limit of the gardens, furthest away from the château, was a marshy area which had to be drained before it could be laid out, and with that aim two bassins were excavated. The larger Ile Royale and smaller Miroir d'Eau together formed a single ensemble. The Miroir d'Eau was edged with statues. An island, known as the Ile Royale or Ile d'Amour, in the middle of the larger bassin was the focal point for eighteen radiating paths and gave the bosquet its name.

The lack of maintenance of the larger piece of water led to its destruction at the beginning of the nineteenth century, when it was replaced by an English garden, the Jardin du Roi.

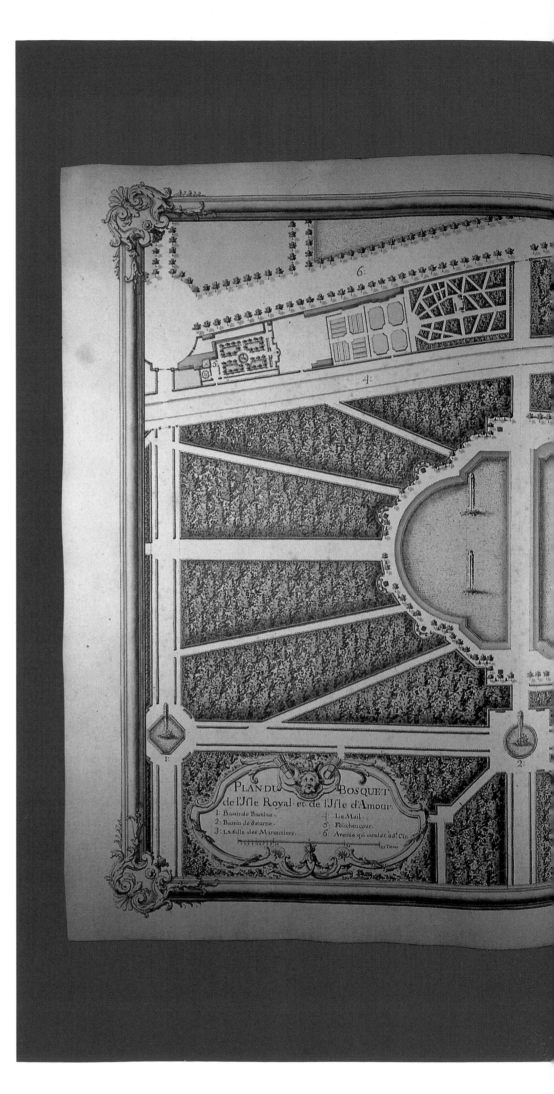

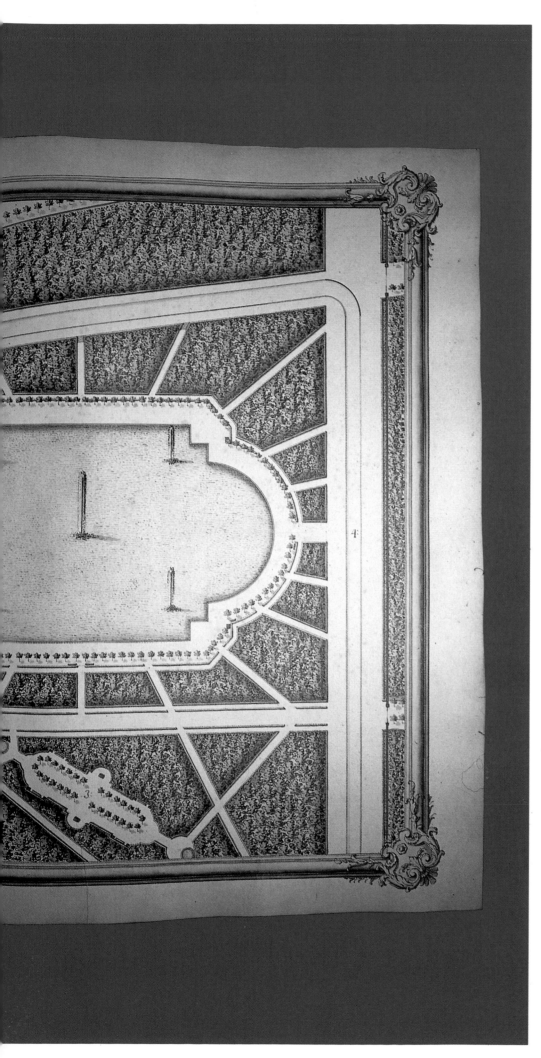

**Plan from the album of
Jacques Dubois**
Dubois' caption is somewhat
misleading: the smaller bassin
on the left is the Mirroir d'Eau,
while the larger bassin on the
right was known both as the Ile
Royale and as the Ile d'Amour.
(North is at the bottom.)

The Ile Royale and Miroir d'Eau

Le Nôtre began with the excavation in 1671 of the larger of the two pieces of water, to which he gave a rectangular form with an apsidal end and an island in the centre. There were copious water features both here and in the adjacent Miroir d'Eau, and the extremities were further decorated in 1683 with single fountains.

The Miroir d'Eau was also known as the Vertugadin (hooped petticoat), from the shape of the grass bank surrounding it, reminiscent of the farthingales worn by women at the beginning of the seventeenth century. It was bounded to the east by six trelliswork niches, made in 1680 to take a collection of antique statues.

In 1684 the island was removed and the water features reduced to a few lances. After 1704 all the fountains on the causeway separating the two bassins were also removed.

The Ile d'Amour
Adam Pérelle's somewhat fanciful engraving of 1681 shows the ensemble at its most ornate. Twenty-four jets in the shape of a circular *berceau* rise from the Cupid-crowned island in the large bassin, in which there were also twenty-four lances. On the causeway between the two pieces of water there were twenty-four fountains springing from shallow bowls, with a further twelve on the wall dominating the large bassin.

The Ile Royale and Miroir d'Eau
Etienne Allegrain's view – part of the set commissioned in 1688 for Trianon – illustrates the bosquet when the fountains had been reduced in number but still survived on the central causeway. The swans had been sent from Touraine and Denmark.

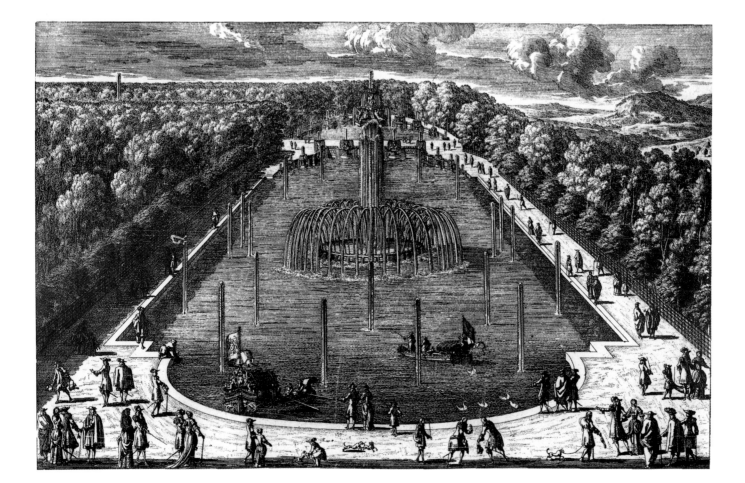

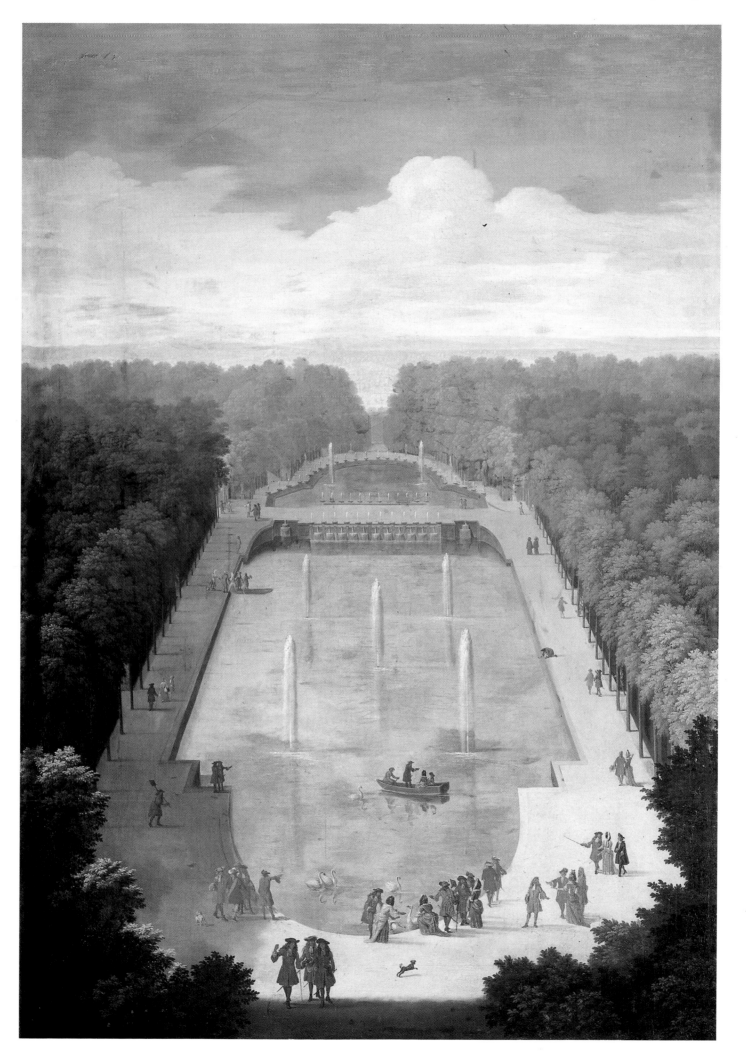

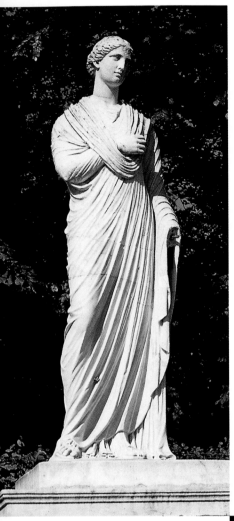

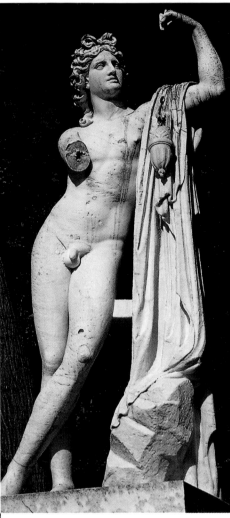

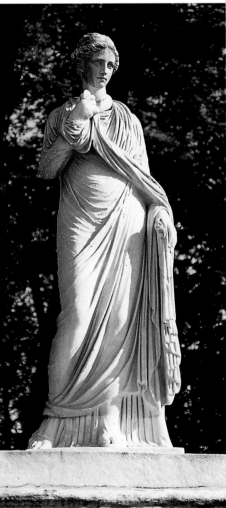

Women draped in a palla

These statues replaced the two Roman empresses, Julia Mesa and Julia Domna. One (*above*) had been in the Galerie des Antiques (where it was called 'Faustina': see p. 202), from whence it was removed to Trianon in 1704. The latter, called 'Julia' in the Galerie des Antiques, had been re-sited in the Salle des Marronniers (ill. p. 204).

Apollo Pothos and Venus

These statues replaced Jupiter and Venus Genetrix, which were sent to the Louvre. They themselves had been seized at the Revolution from the château of Ecouen.

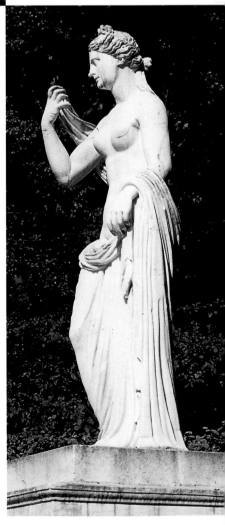

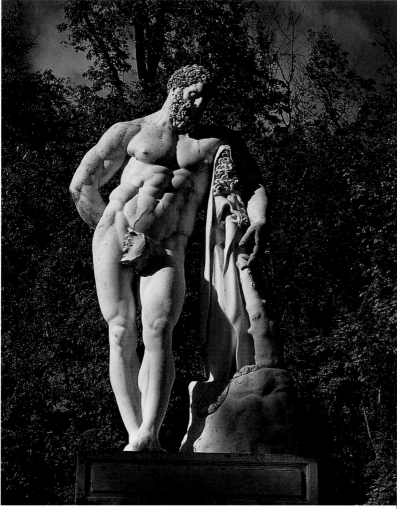

The statues of the Miroir d'Eau and Ile Royale

Around the Miroir d'Eau, six antique statues were set up in 1680: Brutus, Julia Mesa, Venus Genetrix, Jupiter Sator, Julia Domna and a Roman senator. Between 1701 and 1707 Brutus and the Roman senator, situated at the two ends, were replaced by two vases from the Allée Royale carved by Drouilly and Mélo (ill. p. 148). At the Revolution the other statues were removed and only the vases remained. Not until 1821 were the empty places filled with four more antique statues, restored by Lorta (*opposite*).

In 1688 the western end of the Bosquet de l'Ile Royale received two copies from casts of famous antiques, the Farnese Hercules and the Farnese Flora, commissioned in 1684 from Jean Cornu and Jean Raon (*this page*).

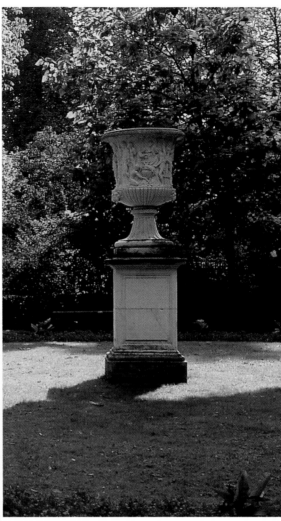

Vases with Bacchic scenes
These two marble vases, carved by Jean Rousselet in Rome between 1680 and 1683, were brought from the Parterre du Nord in the Jardin Haut to decorate two rond-points in the Jardin du Roi.

The Jardin du Roi

Returning from exile at the restoration of the monarchy in 1815, Louis XVIII succeeded his brother Louis XVI and resumed possession of Versailles. In 1817 he had the large piece of water filled in by the architect Dufour, and the space laid out as an English garden planted with exotic trees.

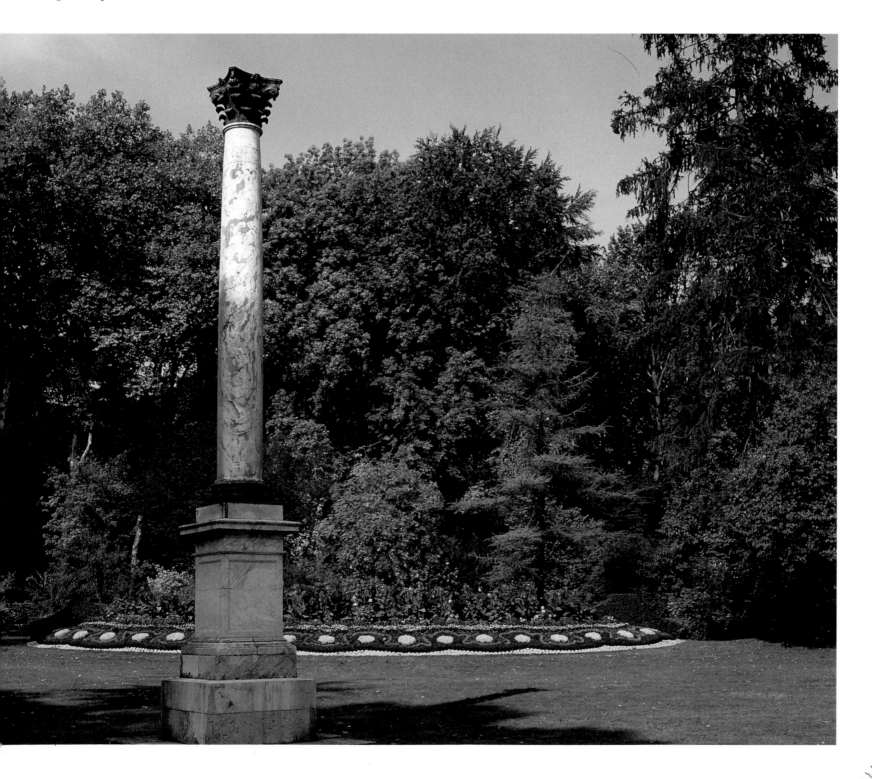

The Salle des Marronniers and the Colonnade

THE BLOCK of woodland situated to the south of the Allée Royale near the Bassin d'Apollon was, like that to the north, divided by a diagonal allée and the two halves thus formed turned into different bosquets.

The north-eastern half was first laid out as the Bosquet des Sources, but was remodelled after 1684 with a marble colonnade. The part to the south-west started out as the Galerie d'Eau, became the Galerie des Antiques in the 1680s and was planted with chestnuts in 1704 to become the Salle des Marronniers.

The Galerie des Antiques and the Colonnade were conceived at the time when the king wanted to establish the artistic supremacy of France over Italy. The first demonstrated his ability to assemble a considerable collection of antique statues in the gardens, while the second gave evidence of the grandeur of a sovereign who was described in the *Mercure galant* in 1686 as 'the most magnificent prince on earth, … who has proved that marble is now more common in France than in Italy'.

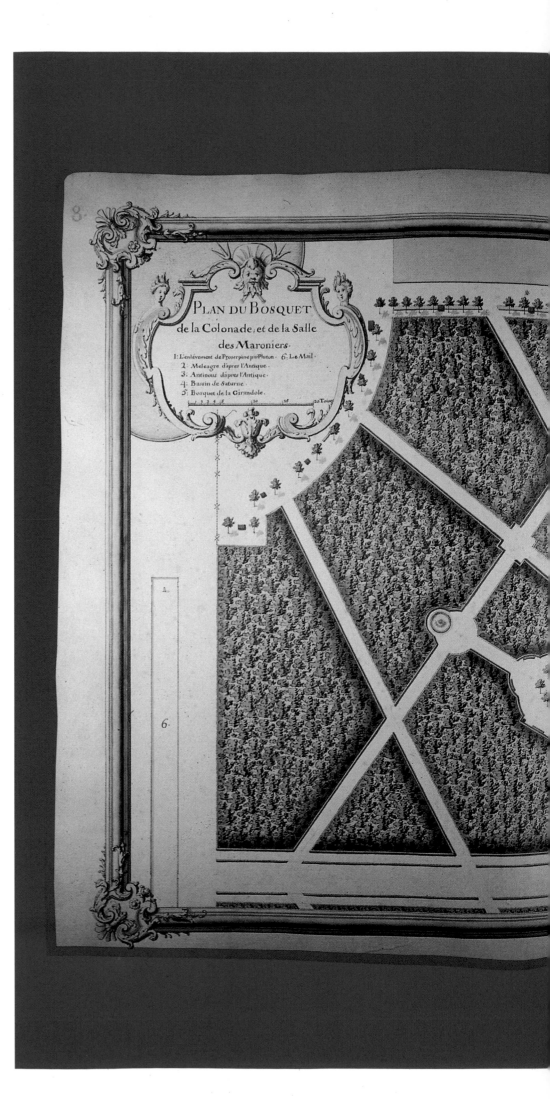

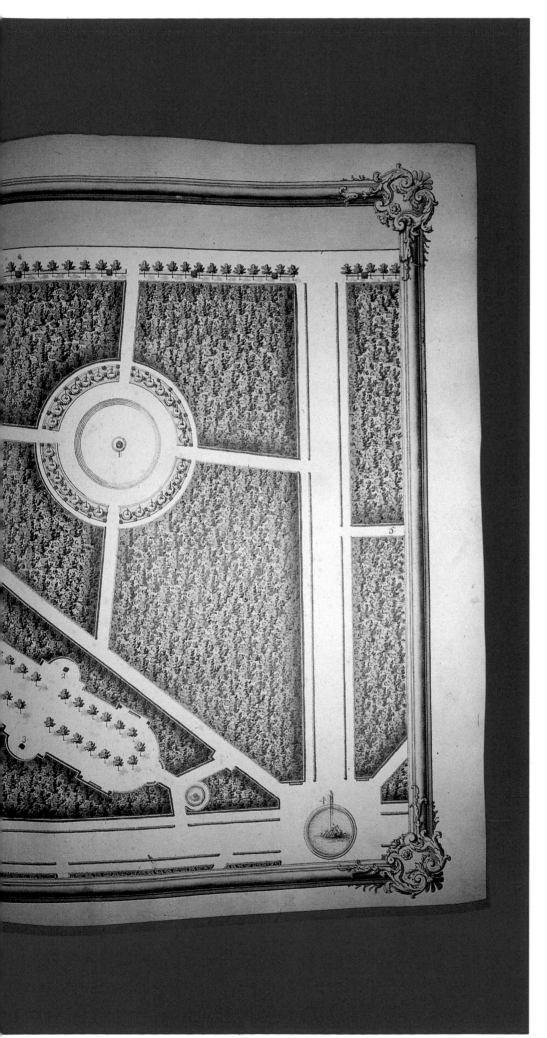

**Plan from the album of
Jacques Dubois**

At the upper right is the
Colonnade and at the lower left
the Salle des Marronniers, on
the site of the Galerie des
Antiques. (North is at the top.)

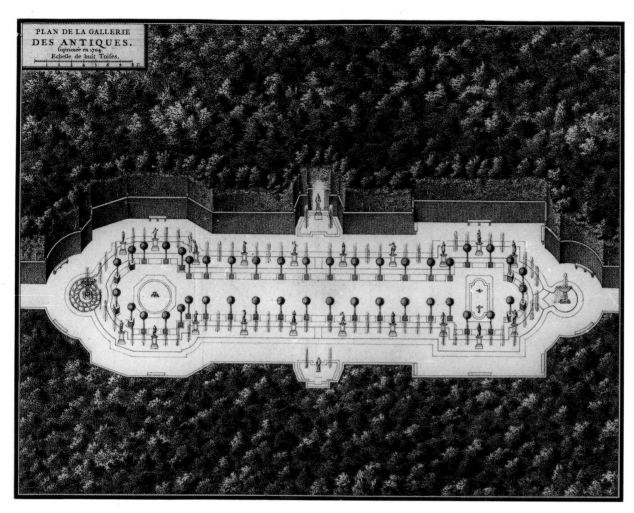

PLAN DE LA GALLERIE
DES ANTIQUES.
supprimée en 1704.
Echelle de huit Toises.

The arrangement of the bosquet

A schematic drawing records the appearance of this long, thin bosquet before its layout was redesigned in 1704. By then it had entrances at both the north-west (left) and south-east (right) ends. Originally, a single path led in asymmetrically from the north-east.

The centre was occupied by a flat area paved in coloured stone, surrounded by a channel crossed in two places by foot-bridges. A fountain stood at each end of the paved area: that at the south-east was rectangular and decorated with dolphins in gilded métail by Houzeau, while at the north-west it was circular and ornamented with two cupids. In 1683 twenty antique statues separated by three lances of water were placed on plinths in the channel, which flowed at each end into bassins containing fountains springing from scallop shells.

Two other fountains with two lances and a statue each, of Meleager and Antinous, occupied niches in the sides of the bosquet. Two new entrances into the bosquet, made in 1685, were decorated with a statue of a Muse and a faun dancing.

The Galerie des Antiques

THIS BOSQUET was begun by Le Nôtre in 1678 and first called the Galerie d'Eau. The potential of the site was realized in 1680, and it was decided to place here the antique statues and copies bought in Rome by Colbert through the intermediary of the Académie de France, which were sent to Versailles in 1679 and 1682.

The Galerie des Antiques

Jean-Baptiste Martin's view from the north-west shows courtiers enjoying the bosquet, while their *roulettes* (light carriages or wheeled chairs, called *vinaigrettes* at the time) wait for them at the entrance. The château appears in the distance on the left. This is another of the paintings recording the gardens that were ordered for Trianon in 1688.

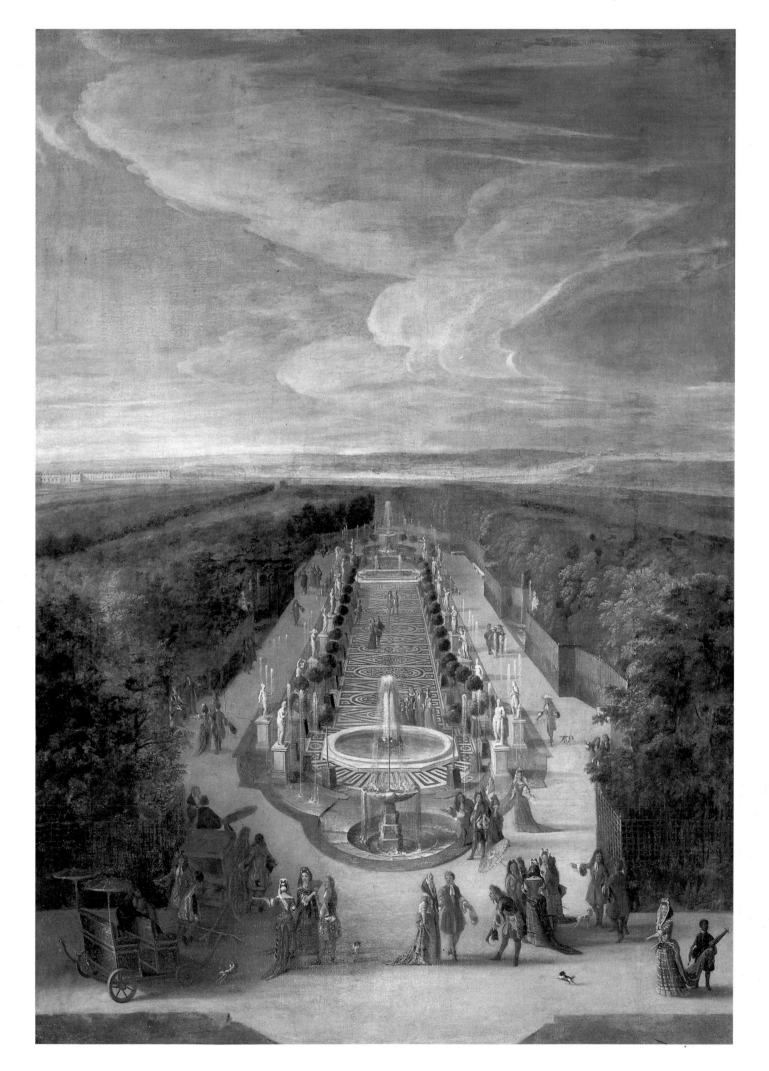

Adonis

Meleager
With Antinous, this was one
of the two copies of antiques
placed in the side fountains of
the bosquet. The boar's head
beside Meleager refers to his
triumph over the beast sent
by Diana to ravage the land in
revenge for an affront
committed by Meleager's
father, king of Calydon.

Faustina
This statue – drawn, like the
others, by Robert de Cotte –
now stands in the Bosquet de
l'Ile Royale (ill. p. 194).

Pandora

The statues in the canal of the Galerie des Antiques

Twenty antique statues faced each other round the paved floor of the bosquet, making an open-air sculpture gallery. The figures were of Julia, Venus, a Roman matron, Silenus, Faustina, Bacchus, a nymph, Mercury and Argus, a gladiator, Pandora, Minerva, Adonis, Pomona, a faun, Cleopatra, a young faun, Ceres, the sign of Capricorn and the Petit Lantin.

When the bosquet was transformed in 1704 most of them went to Marly. Three later returned to Versailles when the Théâtre d'Eau was converted into the Bosquet du Rond-Vert (ills. p. 245).

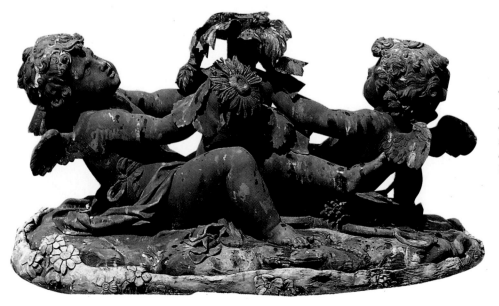

The Fontaine des Amours
This sculpture decorated the circular bassin within the paved area. It was sent to the Jardin du Roi at Trianon when the bosquet was altered.

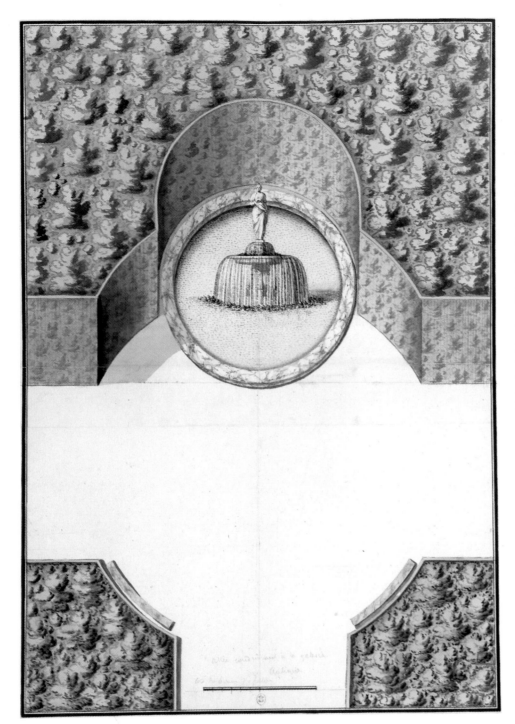

The Salle des Marronniers

In 1704 the Galerie des Antiques was completely remodelled, and planted with chestnuts. The paved area, channel and fountains at the sides were destroyed, and the majority of the statues were sent to Marly. In their place, eight antique busts on plinths joined the surviving Meleager and Antinous. The busts were arranged in pairs – Alexander and Cleopatra, Hercules and Deianeira, Caesar and Numa Pompilius, Marcus Aurelius and Lucius Verus. In 1795 and 1815 all but Marcus Aurelius and Alexander were replaced by a new collection of busts, all male, mainly portraying Roman emperors.

New fountains were created on the axis of the entrance paths (see the plan, pp. 198–99).

The Fontaines des Dames Romaines

The two fountains were each decorated with a statue of a Roman woman, one of them being the antique statue of Julia Mesa from the canal of the Galerie des Antiques. In 1821 both were moved to the Miroir d'Eau (ill. p. 194).

Strolling in the Salle des Marronniers

Note the trellis walls, the terms, and the effect of one of the Fontaines des Dames Romaines seen on axis in the distance. (Engraving by Jean Rigaud, 1741)

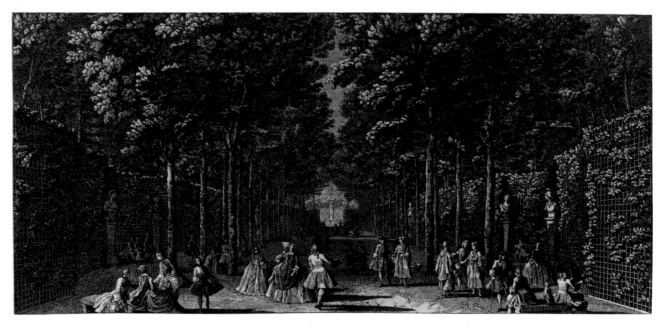

Hannibal

Apollo

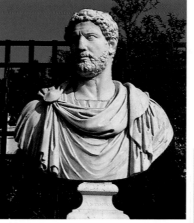

Antoninus Pius

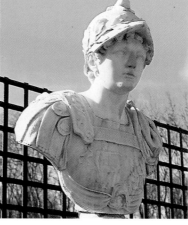

Alexander

Octavian

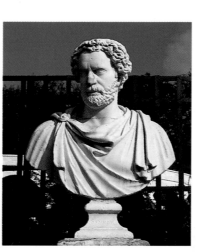

Septimius Severus

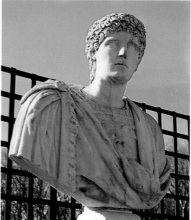

Marcus Aurelius

Otho

205

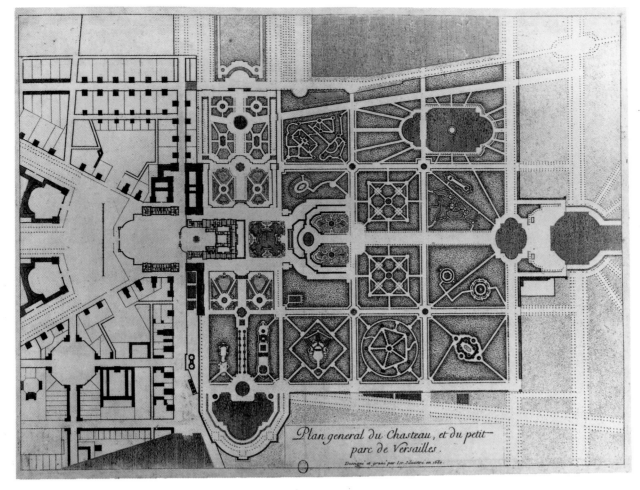

Plan general du Chasteau, et du petit—
parc de Versailles.

Desingné et gravé par Isr. Silvestre en 1680.

The Bosquet des Sources
Le Nôtre's original meandering
layout can be seen in a plan of
1680 by Israël Silvestre, between
the Ile Royale and the Bassin
d'Apollon (upper right).

From Bosquet des Sources to Colonnade

THIS BOSQUET was initially laid out by Le Nôtre in 1678 as a
bosquet de verdure, without any sculpture or decoration. It was
crossed by four paths running along the side of a stream, which
branched into numerous twisting rivulets winding round nine islets.
This first bosquet was destroyed in 1684.

In its final state, the Bosquet de la Colonnade was the last bosquet
of the Jardin Bas to be laid out. Instead of being the design of a
gardener it was that of an architect, Jules Hardouin-Mansart.
Taking his inspiration from the colonnades of greenery often used
in garden design since the Renaissance, he devised a majestic
construction of white and coloured marble, completed in 1688.

The Colonnade about 1690
The Colonnade consists of a
marble peristyle over 40 metres
(131 feet) in diameter with
fountains between the columns.
When Cotelle's view was
painted, there was a single
entrance on the west, and five
steps led down to a central
fountain.

Thirty-two Ionic columns
form the peristyle. Those
flanking the entrance (and
later the other three entrances)
are of violet breccia while the
remaining twenty-four are
alternately of red (*rouge de
Languedoc*) and blue (*turquin*)
marble. The columns are
backed by the same number of
alternately coloured marble
piers to support the white
marble arcade, which is
surmounted by white marble
urns with pine-cone finials.
(In his painting Cotelle has
simplified the colouring of
the piers.)

Outside, opposite the
entrance, the group of Fame
known as *La Renommée du Roi*
stood between 1691 and 1699. It
is now in the Parterre de
Neptune (ill. p. 44).

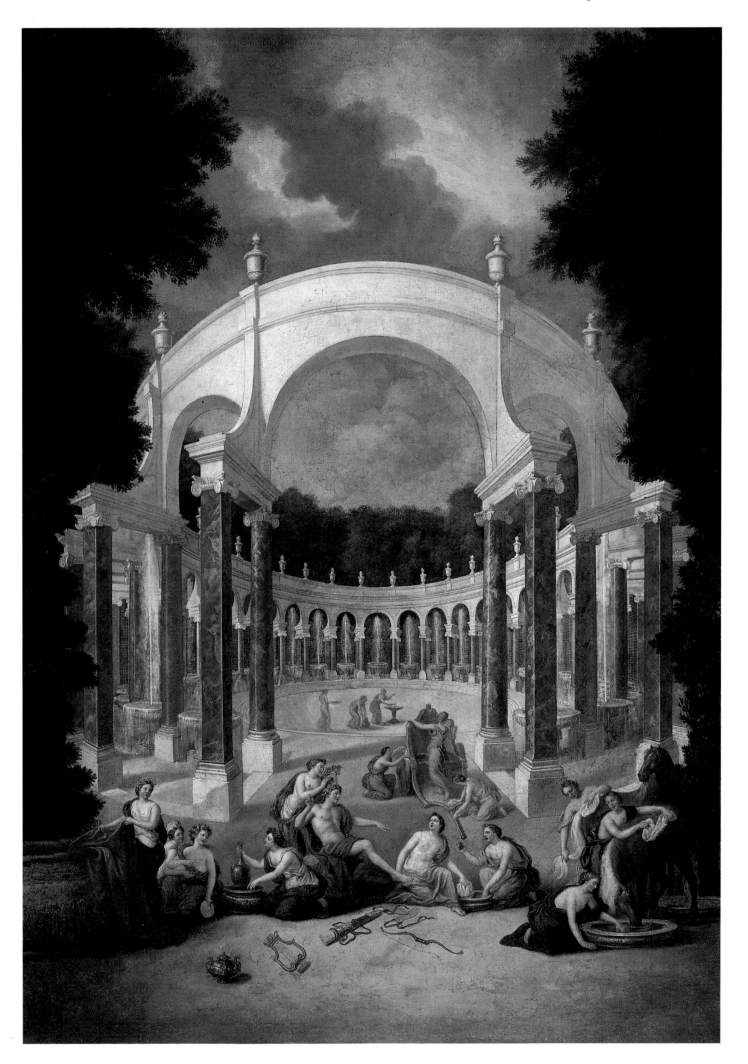

The Colonnade revised

In 1696 the central fountain was replaced by the marble group of the Rape of Proserpine, Girardon's last work, originally intended for the Parterre d'Eau. A small bronze model had been presented to the king in 1693; Girardon did not complete the reliefs on the plinth until 1699.

In 1704, three new entrances were cut through the woods around the Colonnade. The entrance arches are distinguished by columns of violet breccia, seen here framing the sculpture.

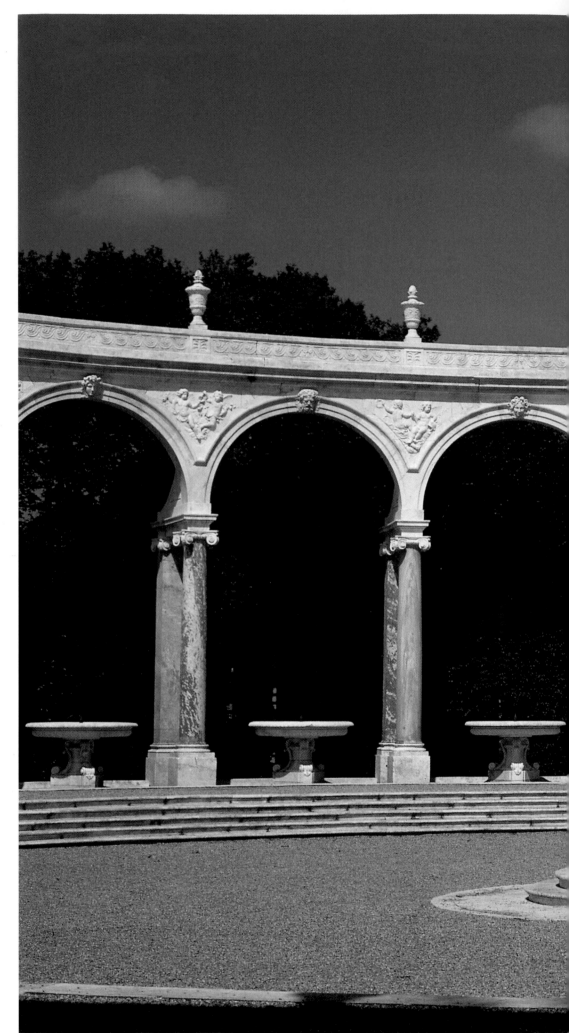

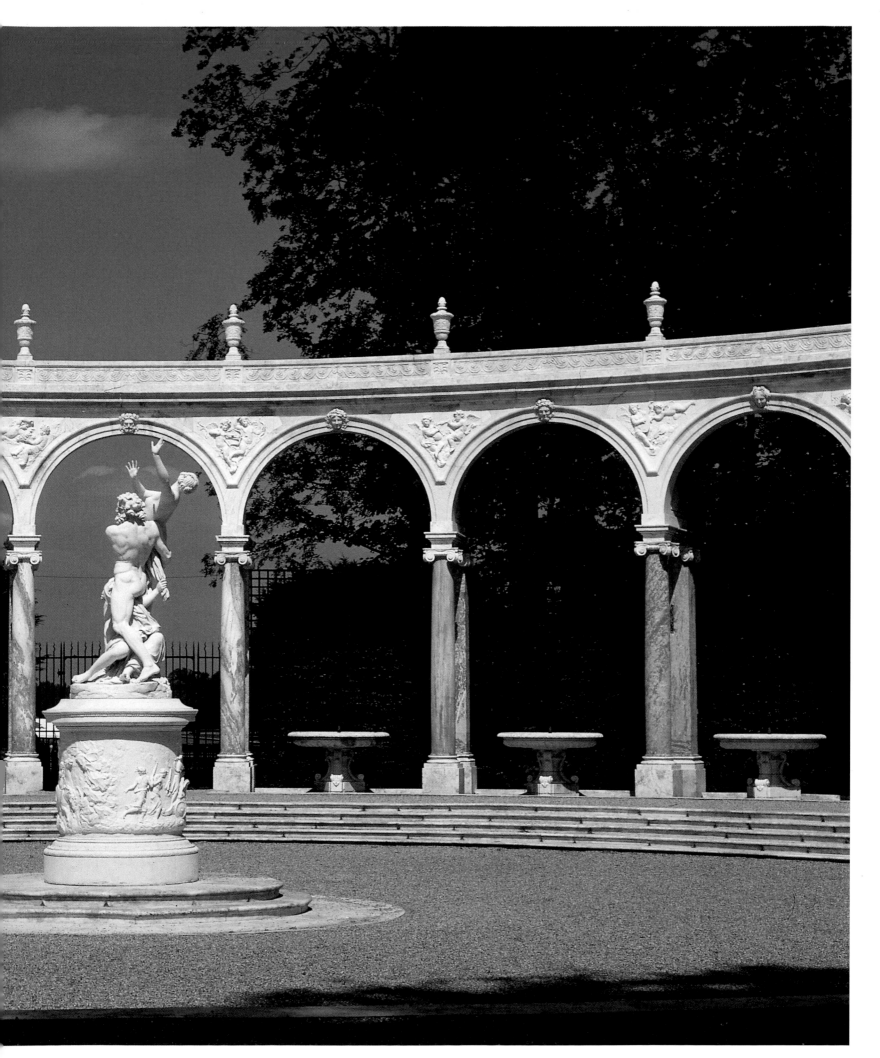

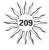

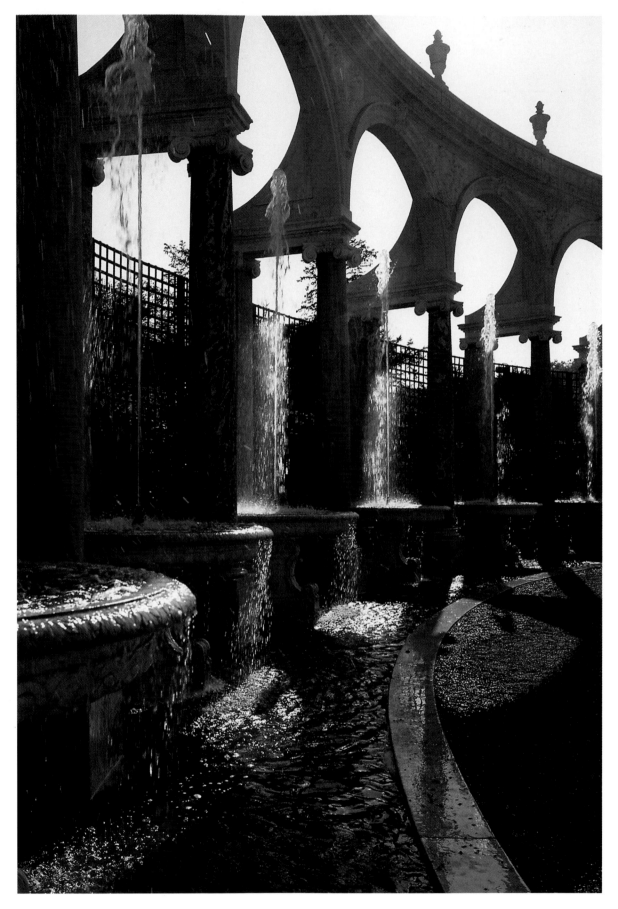

The fountains of the peristyle
Thirty-one white marble fountains are placed between the columns, sending up a spout of water which falls in a sheet into the surrounding channel. When the three new entrances were made, the number of fountains was reduced to twenty-eight.

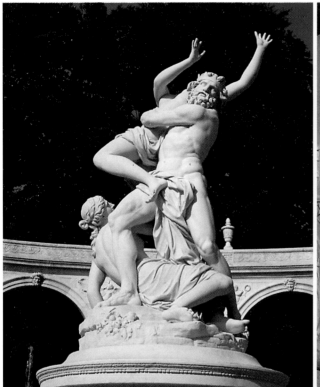

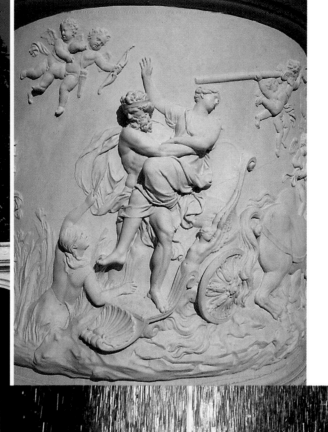

The Rape of Proserpine

Girardon's group and its plinth tell the story, taken from Ovid's Metamorphoses, of how Venus decided to enflame the heart of Pluto, King of the Underworld, with love for his niece Proserpine. He carried her away in spite of the attempts of the nymph Cyane to hinder him. Proserpine's mother, Ceres, sought them throughout the land, half-crazed with grief. To placate her, Jupiter divided the year in two and decreed that Proserpine should spend the first half with her mother and the second half with Pluto in Hades. This myth symbolized the cycle of the seasons: autumn and winter are the time Proserpine has to spend in her underground kingdom, while in spring and summer she returns to the world with warmth and sunshine.

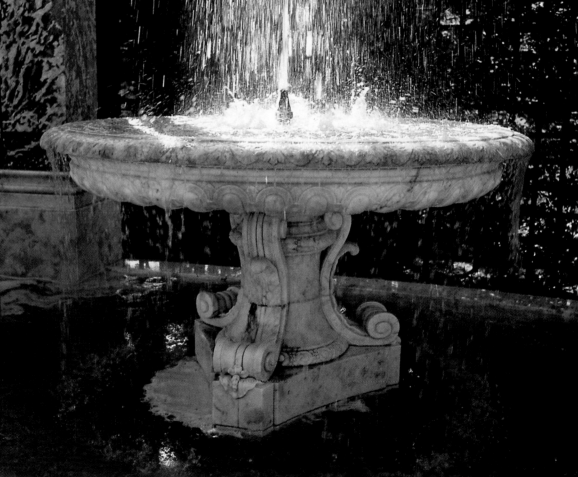

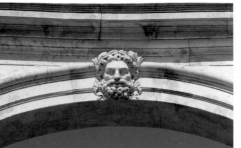

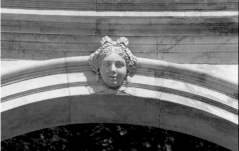

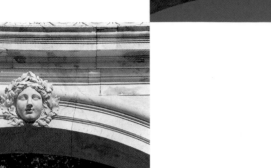

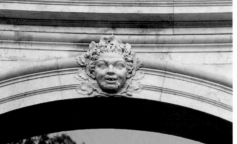

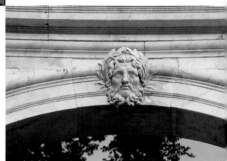

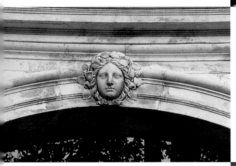

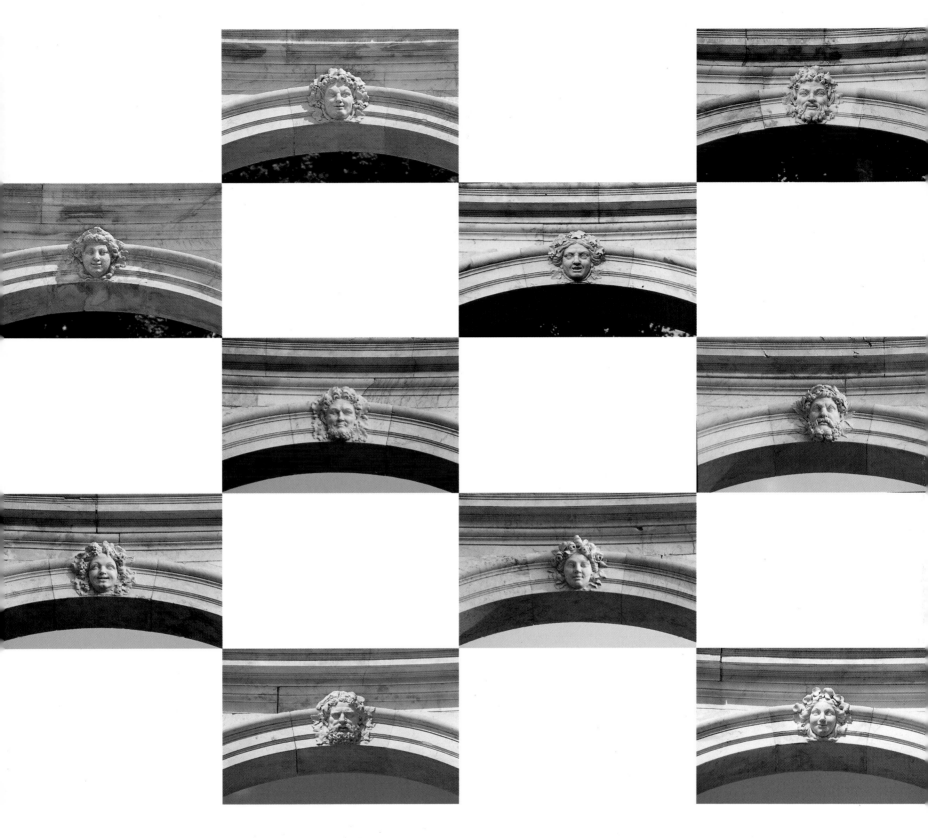

The keystone masks
The keystones of the thirty-one arches are decorated with masks on pastoral and marine themes, alternating male and female figures. They were carved between 1685 and 1688 by thirteen sculptors.

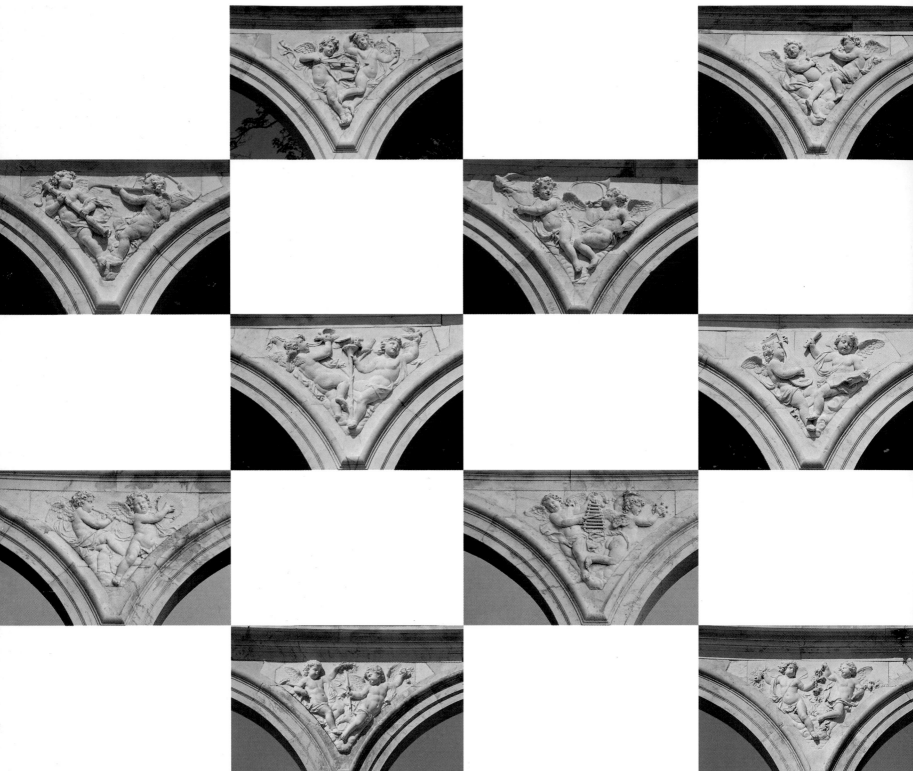

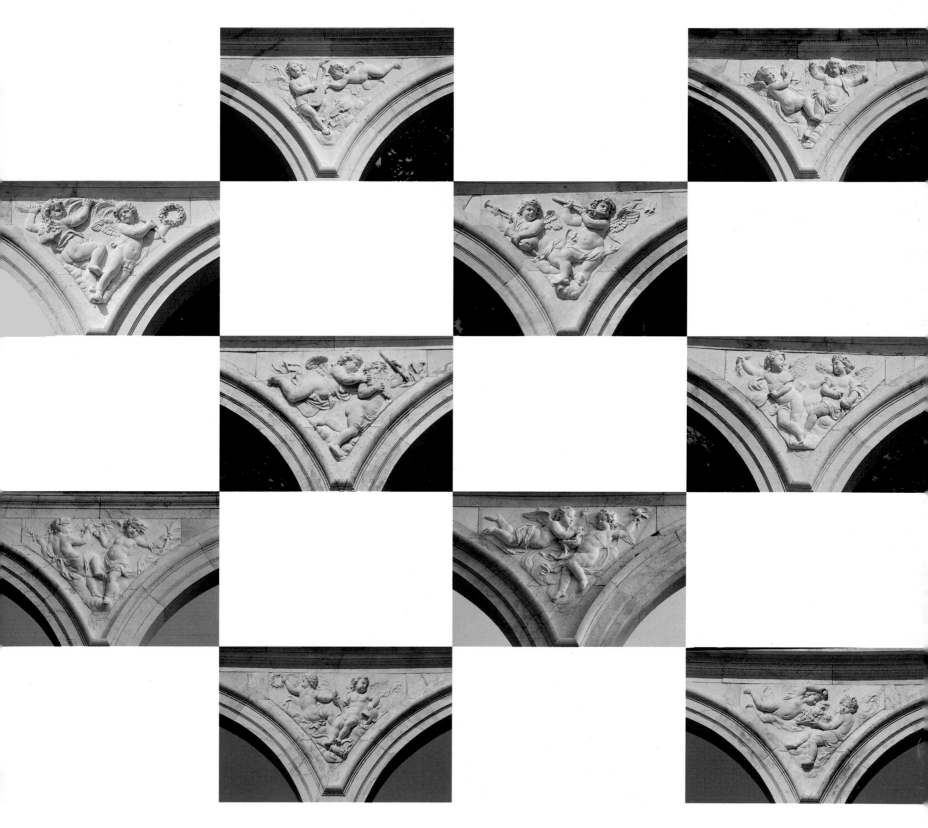

The spandrels

The thirty-two spandrels of the arcades are filled with reliefs of gambolling putti and cupids, carved between 1685 and 1687 by Coysevox, Tuby, Vigier, Leconte, Le Hongre, Mazière and Granier.

The Bosquet de l'Encelade and Bosquet des Dômes

THESE TWO BOSQUETS, situated to the north of the Allée Royale, were begun in 1675 and were arranged in a similar manner to the Galerie des Antiques and the Colonnade, on the opposite side.

Apollo was not the only god with whom the king was associated in the gardens. The struggle of the monarchy first against the Fronde, then against the European powers, evoked comparison with other personalities on Olympus. In the Bosquet de l'Encélade Louis XIV was likened to Jupiter, king of the gods, overcoming the Giants and the Titans. The analogy was made explicit in a ballad which Jean de La Fontaine dedicated to the king.

The adjacent Bosquet des Dômes celebrated the military glory of the ruler. It was initially known as the Bosquet de la Renommée, from the figure of Fame formerly on the central fountain.

The bassin in the Bosquet des Dômes

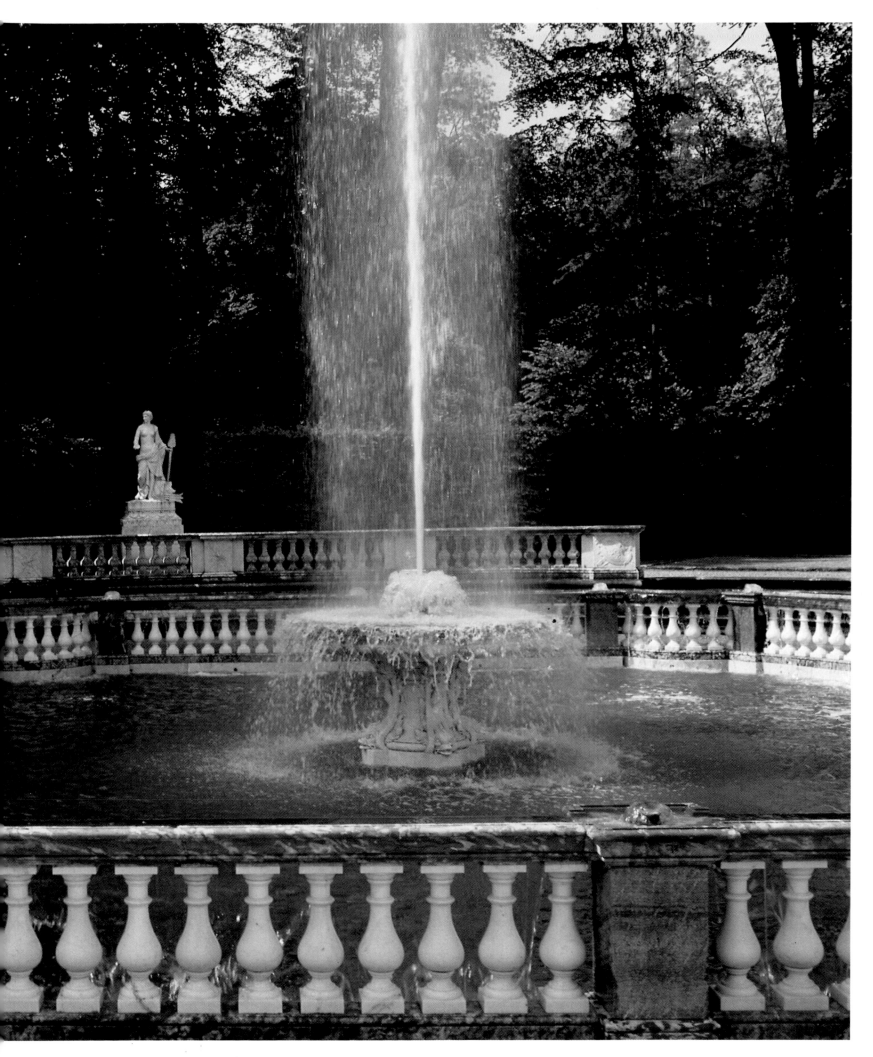

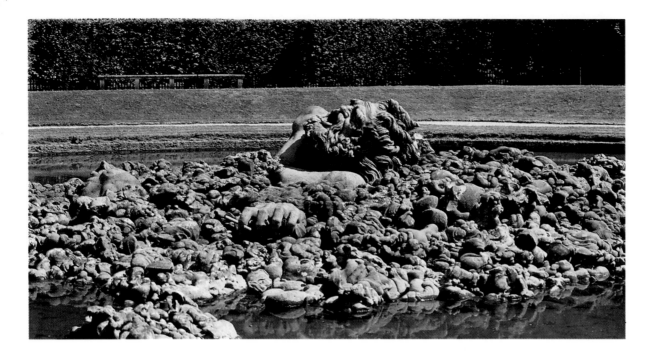

The Bosquet de l'Encelade

THE DEATH of Enceladus is an episode in the struggle of the Giants against the new gods of Greece. The Giants, born from the blood that fell upon the earth from Uranus when he was mutilated by Saturn, attacked Olympus in revenge. Jupiter repulsed them with his thunderbolt, and when one of them, Enceladus, attempted to escape, Minerva buried him under Mount Etna.

In order to have the greatest effect of surprise, access to this octagonal bosquet was by a path with an elbow bend which led through the woodland from the north-east corner. Another path, also with an elbow bend, left the bosquet from the opposite side and led to the Bosquet de Dômes.

The centre of the bosquet was occupied by a large round bassin surrounded by a turf border, within which a fountain took the form of Enceladus overwhelmed by rocaille 'lava', executed by Berthier. The rest of the salle was composed of a sanded path with an octagonal border of grass steps, decorated at each angle with a small rocaille pool and jet. Round the perimeter was a trellis arbour pierced by sixteen arched openings, alternating with vases grouped in threes.

In 1678 the fountains on the octagonal terrace were further decorated by rocaille bowls each supported on a little rock, and vases were placed on pilasters in the surrounding trelliswork. In 1706 the ensemble was simplified and the small fountains removed.

Jupiter triumphant
Jean Cotelle's painting for the Grand Trianon (c. 1690) imagines the bosquet as the scene of Jupiter's anger. As the king of the gods hurls his thunderbolts, from Enceladus' mouth an immense column of water rises and smaller jets spout from between his fingers. Thus what La Fontaine called the 'hundred envious rivals' of Louis XIV will be overwhelmed.

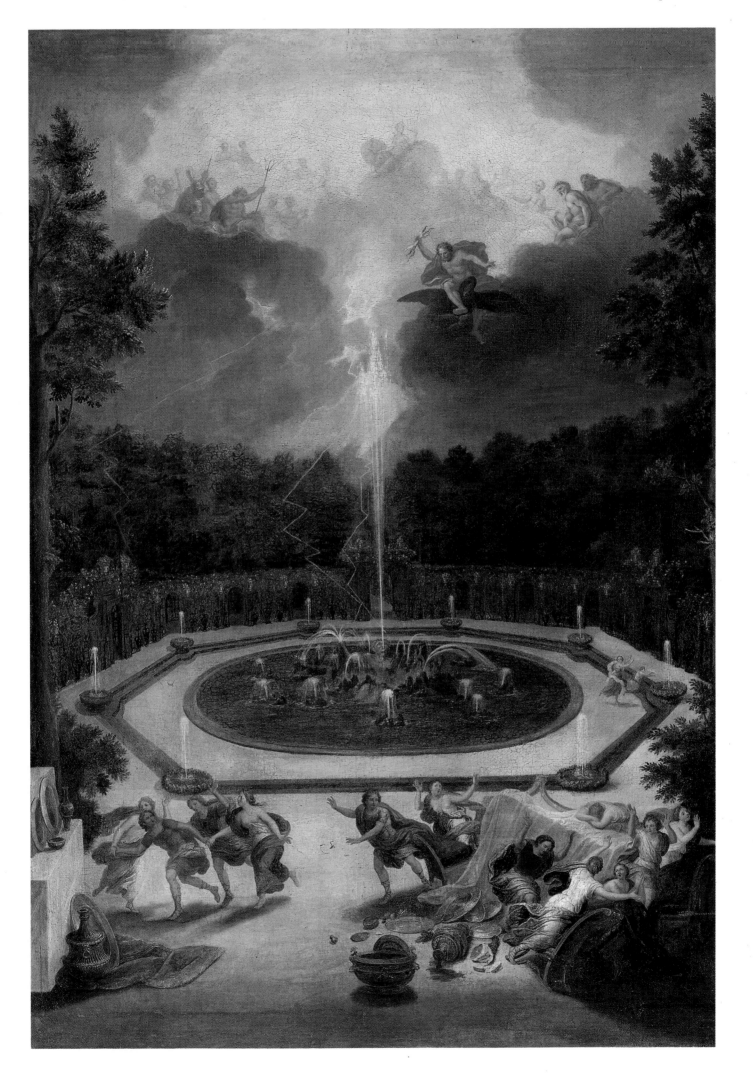

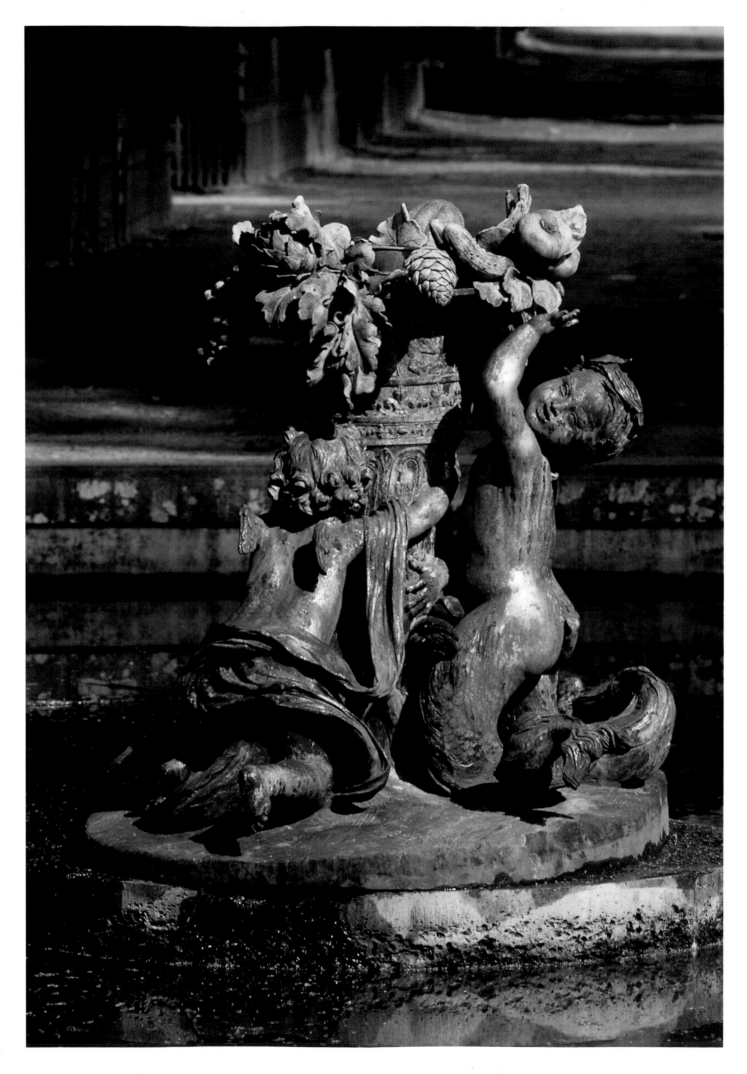

The Bosquet de la Renommée

A single path with an elbow bend led to a central circular salle (*right*). Opposite the entrance, in the middle of a hexagonal bassin, stood the Fontaine de la Renommée, with Fame as a winged female figure standing on a globe. Made by Gaspard Marsy in 1676 from a design by Le Brun, it was placed in position the following year. A column of water rose from Fame's trumpet, and eighteen bubbling jets were set into the gilded balustrade surrounding the bassin.

A second balustrade, of white marble with gilded metal balusters, interrupted by four flights of steps, surrounded and overlooked the fountain, while two pavilions were set back on the south-east and north-west among the trees surrounding the bosquet to complete the decorative scheme. Eight statues (some originally intended for the Grand Parterre d'Eau) stood in niches in the surrounding trelliswork.

When the sculptures from the Grotte de Téthys were moved here, some of the surrounding statues were displaced (they went to the Parterre du Nord in 1685). The statue of Fame was also removed, as it obscured the view of the Apollo group. It was replaced by a group of winged and fish-tailed putti holding a cornucopia (*opposite*), which was itself in turn replaced when the bassin was remodelled again in the early eighteenth century. (Drawing by Israël Silvestre, 1682)

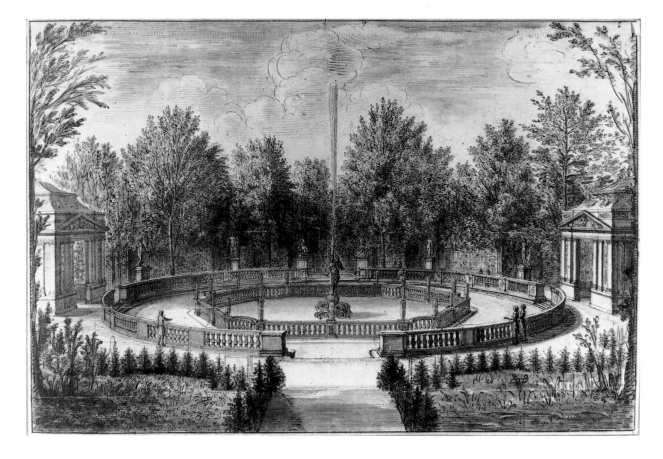

Bosquet de la Renommée, Bosquet des Bains d'Apollon, then Bosquet des Dômes

THIS BOSQUET, situated in the other half of the same block of woodland as the Bosquet de l'Encelade, was at first called the Bosquet de la Renommée and devoted to the military victories of Louis XIV.

After the demolition of the Grotte de Téthys (ill. p. 123), in 1684, its marble sculptures were repositioned here, and with the change of theme this became the Bosquet des Bains d'Apollon.

When the groups were moved to the Bosquet du Marais, the two pavilions of 1677–81 remained as the principal feature in the bosquet, which has been known since as the Bosquet des Dômes, even though the pavilions were demolished in 1820.

Putti with a cornucopia

In the central fountain, the statue of Fame was replaced by the group *opposite*, also in gilded *métail* and by Gaspard Marsy from a design by Le Brun. It was taken to Trianon in 1705 when the bosquet was again altered.

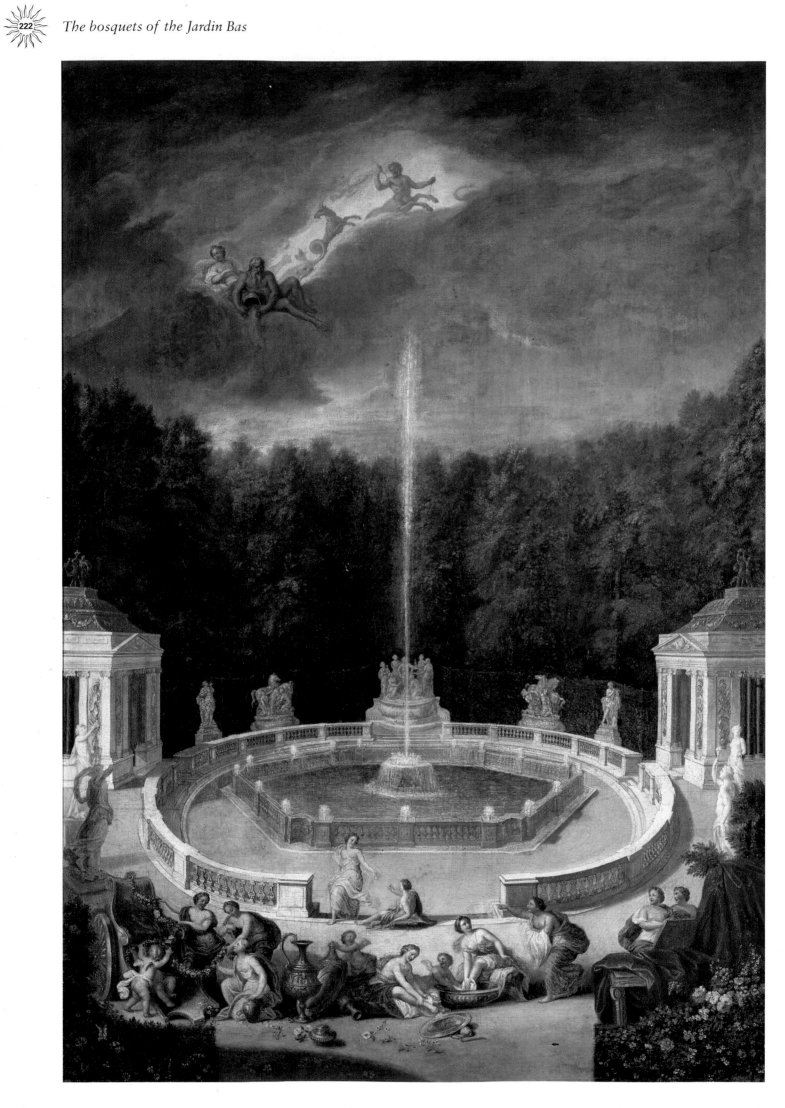

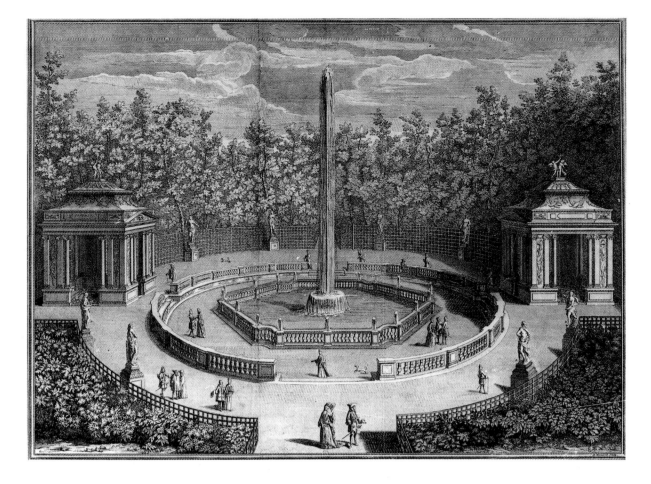

The Bosquet des Dômes

Two pavilions, the first work of Hardouin-Mansart in the gardens, were built in the bosquet between 1677 and 1681. Their floors were paved with marble in a rosette pattern with fleurs-de-lis in the corners; the four sides were open, each entrance framed by two Ionic columns of marble from Rance and Givet; and the decoration consisted of twenty-four gilded panels of military trophies, for which the models had been made by Lespingola and Buirette to designs by Girardon. Pediments on the side facing the bassin featured the arms of France. The pavilions were surmounted by domical roofs, crowned by gilded *métail* groups of putti holding trumpets, executed in 1680 by Lespingola, Le Hongre and Mazeline.

The bosquet was given its new name, des Dômes, in 1705 when a new entrance was created in the direction of the Allée Royale, and the three groups from the Grotte de Téthys were moved on to the Bosquet du Marais. Two new statues were brought to fill the spaces. (Engraving by Girard, 1714)

The Bosquet des Bains d'Apollon

The sculptures brought from the Grotte de Téthys in 1684 – Apollo tended by nymphs, the Horses of the Sun, and Acis and Galatea – gave the bosquet its second name. Four new pieces were also commissioned by Louvois in 1686; they appear at the sides in Jean Cotelle's painting. The pavilions beyond them gave the bosquet its final name.

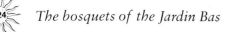

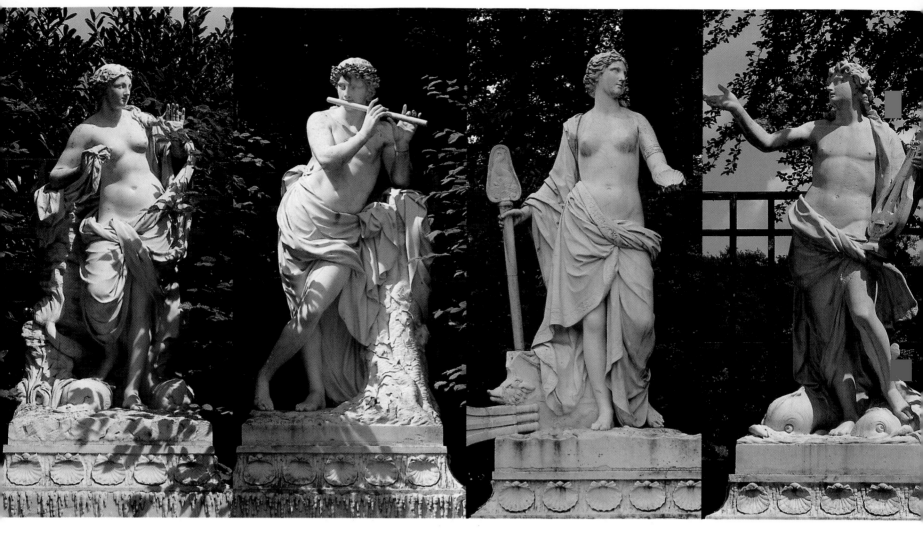

Galatea

(Jean-Baptiste Tuby)

Part of the ensemble in the
Grotte de Téthys, this statue of
Galatea and its companion,
Acis, were made in 1674. Ten
years later they were moved here
with the groups of Apollo and
the Horses of the Sun.

Acis

(Jean-Baptiste Tuby)

Acis was the son of the god Pan
and in love with Galatea. The
Cyclops Polyphemus in jealous
fury crushed him under a rock,
and his blood gushing from
beneath the stone was turned by
Galatea into the River Acis at
the foot of Mount Etna.

Leucothea

(Joseph Rayol)

After throwing herself into the
sea with her son Melicertes,
Ino became changed into
Leucothea, a sea goddess
who guides sailors.

Arion

(Jean Raon)

Arion was a great bard and
beloved of Apollo, who warned
him in a dream that he would be
attacked by the sailors on his
ship. He obtained from them
leave to sing for the last time
then threw himself overboard,
whereupon he was rescued by
one of the dolphins who had
gathered to hear the music.

The statues in the bosquet

Four statues were commissioned by Louvois for the Bosquet des
Bains d'Apollon from designs by Girardon, with themes of the sea
and the sun: Leucothea, Arion and Daybreak were placed in position
between 1690 and 1698, but Aurora was not finished until 1704, so
her place was filled by Amphitrite, purchased in 1684.

Aurora was brought to the bosquet in 1705, at the same time as
Callisto (ordered for Marly), as replacements for the three groups of
Apollo and the Horses of the Sun. Acis and Galatea from the Grotte
de Téthys remained in the bosquet.

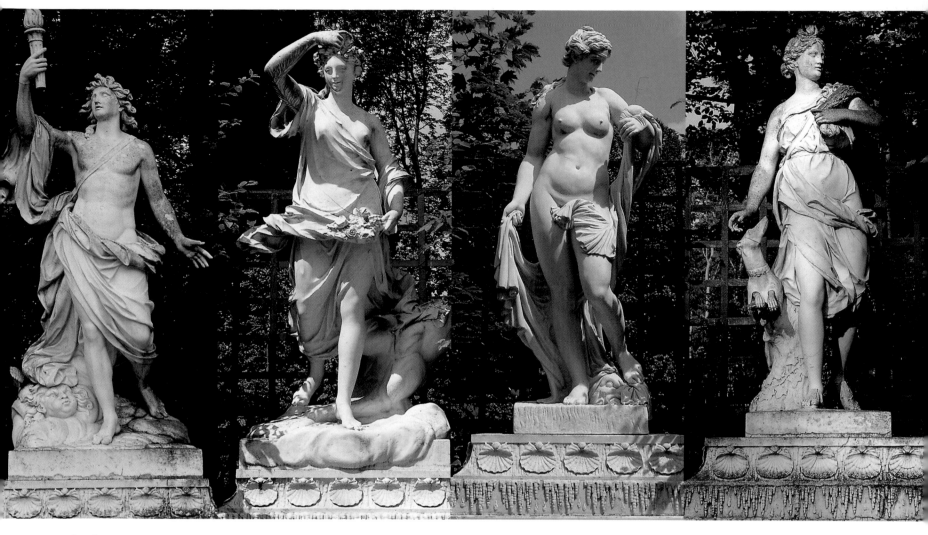

Daybreak

(Pierre Legros the elder)

Carrying his torch aloft, Daybreak personifies the morning star which awakens Aurora.

Aurora

(Philippe Magnier)

Aurora opens the gates of heaven to the chariot of the sun.

Amphitrite

(Michel Anguier)

Modestly fleeing the importunities of Neptune, Amphitrite was returned to the god by dolphins and became queen of the sea. (Anguier's statue has been replaced by a copy.)

Callisto

(Anselme Flamen)

A nymph and companion of Diana, Callisto was made pregnant by Jupiter who had taken the form of the goddess to overcome her chaste resolve.

The new bassin

At the end of Louis XIV's reign the metal balustrade round the bassin was replaced by a new balustrade of red marble with white marble balusters reversing the colours of the outer balustrade, where simultaneously the metal balusters were replaced in red marble. The following year Lespingola, Hardy, Poirier and François made for the centre of the bassin a new white marble fountain in the form of a bowl supported by four dolphins.

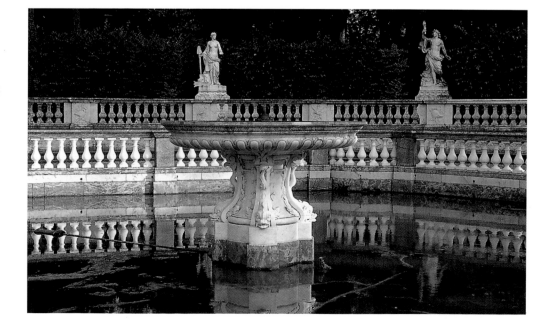

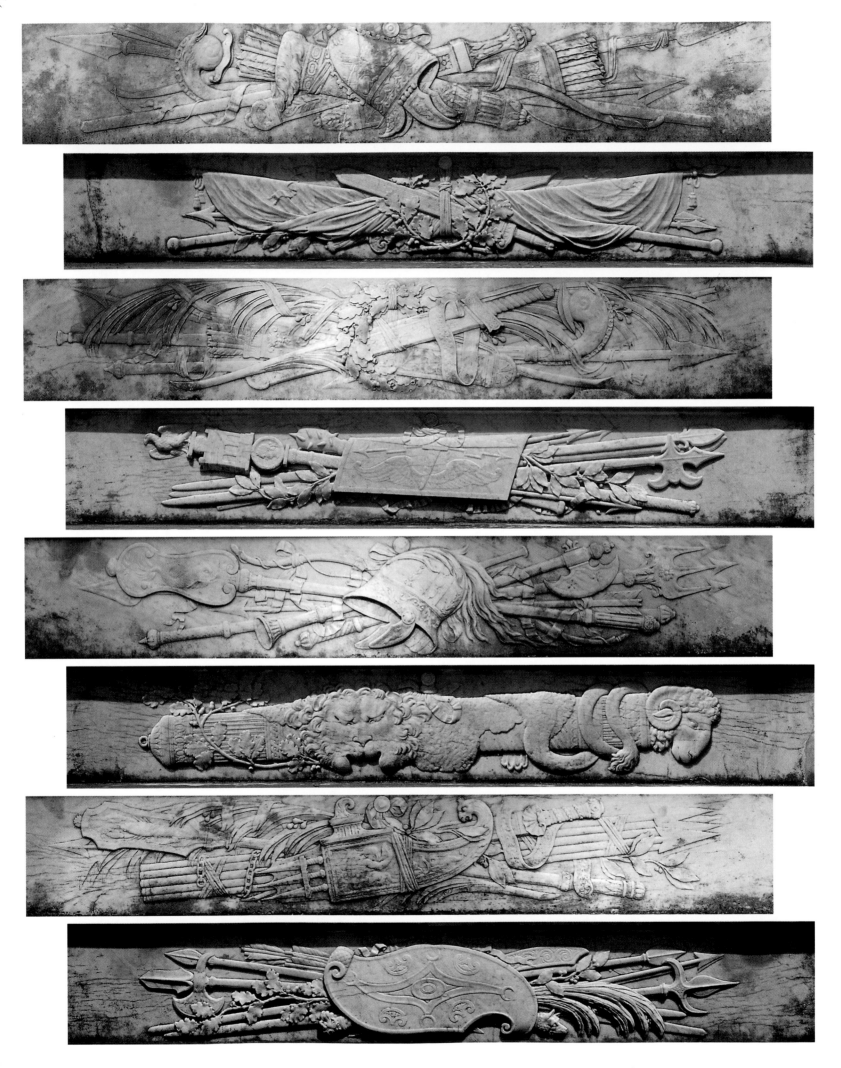

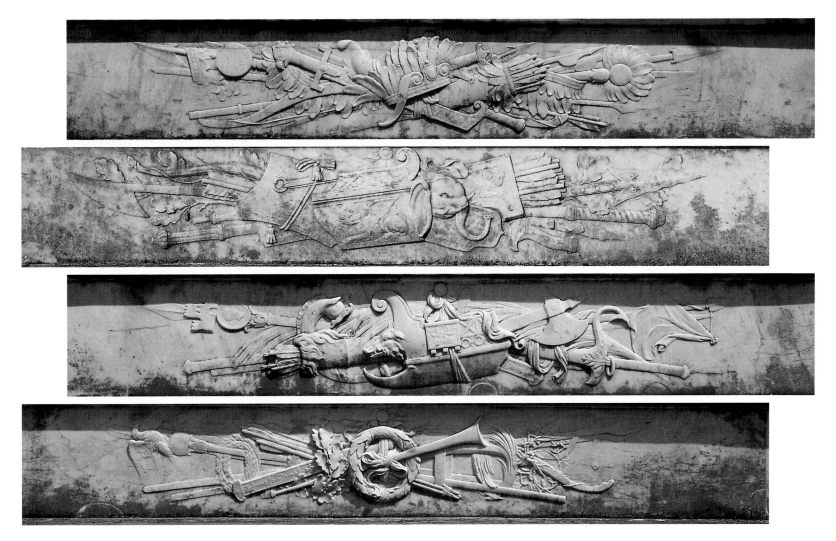

Some of the forty-four reliefs on the bench fronts

Reliefs on the benches and dies of the outer balustrade

The outer balustrade is divided into four arcs of a circle. Each segment has a white marble bench below, while the balusters above are separated by white marble dies, all carved in relief with trophies of arms representing different nations. Work on them was begun in 1677 by Girardon, who provided the models, and by Mazeline and Guérin.

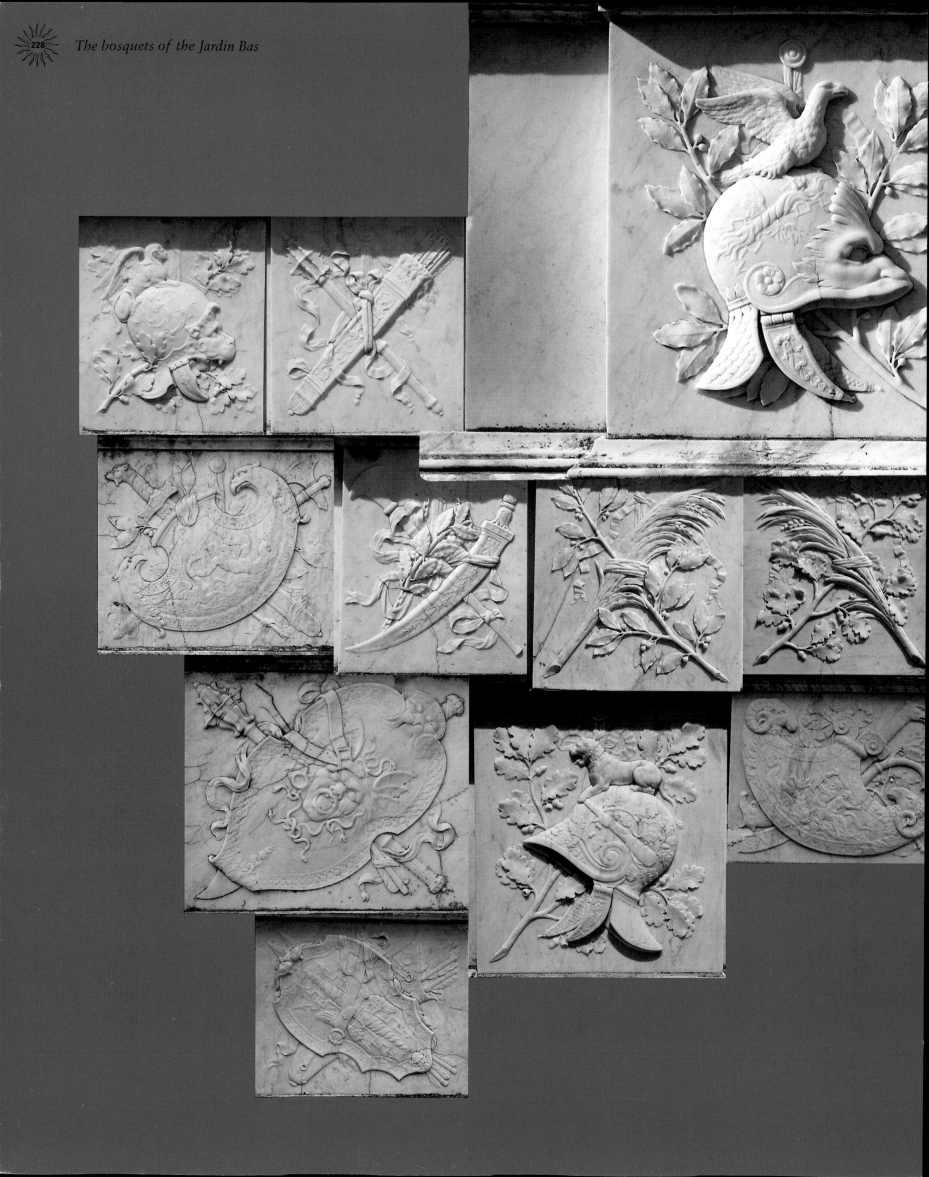

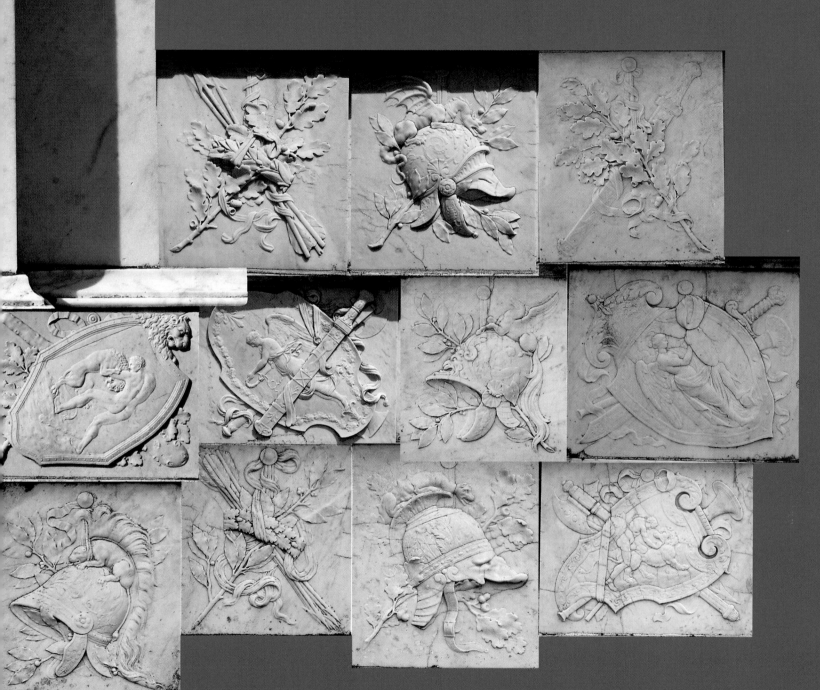

Some of the twenty-four reliefs on the dies between the balusters

From Salle des Festins to Bosquet de l'Obélisque

T HE SALLE DES FESTINS, the Montagne d'Eau
and the Théâtre d'Eau were the three
bosquets devised from 1671 in the north part
of the Jardin Bas. The furthest bosquet, and
therefore the last of the three to be laid out,
was originally called the Salle du Conseil or
Salle des Festins and was elaborately decorated.
In 1706 it was simplified by Hardouin-Mansart
and in 1710 it became the Bosquet de
l'Obélisque, a name taken from the great
column of water rising from its central bassin.

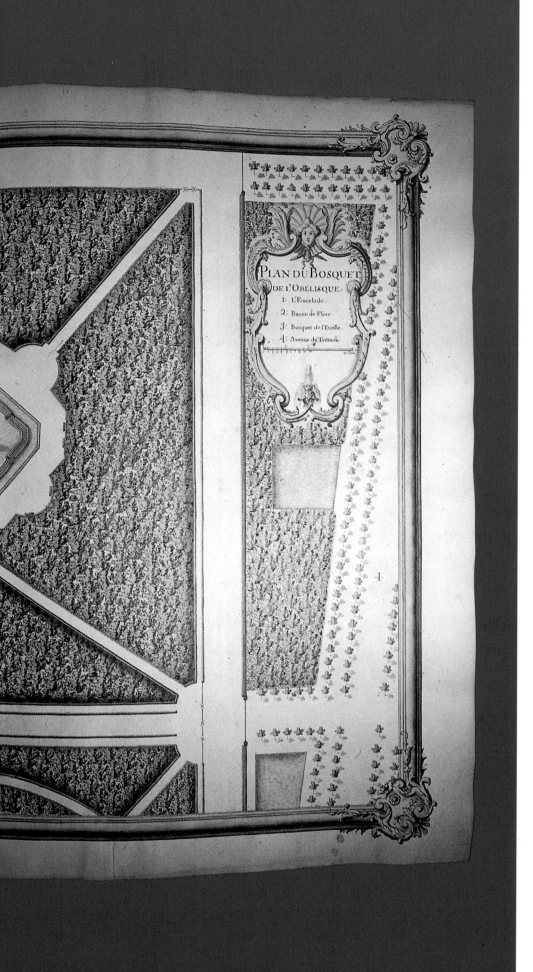

Plan of the Bosquet de l'Obélisque from the album of Jacques Dubois

The Bosquet de l'Encélade is visible to the south (left), and part of the Bosquet de l'Etoile to the east (below).

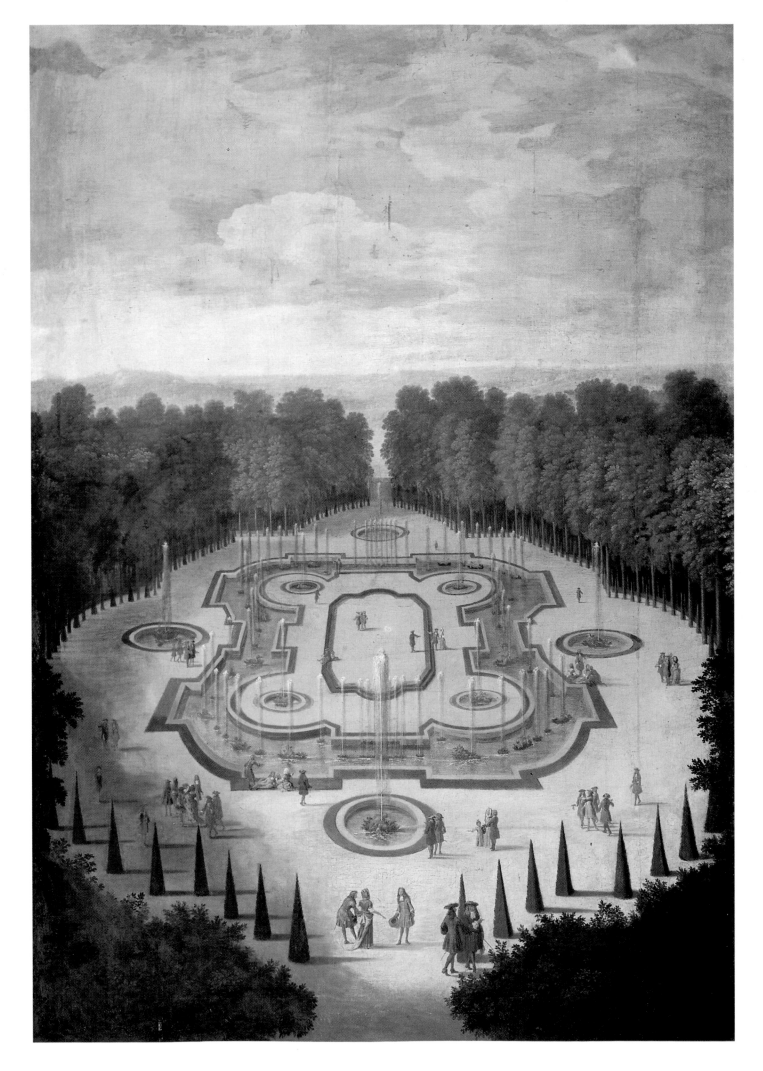

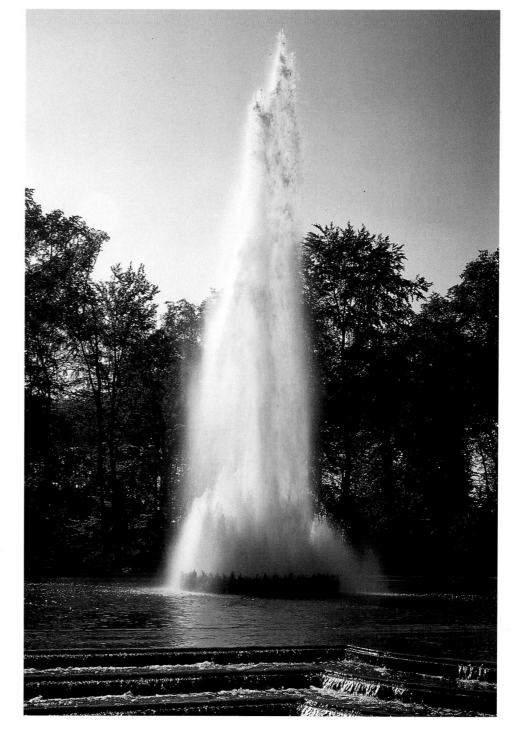

The Salle des Festins

The *salle*, orientated south-east/north-west, was reached by four paths. It was roughly lozenge-shaped, and in 1672 a round bassin with a jet was installed at each of the four 'points'.

The centre was occupied by an island surrounded by a canal decorated with fifty lances of water. Access to it was via two little swing-bridges opposite the axial entrance paths. The island had four small bassins set into lobes at the corners, and in the middle a platform raised by two steps, on which four marble vases, executed by Bertin from designs by Hardouin-Mansart, were placed in 1691. (Etienne Allegrain's view, seen here, was commissioned in 1688, before their installation.)

The bosquet was surrounded by a hornbeam hedge, with forty-eight clipped yews in front of it alternating with trees planted in bands of turf, and at one time the island was bordered by fifty-eight yews which were continued down the four paths leading in through the woods.

In 1681 the secondary groups from the Bassins des Saisons (ills. p. 142) were brought to this bosquet: those from the fountains of Spring and Winter were used to decorate the canal around the island; those from the fountain of Summer were placed in the small round bassins; while those from the fountain of Autumn were installed in the large bassins in the corners. In 1697 the elements from Summer were sent to the château of Meudon. When the bosquet was altered in 1706, the remainder were removed and repositioned at Trianon.

The Bosquet de l'Obélisque

In 1706 a new path was cut from the Théâtre d'Eau, crossing the Bosquet de l'Etoile and continuing west into the Salle des Festins. Hardouin-Mansart simplified the design by replacing the island with a large bassin raised on five steps, surrounded by a canal and a border of turf. A cluster of 230 jets spouting water from a clump of metal reeds in the centre came to be known as the Obelisk.

Bosquet de l'Etoile, de la Montagne d'Eau, and de l'Etoile again

THIS BOSQUET, originally called the Bosquet de l'Etoile, was conceived in 1666 as a *cabinet de verdure* with paths arranged in a star, and was one of the first to be laid out in this part of the Jardin Bas (see the plan p. 37, top).

In 1671 it was made more elaborate, with new paths giving it some resemblance to a labyrinth, and a central fountain from which it took its new name, Bosquet de la Montagne d'Eau.

When the bosquet was altered once more at the beginning of the eighteenth century it was again simplified, and resumed its earlier name of Bosquet de l'Etoile.

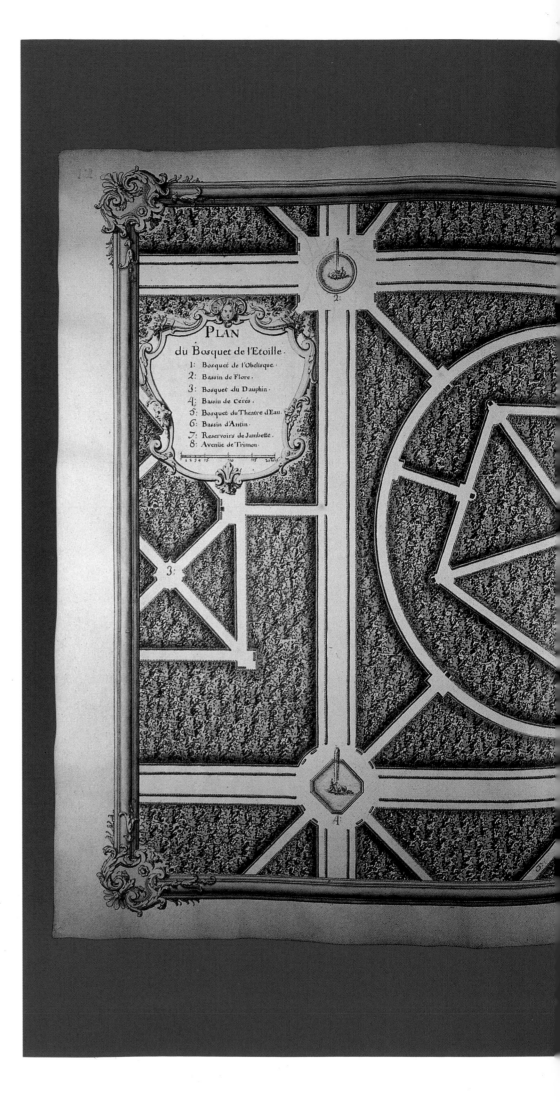

PLAN
du Bosquet de l'Etoille.
1: Bosquet de l'Obelisque.
2: Bassin de Flore.
3: Bosquet du Dauphin.
4: Bassin de Cérés.
5: Bosquet du Theatre d'Eau.
6: Bassin d'Antin.
7: Reservoirs de Jambette.
8: Avenüe de Trianon.

Plan from the album of Jacques Dubois

The serpentine paths of the original Bosquet de l'Etoile (cf. p. 236) had disappeared altogether by Louis XIV's death in 1715.

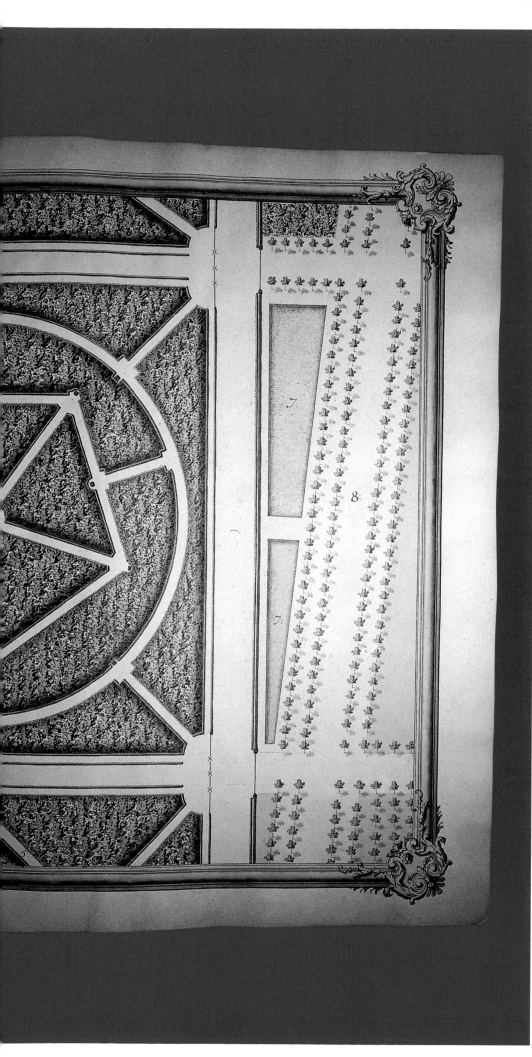

The Muse with a goat-skin
Among the statues in the bosquet is that of a Muse wearing a goat-skin over her chiton. Known in the time of Louis XIV as a bacchante, from the bunches of grapes framing the head (added to the body by a would-be restorer), this sculpture is one of the few antique pieces at Versailles which have survived the last three centuries without being moved.

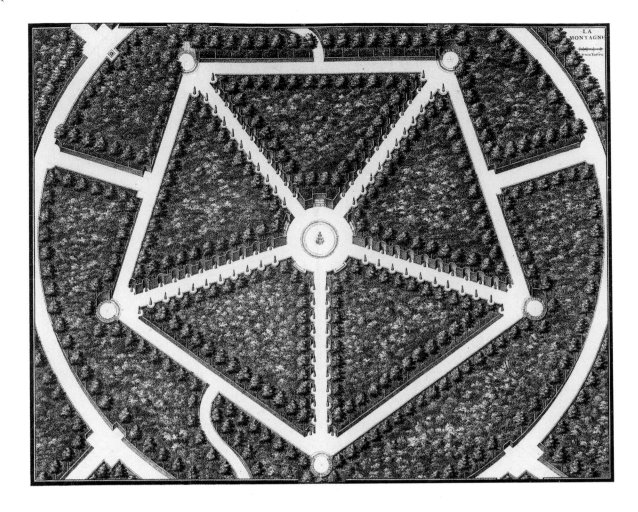

The layout of the bosquet

The central circular *salle* was enclosed by a high trellis fence incorporating five alcoves, surmounted by a projecting cornice decorated with vases of flowers.

Five paths arranged in a star converge on the salle, each containing twenty-two niches decorated with a rocaille mount and a jet of water which fell back into a narrow sloping channel. These paths, lined for their entire length with a trellis fence planted with honeysuckle and flowers, led to rocaille fountains placed at the angles of the surrounding pentagonal walk. The four niches in the outer circular walk held statues.

In 1697 the rocks in the paths of the star were replaced by 110 clipped yews, and in 1707 five antique statues were substituted for the rocaille fountains in the corners of the pentagon. This plan shows the bosquet between those two operations. The two original serpentine paths still survive, but there are two additional straight ones.

The Bosquet de la Montagne d'Eau

Four paths led from the corners of the block of woodland to the interior of the bosquet and joined a circular walk. Further paths (in the first Bosquet de l'Etoile, only two, of serpentine form) continued and met a pentagonal walk, from whose angles other paths converged on the centre of the bosquet, laid out as a *salle de verdure* with a bassin and jet in the middle. The fountain, springing from a rocaille mount, was called the 'mountain of water'.

The fountain of the Montagne d'Eau

In 1670 the central bassin in the bosquet was given a rocaille mount with a lance of water from the top and eleven jets round the base, which earned it the name of Montagne d'Eau, while the raised rim of the bassin was lowered in five places to let the water overflow into the surrounding canal.

Jean Cotelle's painting (*c.* 1690) shows the bosquet as the setting for a scene taken from Ovid's *Metamorphoses*, in which the nymph Arethusa, pursued by the river-god Alpheus, is about to be rescued by Diana and changed into a spring.

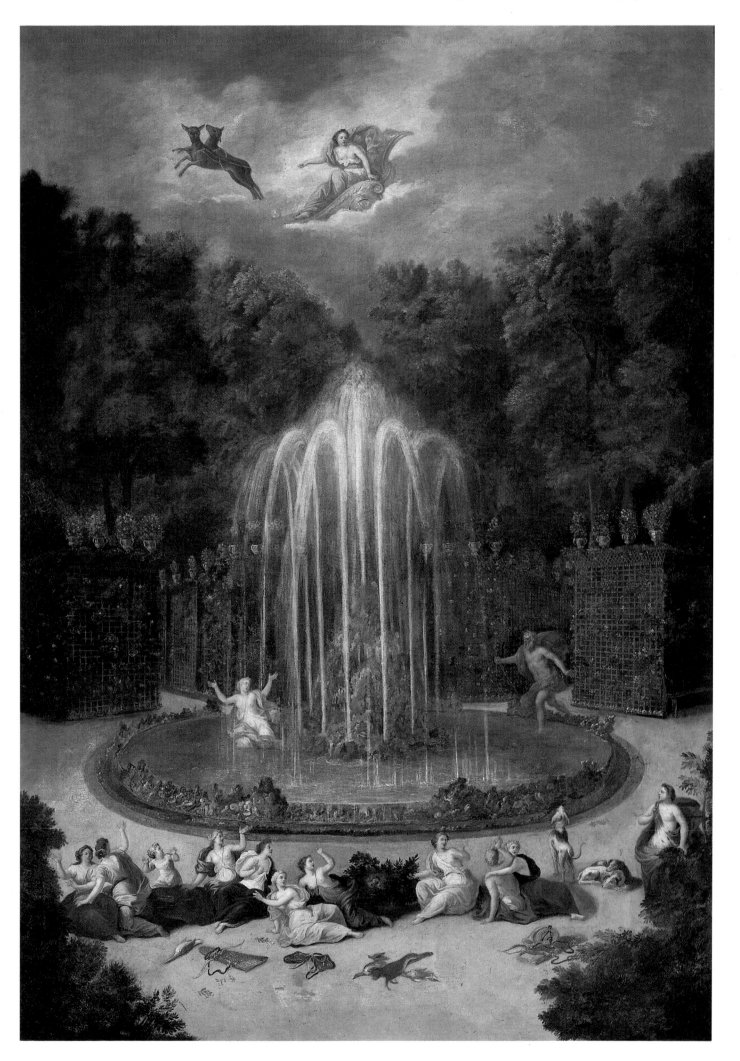

From Bosquet du Théâtre d'Eau to Bosquet du Rond-Vert

NOTHING remains today of the magnificence of this bosquet, which under Louis XIV must have been one of the finest and certainly the most perfect in detail of all *théâtres de verdure*. Laid out by Le Nôtre in 1671–74, it belongs to the same group as the other great bosquets of the Jardin Bas – the Labyrinthe, Salle des Festins, Montagne d'Eau and Marais. Its originality stemmed as much from the allegorical décor by Le Brun as from its ingenious water features, devised by the fountainers Francine and Denis.

A way into the bosquet lay at each of its four corners, leading via walks forming a square to the entrance to the theatre, on the north. The circular salle was arranged as an 'auditorium' with three tiers of turf seats, and a 'stage' decorated with four fountains alternating with three radiating cascades.

The two parts of the theatre were separated by a row of nine waterspouts in an elongated rocaille bassin, forming the equivalent of a curtain (ill. p. 242). In 1671 more extensive rocaille décor by Charles Berthier and Philippe Quesnel was introduced, and on top of the bank surrounding the stage ten vases were placed, planted with flowering shrubs. Figure sculpture was introduced in 1674. In 1677 a *palissade de verdure* or colonnade of greenery was formed behind the steps in the 'auditorium' by twenty pleached trees, their trunks entwined with climbing flowers, with a row of clipped balls along the top. In the arcade so formed were placed twenty rocaille fountains, each with a jet of water rising to the top of the arch (ill. p. 243).

In the 1680s the four niches in the square walk encircling the bosquet were filled with

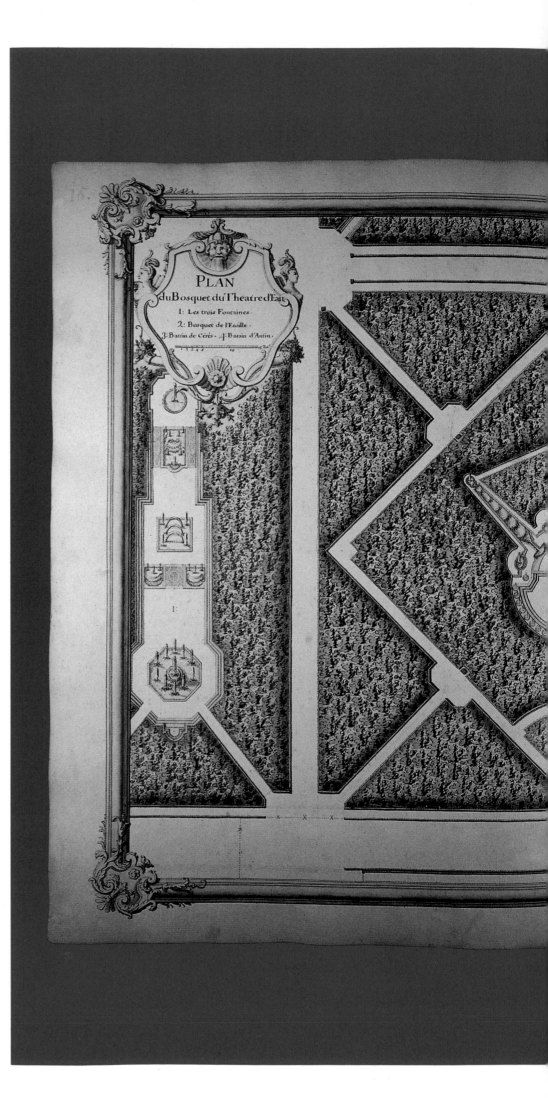

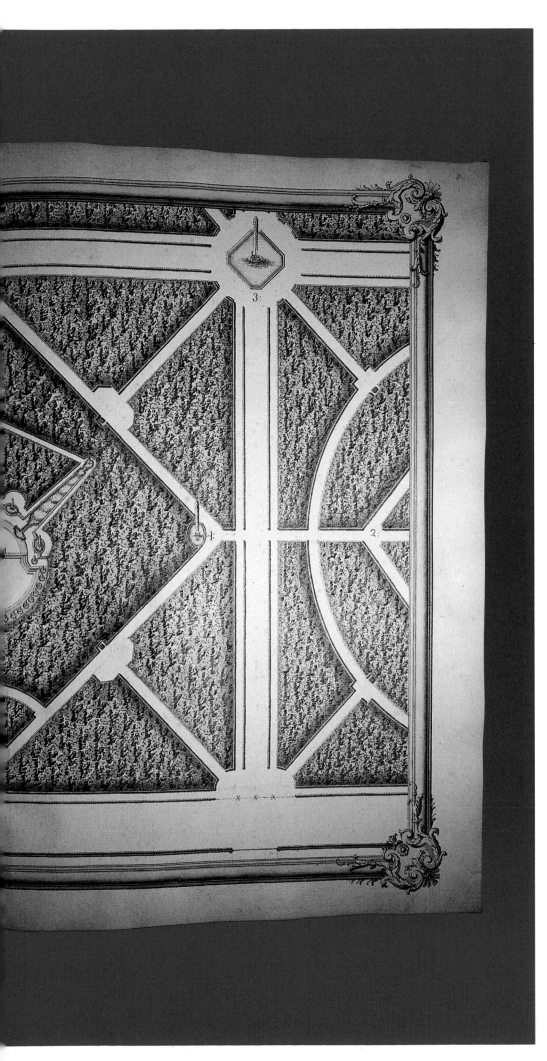

statues, but they did not remain long in position and were constantly replaced. A Callipygian Venus by François Barois was taken in 1695 to Marly. A Ganymede by Jean Joly was replaced in 1704 by an antique term of Jupiter from the Montagne d'Eau, brought to the bosquet to accompany an antique term of Juno: both went to the Louvre at the Revolution. Ganymede eventually returned to the bosquet, in its remodelled form as the Rond-Vert. A faun by Jean Raon was replaced in 1717 by a Bacchus by Guillaume Coustou the elder from Marly. Finally, a group of Marsyas and Olympus by Jean-Baptiste Goy was moved to the Salle de Bal in 1912 (ill. p. 178).

In 1709, a new fountain was created at the point of the enclosing square nearest to the Bosquet de l'Etoile: it was known as the Fontaine de l'Ile aux Enfants or d'Antin.

The bosquet survived the reign of Louis XV, but was then stripped of its waterworks and refashioned in the English style under Louis XVI to become the Bosquet du Rond-Vert.

Plan of the Théâtre d'Eau from the album of Jean Dubois
The bosquet lies between the Bosquet des Trois Fontaines to the east (left) and the Bosquet de l'Etoile. (North is at the bottom.)

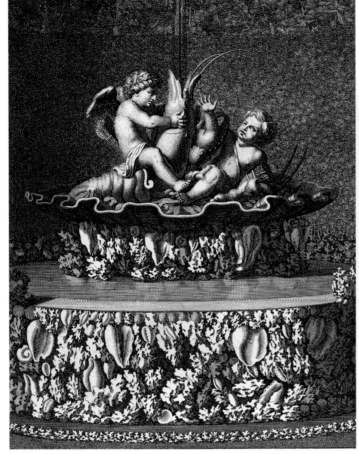

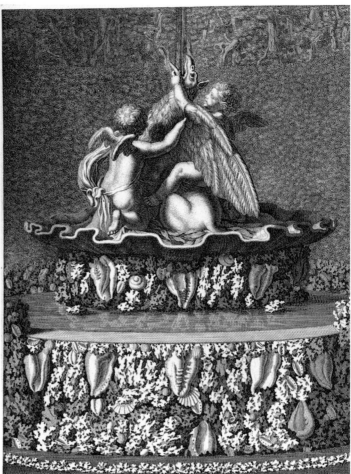

The fountains round the stage:

Cupids with a crayfish
(Jacques Houzeau)

Cupids with a griffin
(Benoît Massou)

Cupids with a lyre
(Pierre Legros the elder)

Fountains in the Théâtre d'Eau

In 1674, the fountains on the stage and the radiating cascades were decorated with figures in *métail*, and a rocaille fountain opposite the entrance to the theatre was surmounted by a cupid riding a dolphin (later moved to Trianon). In the four groups round the stage, playful cupids were depicted with a lyre (representing the sun) and a crayfish (the moon), framing others alluding to the elements, with a swan (fire and water) and a griffin (air and earth).

The figures at the top of the cascades celebrated royal majesty, by means of three cupids symbolizing physical force, sacred power and material prosperity, qualities attributed by the Greeks to Apollo to maintain the harmony of the universe, and here lent to Louis XIV in the guise of military valour, power, and wealth.

Their original appearance was recorded in engravings by Jean Le Pautre, of 1677 and 1678.

Cupids with a swan
(Jean-Baptiste Tuby)

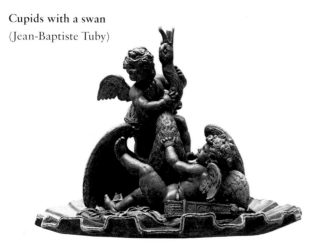

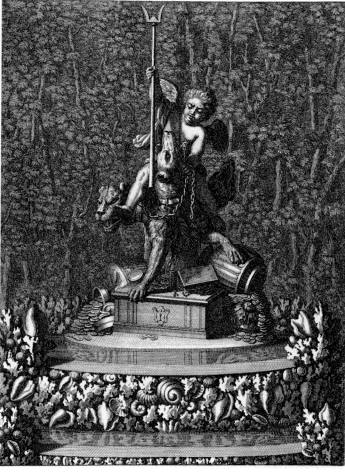

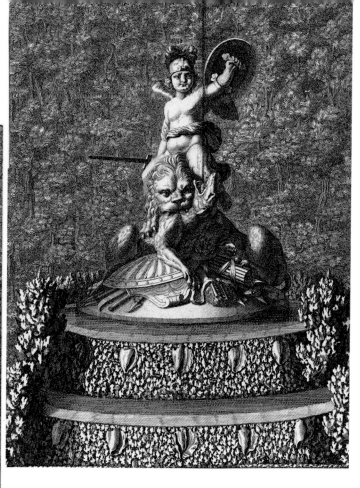

The fountains on the radiating cascades:

Jupiter, or the Genius of Power
(Pierre Legros the elder)
A crowned cupid, armed with Jupiter's thunderbolt, rides an eagle perched on a star-studded globe. A jet of water spouts from the bird's open beak.

Pluto, or the Genius of Wealth
(Benoît Massou)
A cupid armed with Pluto's staff rides Cerberus, seated on caskets of jewels and urns full of coins. A jet rises from one of the heads of the dog.

Mars, or the Genius of Valour
(Martin Desjardins)
A helmeted cupid, holding a sword and shield, rides a lion devouring a wolf, from whose mouth spurts a jet of water.

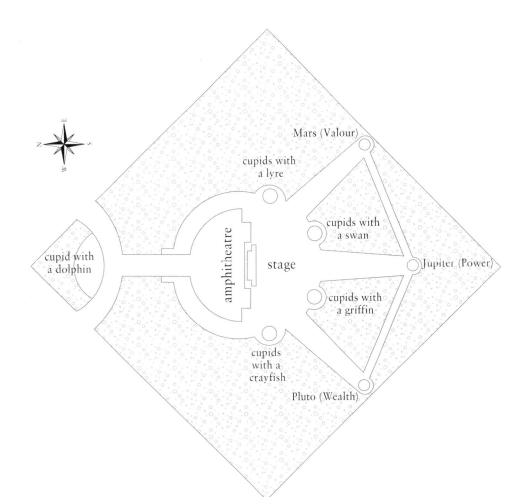

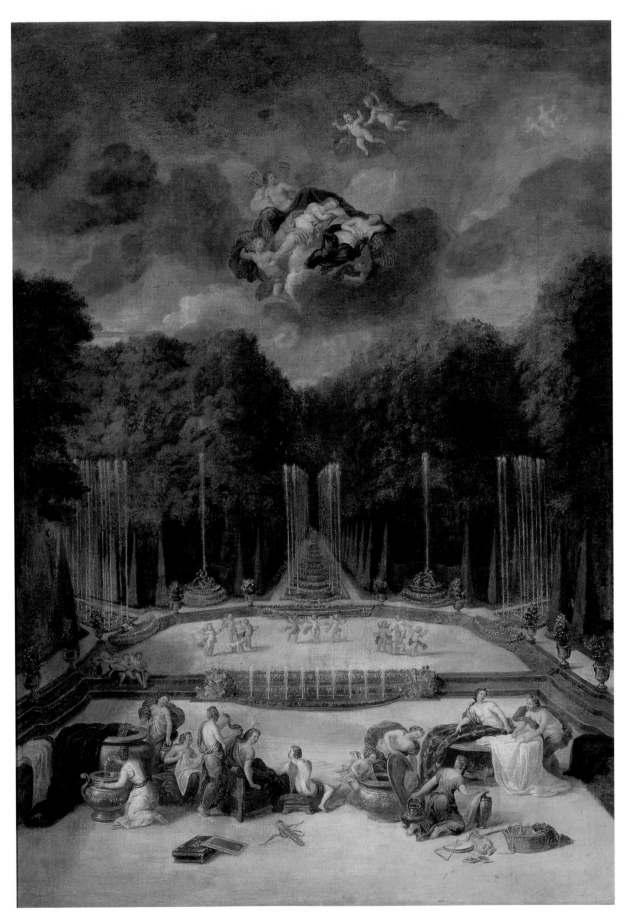

The stage of the Théâtre d'Eau
This painting by Jean Cotelle
(*c.* 1690) shows the view
towards the stage. Marking its
division from the auditorium is
a long rocaille fountain, with
spouts which could take the
form of curved, straight or
bubbling jets, grilles of water,
plumes or fleurs-de-lis. Behind
the stage we see the groups of
cupids with a swan and a griffin,
between the cascades whose
lances of water continue right to
the back of the bosquet.

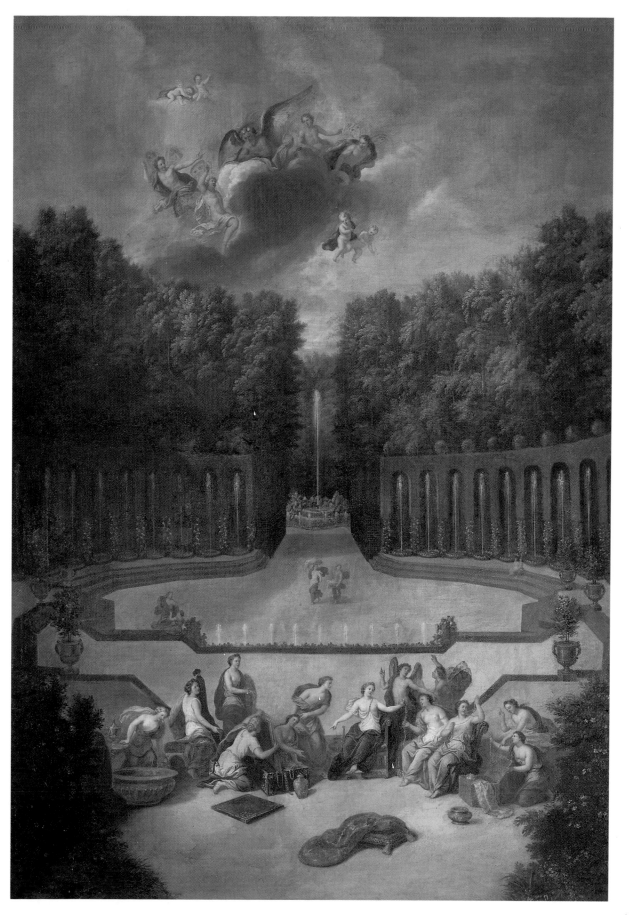

**The auditorium and entrance
of the Théâtre d'Eau**

Here, Cotelle shows us the view
from the stage. Single jets of
water shoot up behind the turf
seats and give variety to the
colonnade of greenery.

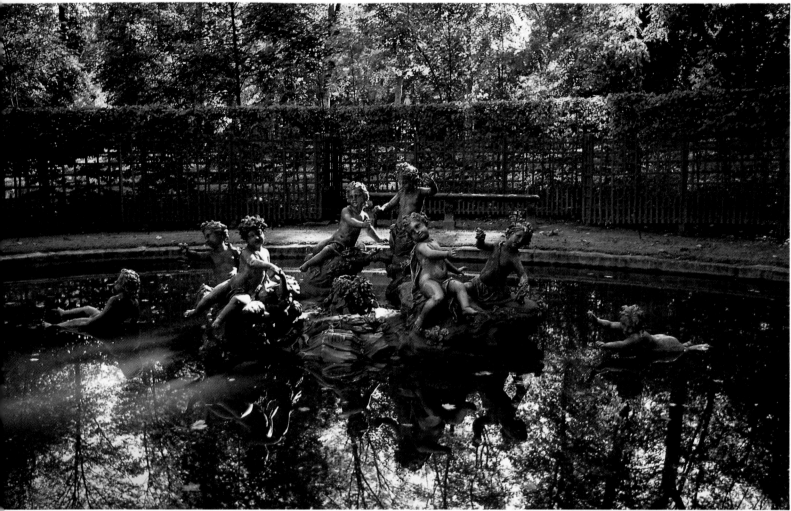

The Fontaine de l'Ile aux Enfants

In 1709 the Théâtre d'Eau was given a new fountain, at the end of a short path created at the western point of the bosquet, continuing the walk crossing the Bosquet de l'Etoile (see the plan p. 239). The Fontaine de l'Ile aux Enfants was also known as the Bassin d'Antin, after the Director of the Bâtiments du Roi who succeeded Hardouin-Mansart. It was made of gilded *métail* by Jean Hardy (the sculptor in charge of the maintenance of the gardens of Versailles after the death of Claude Bertin), incorporating eight figures of putti taken from bassins in the gardens of Marly.

The Fontaine de l'Amour au Dauphin

This group was fashioned in *métail* by Gaspard Marsy in 1672, and installed in 1674 on the rocaille fountain opposite the entrance to the theatre. Cupid sitting on a dolphin, perched on three superimposed bowls, draws an arrow from his quiver which emits a jet of water.

In 1704 the fountain was sent to Trianon, first to the Bassin du Plat-Fond and then in 1732 to the Jardin du Roi.

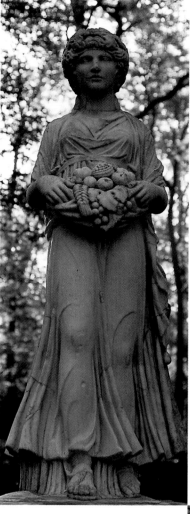

Ganymede

This copy of an antique, carved in Rome by Jean Joly from a model by Carlier, had stood here before, in the Théâtre d'Eau. It was moved to the refashioned Bosquet de l'Etoile, then returned in 1912 to its original home, which in the interval had become the Bosquet du Rond-Vert.

The Bosquet du Rond-Vert

During the replanting of the gardens in 1775 the Théâtre d'Eau was razed, leaving only the circular walk round it. Two new paths led through the woods to a round lawn, the 'green circle' that provided the new name for the bosquet, which was gradually adorned with sculpture.

The new statues in the bosquet

The bosquet contains three statues from the Galerie des Antiques: Cleopatra (*left*), Pomona (*above*) and Ceres (*right*). The first two had been sent to Trianon in 1704, then at the Revolution were stored in the château at Versailles with the third statue. They were restored by Jean-Baptiste Beaumont, transported to Saint-Cloud in 1828, then back to Trianon, and finally placed in the Rond-Vert shortly before 1850.

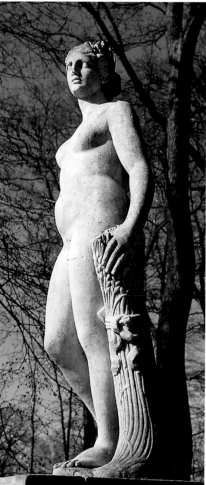

From Bosquet du Marais to Bosquet de la Grotte des Bains d'Apollon

THIS BOSQUET, situated on high ground in the northern block of woodland nearest to the château, was redesigned several times before the end of the eighteenth century, when it found a décor that made full use of its potential.

First, a salle known as the Marais (marsh) was laid out in the upper part. Then a second – the Salle des Bains de Diane – was planned in the lower section. Meanwhile, the upper part temporarily became a new Bosquet des Bains d'Apollon. Plans for the lower area were abandoned at the death of Louis XIV, and took shape only under Louis XV as a pavilion for the amusement of his son: the Petit Bosquet du Dauphin.

Not until the reign of Louis XVI were the two parts united to form a single ensemble: the Grotte des Bains d'Apollon. Designed in the new taste of the English garden, the bosquet was given a 'natural' grotto incorporating a cascade, which echoed the Mur d'Eau in the Bosquet des Rocailles on the other side of the Parterre de Latone.

The Grotte des Bains d'Apollon
The French Revolution halted the attempt to remodel the gardens in the English fashion, and Versailles remained a *jardin à la française*. This particular bosquet, designed by the painter Hubert Robert in 1778, combined the two styles and left a reminder of that hesitation. Laid out in the naturalistic manner of the English garden, a rough-hewn grotto provided the background for a Classical masterpiece which had started life in the Grotte de Téthys: the group of Apollo tended by nymphs, flanked by the Horses of the Sun, by the sculptor François Girardon.

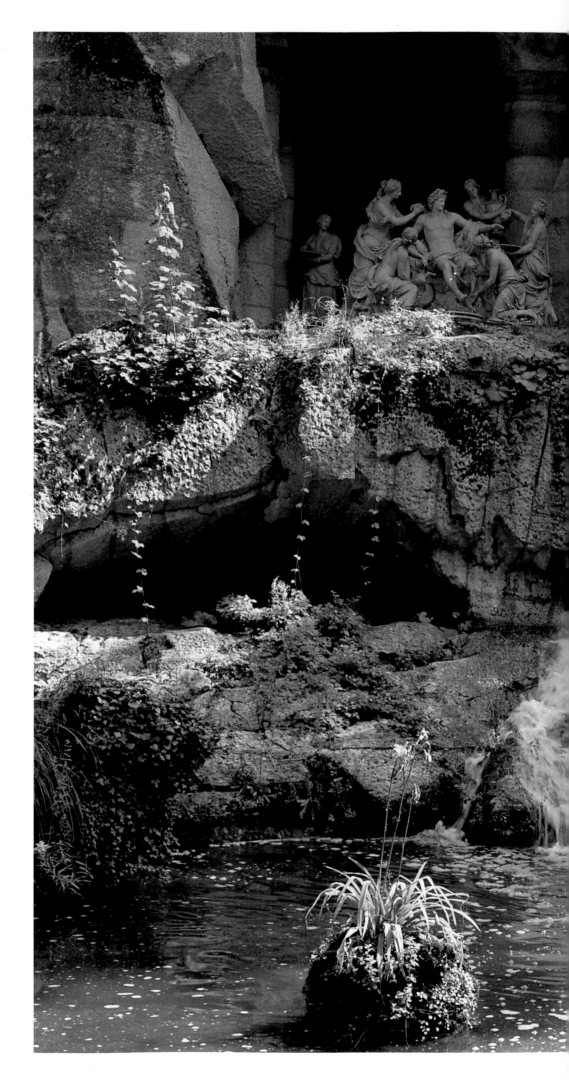

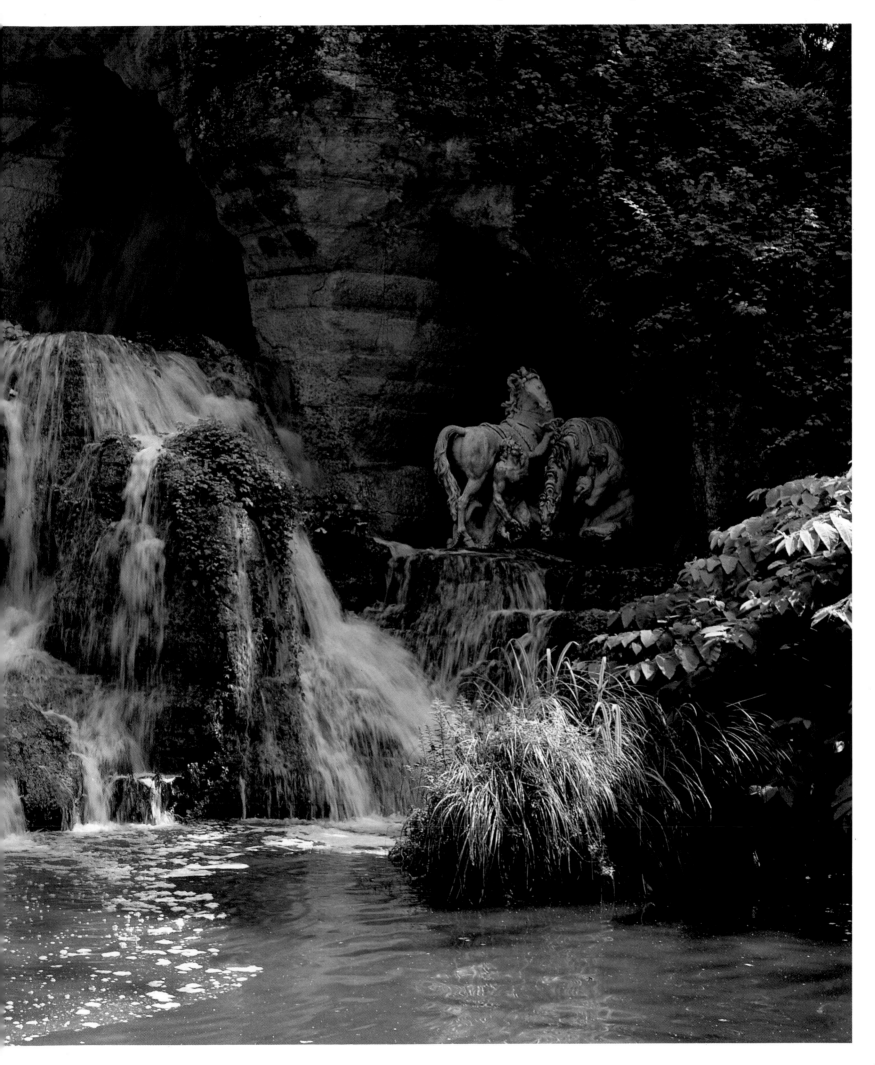

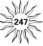

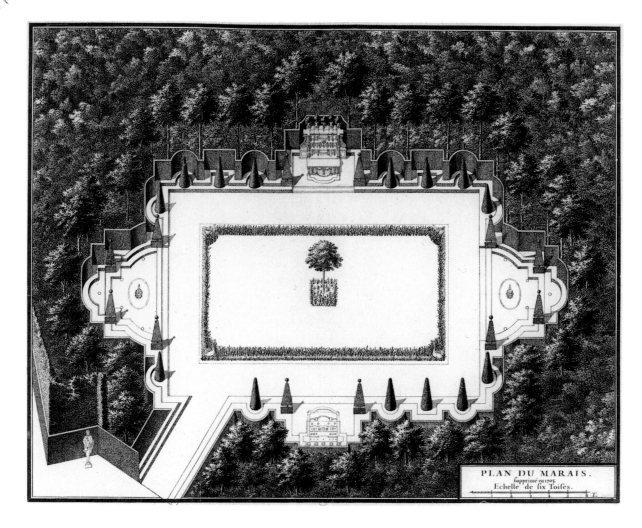

PLAN DU MARAIS.
supprimé en 1705.
Echelle de six Toises.

The Marais or upper bosquet

The bosquet was surrounded by a raised band of turf, with yews clipped into pyramids and cones in front of trelliswork niches.

At each end was a *cabinet de verdure* with an oval 'dining table' of marble, on which stood a gilded basket filled with tin flowers painted in lifelike colours, with a jet of water spouting from the centre.

On either side of the bassin were *buffets d'eau* of red and white marble, made from models by Mazeline and Houzeau. Along the top of each was a row of five marble vases, between which the water bubbled then ran down the *buffet* in a smooth sheet; other jets emerged from gilded metal frames shaped like vessels, creating the illusion of rock crystal ewers set in metal mounts.

The diagrammatic view (*left*) shows the overall design. Cotelle's view (*opposite*) conveys the effect in colour, with the fountains playing. Beside one of the 'dining tables', Venus watches over the sleeping Adonis.

The Bosquet du Marais or du Chêne-Vert

This first bosquet, on the higher ground within the compartment of woodland, was laid out by Le Nôtre and Francine between 1670 and 1674. The genesis of its creation was explained by Charles Perrault in his *Mémoires de ma vie*: 'The king left everything in the hands of M. Colbert, and M. Colbert turned to us [the Perrault brothers] for the majority of the designs that were needed. But the ladies, noticing that the king took great delight in this, wished to contribute to his pleasure.... Madame de Montespan provided the design for the Marais.'

A large rectangular bassin, surrounded by turf and fringed with tin reeds hiding waterspouts, had a swan in *métail* by Houzeau at each corner with a jet of water emerging from its beak. In the centre of the bassin was a rock decorated with more reeds, also with jets among them, and standing on this rock was a tree fashioned of iron with tin leaves and jets springing from the tips of the branches, spraying water over the bassin. The ensemble was highly elaborate, with all the metalwork painted in naturalistic colours to give the illusion of a real marsh. The tree was called the Chêne-Vert (green oak), providing the bosquet with its alternative name. All was destroyed in 1705.

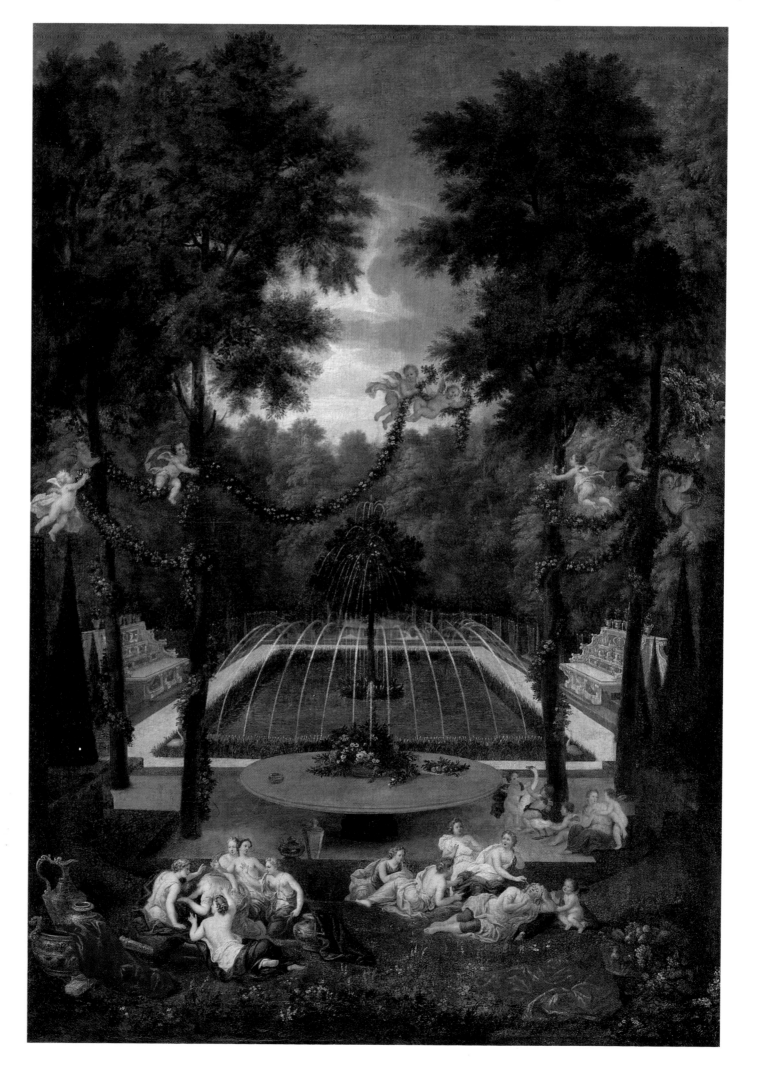

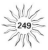

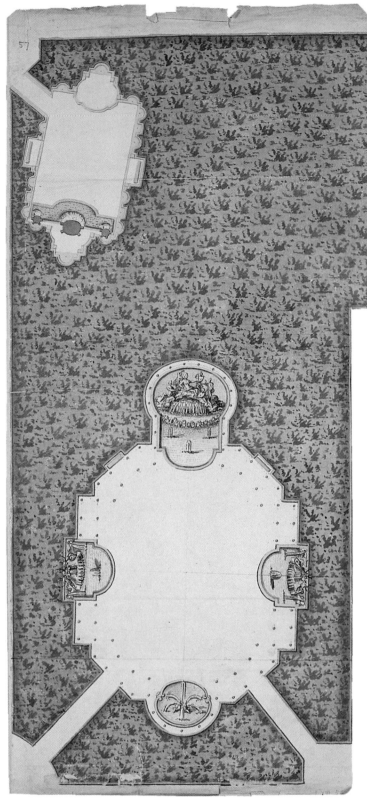

The new Bosquet des Bains d'Apollon, and early forms of the lower bosquet

When the bosquets of the Jardin Bas were altered in 1704–5, the groups of Apollo and the Horses of the Sun, originally from the Grotte de Téthys, were moved from the Bosquet des Dômes to the Bosquet du Marais, which underwent a complete transformation. The large bassin was destroyed, and the table opposite the entrance was replaced by a monumental fountain on which the three groups were installed.

Possibilities for the lower part of the bosquet were being considered as early as 1684. As in the Salle de Bal, the difference in levels would have made the construction of a cascade feasible, and two projects on the theme of Parnassus, by Le Nôtre and Hardouin-Mansart, were presented to Louis XIV the following year. The idea was soon abandoned, then taken up again in 1699 but with no greater success.

After the upper part had been remodelled as the Bains d'Apollon, it was proposed in 1713 to lay out the lower part as Bains de Diane. That project too was abandoned.

Finally, in 1736, the lower part of the bosquet was laid out by Louis XV as a pleasure ground for his son, the Dauphin.

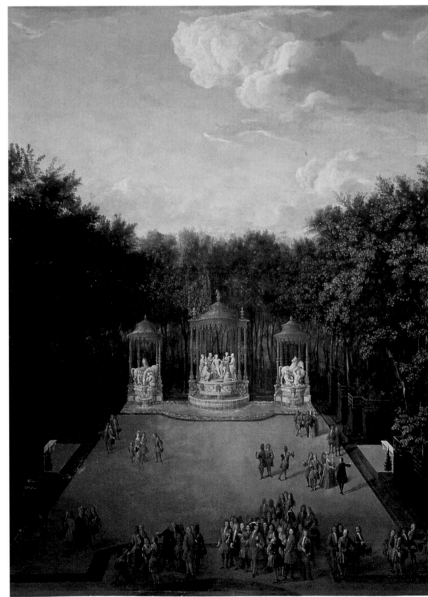

The two bosquets

A plan shows the existing upper-level Bosquet des Bains d'Apollon (top) and a proposal for a new large lower-level Bosquet des Bains de Diane. Models for three fountains were made by Hardy, but with the king's death in 1715 the scheme went no further.

The Bosquet des Bains d'Apollon

The three sculptural groups were placed on marble plinths, with waterspouts in masks set along the front, and protected from the weather by three richly worked and gilded canopies. This painting by Pierre-Denis Martin, commissioned for the Salon des Sources at Trianon, shows the opening ceremony at the bosquet conducted by the king in 1705.

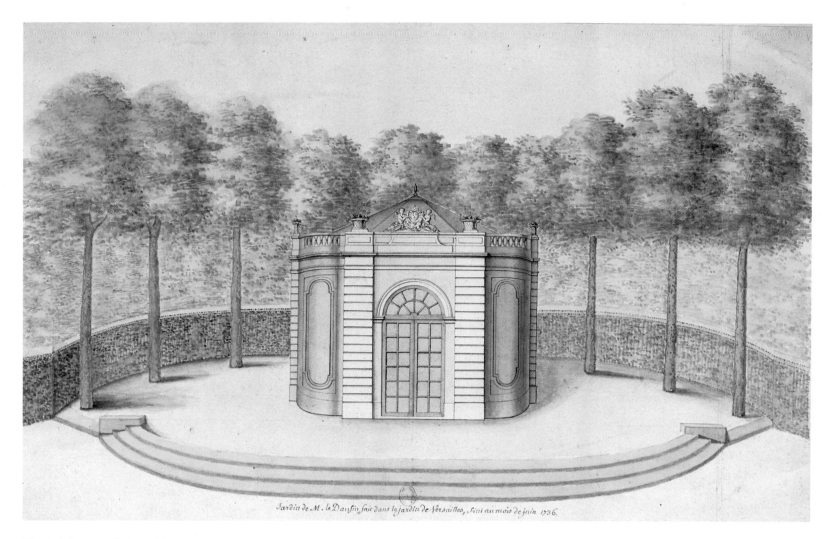

Jardin de M. le Dausin, fait dans le jardin de Versailles, fini au mois de juin 1736.

The Petit Bosquet du Dauphin

An octagonal pavilion designed by Jacques Gabriel, Premier Architecte du Roi, was set on a horseshoe-shaped terrace. The parterre facing it contained a fountain with a child riding a dolphin and, from 1746, two statues of the Dauphin's parents (commissioned by the Duc d'Antin in 1725 for the park of his residence at Petit-Bourg). Queen Marie Leczinska as Juno was the work of Guillaume Coustou the elder, and Louis XV as Jupiter was by Guillaume's brother Nicolas. A few years later, the bosquet was destroyed and the statues sent first to Trianon, then to the Louvre.

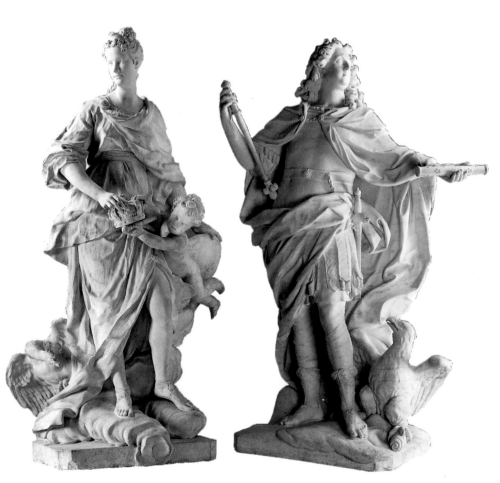

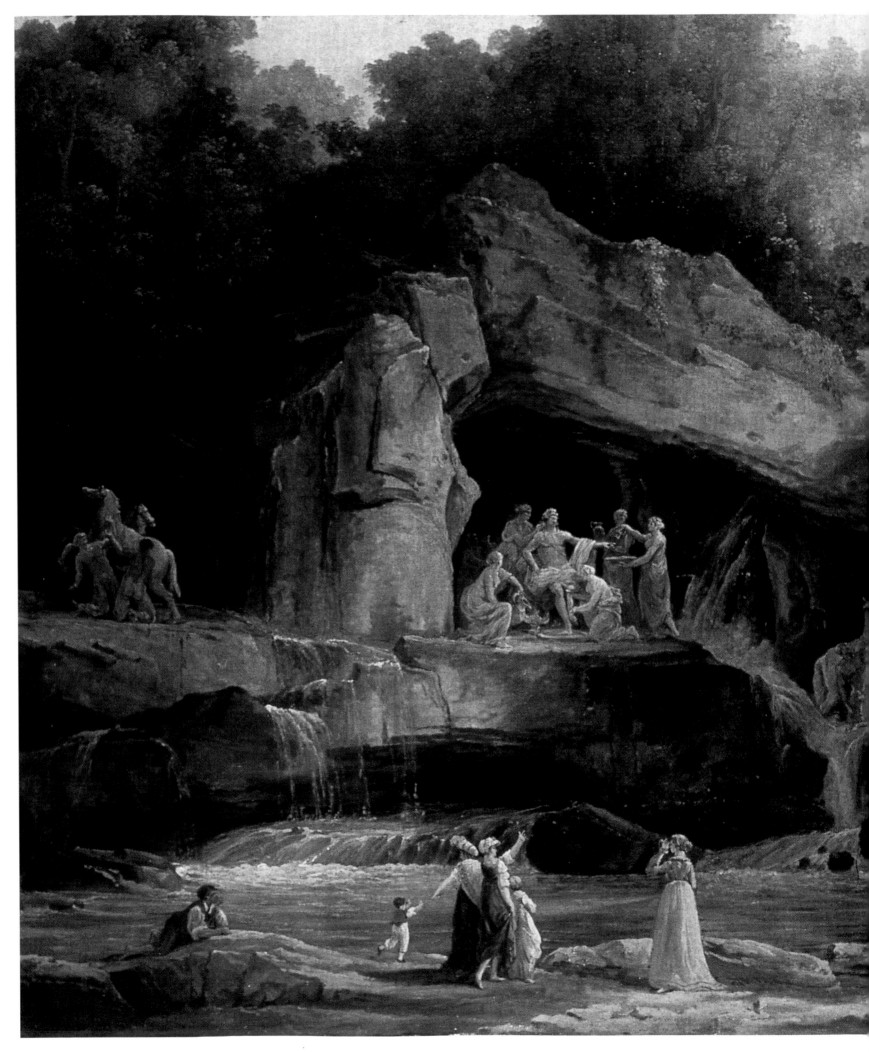

The Bosquet de la Grotte des Bains d'Apollon

In 1774, on the accession of Louis XVI, grandson and successor of Louis XV, replanting of the gardens of Versailles began. At that time, the upper and lower parts of the bosquet were united to form a setting for the groups of Apollo and the Horses of the Sun. The architect Richard Mique and the painter Hubert Robert both submitted plans, and finally that of the latter was implemented in 1778.

Although in a different setting, the groups were arranged as they had been in the Grotte de Téthys. The Sun, in the guise of Apollo, is tended by six nymphs at the end of his daily course through the sky, while his horses, one group on each side, are groomed by tritons.

The Grotte des Bains d'Apollon

To provide protection for the three groups, Hubert Robert took up the theme of the former Grotte de Téthys (ill. p. 123) and reinterpreted it as a naturalistic grotto in the style of the English garden.

Positioned in the centre of the bosquet and orientated to the west, the grotto was surrounded by paths which led from the entrances on the east and west. The sculptor Yves-Eloi Boucher made the first model for the rock formation, which was then executed by the brothers Thévenin, builders employed by the Bâtiments du Roi. In 1781 the three groups were installed.

This painting, by Hubert Robert, shows the romantic effect of the grotto in 1803.

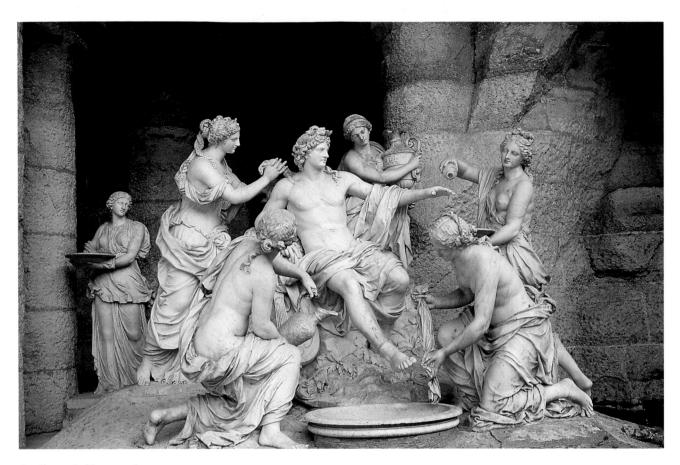

Apollo tended by nymphs

The group of seven marble figures was carved between 1666 and 1675 by Girardon in collaboration with Regnaudin. A Classical ensemble on a mythological theme, it includes a specific allusion to the reign of Louis XIV: a frieze on the ewer carried by the nymph kneeling beside Apollo illustrates the crossing of the Rhine by the French army during the Dutch war.

The Horses of the Sun

The pieces were commissioned in 1666 from two artists of the first generation of sculptors at Versailles, Gilles Guérin and Thibaut Poissant, but ultimately Guérin alone carved the left-hand group (*right*), while the right-hand group (*opposite*) is by Gaspard and Balthazar Marsy.

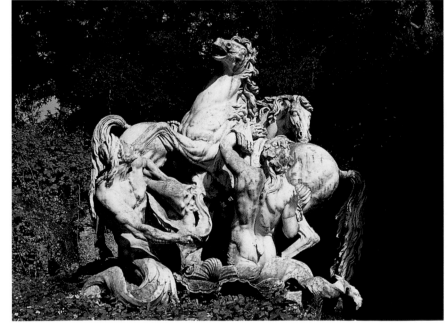

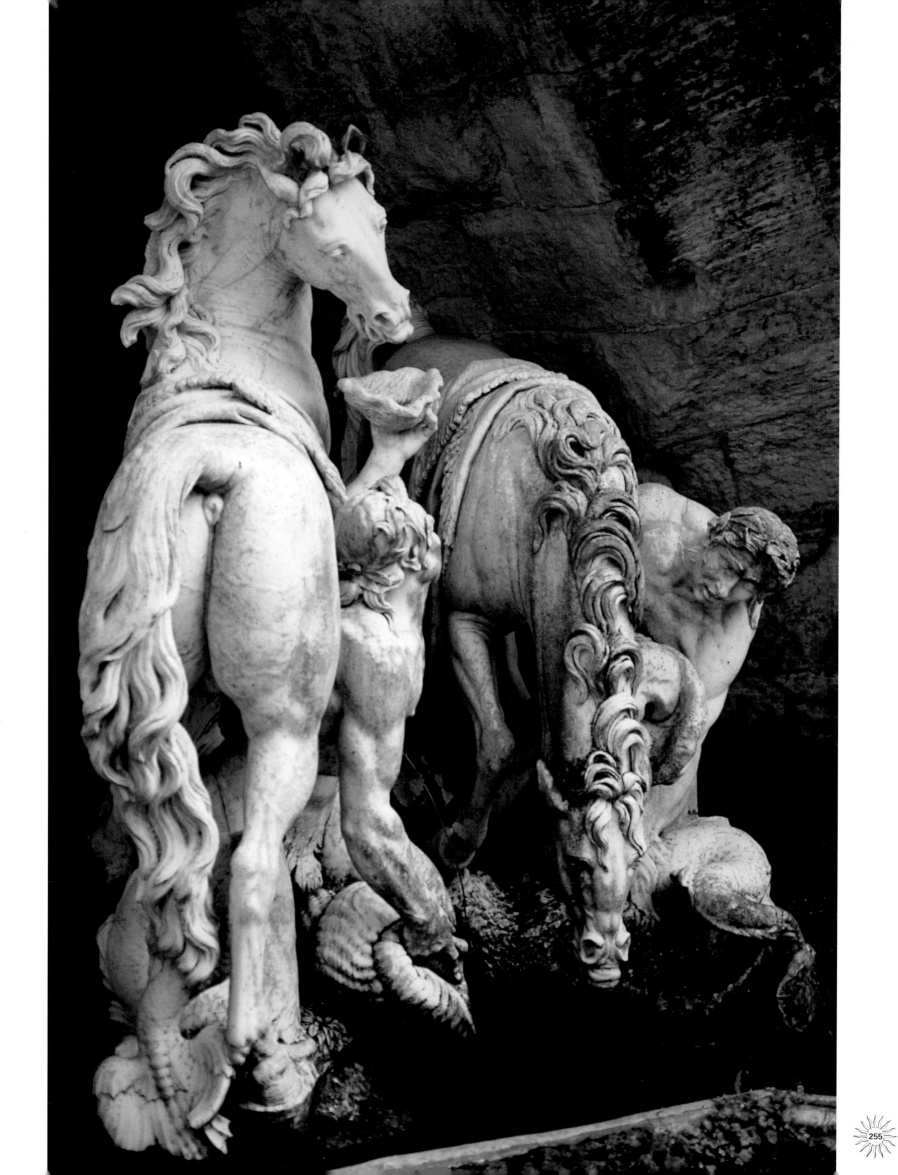

'The great art is to please…'

MOLIÈRE
La Critique de l'Ecole des Femmes (1663), Scene 6

Molière was one of the great dramatists of
the seventeenth century, and his works were often
presented for the first time in the gardens of Versailles.
His comedies of manners reflected society
during the reign of Louis XIV, and this comment by
one of his heroes is indicative of the attitude
of the artist to the power of
the monarchy.

Hornbeam (*Carpinus betulus*)
Third and last species representative of the French garden, the common hornbeam is a tree tolerant of shade and easy to clip. Used in straight *palissades* along allées and round parterres and bosquets, it forms those walls of greenery up to 8 metres (26 feet) high known as *charmilles* which lend the gardens of Louis XIV their characteristic aspect.

III
LIGHT DIVERSIONS AND MAJOR ENGINEERING

Fêtes

Waterworks

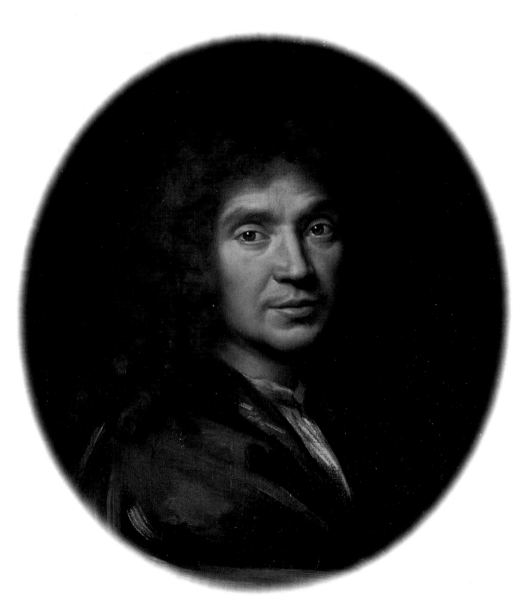

Fêtes

Jean-Baptiste Poquelin, called Molière (1622–73)
Appointed Comédien du Roi in 1665, Molière achieved a synthesis between comedy, music and dance, and prepared the way for the *ballet de cour* to develop into the *comédie-ballet* interpreted by professionals. In 1680 his theatre company merged with that of the Hôtel de Bourgogne and gave birth to the celebrated Comédie Française. (Portrait by Pierre Mignard)

IF THE OVERALL STRUCTURE of the garden layout was indicative of the order demanded by Louis XIV in public, the settings of the bosquets on the other hand are sumptuous, magnificent and above all imaginative. A number of them were devised originally for a fête for which they provided the background scenery, and were only given their definitive form at the end of the festivities, by which time their ephemeral décor had inspired their future arrangement.

Court festivities were known as *fêtes galantes* and were organized by the special Département de l'Argenterie, des Menus Plaisirs et Affaires de la Chambre. They were conceived for the private pleasure of Louis XIV, and developed into vast operations intended to integrate the nobility into the new political framework of the kingdom, and to spread propaganda about the greatness of France.

Like the decorations of the gardens themselves, the fêtes at first drew their themes from the tradition of great sixteenth-century celebrations influenced by the Italian Renaissance, before turning to direct glorification of the king.[42] They then became the subject of written and illustrated accounts, to be sent into the French provinces and to foreign courts.

The story of the fêtes is that of the evolution of the performing arts: from being amateur actors in a private entertainment organized for themselves, the king and his courtiers gradually became honoured spectators at a public show which was left more and more to professionals.

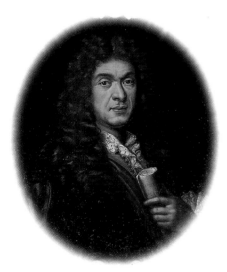

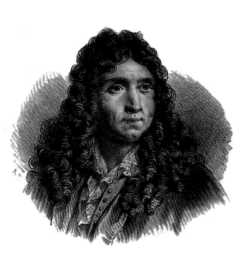

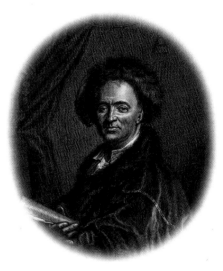

Jean-Baptiste Lulli (1632–87)

Lulli was a Florentine musician who became Surintendant et Compositeur de la Musique de Chambre du Roi in 1661. He introduced France to *tragédie lyrique* or opera, which replaced *comédie-ballet*, and then became Director of the Académie de Musique.

Charles-Louis Beauchamps (1636–1705)

In 1664 Beauchamps was appointed Maître de Ballets in the new Académie de Musique founded by the king, and was responsible for establishing rules for ballet, which became the province of experts.

Previously, at the beginning of the reign, the king and nobility had taken part in ballets written for them by court poets. In 1653 the king appeared as Apollo in the ballet of *Night*, composed by Benserade, and in 1662 in the Tuileries he led the tournament celebrating the birth of his son. After that, he participated increasingly rarely, and appeared for the last time in 1669 in the ballet of *Flora*.

Jean Bérain the younger (1640–1711)

Appointed Dessinateur de la Chambre et du Cabinet du Roi in 1674, Bérain succeeded Henri Gissey then Charles Vigarani as manager of the decorations for the royal fêtes. He helped to form the style of theatrical costumes and décor which marked the whole period.

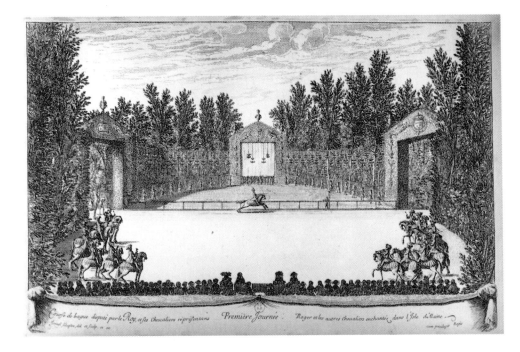

The first day:

Opening ceremonies

On the site of the former bassin at the entrance to the Allée Royale, the guests found a bank of tiered seating. The 'stage' was backed by a frame covered with pine branches, with three porticos decorated with military trophies and surmounted by the royal arms.

At about six in the evening the spectacle commenced with a procession led by the herald of arms followed by three pages, four trumpeters and two drummers. Next came the king as Ruggiero (one of the heroes of *Orlando furioso*) preceded by the Duc de Saint-Aignan, eight trumpeters, two drummers, and the Duc de Noailles, and followed by the nobles of the kingdom who, advancing two by two, acted the part of Ruggiero's suite. The procession was brought up by Monsieur le Duc, son of the Prince de Condé, acting the part of Orlando.

All the knights and their horses were magnificently arrayed. Louis XIV wore a breastplate of cloth-of-silver covered with gold embroidery and diamonds; the plumes on his helmet were flame red and his horse's harness gleamed with gold, silver and precious stones. The device on his shield, which was carried by a page in flame-red livery, was a sun with the motto, composed by Périgny, '*nec cesso, nec erro*' (I neither stop nor stray).

The procession was followed by the chariot of Apollo, drawn by four horses in caparisons decorated with golden suns, and driven by a coachman dressed as Time. Inside were the Ages of Gold, Silver, Bronze and Iron, played by actors from Molière's company. The Hours of the Day and the Signs of the Zodiac flanked it, followed by the knights' pages carrying their lances and shields. Twenty shepherds in charge of the barrier for tilting at the ring completed the procession, which came to a halt facing the queen and queen mother.

Apollo and the Four Ages recited a compliment to Queen Marie-Thérèse and announced the return of the Age of Gold (*left, above*).

Tilting at the ring

The king took part in the contest in which the knights had to dislodge at the gallop with the tip of their lance a ring suspended from a post. The brother of Mademoiselle de La Vallière was the winner, and received from the hands of the queen mother, Anne of Austria, a gold sword set with diamonds.

'Les Plaisirs de l'Isle Enchantée'

THE GARDENS OF VERSAILLES were used as the theatre for three great *fêtes galantes*. Under the title of *Plaisirs de l'Isle Enchantée*, the first took place during the week of 7–14 May 1664, in three days of festivities, and attracted six hundred guests. The themes, derived from fêtes of the preceding reign, were very specific and were chosen for the occasion by the Gentilhomme de la Chambre, François de Beauvilliers, Duc de Saint-Aignan: they came from the allegorical poems *Orlando furioso* by Ariosto and *Gerusalemme liberata* by Tasso. By using her magic, the sorceress Alcina held Ruggiero and his knights on her enchanted island; to keep themselves amused, the captives took part in tilting at the ring and attended a play and a ballet.

The scenery for the fête was devised by Charles Vigarani, Intendant des Machines et Plaisirs du Roi, and the decorations and costumes were made by Gissey. Charles Perrault was charged with writing the official account, illustrated by Israël Silvestre.

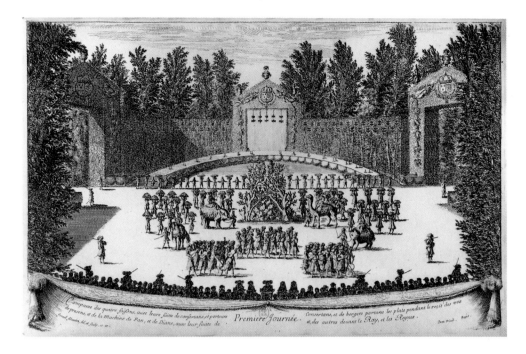

The procession of the Seasons

At nightfall the king rejoined the two queens. Chandeliers were lit, and thirty-four musicians played for ballets which were danced by the Signs of the Zodiac and by the Seasons – acted by four members of Molière's company mounted on a Spanish steed, an elephant, a dromedary and a bear. They were followed by twelve gardeners, twelve harvesters, twelve grape-pickers, and twelve old men who brought in the refreshments.

Fourteen musicians preceded another chariot in the form of a rock with two laurel trees (*left*) in which sat Molière and his wife as Pan and Diana, reciting a complimentary speech to the royal couple.

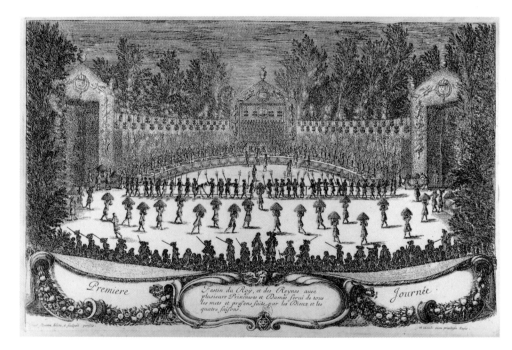

The refreshments

To the music of thirty-six violins, the Officiers de la Bouche du Roi set up a table, lit by two hundred torches carried by masqueraders. Those who took part in the meal were the queen mother, the king, the queen, Monsieur (the king's brother) and his wife, and thirty-six ladies of the court accompanying them, including Mademoiselle de La Vallière. The male courtiers, gathered behind the barrier, were only allowed to look on. Once the refreshments were finished, the court returned to the château in coaches.

Louise-Françoise de La Baume Le Blanc, Duchesse de La Vallière et de Vaujours

The fête was officially in honour of the queens, Anne of Austria and Marie-Thérèse, but tacitly it was understood to be dedicated to Mademoiselle de La Vallière, the king's favourite from 1661 to 1667 and lady-in-waiting to Madame, wife of the king's brother. (Portrait by Jean Nocret)

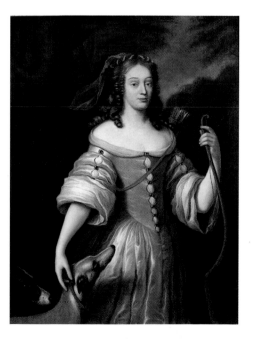

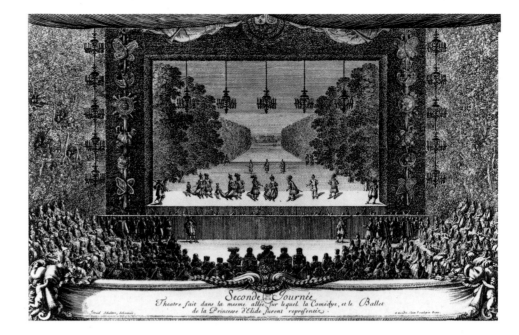

The second day:

Comedy with dance and music

At nightfall, Ruggiero and his suite presented for the queen's pleasure a spectacle which was held in the middle of the Allée Royale. In a green theatre, covered with a canvas awning and lit by torches, the guests saw the première of *La Princesse d'Elide*, a comedy by Molière with music and ballet interludes by Lulli, choreographed by Beauchamps and with costumes designed by Gissey.

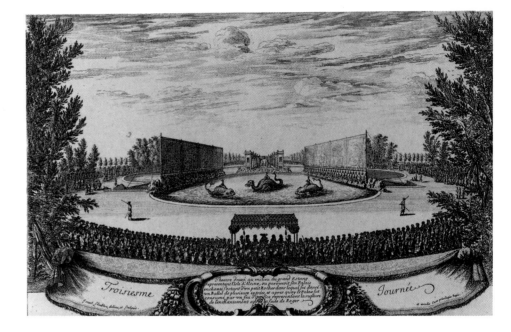

The third day:

Ballet du Palais d'Alcine

The bassin at the far end of the Allée Royale (soon to be decorated with the Fontaine d'Apollon) was the scene of the island and palace of Alcina, where she held prisoner Ruggiero and his knights. Violinists, trumpeters and drummers sat on two daises hung with tapestry.

The spectacle commenced at nightfall, with three actresses from Molière's company, riding sea-monsters, playing Alcina, Celia and Dirce. They explained the action of six ballet interludes, danced by four giants and four dwarfs.

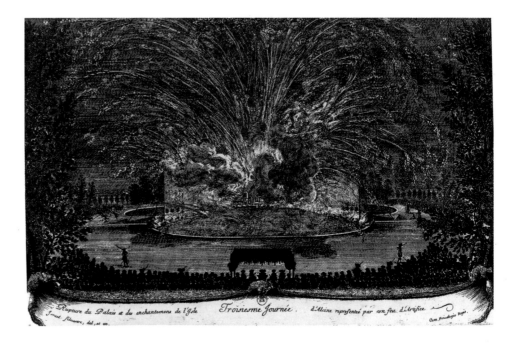

The fireworks

In the last scene Melissa slipped on to Ruggiero's finger the ring which destroyed the power of Alcina. A crack of thunder followed by a firework display marked the liberation of the knights and the destruction of the palace.

The festivities continued until 14 May, with tilting at the quintain, visits to the Ménagerie, a lottery and theatrical performances, including the first version of Molière's *Tartuffe*. The court then proceeded to Fontainebleau.

'Le Grand Divertissement Royal de Versailles'

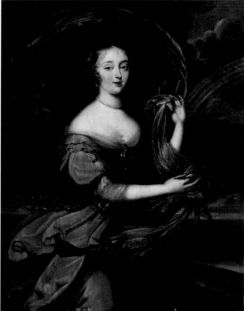

THE SECOND great fête of the reign was held on a single day, 18 July 1668. Ten years later, the historiographer Félibien wrote a detailed account of it, with five engravings by Jean Le Pautre as illustrations.

This time the fête was not based on literature: instead, it celebrated the Treaty of Aix-la-Chapelle, which marked the successful conclusion of the War of Devolution against Holland (1667–68).

It also honoured Louis XIV's new favourite, Madame de Montespan.

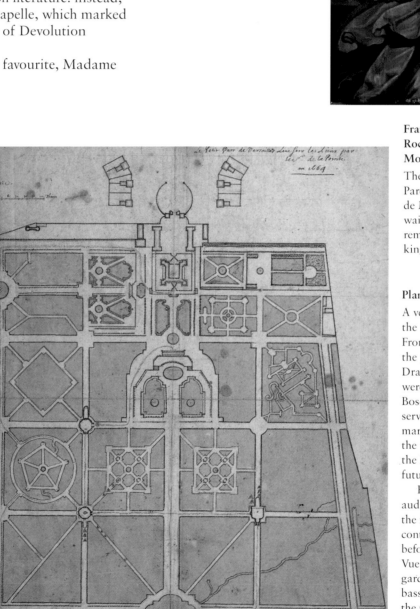

Françoise Athénaïs de Rochechouart, Marquise de Montespan

The wife of Louis-Henri de Pardaillan de Gondrin, Marquis de Montespan, was lady-in-waiting to the queen. She remained in favour with the king from 1667 to 1680.

Plan of the fête

A very faint brown line shows the route taken by the guests. From the château (top centre) the party went to the Bassin du Dragon (top left). Refreshments were served in the pentagonal Bosquet de l'Etoile (kitchen and service tents are drawn in the margin). Guests then followed the wall of the gardens down to the Pièce d'Eau des Cygnes, the future Bassin d'Apollon.

For the entertainments, the audience moved round three of the four sites which were to contain the Bassins des Saisons, before ending at the Point de Vue in the very centre of the gardens (for the locations of the bassins and the Point de Vue see the plan p. 138): from the Pièce d'Eau des Cygnes they went half-right to the future Bassin de Saturne, for a *comédie-ballet*; across to the future Bassin de Flore for a banquet; back towards the château to the future Bassin de Cérès for a ball; and finished with fireworks at the Point de Vue. (Plan by F. Delapointe, annotated)

Refreshments in the Bosquet de l'Etoile

The king arrived from Saint-Germain-en-Laye on the day of the fête, which opened in the late afternoon with a visit to the newly installed Fontaine du Dragon. Followed by the court, he then made his way to the Bosquet de l'Etoile where refreshments were served, for which the arrangements had been made by the Maréchal de Bellefonds, Premier Maître d'Hôtel.

Five sideboards made of greenery, laid with melons, figs and pomegranates, were set up round the salle of the bosquet, while the centre was filled with five serving tables decorated with a grotto composed of cold meats, vessels of wine, and a palace made of marzipan and sweetmeats. The tables were separated by three vases planted with shrubs laden with crystallized fruit.

The paths leading to the bosquet were lined with pear trees, apricot trees, orange trees, peach trees and currant bushes. At the ends of the paths were flower-decked niches holding statues of Pan and male and female fauns.

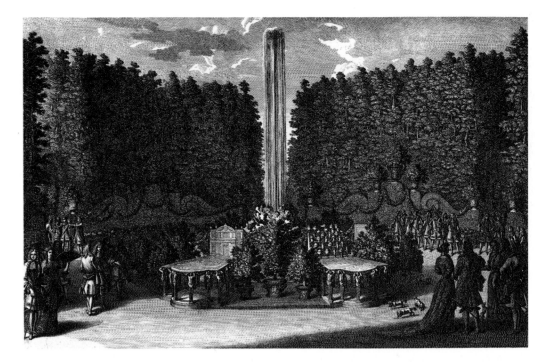

Comédie-ballet at the future Bassin de Saturne

When the refreshments were finished, the king entered his carriage, the queen her sedan chair, and the courtiers their coaches. The cortege followed the wall of the gardens, skirting the Bassin des Cygnes whose fountains gleamed in the setting sun, and arrived at the site of the future Bassin de Saturne where the gathering was greeted by a spectacle for whose arrangement François de Blanchefort, Duc de Créqui and Premier Gentilhomme de la Chambre, had been responsible.

A theatre had been constructed, designed by Vigarani, which was hung with tapestries, roofed with blue canvas scattered with fleurs-de-lis, and lit by thirty-two crystal chandeliers. Statues of Victory and Peace flanked the stage. The audience was entertained with the premiere of Molière's comedy *Georges Dandin*, and interludes of singing and dancing entitled *Fêtes de l'Amour et de Bacchus* by Lulli.

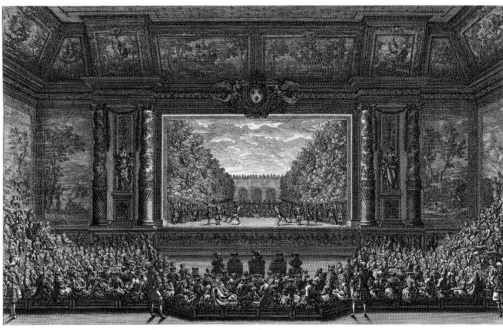

Banquet at the site of the future Bassin de Flore

The court then continued to the future Bassin de Flore to take part in a banquet laid out in an octagonal room designed by Gissey. Roofed with a dome of trelliswork open to the sky above panels painted by Georges Charmeton, the octagon was lined with arches decorated with military trophies painted on transparent panels backlit by chandeliers.

Opposite the entrance, a large serving table was laid with vases and silver plate in front of a great table occupying the middle of the room, with as a centrepiece a fountain in the form of a rock. The rock, open on all four sides and surmounted by Pegasus and by Apollo and the Muses, prefigured the central decoration in the Grand Parterre d'Eau (ills. pp. 82–83).

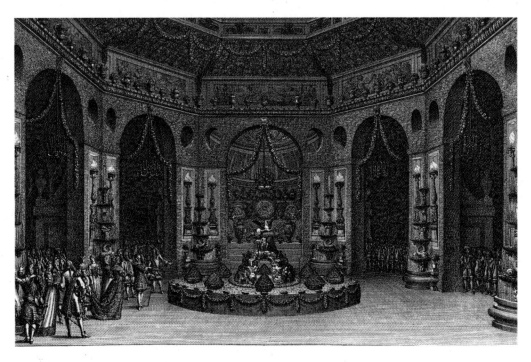

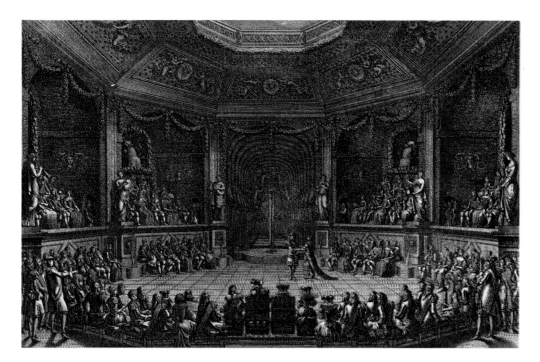

Ball on the site of the future Bassin de Cérès

The court next came to a ballroom erected on the site which was to be occupied by the Bassin de Cérès. This too was octagonal. The side facing the entrance opened into a long gallery of greenery, terminated by a rocaille grotto.

The ballroom, devised by Le Vau, seemed to be clad with marble and porphyry. Four high platforms for musicians and spectators were recessed into leafy arcades, at the back of which were rocaille niches containing Arion with two tritons, and Orpheus with two nymphs. Eight female figures on pedestals separated the recesses, and into each pedestal was set a mask spouting water into a bowl below, further decorated with two columns of water. The coved ceiling, open to the sky in the centre, consisted of eight silvered panels with a background of fleurs-de-lis, displaying golden suns held by the Months and the Signs of the Zodiac.

Lighting was provided by chandeliers concealed in the gallery extending back behind the 'stage'. That gallery, the precursor of the Théâtre d'Eau (cf. ill. p. 242), was composed of arches of greenery framed by eight satyr terms.

The view was closed by a rocaille grotto, with a fountain in the form of a sea-monster held by two tritons. Water bubbled from it, and overflowed into a first bassin decorated with monsters arranged face-to-face, who in turn spouted water into a second bassin. From here the water ran on either side of the path in two canals, punctuated by eight lances, down to the entrance of the gallery, where a column of water was thrown into the air by four dolphins.

Illuminations and fireworks at the Point de Vue, at the entrance of the Allée Royale

After the dancing, the court moved to the Point de Vue. The ramps and the bassins of the Parterre de Latone and the Allée Royale were outlined with statues, vases and terms painted on transparent illuminated frames.

When the fountains stopped playing, the first firework display was staged in the Bassin des Cygnes and the Parterre de Latone. From both sides of the château, in which the windows were lit, another display of fireworks set the sky on fire just before the first light of dawn. The court then returned to Saint-Germain-en-Laye.

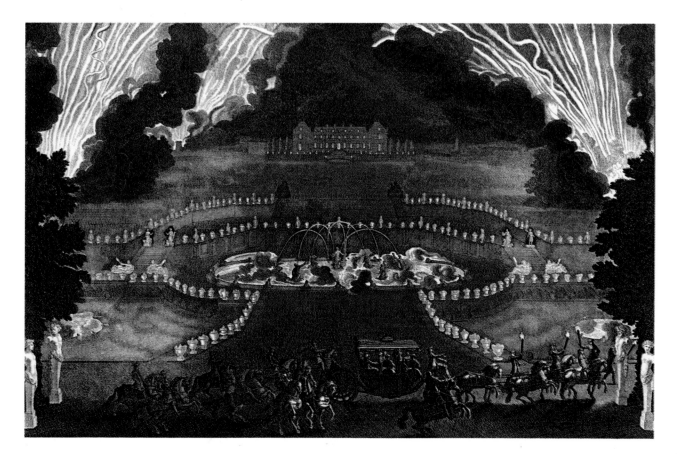

Fête for the recovery of Franche-Comté

The third great *fête galante* of the reign extended over nearly two months, marking the first long stay of the king at Versailles. Between 4 July and 31 August 1674, six days of festivities celebrated the reconquest of Franche-Comté. With the exception of Racine's tragedy *Iphigénie* which was given its premiere, all the spectacles had already been seen before during earlier fêtes.

The organization was by Colbert, the Duc d'Aumont (Premier Gentilhomme de la Chambre), and the Maréchal de Bellefonds, and the official account was once again written by Félibien, illustrated by seven engravings by Le Pautre and François Chauveau.

This was the last large-scale event staged in the gardens. After the king took up permanent residence at Versailles, the court inclined to more intimate fêtes held in apartments within the château.

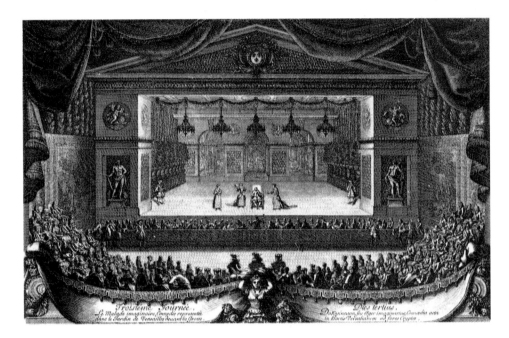

4 July

Tragédie lyrique in the Cour de Marbre.

11 July

Concert in the Trianon de Porcelaine and banquet in the Salle du Conseil, lit by over 150 chandeliers.

19 July

After refreshments served at the Ménagerie, the king and court embarked on the Grand Canal for a concert, leaving the boats at the Parterre d'Apollon where carriages were waiting to take them to the Grotte de Téthys.

The area in front of the grotto was arranged as a theatre, whose 'proscenium arch' by Le Brun was flanked by statues of Hercules subduing the Hydra and Apollo trampling the serpent Python under foot. The illuminated façade and newly positioned marble groups at the back of the grotto, visible through the open grilles, provided the scenery for Molière's *comédie-ballet* of *Le Malade imaginaire*, presented by his company a year after his death (*left*).

28 July

Refreshments in the new Bosquet du Théâtre d'Eau; ballet *Les Fêtes de l'Amour et de Bacchus* by the Bassin du Dragon; ride round the gardens in open carriages; fireworks on the Grand Canal and a '*media-noche*' (midnight) supper in the Cour de Marbre.

18 August

After refreshments served in the Bosquet de la Girandole, the court repaired to the Orangerie to watch Racine's tragedy *Iphigénie*, with the title role played by Marie Desmares (whose stage name was La Champmeslé).

Next on the programme was a firework display organized by Le Brun, watched from the Parterre de la Tête du Grand Canal (*opposite, above*). A highly ornamented frame had been erected on either side of the canal, on which the machines carrying the set pieces rolled forward – two decorated with figures of Fame, and between them a larger structure featuring a rock with an obelisk crowned by a sun. The ornamentation of the latter foreshadowed the group of France Triumphant in the future Bosquet de l'Arc de Triomphe (ill. p. 64).

Boxes of fireworks laid along the sides of the canal were set off to mark the progress of the set pieces, and when they arrived in front of the king a firework display erupted terminating in a *girandole* or cartwheel of fire.

31 August

At one o'clock in the morning, the court left the château and passing through the illuminated gardens embarked on the Grand Canal, which was also lined with lights (*opposite, below*). Two groups of fountains flanked the entrance to the canal, and arranged along its entire length and the two arms were 650 terms mounted on illuminated transparent panels, with four square pavilions marking the point where the sections of canal crossed.

The ends of the arms leading to the Ménagerie and to Trianon featured Apollo and Neptune, while the far end of the canal was arranged as the palace of Tethys. At dawn, the court returned to the château.

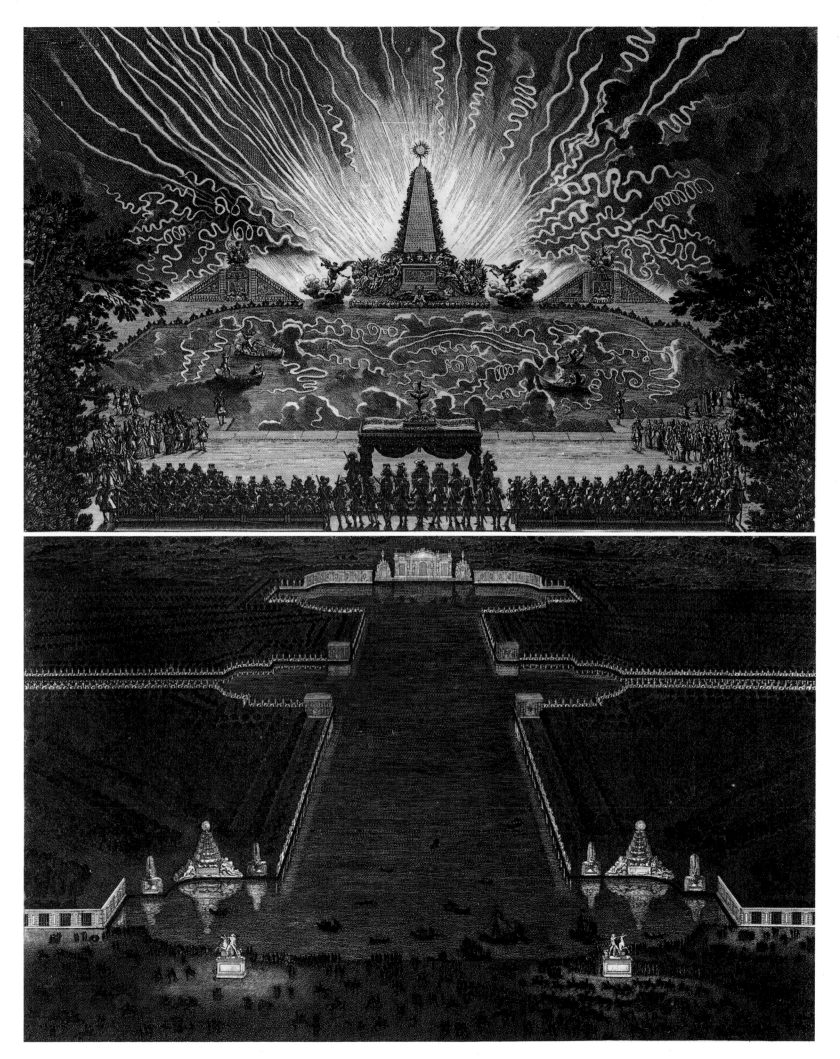

Waterworks

T HE FRENCH GARDEN was inconceivable
without ornamental water, mirror ponds,
cascades and fountains, and the country
retreats of the reign of Louis XIV were no
exception to the rule. Vaux, Chantilly, Saint-
Cloud, Liancourt, Rueil, Sceaux and many
others proudly flaunted the variety of their
water features, favoured as they were by the
proximity of ponds, streams or rivers. The
great problem of Versailles was that it was
situated on chalky soil and dramatically lacked
water, so that ever greater ingenuity had to be
exercised to find the means of satisfying royal
demands for more and more fountains, and
larger and larger pieces of ornamental water.

At the beginning of Louis XIV's reign, the
pond of Clagny to the north-west of the
château was sufficient to feed the fountains in
the gardens (ill. p. 53, top). It soon proved
unable to meet the increasing requirements,
however, and solutions were sought to the
south. Ponds and watercourses of the higher
ground near Versailles were linked to bring
water to the château, but that expedient too
soon revealed its limitations and it became
necessary to go as far as the Rivers Eure and
Seine for water in greater quantities.

To the difficulty of distance was added that
of levels: the situation of the château on higher
ground than most of the surrounding
countryside made gravity feed problematic.
Informed opinion of the time was locked in
bitter dispute over the best solution, and
incidentally opened the way to important
progress in techniques of water supply.[43]

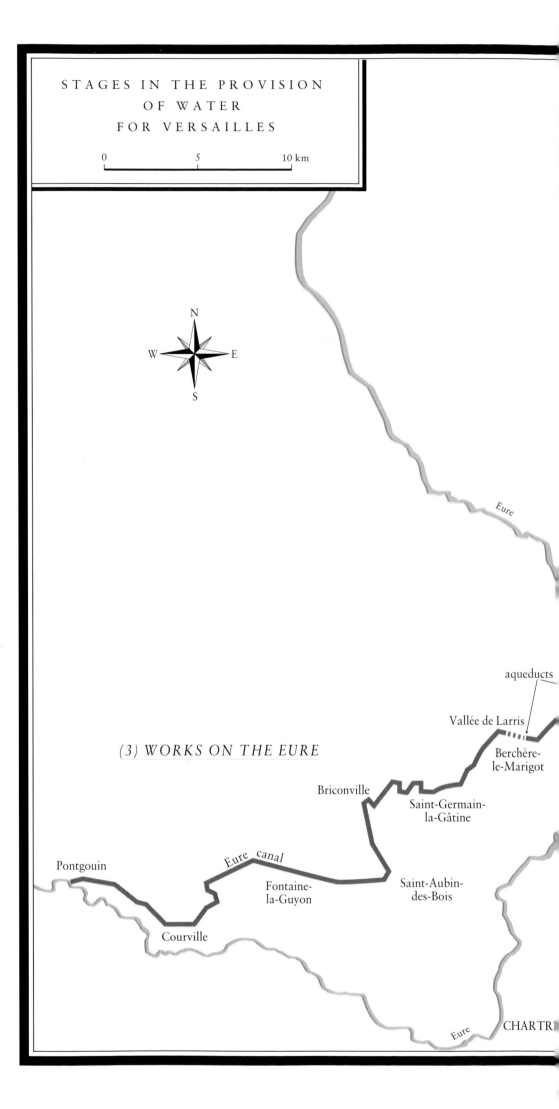

STAGES IN THE PROVISION
OF WATER
FOR VERSAILLES

0 5 10 km

Eure

aqueducts

Vallée de Larris

Berchère-
le-Marigot

(3) WORKS ON THE EURE

Briconville

Saint-Germain-
la-Gâtine

Pontgouin Eure *canal*

Fontaine-
la-Guyon Saint-Aubin-
des-Bois

Courville

Eure CHARTR

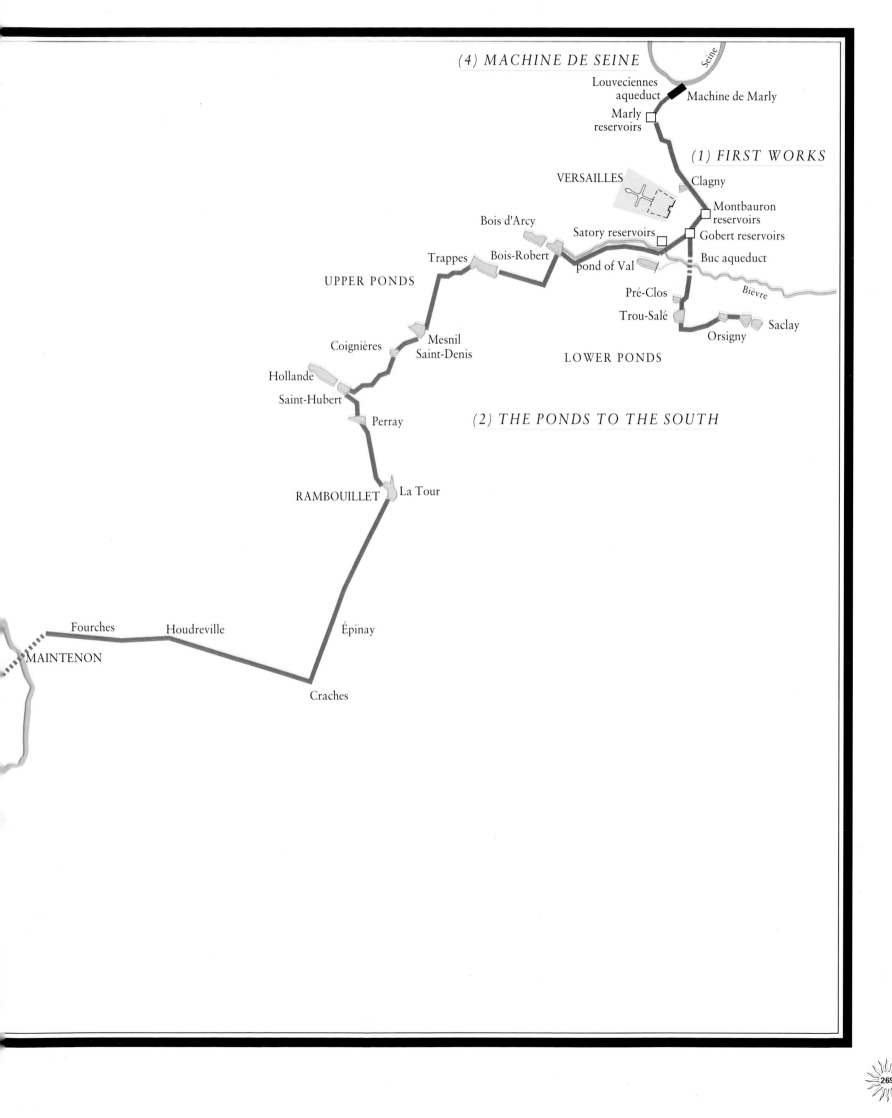

The water tower with the new pump of Clagny

Beginning in 1662, Louis XIV had his father's gardens redesigned by Le Nôtre. On the site of the first pump, in 1664 Le Vau constructed a building to house a more powerful pump designed by the engineer Denis Jolly. Driven by two horses, it forced water up to a reservoir situated on a higher storey of the building. It was improved in the 1670s but abandoned in 1680, and in 1736 the pond – which was still directly feeding the fountains at the head of the Grand Canal – was filled in.

Early works

UNDER LOUIS XIII the modest fountains in the royal park were supplied with water by a pump situated to the north of the hunting lodge, fed by the nearby pond of Clagny. Designed by the hydraulic engineer Claude Denis, this original pump was the first in a long line of sophisticated operations, necessitated by the continual elaboration and alteration of the gardens.

The reservoirs to the north

In 1666 the water tower was supplemented by a second reservoir on the roof of the Grotte de Téthys, then the following year three additional reservoirs were installed between the grotto and the pump (ill. p. 119). In 1668 the pump was reinforced by five windmills with scoops built by Le Vau north of the pond, and a sixth which brought water back from the Pièce d'Eau des Cygnes to the pond.

When the grotto was demolished in 1684, its reservoir was replaced by a water tower installed to the east. During the construction of the north wing of the château, the three reservoirs were reduced to two and repositioned to become the water supply for the wing.

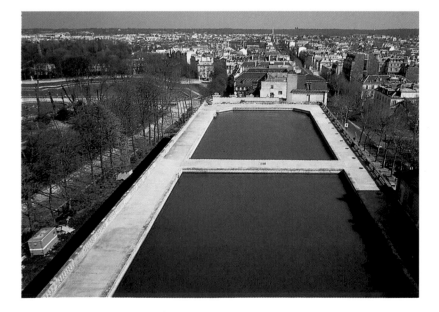

The ponds to the south

WHEN the pond of Clagny proved no longer sufficient, attention was turned to the hills of Satory, above the château to the south. In 1668 work started on the River Bièvre, which was dammed to make the pond of Val. In addition the project comprised four windmills and one watermill, the Moulin de Launay. These raised water to two reservoirs, Satory and the Désert, also linked to ponds in the hills.

Even these efforts proved insufficient. In 1678, the project of a canal from the Loire to Versailles conceived by the Fermier-Général Pierre-Paul de Riquet was judged unrealistic by the astronomer-surveyor Picart, who came forward with an idea that was adopted: to take water from the ponds of Bois-d'Arcy and Trappes.

In 1683 this operation was continued as far as Rambouillet by Picart's colleague, the mathematician Philippe de La Hire. In two years, seven ponds – known as the 'upper ponds' – were connected in this way by a channel with the earlier 'lower ponds'.

The underground reservoirs

When the first Parterre d'Eau was being laid out in 1672, the need to provide water for the new fountains led the brothers François and Pierre Francine to devise three new reservoirs under the terrace of the château. These underground reservoirs, together with those to the north of the château, are still used for the *grandes eaux* in the gardens, when the fountains play at full pressure.

The Buc aqueduct

In 1683 Thomas Gobert, an engineer who held the position of Intendant des Bâtiments, had a two-storey aqueduct built, 580 metres (1,900 feet) long, above the valley of the Bièvre to link the lower ponds – Saclay, Orsigny, Bois-Robert, Trou-Salé and Pré-Clos – to the new reservoirs in the Parc aux Cerfs, also known as the Gobert reservoirs, to the south-east of the château.

Works on the Eure

IN the face of greater and increasingly pressing demands for water, it was proposed to divert the waters of the River Eure into a canal. In 1684 it was decided to link the last of the upper ponds, La Tour, to Pontgouin, the first point in the river higher than Versailles, which would provide extra supplies through gravity.

The following year, the engineer Vauban was put in charge of the construction of the Eure canal. It was planned to be 83 kilometres (52 miles) long, with two aqueducts at Larris and Maintenon. Thirty thousand soldiers from sixteen regiments were placed under the command of the Maréchal d'Uxelles to undertake the work. Three years later the outbreak of war interrupted the operation and the project, resumed a century later under Louis XVI, was finally abandoned at the Revolution.

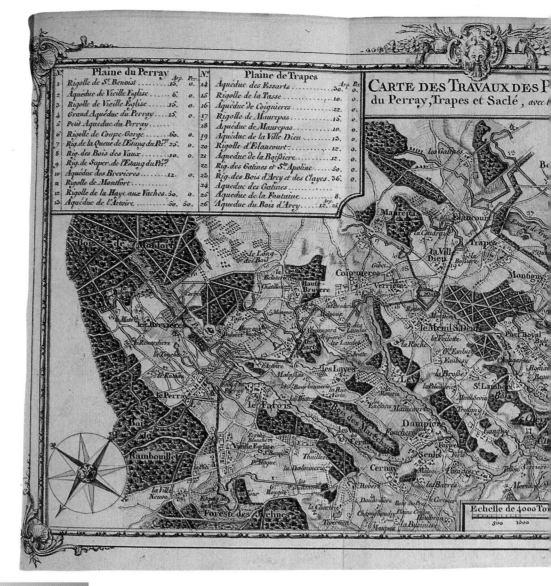

	Plaine du Perray			Plaine de Trapes	
1	Rigolle de St Benoist	15.	14	Aqueduc des Essarts	30.
2	Aqueduc de Vieille Eglise	6.	15	Rigolle de la Tasse	10.
3	Rigolle de Vieille Eglise	15.	16	Aqueduc de Coignieres	22.
4	Grand Aqueduc du Perray	15.	17	Rigolle de Maurepas	15.
5	Petit Aqueduc du Perray		18	Aqueduc de Maurepas	10.
6	Rigolle de Coupe-Gorge	60.	19	Aqueduc de la Ville Dieu	13.
7	Rig. de la Queue de l'Estang du Perray	25.	20	Rigolle d'Elancourt	12.
8	Rig. des Bois des Vaux	10.	21	Aqueduc de la Boissiere	12.
9	Rig. de Super. de l'Estang du Perray		22	Rig. des Gatines et St Apoline	60.
10	Aqueduc des Brevieres	12.	23	Rig. des Bois d'Arcy et des Clayes	36.
11	Rigolle de Montfort		24	Aqueduc des Gatines	
12	Rigolle de la Haye aux Vaches	60.	25	Aqueduc de la Fontaine	8.
13	Aqueduc de l'Arteire	60.	26	Aqueduc du Bois d'Arcy	12.

CARTE DES TRAVAUX DES P... du Perray, Trapes et Saclé, avec...

Echelle de 4000 To...

The Maintenon aqueduct

The Eure canal at Maintenon was to run in a three-tiered aqueduct, 73 metres (240 feet) high and 5 kilometres (3 miles) long. Only the lower tier was built, over a stretch of a single kilometre.

The Montbauron reservoirs

At the same time as the Eure projects were in hand, Louvois decided in 1685 on the construction of new reservoirs on the hill of Montbauron, which lay on higher ground than the château to the east of the town. Of the four planned, two were completed. Today, only the northern one is used for the *grandes eaux*.

Here we see the reservoirs in the foreground, then the town of Versailles and the entrance front of the château. (Painting by Jean-Baptiste Martin, 1688)

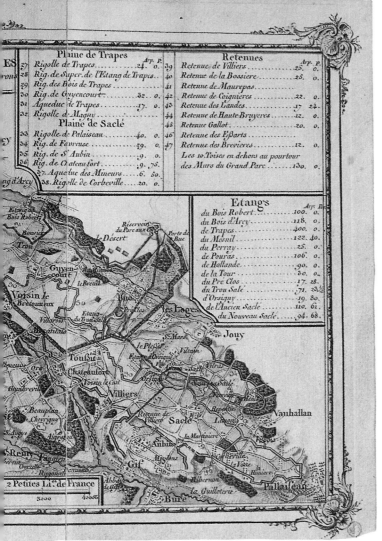

The 'machine' or pumping station of Marly
The pumping station is on the riverbank; note the aqueduct on the hill behind. (Painting by Pierre-Denis Martin, 1724)

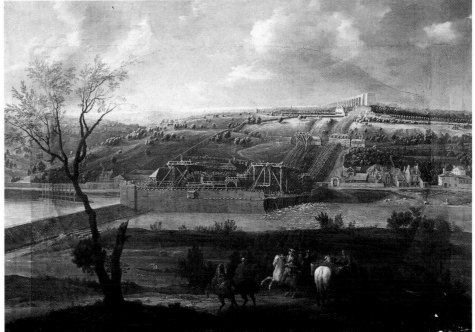

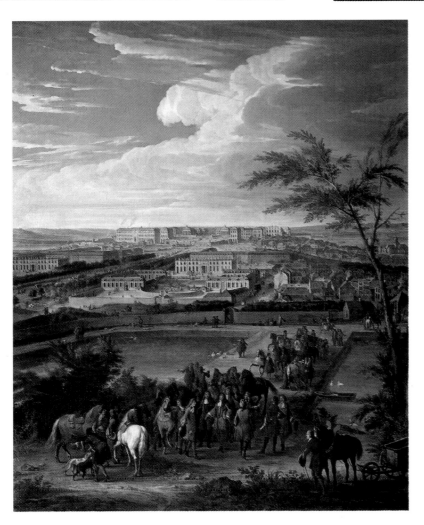

The Machine de Seine

IN THE frantic search to bring water to Versailles, in 1681 Colbert authorized the construction of a 'machine' or pumping station on the Seine. Designed by Arnold Deville from Liège in Belgium and built by the carpenter Rennequin Sualem, it collected water downstream from Bougival at the foot of the hill of Saint-Germain-en-Laye and raised it 162 metres (532 feet) to an aqueduct which took it to Marly and on to Versailles.

Due to the force of the pressure in the pipes, the operation had to be conducted in several stages. Fourteen wheels with a diameter of 12 metres (40 feet) drove sixty-four pumps which pushed the water as far as a first reservoir. From there, a series of pumps raised it to a second reservoir where a new set of pumps took it to the aqueduct of Louveciennes. The water was then piped to the reservoirs of Louveciennes and Deux Portes at Marly, and on via the Grande Ligne to Versailles.

In 1807 the old installation was replaced by a steam-powered pumping station, itself now abandoned.

*To matter, light, water and air,
to gardeners and artists, to all who created
Versailles, and to all who maintain the
gardens, ensuring their survival for
centuries to come.*

Maryvonne Rocher-Gilotte

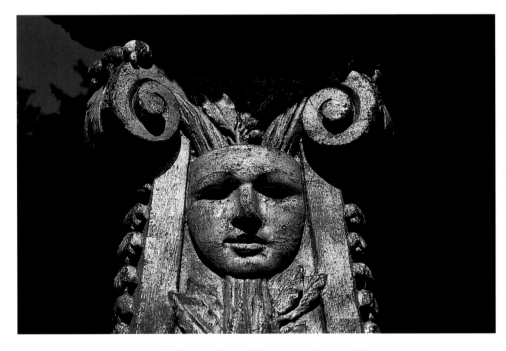

Detail of a torchère in the Bosquet des Rocailles

'Versailles, like all that is great, is now and always will be
beautiful. No matter if its fallen stones grow thick with
moss, if its gods of lead, bronze or marble lie abandoned
in its empty bassins, if its once-proud allées of clipped
trees send up dishevelled branches to the sky, even in the
ruins there will always be a majestic and thrilling spectacle
for the dreamer and the poet, who from the great balcony
looks out over eternal vistas after contemplating
ephemeral splendours.'

ALEXANDRE DUMAS
Mémoires d'un médecin. Joseph Balsamo (1846/48)

Glossary of French garden terms

allée
A path or ride of sand, gravel or turf within the garden. It may be tree- or hedge-lined, but lacks the length and breadth of the French *avenue*, which is more of an approach road.

allée d'eau
An *allée* incorporating water features.

bassin
A formal lined pond, or the bowl of a fountain. Often called 'basin' or 'bason' in seventeenth- and eighteenth-century English usage.

berceau
A vaulted arbour (from the rounded hood of a cradle, *berceau*). It may have a frame of trelliswork with plants growing over it, or may be formed of trees trained into a vault shape.

berceau d'eau
A tunnel formed of arching jets of water, framing a passage which remains dry.

bosquet
A block of woodland within a garden. After ornamentation it is properly called a *bosquet aménagé*, although this differentiation is often overlooked in English, and it is usually assumed that a 'bosquet' has been laid out in clearings decorated with statues, fountains, etc. It is roughly the equivalent of the English seventeenth- and eighteenth-century 'wilderness'.

bosquet de verdure
A *bosquet* laid out and ornamented, but relying only on plant material for decoration.

buffet d'eau
A fountain in the form of a stepped table with the water flowing down it from vessels of some sort set on the top and sometimes on the steps as well. Designed to be seen only from the front and sides.

cabinet
A small enclosure or arbour within a larger part of the garden design.

cabinet de verdure
An arbour within a bosquet formed by interlacing branches or trelliswork (*cabinet de treillages*).

charmille
A formal high hedge of clipped hornbeam (*charme*) bordering allées or bosquets.

palissade
A high clipped hedge formed of close-planted trees. In general synonymous with *charmille*, as the hornbeam was the most commonly used tree for this purpose. Lower *palissades* could be made by training jasmine or similar plants up a frame.

parterre
A formal bed of symmetrical layout, usually near the house and seen to best advantage from above.

parterre à fleurs
An early seventeenth-century term for what later developed into the *parterre de pièces coupées pour les fleurs*, in which the box-edged compartments are filled with flowers. The only specific example of this kind of parterre at Versailles was at Trianon.

parterre de broderie
(earlier known as '*parterre en broderie*') A parterre in which the matching divisions of the elaborate design are formed of box on backgrounds of coloured materials such as crushed tile, slate, sand, etc. The patterns are intricate arabesques which seen from above give the impression of embroidery.

parterre d'eau
A parterre in which the beds are replaced by bassins forming the desired pattern.

parterre de gazon
A parterre with simple squares or shapes of turf. Also known as *parterre à l'anglaise*.

parterre de gazon coupé
As above, but with a design cut into the turf.

plate-bande
A border to a parterre in the form of a narrow flower-bed, sometimes also containing topiary.

potager
Kitchen garden.

salle/salon
A large clearing in a bosquet, as distinct from a *cabinet*.

salle de verdure
A clearing whose decoration is limited to plant material.

théâtre de verdure
Ground formed to make an open-air theatre, of circular, oval or semi-circular shape, either covered in turf or more elaborately decorated.

Notes

1. Alfred de Musset, 'Sur trois marches de marbre rose', in *Poésies nouvelles* (1849).
2. Louis de Saint-Simon, *Mémoires* [1694–1723] (1953/61).
3. See Giulio Carlo Argan, *L'Europe des capitales, 1600–1670* (1964).
4. Ernst Gombrich, *The Story of Art* (1952 and later editions).
5. Germain Bazin's *Paradeisos* (English edition 1990) places the French garden in the context of garden history in general.
6. Pietro de' Crescenzi, *Liber ruralium commodorum*, 1305, translated into French by order of King Charles V in 1373 under the title of *Le Rustican*. There is no English edition, but French or Latin copies were available in England from an early date.
7. André Chastel, *La Crise de la Renaissance* (1968).
8. Leon Battista Alberti, *De re aedificatoria* (1485; French translation, *Architecture et art de bien bâtir*, 1553; English translation, *On the Art of Building in Ten Books*, Cambridge, Mass., 1988). Francesco Colonna, *Hypnerotomachia Poliphili* (1499; French translation, *Discours du songe de Poliphile*, 1546; English translation, *The Dream of Poliphilo*, 1987).
9. Denise and Jean-Pierre Dantac place the *jardin à la française* in the context of garden history in France in *Le Roman des jardins en France, leur histoire* (1987). Kenneth Woodbridge analyses the evolution of the style in *Princely Gardens. The Origins and Development of the French Formal Style* (1986), as does William Howard Adams in *The French Garden 1500–1800* (1979).
10. Chastel, op. cit.
11. Bernard Palissy, *Recepte véritable par laquelle tous les hommes de la France pourront apprendre à multiplier leurs trésors* (1564).
12. Charles Estienne, *Praedium rusticum*, translated and expanded by Jean Liébault under the title *Agriculture et maison rustique* (1564).
13. Louis Savot, *L'Architecture française et des bâtiments particuliers* (1624).
14. Michel Conan describes the new role of the gardener in the seventeenth century in 'Les Jardins au temps du maniérisme', in *Annales de la Recherche Urbaine*, 18/19 (June 1983). He also addresses this subject in the afterwords to the 1981 republications of Salomon de Caus' *Hortus palatinus* and André Mollet's *Jardin de plaisir*.
15. Franklin Hamilton Hazlehurst, *Gardens of Illusion. The Genius of André Le Nôtre* (1980), provides a detailed study of the originality and variety of Le Nôtre's designs.
16. See Daniel Meyer, *Quand les rois régnaient à Versailles* (1982). Two other works also give detailed information on the history of Versailles: Pierre Verlet, *Le Château de Versailles* (1961), and Alfred and Jeanne Marie, *Versailles. Son histoire,* 4 vols (1968–84).
17. Jean-Baptiste Colbert, *Lettres, instructions et mémoires*.
18. Louis XIV, *Mémoires du règne pour servir à l'instruction du Dauphin* (1670).
19. Claude-François Ménestrier, *Quatre soleils vus en France* (1704).
20. For the evolution of royal discourse see Jean-Marie Apostolidès, *Le Roi-machine. Spectacle et politique au temps de Louis XIV* (1981), and Jean-Pierre Néraudau, *L'Olympe du Roi-Soleil* (1986).
21. Jean-François Blondel, *Architecture française* (1752).
22. The development of the royal town can be followed in Emile and Madeleine Houth, *Versailles aux trois visages: le Val de Galie, le château des rois, la cité vivante* (1980).
23. Simone Hoog, *Louis XIV. Manière de montrer les jardins de Versailles* (1982).
24. André Félibien, *Description de la grotte de Versailles* (1672) and *Description sommaire des jardins de Versailles* (1674 and later editions).
25. The quotation above is taken from a study devoted to the gardens, *Les Jardins de Versailles* (1906). By Pierre de Nolhac see also *La Création de Versailles, Versailles résidence de Louis XIV, Versailles au XVIIIè siècle*, and *L'Art à Versailles*.
26. Louis Corpechot, *Les Jardins de l'intelligence* (1912).
27. Bernard Jeannel, *Le Nôtre* (1985).
28. By Emanuela Kretzulesco-Quaranta in *Les Jardins du songe. 'Poliphile' et la mystique de la Renaissance* (1976).
29. Pierre de Nolhac, *Les Jardins de Versailles* (1906).
30. Gerold Weber devotes an exhaustive and fully illustrated study to the art of fountains in the seventeenth century in *Brunnen und Wasserkünste in Frankreich im Zeitalter von Louis XIV* (1985).
31. Hélène Himmelfarb, 'Un Domaine méconnu de l'empire lullyste: le Trianon de Louis XIV, ses tableaux et les livrets d'opéras, 1687–1714', in *Actes du colloque Jean-Baptiste Lully* (1990).
32. Michel Martin, *Les Monuments équestres de Louis XIV. Une grande entreprise de propagande monarchique* (1986).
33. Simone Hoog, *Le Bernin. Louis XIV, une statue déplacée* (1989).
34. Cesare Ripa, *Iconologia* (1593; French translation, *Iconologie où les principales choses qui peuvent tomber dans la pensée touchant les vices et les vertus sont représentées sous diverses figures*, 1643).
35. Claude Nivelon, *La Vie de Charles Le Brun, c.* 1700, manuscript, Bibliothèque Nationale, Paris.
36. Edouard Guillou, *Versailles. Le Palais du Soleil* (1963).
37. Christiane Pinatel, *Les Statues antiques des jardins de Versailles* (1963). Francis Haskell and Nicolas Penny, *Taste and the Antique: the Lure of Classical Sculpture 1500–1900* (London 1981).
38. Liliane Lange, 'La Grotte de Thétis [sic] et le premier Versailles de Louis XIV', in *Art de France*, 1 (1961).
39. Ovid, *Metamorphoses*.
40. Pierre Francastel, *La Sculpture de Versailles* (1930), and François Souchal, *French Sculptors of the 17th and 18th centuries. The Reign of Louis XIV*, 3 vols (1977–87).
41. In 1677 Charles Perrault published *Le Labyrinthe de Versailles*, a guide illustrated with forty-one engravings by Sébastien Le Clerc. The king's copy was hand-coloured in gouache by Jacques Bailly: it is published here for the first time in colour.
42. Marie-Christine Moine, *Les Fêtes à la cour du Roi-Soleil, 1653–1715* (1984).
43. L. A. Barbet, *Les Grandes eaux de Versailles* (1907).

Bibliography

General garden history

Bazin, G. *Paradeisos. The Art of the Garden* (English edition, London 1990)
Benoist-Méchin, J. *L'Homme et ses jardins* (Paris 1975)
Berrall, J. S. *The Garden. An Illustrated History* (London 1966)
Charageat, M. *L'Art des jardins* (Paris 1962)
Clifford, D. *A History of Garden Design* (London 1962)
Crouzet, F., M. Saudan and S. Saudan-Skira *De Folie en folies. La découverte du monde des jardins* (Geneva 1987)
Enge, T., and C. F. Schröer *Garden Architecture in Europe 1450–1800, from the Villa Garden of the Italian Renaissance to the English Landscape Garden* (Cologne 1992)
Gothein, M. L. *A History of Garden Art* (New York 1979)
Grimal, P. *L'Art des jardins* (Paris 1954)
Gromort, G. *L'Art des jardins* (Paris 1934)
Hautecoeur, L. *Les Jardins des dieux et des hommes ou la grande épopée des jardins* (Paris 1959)
King, R. *The Quest for Paradise* (Weybridge 1979)
Lehrman, J. *Earthly Paradise. Garden and Courtyard in Islam* (London 1980)
Mosser, M., and G. Teyssot, eds *The History of Garden Design. The Western Tradition from the Renaissance to the Present Day* (London 1991)
Thacker, C. *The History of Gardens* (London 1979)

Renaissance and Baroque

Acton, H. *The Villas of Tuscany* (London 1973)
Alciat, A. *Toutes les emblèmes* (Paris 1987)
Argan, G. C. *L'Europe des capitales 1600–1700* (Geneva 1964)
Bajard, S., and R. Bencini *Villas and Gardens of Tuscany* (Paris 1993)
Chastel, A. *La Crise de la Renaissance* (Geneva 1968)
Coffin, D. R. *The Villa d'Este at Tivoli* (Princeton 1960)
Colbert, J.-B. *Lettres, mémoires et instructions* (published 1868)
Colonna, F. *The Dream of Poliphilo*, translated by M. Hottinger (Dallas 1987)
Goubert, P. *Louis XIV et vingt millions de français* (Paris 1966)
Hansmann, W. *Gartenkunst der Renaissance und des Barock* (Cologne 1983)
Kretzulesco-Quaranta, E. *Les Jardins du songe. 'Poliphile' et la mystique de la Renaissance* (Paris 1976)
Le Roy-Ladurie, E. *L'Ancien Régime 1610-1770* (Paris 1991)

Mader, G., and L. Neubert-Mader *Jardins italiens* (Paris 1987)
Masson, G. *Italian Gardens* (London 1961)
Mitford, N. *The Sun-King* (London 1966)
Ripa, C. *Iconologia* (Rome, 1593: first French edition, *Iconologie où les principales choses qui peuvent tomber dans la pensée touchant les vices et les vertus sont représentées sous diverses figures*, 1643; modern French edition 1987; English edition 1991)
Shepherd, J. C., and G. A. Jellicoe *Italian Gardens of the Renaissance* (London 1925)
Strong, R. *The Renaissance Garden in England* (London 1979)
Theurillat, J. *Les Mystères de Bomarzo et des jardins symboliques de la Renaissance* (Geneva 1973)

Gardens in France

Adams, W. H. *The French Garden 1500–1800* (New York 1979)
Andia, B., G. de Joudiou and P. Wittmer *Cent jardins à Paris et en Ile-de-France* (Paris 1992)
Arneville, M.-B. d' *Parcs et jardins sous le Premier Empire* (Paris 1981)
Biver, P. *Histoire du château de Meudon* (Paris 1923)
Blondel, J.-F. *Architecture françoise* (Paris 1752–56)
Blunt, A. *Art and Architecture in France 1500–1700*

(Harmondsworth 1957 and later editions)

Bonnassieux, P. *Le Château de Clagny et Madame de Montespan* (Paris 1881)

Boyceau de la Barauderie, J. *Traité du jardinage selon les raisons de la nature et de l'art* (Paris 1638)

Campanella, T. *La Cité du soleil* (Paris 1623)

Catheu, F. de 'Le Château et le parc de Sceaux', in *Gazette des Beaux-Arts* (Paris 1939)

Caus, S. de *Hortus palatinus* (1620; French edition with afterword by Michel Conan, Paris 1981)

— *Les Raisons des forces mouvantes* (1615)

Cayeux, J. de *Hubert Robert et les jardins* (Paris 1987)

Charageat, M. 'Le Parc d'Hesdin', in *Bulletin de la Société d'Histoire de l'Art français* (1950)

Chirol, E. *Le Château de Gaillon. Un premier foyer de la Renaissance en France* (Rouen 1952)

Conan, M. 'Jardins et paysages au XVIIè siècle en France', in *Colloque du Centre Culturel de l'Ouest* (Fontevraut 1990)

— 'Les Jardins au temps du maniérisme', in *Annales de la Recherche Urbaine* 18/19 (June 1983)

Cordey, J. *Vaux-le-Vicomte* (Paris 1924)

Courville, X. de *Liancourt, sa dame et ses jardins* (Paris 1925)

Dezallier d'Argenville, A.-J. *La Théorie et la pratique du jardinage* (Paris 1709)

Dezallier d'Argenville, A. N. *Voyage pittoresque des environs de Paris ou description des maisons royales, châteaux* (Paris 1755)

Du Cerceau, J. Androuet *Les Plus excellents bastiments de France* (Paris 1576–79)

Duchesne, A. 'Des Changements de styles dans l'art des jardins et la rénovation des jardins à la française', in *Jardins d'aujourd'hui* (1932)

Estienne, C., and J. Liébault *L'Agriculture et la maison rustique* (Paris 1583)

Fleurent, M. *Vaux-le-Vicomte, la clairière enchantée* (Paris 1989)

Ganay, E. de *Les Jardins à la française en France au XVIIIe siècle* (Paris 1943)

— *Les Jardins de France et leur décor* (Paris 1949)

Gebelin, F. *Les Châteaux de la Renaissance* (Paris 1927)

Gibeault, G. *Les Anciens jardins de Fontainebleau* (Paris 1913)

Girardin, R.-L. de *De la composition des paysages* (Paris and Geneva 1777; new edition with afterword by Michel Conan, Paris 1979)

Hazlehurst, F. H. *Jacques Boyceau and the French Formal Garden* (Athens, Georgia, 1966)

Houdard, G. *Les Châteaux royaux de Saint-Germain-en-Laye 1124–1789* (Saint-Germain-en-Laye 1909)

Jardins et paysages des Haut-de-Seine de la Renaissance à l'art moderne, exhibition catalogue (Nanterre 1982)

Karling, S. 'The importance of André Mollet and his family in the development of the French formal garden', in *The French Formal Garden* (Dumbarton Oaks Colloquium on the History of Landscape Architecture, 1974)

Laborde, A. L. J. *Description des nouveaux jardins de France, et de ses anciens châteaux* (Paris 1808–25)

Laird, M. *The Formal Garden* (London 1992)

Le Dantec, D. and J.-P. *Le Roman des jardins de France. Leur origine* (Paris 1987)

Lesueur, F. *Le Château d'Amboise* (Paris 1935)

— *Le Château de Blois* (Paris 1921)

Lesueur, P. 'Fra Giocondo en France', in *Bulletin de la Société de l'Art français* (1931)

— and F. 'Pacello de Mercogliano et les jardins d'Amboise, de Blois et de Gaillon', in *Bulletin de la Société de l'Histoire de l'Art français* (1936)

Magne, E. *Le Château de Marly* (Paris 1934)

— *Le Château de Saint-Cloud* (Paris 1932)

Mariage, T. *L'Univers de Le Nostre. Les origines de l'Aménagement du Territoire* (Brussels 1990)

Marie, J. and A. *Marly* (Paris 1947)

Mayer, M. *Le Château d'Anet* (1961)

Millet, N. *French Renaissance Fountains* (New York 1977)

Mollet, A. *Le Jardin de plaisir* (1651; edition with afterword by Michel Conan, Paris 1981)

Mollet, C. *Théâtre des plans et jardinages* (Paris 1652)

Morel, J.-M. *Théorie des jardins ou l'art des jardins de la nature* (1776)

Ovid, *Metamorphoses*, translated by M. Innes (London 1955)

Piganiol de la Force, J. A. *Description de Paris, de Versailles, de Marly, de Meudon, de Fontainebleau et de toutes les autres belles maisons et châteaux des environs de Paris* (Paris 1742)

Poëte, M. *Au Jardin des Tuileries* (Paris 1924)

Renouard, N. *Les Métamorphoses d'Ovide traduites en prose française* (Paris 1621)

Saule, B. *De la naissance à la gloire. Louis XIV à Saint-Germain 1638–1682*, exhibition catalogue (Saint-Germain-en-Laye 1988)

Serres, O. de *Le Théâtre d'agriculture et mesnage des champs* (Paris 1600)

Stein, H. *Les Jardins de France des origines à la fin du XVIIIe siècle* (Paris 1913)

Strandberg, R. 'The French Formal Garden after Le Nôtre', in *The French Formal Garden* (Dumbarton Oaks Colloquium on the History of Landscape Architecture, 1974)

Ward, W. H. *French Châteaux and Gardens in the XVIth century* (London 1919)

Watelet, C.-H. *Essai sur les jardins* (Paris 1774)

Weber, G. *Brunnen und Wasserkünste in Frankreich im Zeitalter von Louis XIV* (Worms 1985)

Weiss, A. S. *Miroirs de l'infini. Le jardin à la française et la métaphysique au XVIIe siècle* (Paris 1992)

Wiebenson, D. *The Picturesque Garden in France* (Princeton 1978)

Woodbridge, K. 'The Picturesque Image of Richelieu's garden at Rueil', in *Garden History* (Spring 1981)

— *Princely Gardens. The Origins and Development of the French Formal Style* (London 1986)

Versailles

Alleau, R. *Guide de Versailles mystérieux* (Paris 1966)

Babelon, J.-P. 'La restauration des jardins de Versailles', in *Monumental* (Paris 1993)

Bellaigue, R. de *Le Potager du Roy 1678–1793* (Versailles 1982)

Berger, R. W. *In the Garden of the Sun King. Studies on the Park of Versailles under Louis XIV* (Dumbarton Oaks 1985)

Bottineau, Y. *Versailles. Miroir des princes* (Paris 1911)

Brière, G. *Le Parc de Versailles. Sculpture décorative* (Paris 1911)

Caffin-Carcy, O., and J. Villard *Versailles et la révolution* (Versailles 1988)

Combes, Sieur de *Explication historique de ce qu'il y a de plus remarquable dans la maison royale de Versailles* (Paris 1681)

Corajoud, M., J. Coulon and M.-H. Loze *Versailles: lecture d'un jardin*, Mission de la Recherche Urbaine (1982)

Dangeau, P. de Courcillon, Marquis de *Journal de la cour de Louis XIV* (Paris 1807)

Degos, G. *Le Parc de Versailles. Promenades dans un merveilleux château de verdure* (Paris 1989)

Demortain *Plans, profils des villes et châteaux avec bosquets et fontaines, dressés par le fontainier Girard* (1714–15)

Desjardins, G. *Le Petit Trianon. Histoire et description* (Versailles 1885)

Dubois, J. *Versailles aux quatre saisons* (Paris 1985)

Dussieux, L. *Le Château de Versailles, histoire et description* (Paris 1881)

Félibien, A. *Description de la grotte de Versailles*

(1672)

— *Description sommaire de Versailles* (1674 and later editions)

— *Description sommaire de Versailles antique et nouveau* (Paris 1703)

Francastel, P. *La Sculpture de Versailles* (Paris 1930)

— 'La replantation du parc de Versailles au XVIIIe siècle', in *Bulletin de la Société d'Histoire de l'Art français* (Paris 1950)

Gebelin, F. *Versailles* (Paris 1965)

Girard, J. *Versailles aux couleurs du temps* (Versailles 1983)

Girardet, G. *Manière de montrer les jardins de Versailles* (Paris 1951)

Givry, J. de *Versailles, féerie des jardins* (Les Loges-en-Josas 1988)

— and J.-P. Néraudau *Versailles. L'Ame du parc* (Paris 1985)

Guillou, E. *Versailles. Le Palais du Soleil* (Paris 1963)

Hibbert, C. *Versailles* (New York 1972)

Hoog, S. *Le Bernin. Louis XIV, une statue déplacée* (Paris 1989)

— 'Royal dédale', in *Connaissance des Arts* (1988)

Houth, E. and M. *Versailles aux trois visages: le Val de Galie, le château, la cité vivante* (Versailles 1980)

Les Jardins de Versailles et de Trianon d'André Le Nôtre à Richard Mique, exhibition catalogue (RMN, Paris 1992)

Josephson, R. 'Le Grand Trianon sous Louis XIV', in *Revue de l'Histoire de Versailles et de Seine-et-Oise* (Versailles 1927)

Jourdain, Madame *Remarques historiques sur les figures, termes et vases qui ornent les jardins du parc de Versailles, avec les symboles qui les accompagnent, 1695*, manuscript, Bibliothèque de l'Arsenal, Paris

Kemp, G. van der *Le Parc de Versailles* (Versailles 1967)

Lablaude, P.-A. 'Restauration et régénération de l'architecture végétale du jardin de Versailles', in *Monumental* (Paris 1993)

— *The Gardens of Versailles* (London 1995)

La Fontaine, J. de *Les Amours de Psyché et Cupidon* (Paris 1669)

Lange, L. 'La Grotte de Thétis [*sic*] et le premier Versailles de Louis XIV', in *Art de France* 1 (1961)

La Quintinye, J.-B. de *Instructions pour les jardins fruitiers et potagers* (Paris 1690)

Le Brun, C. *Recueil de desseins de fontaines et de frises maritimes* (Paris 1693)

Le Guillou, J.-C. *Versailles, histoire du château des rois* (Paris 1988)

Lemoine, P. *Le Château de Versailles. Le Musée national des châteaux de Versailles et de Trianon* (Paris 1987)

Le Rouge, G. *Les Curiosités de Paris, de Versailles, de Marly, de Vincennes, et de Saint-Cloud et des environs* (Paris 1716)

Levron, J. *La Vie quotidienne à la cour de Versailles aux XVIIe et XVIIIe siècles* (Paris 1965)

[Louis XIV] Hoog, S. *Louis XIV. Manière de montrer les jardins de Versailles* (Paris 1982)

Mabille, G. 'La Ménagerie de Versailles', in *Gazette des Beaux-Arts* (Paris 1974)

Marie, A. and J. *Versailles – son histoire*: 1. *Naissance de Versailles* (Paris 1968); 2. *Mansart à Versailles* (1972); 3. *Mansart et Robert de Cotte* (1976); 4. *Versailles au temps de Louis XV 1715–1745* (1984)

Mauricheau-Beaupré, C. *Le Château de Versailles et ses jardins* (Paris 1924)

Mazin, R. *Une Promenade à Versailles* (Paris 1981)

Meyer, D. *Quand les rois régnaient à Versailles* (Paris 1982)

Monicart, J.-C. de *Versailles immortalisé* (Paris 1720)

Néraudau, J.-P. *L'Olympe du Roi-Soleil. Mythologie et idéologie royale au Grand Siècle* (Paris 1986)

Nolhac, P. de *La Création de Versailles* (Versailles 1901)

— *Les Jardins de Versailles* (Paris 1906)
— *Versailles et les Trianons* (Paris 1906)
— *Versailles, résidence de Louis XIV* (Paris 1925)
— *Versailles au XVIIIe siècle* (Paris 1925)
Pérelle, A. *Recueil général du château de Versailles* (Paris 1664–89)
Pérouse de Monclos, J.-M. *Versailles* (Paris 1991)
Perrault, C. *Le Labyrinthe de Versailles* (1677; edition with afterword by Michel Conan, Paris 1982)
Pichard du Page, R. *Versailles* (Paris 1956)
Piganiol de la Force, J.-A. *Nouvelle description des chasteaux et parcs de Versailles* (Paris 1701)
Pinatel, C. *Les Statues antiques des jardins de Versailles* (Paris 1963)
Projets pour Versailles, exhibition catalogue (Archives Nationales, Paris 1985)
Raynal, M. 'Le Manuscrit de C. Denis, fontainier de Louis XIV à Versailles', in *Versailles* (1969, 1971)
Rocher-Gilotte, M., and P.-R. Leclercq *Versailles, songe royal* (Paris 1994)
Saint-Simon, L. de Rouvroy, duc de *Mémoires* (Paris 1953/1961; English translation, London 1964)
Scudéry, M. de *Promenade de Versailles* (Paris 1669)
Souchal, F. 'Les Statues aux façades du Château de Versailles', in *Gazette des Beaux-Arts* (Paris 1972)
Taylor-Leduc, S. B. 'The replantation of Versailles in the eighteenth century', in *Journal of Garden History*, vol. 14, no. 2 (1994)
Thomassin, S. *Recueil des statues, groupes, fontaines, termes, vases et autres magnifiques ornements du Château et du Parc de Versailles* (Paris 1694)

Verlet, P. *Le Château de Versailles* (Paris 1961)
Vincent, J. *Versailles, les arbres du parc* (Paris 1960)
Walton, G. *Louis XIV's Versailles* (Chicago 1986)

André Le Nôtre
Corpechot, L. *Les Jardins de l'intelligence* (Paris 1912)
Ganay, E. de *André Le Nostre* (Paris 1962)
Hazlehurst, F. H. *Gardens of Illusion. The Genius of André Le Nostre* (Nashville 1980)
Jeannel, B. *Le Nôtre* (Paris 1985)

The artists of Versailles
Benoist, L. *Coysevox* (Paris 1930)
Bourget, P., and G. Cattaui *Jules Hardouin-Mansart* (Paris 1960)
Chaleix, P. *Philippe de Buyster. Sculpteur 1595–1688* (Paris 1967)
Francastel, P. *Girardon* (Paris 1930)
Jouin, H. *Charles Le Brun et les arts sous Louis XIV* (Paris 1889)
Laprade, A. *François d'Orbay, architecte de Louis XIV* (Paris 1960)
Martin, M. *Les Monuments équestres de Louis XIV. Une grande entreprise de propagande monarchique* (Paris 1986)
Mousset, A. *Les Francine*: see 'Fountains and waterworks', below
Souchal, F. *French Sculptors of the 17th and 18th Centuries. The Reign of Louis XIV*, 3 vols (Oxford 1977, 1981, 1987)
Walton, G. E. *The Sculpture of Pierre Puget* (New York 1967)

Fêtes
Apostolidès, J.-M. *Le Roi-machine. Spectacle et politique au temps de Louis XIV* (Paris 1981)
Beaussant, P. *Lully ou le musicien du Soleil* (Paris 1991)
Benserade, I. de *Les Oeuvres de Monsieur de Benserade* (Paris 1697)
Félibien, A. *Les Fêtes de Versailles. Chroniques de 1668 et 1674* (Paris 1994)
La Gorce, J. de *Bérain, dessinateur du Roi-Soleil* (Paris 1986)
Moine, M.-C. *Les Fêtes à la cour du Roi-Soleil, 1653–1715* (Paris 1984)
Strong, R. *Splendor at Court: Renaissance Spectacle and the Theater of Power* (New York 1973)

Waterworks
Barbet, L. A. *Les Grandes eaux de Versailles. Installations mécaniques et étangs artificiels, description des fontaines et de leurs origines* (Paris 1907)
Christiany, J. 'L'Hydraulique dans l'art des jardins du XVIIe siècle', in *Colloque du Centre Culturel de l'Ouest* (1990)
Frelaut, C. *La Machine de Marly* (Louveciennes 1988)
Mousset, A. *Les Francine, créateurs des eaux de Versailles, intendants des eaux et fontaines de 1627 à 1784*, Mémoire de la Société Historique de Paris et Ile-de-France (1930)
Paris, M.-J. *Versailles. Le Grand aqueduc de Buc (1686) ou la manière de conduire les eaux au parc* (Buc 1986)

Acknowledgments for illustrations

The photographs of the gardens of Versailles are by Maryvonne Rocher-Gilotte. The sources of additional historical and documentary illustrations are set out in the list below, by page number.

b = bottom c = centre l = left r = right t = top

11 t London, British Museum; b Paris, Bibliothèque Nationale. 12 t Paris, Bibliothèque Nationale; b London, British Museum. 13 t Paris, Bibliothèque Nationale; b London, British Museum. 16 Paris, Bibliothèque Nationale. 17 t, b Paris, Bibliothèque Nationale. 18 t, b Paris, Bibliothèque Nationale. 19 Musée du Château de Versailles, RMN. 20 Paris, Bibliothèque Nationale. 21 Paris, Bibliothèque Nationale. 22–23 Musée du Château de Versailles, RMN. 24 l, r Musée du Château de Versailles, RMN. 25 l Paris, Musée du Louvre, RMN; c, r Musée du Château de Versailles, RMN. 26 Musée du Château de Versailles, RMN. 27 l Musée du Château de Versailles, RMN; c Paris, Musée du Louvre, RMN; r Musée du Château de Versailles, photo Giraudon. 28 Paris, Bibliothèque Nationale. 29 Paris, Musée du Louvre, RMN. 34–35 Bibliothèque Municipale de Versailles; 35 r Illustration by Michel Durand. 36 t Paris, Bibliothèque Nationale; b Paris, Bibliothèque de l'Institut. 37 t Paris, Bibliothèque Nationale; b Paris, Archives Nationales. 38 Musée du Château de Versailles, RMN. 39 Musée du Château de Versailles, RMN. 42 Musée du Château de Versailles, RMN. 43 b Rome, Villa Borghese. 46–47 Musée du Château de Versailles, RMN. 52 Musée du Château de Versailles, RMN. 53 t Paris, Bibliothèque Nationale. 56–57 Paris, Bibliothèque Nationale. 59 br Paris, Bibliothèque Nationale. 60–61 Paris, Bibliothèque Nationale. 62 Musée du Château de Versailles, RMN. 63 Musée du Château de Versailles, RMN. 64 Paris, Bibliothèque Nationale. 65 Paris, Bibliothèque Nationale. 66–67 Bibliothèque Municipale de Versailles. 68 tl Musée du Château de Versailles, RMN. 70–71 Bibliothèque Municipale de Versailles. 72 Musée du Château de Versailles, RMN. 73 tr Paris, Bibliothèque Nationale. 75 tl, tr Paris, Bibliothèque Nationale. 78 Paris, Bibliothèque Nationale. 79 t Paris, Bibliothèque

Nationale; c Paris, Musée du Louvre, Département des Arts Graphiques, RMN; b Paris, Bibliothèque Nationale. 82 t Paris, Bibliothèque Nationale; bl, br Paris, Musée du Louvre, Département des Arts Graphiques, RMN. 83 t Paris, Bibliothèque Nationale; b Besançon, Musée des Beaux-Arts. 88 t Paris, Bibliothèque Nationale. 91 Musée du Château de Versailles, RMN. 100 t Paris, Bibliothèque Nationale; bl Stockholm, Nationalmuseum; br Paris, Bibliothèque Nationale. 101 l, r Paris, Bibliothèque Nationale. 103 t Musée du Château de Versailles, RMN. 110 Musée du Château de Versailles, RMN. 111 Musée du Château de Versailles, RMN. 112 tr, b Paris, Musée du Louvre, RMN, photos R. G. Ojeda. 117 b Musée du Château de Versailles, RMN. 119 Musée du Château de Versailles, RMN. 120 Musée du Château de Versailles, RMN. 121 Paris, Bibliothèque Nationale. 122 Paris, Bibliothèque Nationale. 123 Paris, Bibliothèque Nationale. 124–25 Bibliothèque Municipale de Versailles. 126 Paris, Bibliothèque Nationale. 128 t Paris, Bibliothèque Nationale; 128 b–129 b Paris, Bibliothèque Nationale; 129 t Stockholm, Nationalmuseum. 140 Paris, Bibliothèque Nationale. 141 Paris, Bibliothèque Nationale. 144 Musée du Château de Versailles, RMN. 145 Paris, Musée du Louvre, RMN. 148 r Paris, Bibliothèque Nationale. 154 t, b Musée du Château de Versailles, RMN. 159 br Musée du Louvre, RMN. 162 Paris, Bibliothèque Nationale. 163 t Musée du Château de Versailles, RMN; b Paris, Bibliothèque Nationale. 164 b Paris, Archives Nationales. 165 Paris, Bibliothèque Nationale. 166–67 Bibliothèque Municipale de Versailles. 168 t Paris, Bibliothèque Nationale. 169 t Paris, Bibliothèque Nationale. 172–73 Bibliothèque Municipale de Versailles. 174 Paris, Bibliothèque Nationale. 175 Musée du Château de Versailles, RMN. 180–81 Bibliothèque Municipale de Versailles. 182 Musée du Château de Versailles, RMN. 183 (base map) Paris, Bibliothèque Nationale. 184 Paris, Bibliothèque du Petit-Palais, Ville de Paris. 185 Musée du Château de Versailles, RMN, photo G. Blot. 186 Paris, Bibliothèque du Petit Palais, Ville de Paris. 187 Paris, Bibliothèque du Petit Palais, Ville de Paris. 188 b Musée du Château de

Versailles, RMN. 190–91 Bibliothèque Municipale de Versailles. 192 Paris, Bibliothèque Nationale. 193 Musée du Château de Versailles, RMN. 198–99 Bibliothèque Municipale de Versailles. 200 Paris, Bibliothèque Nationale. 201 Musée du Château de Versailles, RMN. 202 tl, tr Paris, Bibliothèque Nationale. 203 t Paris, Bibliothèque Nationale. 204 t, b Paris, Bibliothèque Nationale. 206 Paris, Bibliothèque Nationale. 207 Musée du Château de Versailles, RMN. 219 Musée du Château de Versailles, RMN. 221 Paris, Bibliothèque Nationale. 222 Musée du Château de Versailles, RMN. 223 Paris, Bibliothèque Nationale. 230–31 Bibliothèque Municipale de Versailles. 232 Musée du Château de Versailles, RMN. 234–35 Bibliothèque Municipale de Versailles. 236 Paris, Bibliothèque Nationale. 237 Musée du Château de Versailles, RMN. 238–39 Bibliothèque Municipale de Versailles. 240 t Paris, Bibliothèque Nationale; c, b Washington, National Gallery of Art. 241 t Paris, Bibliothèque Nationale. 242 Musée du Château de Versailles, RMN. 243 Musée du Château de Versailles, RMN. 248 Paris, Bibliothèque Nationale. 249 Musée du Château de Versailles, RMN. 250 l Paris, Archives Nationales; r Musée du Château de Versailles, photo Giraudon. 251 t Paris, Bibliothèque Nationale; b Paris, Musée du Louvre, RMN. 252–53 Paris, Musée Carnavalet, Ville de Paris. 258 Chantilly, Musée Condé, photo Giraudon. 259 l Chantilly, Musée Condé, photo Giraudon; c Paris, Musée de l'Opéra; r Paris, Bibliothèque Nationale. 260 Paris, Bibliothèque Nationale. 261 t, c Paris, Bibliothèque Nationale; b Musée du Château de Versailles, RMN. 262 Paris, Bibliothèque Nationale. 263 t Paris, Bibliothèque Nationale; b Musée du Château de Versailles, RMN. 264 Paris, Bibliothèque Nationale. 265 Paris, Bibliothèque Nationale. 266 Paris, Bibliothèque Nationale. 270 t Paris, Bibliothèque Nationale; b Robert Polidori. 271 l Robert Polidori. 272–73 t Paris, Archives Nationales; 273 tr, b Musée du Château de Versailles, RMN.

Index

Figures in *italic* type refer to pages on which illustrations appear.

A reference in **bold** type preceded by an asterisk signals the main treatment of a topic (which will include illustrations).